The Ansel Adams Guide

BOOK I

Basic Techniques
of Photography

REVISED EDITION

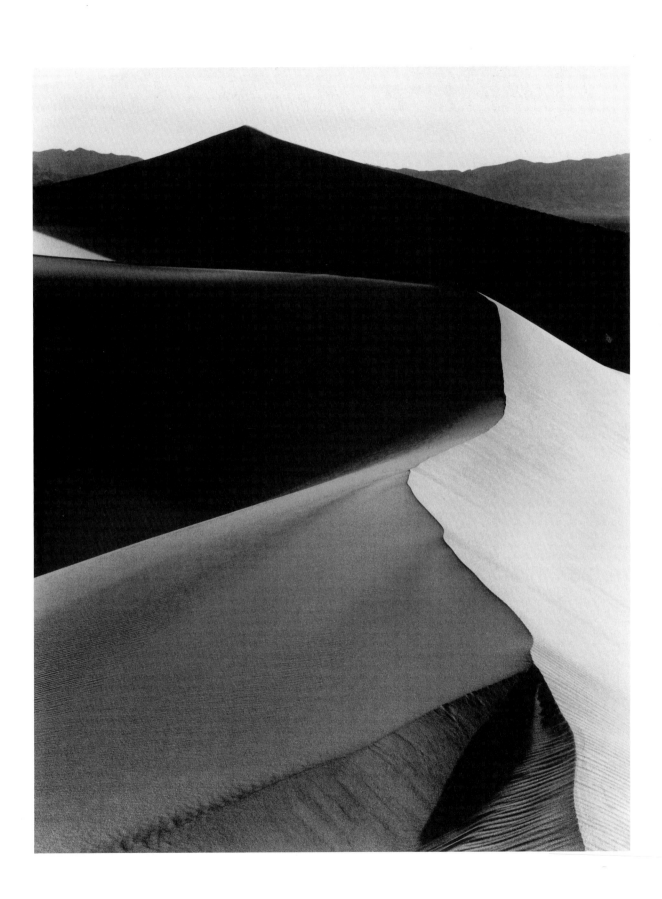

The Ansel Adams Guide

BOOK I

Basic Techniques of Photography

REVISED EDITION

JOHN P. SCHAEFER

Little, Brown and Company

Boston • New York • London

In 1976, Ansel Adams selected Little, Brown and Company as the sole authorized publisher of his books, calendars, and posters. At the same time, he established The Ansel Adams Publishing Rights Trust in order to ensure the continuity and quality of his legacy — both artistic and environmental.

As Ansel Adams himself wrote, "Perhaps the most important characteristic of my work is what may be called print quality. It is very important that the reproductions be as good as you can possibly get them." The authorized books, calendars, and posters published by Little, Brown have been rigorously supervised by the Trust to make certain that Adams' exacting standards of quality are maintained.

Only such works published by Little, Brown and Company can be considered authentic representations of the genius of Ansel Adams.

Revised Edition, 1999

Frontispiece: Ansel Adams, *Sand Dunes, Sunrise, Death Valley National Monument, California, 1948*

Library of Congress Cataloging-in-Publication Data

Schaefer, John Paul, 1934–
 The Ansel Adams Guide: basic techniques of photography/ John P. Schaefer. — Rev. ed.
 p. cm.
 Includes bibliographical references and index.
 ISBN 0-8212-2613-4 (hc)
 ISBN 0-8212-2575-8 (pb)
 1. Photography — Handbooks, manuals, etc. I. Adams, Ansel, 1902– II. Title. III. Title: Basic Techniques of Photography.
 TR146.S374 1999 98-43467
 771 — dc21

Technical photography by Alan Ross
Technical illustrations by Tom Briggs Design
Designed by Douglass Scott/WGBH Design
Typeset in Adobe Garamond by MJ Walsh, Cathleen Damplo, and Amity Femia/WGBH Design
Printed and bound by Quebecor Printing

To Ansel Adams
whose camera gave voice to his eye for beauty
and his soul's concerns

Contents

Chapter Seven
Developing the Negative 205

Chapter Eight
Introduction to Basic Printing 243

Chapter Nine
Making a Fine Print 281

Foreword to the Revised Edition

Recent technical advances have had a profound impact on the way photography is practiced today. The development of tabular-grain films by Kodak for both black-and-white and color photography has led to the introduction of high-speed, fine-grain films, the Holy Grail sought by every photographer. Other manufacturers have followed suit and introduced comparable products. One consequence of these developments has been the introduction and popularity of the Advanced Photo System (APS), whose smaller cameras and smaller film format deliver photographic results that were formerly the exclusive domain of the 35mm system. Another is that medium-format cameras, coupled with the new films, can now deliver images with qualities that previously could be achieved only with large-format cameras. And several manufacturers have introduced medium-format cameras that rival sophisticated 35mm cameras in handling ease while delivering a significantly larger negative. Thoughtfully designed and constructed large-format cameras are also now available and have impressive features that make them lighter, stronger, and more versatile than ever.

The integration of computer technology and the camera has dramatically extended the capabilities of small- and medium-format systems. Electronic automation of the camera can deliver precise exposure control, autofocusing, and a myriad of features that are powerful and often daunting. Advances in the optical sciences and in lens manufacturing has led to the creation of lenses that are optically superb; zoom lens quality continues to improve, and the zoom lens has become the primary lens for many photographers.

Digital filmless cameras are rapidly improving in quality and may soon become the "snapshot" camera of choice for photographers who have access to a simple computer system and a color printer. Advanced digital cameras are already making their presence felt in photojournalism and advertising and are destined to play a major role in the photography of the twenty-first century. The advent of digital imaging and the electronic darkroom has opened up an entirely new approach to image making for photographers and other serious artists.

For those who work in the traditional black-and-white medium, the evolution of variable-contrast papers since the 1980s has changed the way most photographers approach black-and-white printmaking. Low-cost dichroic enlarger heads and variable-contrast heads have become key pieces of darkroom equipment for both color and black-and-white photography and have greatly simplified and improved printing techniques.

This new edition of *Basic Techniques of Photography, Book 1* integrates these changes into the basic text of the first edition based on the writings of Ansel Adams. With the remarkable technical advances that continue to take place, the

potential of photography as a vehicle for communication and artistic expression continues to grow. It is the objective of this series of books to integrate modern practices with the time-tested principles developed by Ansel Adams in his thoughtful and enduring writings on the subject.

Preface

Ansel Adams was a passionate human being. He cared deeply about people, about wilderness, conservation, music, and teaching. But photography was his obsession. The photographs he created speak eloquently of the heroic nature of our mountains, the tragedies of displaced people, and the extraordinary beauty of the world. Photography was Ansel's visual voice, the integrating theme of his life.

In his aesthetic and technical standards, Ansel was without peer. His mastery brings to mind George Bernard Shaw's tribute to Mozart on the hundredth anniversary of the composer's death: "In art the highest success is to be the last of your race, not the first. Anybody, almost, can make a beginning: the difficulty is to make an end — to do what cannot be bettered."

Ansel loved to teach. *Making a Photograph,* first published in 1935, is a comprehensive volume that details his basic approach to photography. Despite the enormous advances that have taken place since then in the development of cameras and photographic materials, the book retains its vitality today.

Ansel's systematic approach to photography, his practice of testing and evaluating each of the materials he worked with, resulted in an impressive command of the technical aspects of the medium. He was highly regarded in his work as a consultant to the industry. Through formal teaching, workshops, and a series of technical books, he generously shared what he had learned.

Although most of his writing was addressed to the advanced student or the professional, Ansel believed that his approach to photography was universally applicable. He planned but was unable to start a book geared toward beginning photographers; it was to be written at a level suitable for the novice who wished to make fine photographs but lacked the technical background, equipment, and experience to utilize or easily understand more advanced volumes. This book attempts to fulfill the need that Ansel recognized.

The text has been organized to provide the beginner with all of the information necessary for an understanding of basic photographic principles and how to apply them in the field and darkroom. A number of Ansel's photographs have been included for illustrative purposes, along with explanations of how they were made; among these are twenty-one "interludes," which appear throughout the book as special double-page spreads, each featuring one of Ansel's photographs and a description of a photographic principle or technique used in creating it. These interludes are in large part taken from Ansel's book *Examples: The Making of 40 Photographs*. In addition, extensive quotes from Ansel's writings and talks on photography have been integrated into the text so

that the reader may have the direct benefit of his views and experience. All of these quotes by Ansel Adams are printed in italic to distinguish them from the remainder of the text. On occasion I have abridged or edited the excerpts for clarity in this context; for a list of sources for the quotations, see pages 408–409.

Photography should never be reduced to a "cookbook" approach where the student must slavishly follow a series of instructions. Photography is basically a language through which we can communicate, and in order to use it effectively we need to learn how to read and write in photographic symbols, with photographic tools. The aim of this book is to encourage you to think, see, and respond in photography's language whenever you begin to photograph.

The New Ansel Adams Photography Series consists of four books, titled *The Camera, The Negative, The Print,* and *Polaroid Land Photography.* The present volume follows the basic outline of those texts and draws upon some of the illustrative material and captions therein, but it also includes two chapters on color photography. It is intended to give the motivated beginning photographer an understanding of the basic thought processes and skills that Ansel often used to make fine photographs. As your proficiency increases, you may wish to consult the above-mentioned texts for detailed technical information.

Books are seldom the product of a single hand, and this one is no exception. Jane Tufts's editing skills often gave shape to amorphous material and extracted sense from confused prose, and for that I am especially grateful. Associates at Little, Brown and Bulfinch Press, particularly Janet Swan Bush, Amanda Freymann, Patricia Burke Hansen, and Dorothy Straight, were cooperative and encouraging at every stage, as were the designer, Douglass Scott, and the technical illustrator, Tom Briggs. I also want to thank Pam Feld for her encouragement and her assistance in so many of the tasks involved in assembling the manuscript.

Most of the equipment that appears in this book was loaned by Adolph Gasser of San Francisco, and I wish to extend my warmest thanks to him.

Alan Ross, who worked as Ansel's assistant for a number of years, has generously provided many technical insights and useful suggestions that have been incorporated into the text. He is responsible for most of the demonstration and product photographs in the book and has been a valuable colleague during its creation. Both of us knew Ansel well and shared his philosophy about photography. In the text I have called upon my experiences with Ansel, as well as his own words and examples, as often as possible. Whatever authenticity can be claimed for this book is a product of those memories. I cannot imagine having a better role model.

The Ansel Adams Guide

BOOK I

Basic Techniques of Photography

REVISED EDITION

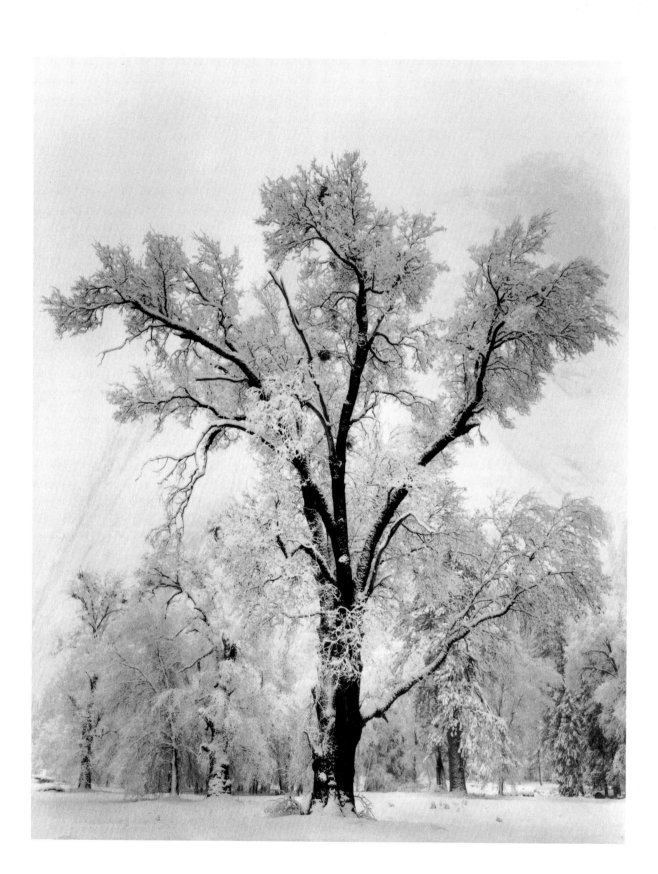

Chapter One

The Language of Photography

All art is a vision penetrating the illusions of reality, and photography is one form of this vision and revelation.

A great photograph is one that fully expresses what one feels, in the deepest sense, about what is being photographed, and is, thereby, a true manifestation of what one feels about life in its entirety. This visual expression of feeling should be set forth in terms of a simple devotion to the medium. It should be a statement of the greatest clarity and perfection possible under the conditions of its creation and production.

My approach to photography is based upon my belief in the vigor and values of the world of nature, in aspects of grandeur and minutiae all about us. I believe in people, in the simpler aspects of human life, in the relation of man to nature. I believe man must be free, both in spirit and in society, that he must build strength into himself, affirming the enormous beauty of the world and acquiring the confidence to see and to express his vision. And I believe in photography as one means of expressing this affirmation and of achieving an ultimate happiness and faith. — ANSEL ADAMS

Language is mankind's most important invention. Through it we communicate and share experiences, emotions, and abstract thoughts. The spoken and the written word are two aspects of language and communication, and visual images are another. The successful photographer is a master of the language in which he communicates, the language of light and form.

Photography is a visual language. It can touch and stimulate our deepest emotions and convey moods ranging from lyrical to somber. Ansel Adams was one of photography's greatest practitioners, a master of the art of making explicit insights, experiences, and philosophy through memorable images. He used photography as a medium to communicate his concerns and values. In his view,

The picture we make is never made for us alone; it is, and should be, a communication — to reach as many people as possible without dilution of quality or intensity. . . . To the complaint "There are no people in these photographs," I respond, "There are always two people; the photographer and the viewer."

Figure 1.1: Ansel Adams, *Oak Tree, Snowstorm, Yosemite National Park, California, 1948.*

Figure 1.2: *Album page of Ansel Adams' first photographs, Yosemite National Park, 1916.*

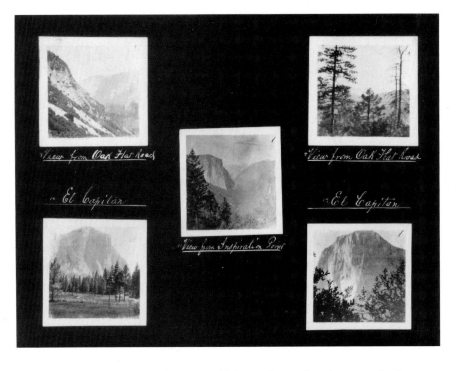

Imagine how different our lives would be without the photograph. In most families every single event of any importance is captured on film. Pictures and snapshots are shared with friends, proud grandparents, and schoolmates, and they even appear in hometown newspapers when the occasion demands. Most of us begin our involvement with photography through the snapshot, and Ansel was no exception.

> *When I first made snapshots in and around Yosemite, I was casually making a visual diary — recording where I had been and what I had seen — and becoming intimate with the spirit of wild places. Gradually my photographs began to mean something in themselves; they became records of experiences as well as of places. People responded to them and my interest in the creative potential of photography grew apace.**

It is tempting to adopt a casual attitude toward snapshots. Their enormous number and universal presence make it easy to dismiss them as something less than "serious" photographs. Ansel did not share this view:

> *The snapshot is not as simple a statement as some may believe. It represents something each of us has seen — more as human beings than as photographers — and wants to keep as a memento, a special thing encountered. The little icons that return from the photo-finisher provide recollections of events, people, and places; they stir memories and create phantasies. Through the billions of snapshots made each year a visual history of our times is recorded in enormous detail.*
>
> *While to many the snapshot is a symbol of thoughtlessness and chance, it is a flash of recognition — something which for many reasons we wish to*

*All italic passages are excerpts from the writings of Ansel Adams. A complete listing of the sources for these quotes can be found on pages 408–409.

perpetuate. It may have real human and historic value. The more we look, the more we see, and the more we see, the more we respond. When we begin visualizing our responses to the world in terms of images, we become photographers in the most rewarding sense of the term.

In any language, if you want to learn how to write, you must first learn how to read. Photographs must also be read, just as we read the words in a book. Photographs, like words, are abstractions, and through light, form, and color they generate emotional reactions and responses. We listen to what they say with our eyes, not with our ears.

To move your level of competence beyond that required to make a snapshot, you must develop skill in reading photographs. Just as adding new words to your vocabulary increases your ability to express ideas, gaining an understanding of photographic principles and techniques and how to use them to create visual symbols enables you to generate moods in photographs to reinforce the messages you want to convey. Many of the examples in this book represent an attempt to analyze photographs and how they were created, a sharing of approaches that you may find useful in your own efforts.

Photography has a soul of its own. The ability to capture and fix a space and a moment in cleanly defined detail and tonal values is unique to photography. Photographs simulate reality so effectively because our minds and memories unconsciously make us participants in the image: the camera's eye becomes our own.

Faithfully used, photography can be an unrivaled medium for communication and artistic expression. Understanding the singular capabilities of a camera, a lens, and film is the first important step in learning to see like a camera. The systematic exploration of photography's tools and techniques is one theme of this book.

With all of my analysis of photography, there is still something quite incomprehensible to me about the photographic process. The physics of the situation are fearfully complex, but the miracle of the image is a triumph of the imagination. The most miraculous ritual of all is the combination of machine, mind, and spirit that brings forth images of great power and beauty.

Great photographs are not a simple measure of life and our surroundings; nor are they the result of mastering the operation of a camera and darkroom manipulations. They are value judgments by the photographer that take the viewer beyond the experience of "peeking through someone else's window." Compelling images are most often powerful expressions of lifelong concerns of the photographer, and these concerns frequently have a universal appeal.

Memorable photographs, moving speeches, music we want to hear again and again, sculpture we return to, ballet, poems and novels that endure, masterpieces of painting — genuine art in any form — all have two elements in common: the artist has an important statement to make, and that statement is made with eloquence. *Eloquence* and *substance* are what we should strive for in any form of expression.

Photographic expression is a skill that can be learned, and the aim of this book is to teach you how to make expressive photographs. While the choice of subject matter for your photographs is a personal one, your photographic messages must reflect your thoughts, concerns, and experiences — whatever is important to you.

Once completed, the photograph must speak for itself. The creative essence of the image has no language but its own. It is a communication from one human being to others. It may repulse or reveal or stimulate; it may be rejected or accepted with perfect freedom or conscience by all concerned.

The approach to photographic expression detailed in the chapters that follow is universal, independent both of the camera and film used and of the images recorded. No book or workshop, no course of study, can make anyone an instant "master"; mastery requires patience, dedication, talent, opportunity, and an intense commitment. Experience has shown that a basic understanding of photographic principles and their systematic application as practiced and taught by Ansel Adams provides a sensible and solid foundation that photographers can use to develop their mastery of the craft and make expressive photographs.

This book is intended as an introduction to photography, and it is structured so that each lesson and technique you learn will make you a better photographer and increase your capabilities. It encourages you to adopt sound working habits and to use a systematic approach to all phases of photography so that its mechanical aspects will not intrude upon the emotional response you should feel when you are moved to create a photograph.

Your rewards as a photographer will be directly proportional to the time and effort you are willing and able to invest, but if after reading this book you choose not to work in a darkroom yourself, you will at least have an understanding of what a competent printer of negatives can do for you. If you choose not to explore the subject of exposure and development control of the negative in detail, you will at least know what factors influence the quality of your negatives. And, most important, you will begin to appreciate the immense potential of photography.

A Brief History of Photography

Cameras of various types have been known for centuries. The *camera obscura* (literally "dark room" in Latin) was a box or room with a small hole in the center of one of the sides or walls. The scene outside the room or box appeared as a projected image, upside down and backward, on the surface opposite the hole. The camera obscura achieved some popularity during the Renaissance, when it was regarded as an entertaining curiosity. You can turn any room into a camera obscura by covering all of the windows with sheets of black plastic or another opaque material and making a hole the size of a penny in one of the window coverings. When you turn out the room lights, the world outside your room will be projected on the wall.

If the scene is projected on a surface of ground glass, you have the equivalent of a modern *view camera.* The first of these was constructed by Robert Boyle in 1670. By placing a piece of translucent paper on the glass surface, the user of the camera could trace the image and make a permanent record of the scene.

Further refinement in the years that followed led to the *camera lucida,* similar to overhead projectors still in use today. If you point the lens of an overhead projector toward a window and place a sheet of white paper on the table where the transparency is normally placed, you will see the scene outside the window projected on the paper.

The camera lucida and its variants became the traveling companions of tourists who wanted permanent records of the places they visited. Sketches made with the aid of a camera were often colored at leisure and placed in an album.

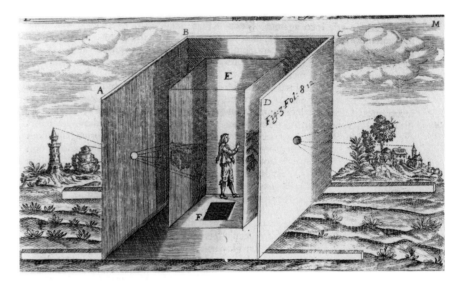

Figure 1.3: *Camera obscura.* Cross-sectional view of an example constructed in Rome in 1646 by Kircher. After positioning the camera, the artist would enter the room through a trap door and trace the projected image on a sheet of paper.

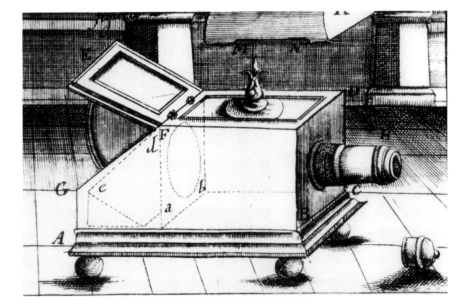

Figure 1.4: *Reflex-box camera obscura.* Fitted with a lens and mirrors, this device, invented by Johann Zahn of Germany in 1685, enabled the artist to lay a sheet of paper on a glass surface and trace the reflected image.

Figure 1.5: *Camera lucida.* Designed by William Hyde Wollaston in 1806, this innovation featured an adjustable prism and lenses that projected an image of the subject onto the artist's drawing board, where it could be easily traced.

The Birth of Modern Photography

At the beginning of the nineteenth century, several individuals began to address the question of how to use chemical means to capture the image projected by the camera lens. The problem was ultimately independently solved by both L. J. M. Daguerre and William Henry Fox Talbot in 1839. The method developed by Fox Talbot is essentially the same one we use today. The principles involved are as follows: (1) a surface (film or paper) is coated in the dark with chemicals that are altered by exposure to light; (2) the film or paper is exposed to light, and an image is developed during or after exposure; and (3) the image is fixed through chemical treatment so that no further change will occur when it is again exposed to light.

The process quickly became easy enough for any determined amateur or professional to perform. As it matured, photography became a new way of communicating, and within a few years of its invention, photographic studios had sprung up all over the world and photographers had begun taking portraits, photographing landscapes, and recording important as well as trivial events. Our love affair with the photograph was under way.

Flea markets and antique shops often have large collections of early photographs, remnants of times past: anonymous portraits of people who are themselves now anonymous; mothers, fathers, and children who have passed beyond the realm of memory; ancestors in search of descendants. With the birth of modern photography, people stopped keeping diaries and started family photo albums.

Photographers soon began to travel to exotic places, photographing pyramids, Indians, landscapes, birds, and animals, capturing images that they

thought a curious public might want to see and buy. Most of these images were trite, but in the mid–nineteenth century they were greeted with the same wonder we now feel in looking at close-up images of distant planets.

Progress in the printing trades paralleled advances in photography, and in the 1860s photographs began to be included in books, magazines, and newspapers. The saying "one picture is worth a thousand words" reflected the consciousness of the public: photography fundamentally changed the way we communicate.

Figure 1.6: William Henry Fox Talbot, *Botanical Specimen, 1839.*

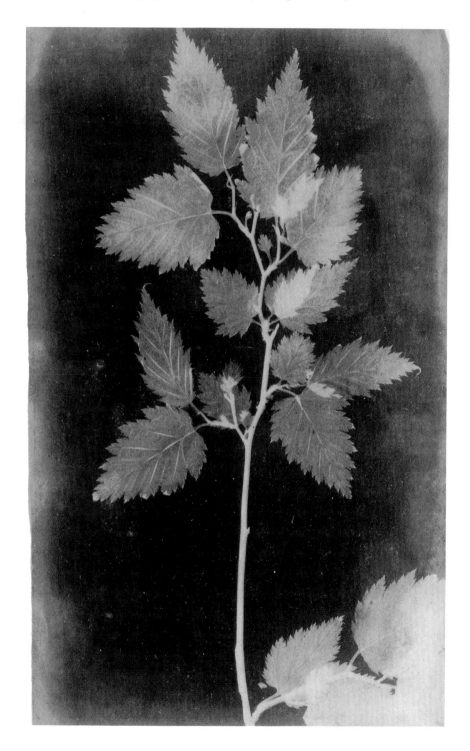

Traditions in Photography

Many early photographers whose reputations survive were trained as artists and approached photography as an alternative to painting and other kinds of printmaking. They brought the traditions and disciplines of the older art forms to their practice of the new medium: sitters in early photographic portraits mimicked typical poses in paintings; traditional still lifes became suitable subjects for the camera; and the principles of composition for landscape painting were applied to photographs as well.

Age-old concepts of composition, form, shading, and color were transformed and applied to photography. Used creatively and intelligently, these elements brought a measure of discipline to the emerging art form. What set photography apart, however, was its unrivaled ability to capture fine details, and

Figure 1.7: Hermann Krone, *Still Life of the Washerwoman, 1853.*

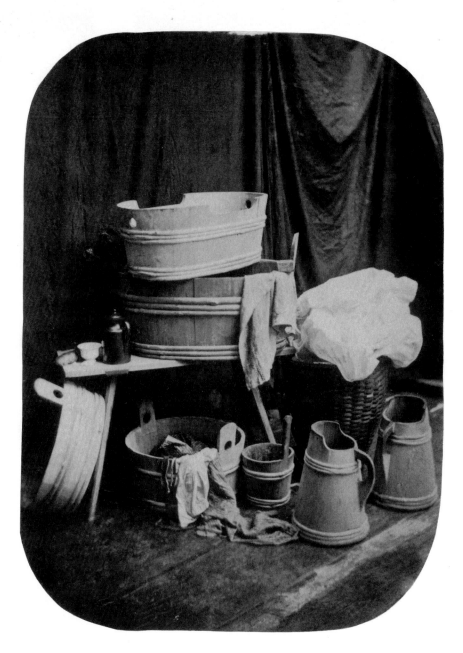

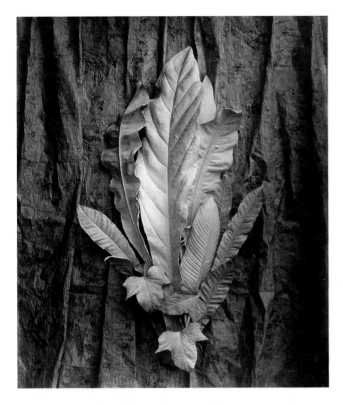

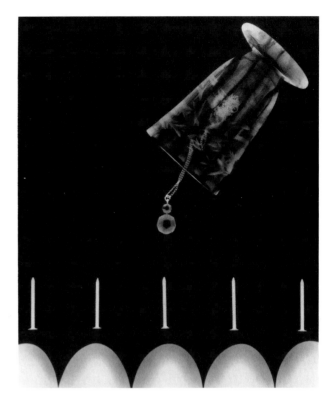

Figure 1.8: Charles Aubry, *A Study of Leaves, 1864.*

Figure 1.9: JoAnn Frank, *Dripping Necklace and Nails, c. 1975.* A photogram.

its rendering of form as delicately graded shades of a single color. Subtle variations in tone that were beyond the scope of the finest painter were easily achieved by the photographer.

Still Lifes The term used to represent a category of paintings or photographs in which the subject is static and limited in context is *still life*. Typical subjects include floral arrangements, bowls of fruit on tabletops, hunting trophies, and so forth. These are often carefully arranged or constructed by the artist, though "found objects" (for example, graffiti, scattered leaves, flowers, and weathered wood) have proved to have the greatest appeal for photographers.

Charles Aubry's *Leaves* and Hermann Krone's *Still Life of the Washerwoman* are early examples of still-life photographs with clear precedents in painting. Ansel Adams' *Rose and Driftwood* (see pages 12–13) is part of the same continuum. For many photographers, still lifes are the product of a creative imagination and a satisfying vehicle for self-expression. Most of the commercial photographs used to advertise products are part of the genre of still life.

Photograms Some of the earliest photographs were what we would now call *photograms* — meaning that instead of a negative's being used to generate a photographic print, the subject of the photograph itself constitutes the "negative." Fox Talbot placed specimens of leaves in a printing frame in direct contact with sensitized paper; when the paper was exposed to sunlight, the image printed out as a silhouette of the leaves. He referred to these as *photogenic drawings*.

The photogram is still used as a means of photographic expression. With modern photographic papers, some of which are extremely sensitive to light, it is possible to generate photograms by casting shadows on enlarging paper. In contrast to photographs made from negatives, each photogram is unique.

Rose and Driftwood,
San Francisco, California,
circa 1932

I had a fine north-light window in my San Francisco home which gave beautiful illumination, especially on foggy days. My mother had proudly brought me a large pale pink rose from our garden, and I immediately wanted to photograph it. The north light from the window was marvelous for the translucent petals of the rose, but I could not find a suitable background. Everything I tried — bowls, pillows, stacked books, and so on — was unsatisfactory. I finally remembered a piece of weathered plywood, picked up at nearby Baker Beach as wave-worn driftwood. Two pillows on a table supported the wood at the right height under the window, and the rose rested comfortably upon it. The relationship of the plywood design to the petal shapes was fortunate, and I lost no time completing the picture.

I have been asked what influenced me to make this picture. At that time, it was widely believed that every photograph should relate to some example in another art form. I seldom, if ever, thought that a photograph might be influenced by another photograph. Of course I had seen flower paintings, but never, as I recall, one of a single large flower. I certainly had not seen any of Georgia O'Keeffe's marvelous large paintings of flower forms. In retrospect I believe that this picture was an isolated inspiration, free of any association in art that I knew about. It was simply a beautiful object with a sympathetic background and agreeable light.

We observe few objects really closely. As we walk on the earth, we observe the external events at two or three arms' lengths. If we ride a horse or drive in an automobile, we are further separated from the immediate surround. We see and photograph "scenery"; our vast world is inadequately described as the "landscape." The most intimate object perceived daily is usually the printed page. The small and commonplace are rarely explored.

Most of my photographs made before 1930 were of distant grandeurs. But as I learned the inherent properties of camera, lens, filters and exposure, I also gained the freedom to see with more sensitive eyes the full landscape of our environment, a landscape that included scissors and thread, grains of sand, leaf details, the human face and a single rose.
— ANSEL ADAMS

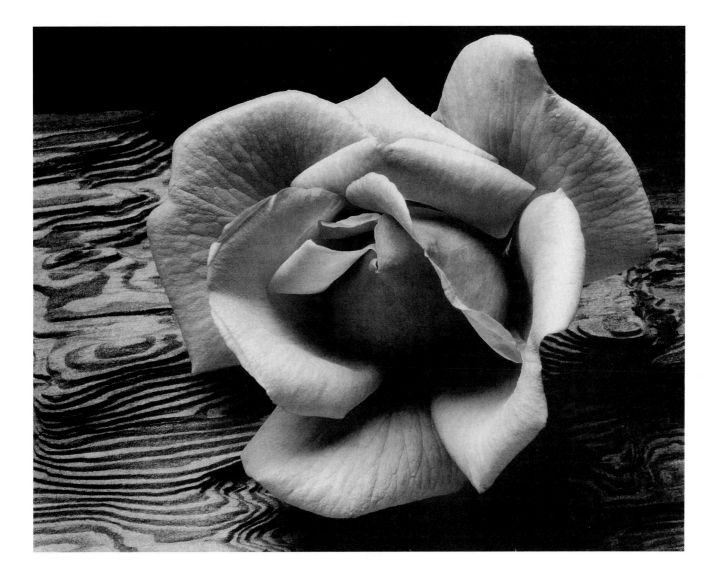

Figure 1.10: David Octavius Hill and Robert Adamson, *Portrait of Two Men (John Henning and Alexander Handyside Ritchie), c. 1845.*

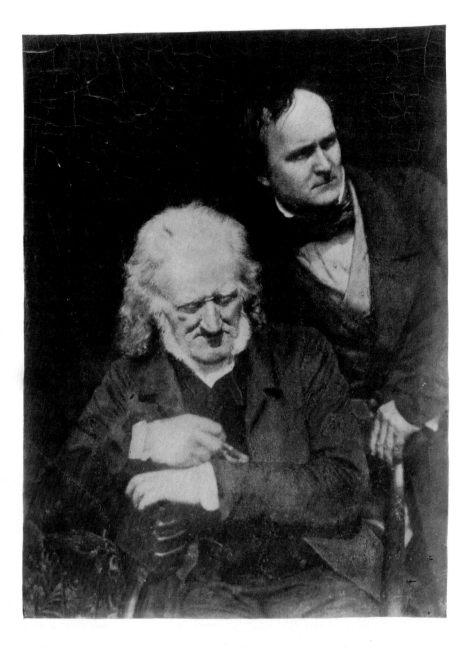

Portraiture One of the earliest uses of photography was for *portraiture,* which continues to be a major interest of photographers.

The photograph of John Henning and Alexander Handyside Ritchie by David Octavius Hill and Robert Adamson — two portraitists whose artistic sensibilities have seldom been equaled — is dramatically posed and lighted. Its composition reflects the drama that painters sought to achieve in the finest portrait studies. The contrast between the faces of the two men forces comparison, and their intense, contemplative stares, directed away from the photographer (and the viewer), make us wonder what held their attention. Powerful portraits reflect the character of the person or people they portray.

Landscapes Landscape photography has been a consistent photographic pursuit from the beginning. Photography offered a straightforward, economical means of making images both of one's own surroundings and of more exotic

parts of the world, enabling people to satisfy their curiosity about distant places and other cultures. By the 1850s, photographers were traveling to remote locales and creating photographs of extraordinary beauty.

The achievements of the early landscape photographers seem the more remarkable when you consider the conditions under which they were forced to work. In addition to cameras and lenses, a portable darkroom tent also had to be carried into the field. It usually required several animals to transport all the equipment. Glass plates were prepared on site, exposed, and immediately developed. If the negative was satisfactory, the glass plate had to be dried and wrapped securely for the long trip home; breakage was a constant danger. Yet out of this era came images that have never been surpassed.

At major tourist attractions, photographers offered their photographs for sale, thus indirectly launching the picture-postcard business. Tourists eagerly purchased photographs as a record for their picture albums.

Landscape photography, particularly in America, also became an important social force. With westward expansion came the recognition that much of the western American landscape was unique, meriting special care and protection. Timothy H. O'Sullivan, a photographer on many Western survey expeditions, printed albums of his photographs of the Yellowstone area (titled *Yellowstone Natural Wonders*) and presented them to Congress to spur the formation of Yellowstone National Park. Other major landscape photographers of the era (among them Carleton E. Watkins, John K. Hillers, William Henry Jackson, E. O. Beaman, William Bell, and Eadweard Muybridge) created images that had

Figure 1.11: (A) Timothy H. O'Sullivan, *Ancient Ruins in the Canyon de Chelle, New Mexico, 1873*. (B) Ansel Adams, *White House Ruin, Canyon de Chelly National Monument, Arizona, 1942*. (*Note:* In 1873, Arizona was still part of New Mexico Territory.)

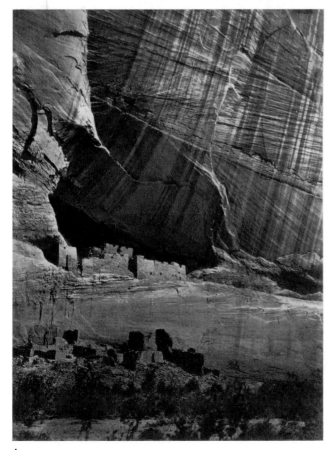

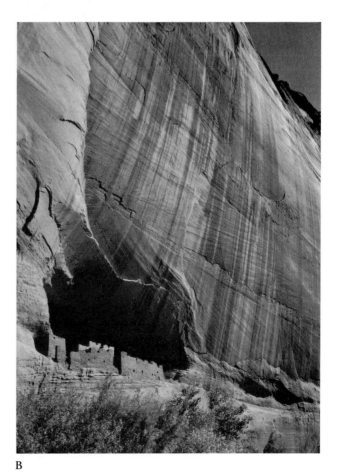

A

B

a profound effect on the public, reinforcing the myth of America's "Manifest Destiny" and the concept of the virgin wilderness.

Many of Ansel's finest works are in the landscape tradition, and one of the most extraordinary is *Mount McKinley and Wonder Lake, Denali National Park,* which reveals the perfect resonance of a heroic mountain, the highest peak in North America, with its glorious setting (see pages 18–19).

Journalism Journalists quickly saw photography's potential for reportage. Photographers enlisted in the military and carried their cumbersome equipment onto the battlefield. In the mid-1800s, action photos were impossible because of the time it took to prepare and expose the photographic plate; still lifes of war scenes, however, proved to be more than adequate to the task.

Roger Fenton photographed the battlefields near Sebastopol in 1855, during the Crimean War. A lifeless lunar landscape, strewn with cannonballs reminiscent of skulls, is titled *Valley of the Shadow of Death.* There is not a hint of the colorful glory of Tennyson's "Charge of the Light Brigade" in Fenton's picture.

These pictures and hundreds like them profoundly affected those who first saw them. For most people, war was an event seen by someone else, reported, and then imagined by the reader. Reports were always biased, emphasizing individual heroism, the triumph of justice over barbarism, victory, or an honorable, strategic retreat. The words used by even the best writers seldom gave the reader a mental image of the terrors of the actual scene. But photographs are often able to overcome the inadequacy of words. Those early images acted as a visual short circuit in the brain of the viewer. He or she now stared at the "reality" of a battlefield instead of trying to imagine something beyond the range of experience.

Figure 1.12: Roger Fenton, *Valley of the Shadow of Death, 1855.*

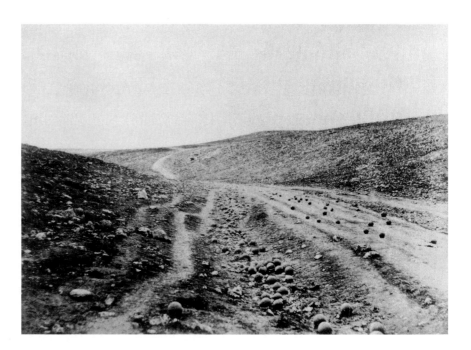

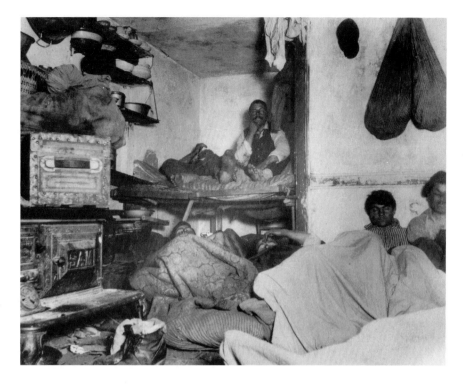

Figure 1.13: Jacob A. Riis, *Five Cents a Spot, Lodgers in Bayard Street Tenement, c. 1889.*

As photojournalists learned to master the language of their craft, they began to create photographic essays as a means of communicating their concerns to the public. An early example of this is the work of Jacob Riis, a reporter for the *New York Herald.* He photographed the city tenements and in 1890 published a book titled *How the Other Half Lives: Studies among the Tenements of New York.* His photographs provided a compelling impetus for social reform.

Photography Today

Technical advances over the last few decades now make it possible for photographers to choose among the finest cameras, lenses, and films ever made. Quality equipment is available at reasonable prices, and the processing of everything from black-and-white negatives and prints to color enlargements can be carried out in a simple darkroom. Polaroid's instant films and prints produce a finished print or color slide minutes after an exposure is made.

Unquestionably the most exciting development in the past decade has been the integration of photography with computer technology. Digital imaging is literally a photographic revolution, pioneering new ways of capturing and creating photographs. Book 2 of this series devotes two chapters to the field of digital photography.

These advances have expanded photography's promise as a vehicle for communication, as well as its capacity to grow as a visual art form. The increasing potential of the medium brings with it a challenge to photographers to extend their own creative horizons, to frame visual questions and to search for answers that reflect the important social and aesthetic issues of our time. To be equal to that challenge, we must make a commitment to learn and master the skills that the medium of photography requires. The purpose of this book is to provide you with guidance that will enable you to acquire those skills and use the language of photography persuasively.

Mount McKinley and Wonder Lake,
Denali National Park, Alaska,
1947

Clear weather in Denali National Park and in Glacier Bay National Monument is usually scarce in midsummer, and the photographer can expect to see horizons only in the sunrise and sunset hours, if then! At other times of day, however, he can turn his lens to the close and intimate aspects of the natural scene.

The ranger cabin at Wonder Lake overlooks a vast valley to the south, beyond which rises, many miles away, the glittering mass of McKinley — eighteen thousand feet of ice and snow soaring above its base. I had an early supper and pulled down the shades to create night in the cabin. I was up and out at midnight and made a photograph of the stark white ghost of the mountain under the gray light of the sky. I then prepared for sunrise, due in less than half an hour. Actively opposing the mosquitoes, I set up the camera and composed the image on my 8 x 10 ground glass.

About 1:30 A.M. the top of the mountain turned pink; then, gradually, the entire sky became golden and the mountain received more sunlight. While the foreground, lake, and distant valley were in shade, the light was very soft, and I wanted to sharpen what shadows there were on the mountain. The No. 15 filter (deep yellow) was satisfactory in lowering the values of the shadowed foreground, but the separation of mountain and sky was not as I had hoped.

I tried two more photographs, but within thirty minutes clouds had gathered and obscured the summit, and they soon enveloped the entire mountain. — ANSEL ADAMS

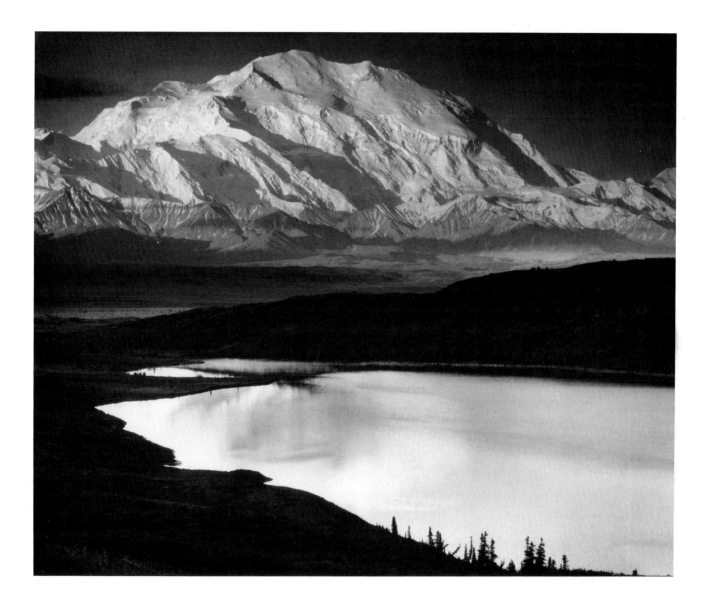

Chapter Two

Camera Systems

I am often asked if there are important differences in performance between good cameras of the same size. There are many excellent cameras available, and the photographer should select one that performs well for him and that is well made throughout its system, of course within the limits of cost and need. In addition, there is a "feel" about a particular camera; an emotional empathy seems to develop toward certain equipment. I sometimes sense that the camera itself may encourage the photographer to relate to particular subjects favorable to the camera's format and other characteristics. This is, of course, a subjective appreciation of the capabilities of the eye and the camera.

— ANSEL ADAMS

Chapter 1 introduced the basic concepts of the photographic process and explained how they evolved. To begin to explore the creative possibilities of making a photograph, you need to understand the characteristics of the equipment you will use and the consequences of the photographic decisions you will make. Equipment translates a scene into a photograph and conveys your visualization of it to the viewer.

Before You Buy a Camera

Figure 2.1: Ansel Adams, *Self-Portrait, Monument Valley, Utah, 1958.*

The array of available camera types is bewildering. Before you enter a camera store, try to read professional reviews of any equipment you may be interested in purchasing. Many photography magazines have monthly features that provide careful, detailed, and independent analyses of cameras, lenses, and other photographic equipment, and various annual buying guides summarize the characteristics and performance of the various products. A few hours of research in a library will increase the probability that the equipment you purchase will meet your expectations.

As you shop for equipment, you will quickly discover that quality costs money; by the time you purchase a camera body and several lenses, your investment is likely to be substantial. One economical way to try out different cameras and lenses in the field before you decide which camera to purchase is to *rent* camera equipment. The experience can provide a margin of comfort when you eventually make your purchase.

In the interest of keeping costs down, you may want to explore the possibility of buying a used camera or lens. You can often realize enormous sav-

ings on secondhand equipment, and most dealers will allow you to test cameras and lenses on a trial basis. In many cases a high-quality used camera or lens will be a better value than a new one; the optical characteristics of a high-quality ten-year-old lens, for example, will not differ substantially from those of a brand-new model, and the used lens will cost a good deal less. For cameras of older vintage, the major thing to be concerned about is the accuracy of the shutter speeds. Test the camera at all shutter speeds and expose at least one roll of film before finalizing your purchase.

Finally, cameras with a minimum of sophisticated electronics are likely to be more durable and reliable as they age — and less expensive to repair. Thus, if you can purchase a good used camera with sound mechanical construction for a fraction of the price of a new one, by all means consider it. Even if a modest amount of repair work or adjustment is needed, the camera may still be an excellent value.

Deciding Which Camera to Buy

Photographers are restless, questing individuals and in some ways sublimate their urge for accomplishment into the desire to possess superior equipment. Without intending to depreciate the magnificent equipment available today, it is suggested that the photographer think first about what he "sees" and what he wants to "say" before he launches into acquisition of advanced equipment. If a man has something to say, he could say it with a box camera with a pinhole for a lens! (But, of course, it could be said more often, more dynamically and more efficiently with a Hasselblad or a Contarex or a Calumet view camera.)

The first experience most people have taking photographs is with a 35mm camera. They take pictures of family events, trips, or visits, to capture and

Figure 2.2: *Camera formats.* Cameras differ substantially in size, weight, and ease of handling. These factors must be balanced against their performance and intended use. (A) A Toyo 8 x 10 field camera and a Minolta Maxxum 8000i 35mm. (B) A Cambo 4 x 5 monorail view camera and three medium-format cameras: Mamiya RB67, Pentax 4.5 x 6 cm, and Pentax 6 x 7.

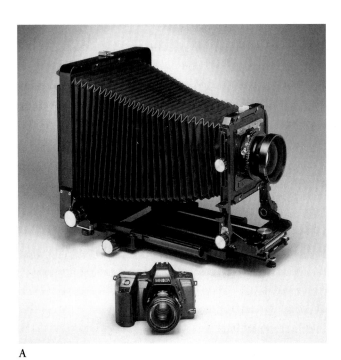

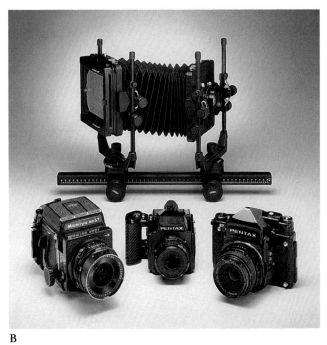

A

B

preserve memories. When an encounter with a particular photograph reveals the medium's creative potential, however, the casual photographer often decides to acquire a "better" camera.

The ubiquitous presence of the 35mm camera frequently prevents beginning photographers from investigating other types of equipment. This may represent a costly mistake on their part, since in photography *a camera's form defines its function.*

You need to consider many factors before you purchase a camera. The basic question to ask is, What messages do I want to share through my photographs? If your concerns relate to situations that are active or mobile (if, for example, you want to do sports, candid, or news photography), your camera of choice should probably be a 35mm model. If heroic landscapes, still lifes, or architectural studies interest you, a view camera would be more suitable. Many commercial photographers find that medium-format cameras are ideal for portraiture and other studio work.

Each camera system has unique qualities and limitations, but these are almost always less important than the ability of the photographer. Over time, most photographers acquire more than one camera, reflecting their changing requirements and broadening interests. Your acquisition of cameras and accessories should always be driven by your need for them, not by an appealing advertisement that suggests that the only thing between you and photographic immortality is the latest automated wonder.

The following discussion highlights some advantages and limitations of camera systems that are commonly available today. Mention of specific products is not meant as an endorsement of those products over other, similar ones; it simply indicates an experience (sometimes a dated one) shared by Ansel Adams and his colleagues.

What a Camera Is and Does

Cameras consist of only four essential parts: a *camera body,* a *film holder and/or transport mechanism,* a *lens,* and a *shutter.* Each of these serves a specific purpose. Figure 2.3 is a drawing of a simple box camera, of which all other cameras are variations.

With cameras that are part of *systems,* some components are sold as *modules* that can be snapped together as needed — for example, separate lenses and camera bodies. Modular designs make a camera more flexible. With interchangeable film holders, you can use the same camera body and lens with several different types of film. Thus, if you want to take both black-and-white and color photographs of a scene, you just change the film holder — it is cheaper and easier than buying and carrying two cameras.

The Camera Body The body of a camera is simply a light-tight box that serves as the supporting structure for the lens and the film holder and may also house some of the controlling devices needed to operate the camera system. On some cameras (including view cameras, folding cameras, and a few roll-film and 35mm camera systems), the lens is focused to produce a sharp image on the film by expanding or contracting the camera body.

Figure 2.3: *The elements of a camera.* The following elements, common to all cameras, are housed either in or on the camera body, a light-tight supporting structure. The *lens* forms an inverted image on the film. The *film plane* holds the film flat and at exactly the right distance behind the lens for precise focus. The *focusing mechanism* moves the lens closer to or farther away from the film, causing subjects at different distances from the camera to be brought into focus. The *diaphragm* controls the amount of light admitted by the lens. The *shutter,* used in conjunction with the diaphragm, controls the duration of the film's exposure to light. The *viewfinder,* or other viewing system, indicates to the photographer the area that will show in the final picture.

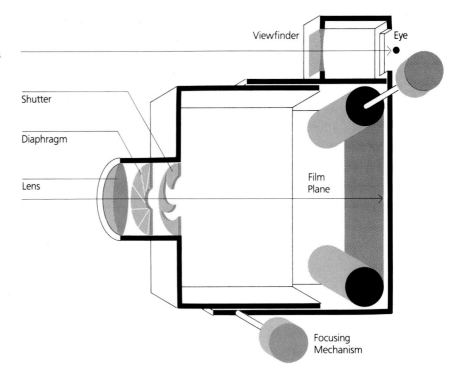

The Film Holder and/or Transport Mechanism A camera must have a means of holding a sheet of film or a segment of a roll of film on a flat plane opposite the lens while the photograph is being taken. In cameras that use *roll film,* the film is wound from one spool onto another; guide tracks and pressure plates frame the film and keep its surface flat and perpendicular to the lens. In most 35mm cameras, the film holder is an integral part of the camera body, while with 2¼-inch roll-film cameras, the film holder may be in the form of separate and interchangeable magazines, or *backs.*

Film for 35mm cameras is packaged in *metal cassettes.* A leader of film that extends from the cassette is threaded onto a second spool (usually part of the camera body) that is geared to advance the film after each exposure. After the film has been completely exposed, it is rewound into the cassette by means of a rewind knob *before* it is removed from the camera. In cameras with *motor drives,* the film is rewound automatically after the last exposure is made.

Film is packaged on *paper-wrapped spools* for cameras that use roll film and have formats larger than 35mm. The opaque paper leader is threaded onto a second spool that takes up the film as it is advanced in the camera. When all of the exposures have been made, the camera's film-advance lever is used to complete the transfer of the film from the original spool to the take-up spool. The roll of film must then be removed from the camera and sealed with a glued paper strip attached to the wrapper. This protects the film from being further exposed by the surrounding light.

With cameras that use *sheet film,* individual sheets contained within special light-tight holders are inserted into the camera body before the exposure is made.

The Lens The camera's lens forms the image that is projected onto the surface of the film. Lenses can be either built into the camera body as permanent fixtures

or attached separately. Cameras with interchangeable lenses are more versatile and more expensive than those without them.

A lens can vary from a simple pinhole (which is technically not a lens, though it does form an image) to a complicated assembly of a dozen or more simple lenses nested in combination. The advantages of a lens over a pinhole are that the image projected on the film is sharper and the exposures are shortened because the lens allows light to pass through a considerably larger opening.

The image produced by a lens can be larger or smaller than the original subject. The magnification produced by a lens depends upon its *focal length* (a measure of magnifying power) and the distance between the lens and the subject. Most cameras have a *focusing knob* or otherwise enable the lens to be adjusted to bring objects into sharp focus on the surface of the film.

In addition to forming an image, lenses are also used to control the amount of light that strikes the film. A roughly circular *diaphragm,* incorporated within the lens barrel and operated by a lens collar, masks off part of the outer circle of the lens, reducing its effective diameter. The diaphragm determines what fraction of the maximum lens diameter is used to allow light to pass through the lens.

The *f-stop,* or simply *stop* (both terms are used), is a measure of the degree to which a lens transmits light. Various diaphragm settings corresponding to discrete *apertures* (f-stops) are etched onto the controlling lens collar. You will see them written as *f/number*—for example, f/2.8. On a lens barrel, the *f/* is omitted for reasons of space and only the numbers appear, adjacent to the appropriate set points on the lens. Mathematically, the *relative lens aperture* equals the *diameter of the lens opening divided by the focal length of the lens.* Details of lens characteristics are discussed in chapter 3.

The Shutter The shutter is a mechanical device that acts as a gate to control the passage of light from the lens to the film. A *leaf shutter* consists of a nest of thin metal blades, shaped to approximate a circle and located in the lens barrel. It is activated when tension is applied to a spring. When the exposure button is pressed, the shutter opens for a set period of time, allowing light to strike and expose the film, and then it snaps shut to prevent further exposure. Leaf shutters are used extensively in lenses for medium- and large-format cameras.

Figure 2.4: *Image formation by a simple lens.* Light from a subject point falling on any part of the lens surface is focused at a single point behind the lens, and the total image is the accumulation of all such points. The lens "gathers" light over its entire surface and focuses it to produce a bright, sharp image.

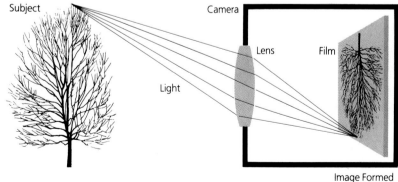

Aperture Control Ring
and Settings (f-stops)

Depth-of-Field
Scale (f-stops)

Distance
Scale (Meters)

Distance
Scale (Feet)

Focusing
Ring

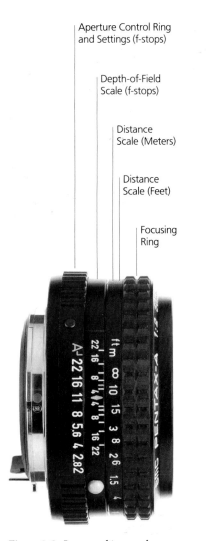

Figure 2.5: *Lens markings and aperture settings.* Lenses for small-format and medium-format cameras have a *focusing ring* located adjacent to a *distance scale.* When the lens is focused on an object, the distance between the two will appear opposite the *diamond marker* on the *depth-of-field scale.* The depth of field can be estimated by reading the distances on either side of the marker opposite the aperture chosen. The *aperture control ring* is coupled to an adjustable diaphragm that halves the effective surface area of the lens (thereby also halving the amount of light passing through it) each time the aperture is decreased by one stop. When the aperture is increased by one stop, the amount of light reaching the film is doubled. Pictured here are apertures with corresponding f/stops.

f/2

f/2.8

f/4

f/5.8

f/8

f/11

f/16

f/22

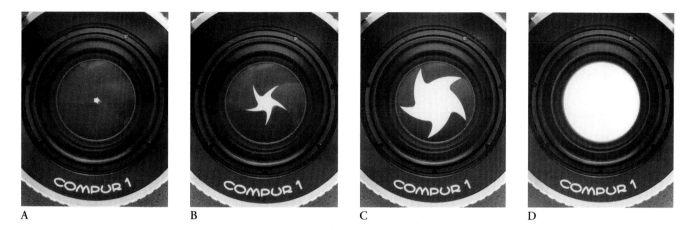

A B C D

Figure 2.6: *Leaf shutter.* Figures A, B, C, and D show the opening sequence of a leaf shutter. The blades open and close extremely quickly. (It is impossible to construct a "perfect" shutter — that is, one that opens and closes instantaneously.)

Figure 2.7: *Focal-plane shutter.* (A) The slit shown here travels very fast across the film from right to left, producing an exposure of $^1/_{500}$ second. (B) This wider curtain slit corresponds to an exposure of $^1/_{250}$ second. At exposures of $^1/_{60}$ second or longer, the first curtain fully uncovers the film before the second begins moving to terminate the exposure. The object of any good focal-plane shutter is to ensure consistent speed and equal illumination over the entire area of the film.

A

B

Alfred Stieglitz, An American Place, New York City, circa 1939

This is one of my first photographs with the Zeiss Contax 35mm camera, given to me by Dr. Karl Bauer, then the Carl Zeiss representative in America. I was proud to have a Contax; it was undoubtedly one of the finest cameras of the time. The Leica was also a superb instrument, of course, but I preferred the operational design of the Zeiss Contax. The functions and operating controls were well planned from the photographer's viewpoint.

On one of my trips to New York in the 1930s, I visited Alfred Stieglitz with the Contax in hand and infected him with my enthusiasm for it. I was sitting on a stool in the main room of his gallery, An American Place, and had just finished loading a fresh roll of film when I saw him walking toward me. I quickly made an exposure. It happens to be one of the rare images of Stieglitz smiling. I was fortunate in guessing the exposure correctly.

Stieglitz was distressed by the poor print quality so prevalent with small camera work. It was so hard for us to understand the bleak quality of most of the 35mm work of the time. The reason was that there were then very few photographers using the small camera who had aesthetic/expressive intentions. For most, the 35mm camera was an instrument for the recording of scenes, events, and people, with the emphasis almost entirely on the realities and activities of the world. The camera was used primarily for reportage, and the prints made mostly for ordinary reproduction in magazines and newspapers, not for display.

Small cameras made such pictures far more immediate, and many negatives could be made in the time required to produce one with a sheet-film camera. The technique of 35mm photography appears simple, yet it becomes very difficult and exacting at the highest levels. One is beguiled by the quick viewing and operation, and by the very questionable inclination to make many pictures with the hope that some will be good. In a sequence of exposures, there is always one better than others, but that does not mean it is a fine photograph! The best 35mm photographers I have known work with great efficiency, making every exposure with perceptive care. — ANSEL ADAMS

For 35mm and a few medium-format cameras, a *focal-plane shutter* is used. The focal-plane shutter consists of a curtain with a gap whose width can be varied. It is located in the camera body, not in the lens. The curtain travels across the front of the film during exposure; its rate of travel and the size of the gap determine the exposure time of the film. With focal-plane shutters, then, shutter speeds are independent of the lens that is attached to the camera. One advantage of this is that it allows lenses to be built without internal shutters, thereby greatly reducing their cost; a disadvantage is that the camera's use is generally limited to shutter speeds of $1/60$ second or slower with an electronic flash.

Advanced Photo System (APS) Cameras

It is significant that the greatest creative photographers use simple basic equipment — everything of adequate quality, nothing that is unessential. If the photographer will first think of the camera in its most elementary terms, he will better understand what equipment is most suitable for his needs. Rather than work from the complex down, it is better to work up from the simple!

George Eastman's genius was recognizing that photography would become a universal pastime only if the entire photographic process could be made as simple as possible. "You push the button, we do the rest" neatly encapsulates his philosophy. The original box cameras produced by Eastman Kodak more than a century ago contained a 100-exposure roll of film. After the film was exposed, the entire camera was sent back to Kodak, where the film was developed, the negatives printed, and the camera reloaded with film and returned to the owner for a modest fee. With the passage of time, picture taking and processing became ever easier.

The technical progress made by the photographic industry is primarily a reflection of the improvement in film technology. With the transition from paper negatives to wet plates, dry plates, and, finally, emulsions coated on flexible films, cameras have decreased in size and increased in sophistication. Advances in lens technology and electronics have introduced an era in which miniature cameras are capable of delivering photographs of outstanding quality. The Advanced Photo System (APS) is a synthesis of the best in current films, cameras, lenses, and computer technology.

APS Film Cartridges

The heart of the APS is the system's film cartridge. The film is contained within a sealed cartridge that is dropped into the camera body. When the film chamber is closed, the film automatically advances to the correct frame for exposure. The size of the negative area for each frame is approximately ¾ x 1¼ inches or ⅔ the size of a 35mm image (1 x 1½ inches). However, because of the fine-grain characteristics of the films used, enlargements of up to 8 x 10 inches yield prints of quite comparable quality.

The APS camera allows you to choose from one of three print formats: C-print (classic — 4 x 6 inches); H-print (HDTV format, i.e., full frame for TV screens — 4 x 7 inches); or P-print (panoramic — 4 x 10 inches). A dial on the

camera is used to set the image framed in the viewfinder to correspond to the format you select for each exposure. The format can be changed for each exposure. What actually occurs is that each exposure produces a full-frame negative but the camera prints a magnetic strip along the edge of the negative that provides instructions to the film processing-and-printing machine to crop the image according to the specified format (C, H, or P). Options are also available that enable you to record the date and time of the photograph on the front or back of the print and to print photo titles. The prints that are returned from the processor include one or more sheets of index prints that display positives of the pictures you have taken. Enlargements can be ordered in whatever format you choose. If you intend to print the negatives in your own darkroom, you can crop the image to your liking.

Several manufacturers are producing scanning devices that will produce a digital file directly from APS film. The cartridge is inserted into the scanner and the data is automatically transferred to a computer, where the rapidly evolving techniques of digital imaging can be applied. Alternatively, a photo player can be connected to a television set and the images viewed in the same way as a videocassette. A remote control allows you to zoom in or pan around the subject, add music or sound, and create an "electronic photo album."

A significant advantage of APS films over 35mm is that film cartridges can be changed in mid-roll, so that a single camera can be used to expose color negative, black-and-white, and transparency films simply by rewinding and exchanging film cartridges. When a partially exposed roll of film is reinserted into the camera, it will automatically advance to the correct frame for the next exposure. Also, in the more advanced APS cameras, exposure data recorded on the magnetic strip will override the normal automatic adjustments made by photo-processing equipment and ensure that the print you receive will have the color balance and exposure you planned when you took the picture. (Automatic color-processing equipment sets the exposure and color balance for each print by averaging all of the colors and light values of each negative and assuming that they equal a middle gray tone. While this assumption is generally valid, most color processors will produce a very poor print if there is a dominant color in the scene or if the lighting is unusual, despite the fact that the negative may be perfectly exposed. To obtain a print that is faithful to the negative the controls on the printer must be overridden manually.)

APS Camera Systems

APS cameras generally look like small versions of 35mm point-and-shoot or single-lens reflex cameras. They are highly automated, have a built-in flash unit, and are usually fitted with a zoom lens. The choices of cameras and features are rapidly expanding and all major manufacturers of cameras now offer one or more APS models.

The Canon Elph is a superb example of a rangefinder APS camera and features a high-quality zoom lens (24–48mm f/4.5–6.2) that produces sharp, contrasty images. The camera has a sophisticated autofocusing system, automated exposure that can detect backlighting situations and compensate with fill-in flash or additional exposure. The stainless steel body is extremely sturdy, and

the camera is light and small enough to fit comfortably in the palm of your hand, shirt pocket, or purse. It is an ideal "snapshot" camera, well suited for taking travel photographs and pictures that you would like to put in a fine photo album.

The view through the finder shows the image with the edges of the selected format masked in black. As you rotate the switch that controls the format selection, the shape of the mask changes to reflect the new selection. The controls for the zoom lens are very responsive to a touch of the thumb and make arriving at tightly framed images easy. With small film formats, where substantial degrees of enlargement are the norm, it is critical to waste as little of the available image area as possible.

The Canon EOS IX, Nikon Pronea 6i, and Minolta Vectis S-1 are examples of single lens reflex cameras that utilize APS technology. All of these cameras feature the advantages of through-the-lens viewing and interchangeable lenses. With the Nikon and Canon APS cameras, most of the lenses that are used on recent models of their 35mm camera systems can be used on their APS camera bodies. For the Minolta Vectis S-1 two standard zoom lenses (28–56mm and 22–80mm) and two telephoto zoom lenses (56–170mm and 80–240mm) are available, along with a macro lens designed for close-up photography. All three of these cameras have extremely sophisticated electronics built into the bodies and require careful study of the operating manual. They have been designed for use by advanced amateurs and professionals and are definitely not in the simple point-and-shoot category. These camera systems merit serious consideration as alternatives or supplements to a 35mm camera *if* the features and limitations of a small, flexible camera system complement your photographic objectives.

Figure 2.8: *Canon Elph.* An amazing number of features — autoexposure control, autofocusing, a high-quality zoom lens, built-in flash, format selection (classic, HDTV format, or panoramic), date and message imprinting, film cassettes that can be changed mid-roll — are housed in an attractive, sturdy metal body. All of these features are hallmarks of this delightful, high-performance APS camera.

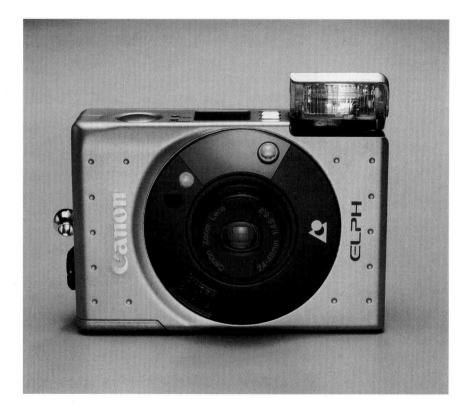

Digital Cameras

Photographic films and paper respond to the impact of light (photons) on crystals of silver halides, and after chemical development a visible image appears. If the film in a camera is replaced with a light-sensitive chip (usually referred to as a *charge-coupled device [CCD]*), the light striking the chip is sensed and recorded electronically. For storage purposes the surface of the chip is divided into a very fine grid of pixels (a contraction of *picture elements),* so that the CCD resembles a sheet of graph paper with very fine divisions. A computer notes the x (horizontal) and y (vertical) coordinates for each pixel and records the color and intensity of the light rays that strike it analogously to the way that the silver particles record the action of light on film. The information is stored electronically in a file.

From the photographer's perspective, the major distinction between the two recording media — film versus digital — is the degree of resolution that each medium can deliver. The ability of film to record detail is orders of magnitude greater than the capability of current digital camera systems because the practical size of the grid into which the electronic data from a CCD can be collected and stored is currently limited. While this gap will continue to narrow, it is highly unlikely the resolution that can be achieved with a digital camera will approach that of film in the foreseeable future. Despite the shortcomings of the current crop of digital cameras, however, they offer advantages that make them worth considering for certain applications.

The least sophisticated digital cameras now sell for less than $500 (1999) but are little more than modern equivalents of "box cameras." Most of these cameras capture images in the resolution range of 480 x 640 pixels. The pictures from these cameras are suitable for display as windows on a computer web site or on a TV monitor, but any attempt to display or print the image in a large size (greater than 4 x 6 inches) will be disappointing.

Digital cameras selling in the range of $500 to $1,000 (1999) offer more features and higher resolution. The Kodak DC-210 looks and handles like a 35mm point-and-shoot camera and delivers a resolution of 864 x 1,152 pixels, which provides sufficient detail to enable you to make a good-quality 4 x 6-inch dye-sublimation print or a 3 x 4-inch photo-quality ink-jet print. A 1.8-inch LCD (liquid crystal display) panel on the back of the camera displays a full-color image of the picture for 10 seconds after each exposure, and you have the option of either saving or deleting the image from a temporary storage file. This "instant editing" feature enables you to save only those pictures that live up to your expectations — if someone blinks at the moment of exposure, erase the shot and try again. Images are stored on a removable 4MB (megabyte) CompactFlash removable memory card (Kodak picture card) that enables you to store from 13 to 31 images in high-resolution mode or 28 to 59 images in low-resolution mode (640 x 480 pixels) — the number depends upon the data-compression mode you choose for image storage. The camera has an autofocus zoom lens with excellent optics equivalent to a 29 to 58mm zoom on a 35mm camera.

With all digital cameras you will need a computer system equipped with suitable hardware (a color printer and a CD-ROM drive) and software to make optimal use of the camera and its capabilities. A cable is provided to enable you to download digital data directly into your computer, and the software that is

Figure 2.9: *Olympus D-340L digital camera.* Digital cameras record and store images electronically that can be downloaded and stored in a computer file. The image can then be displayed on a monitor, enhanced through image-processing techniques, and printed.

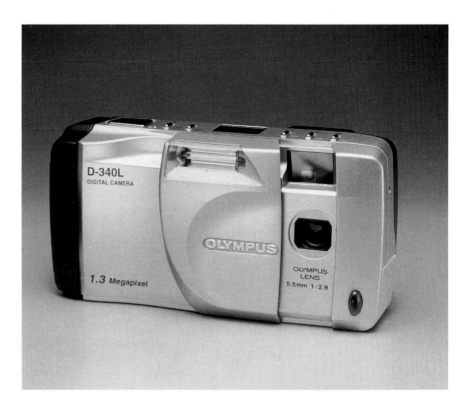

bundled with the camera includes Kodak's Picture Easy Software 3.0, Adobe PhotoDeluxe, Adobe PageMill, Windows 98 mounter, and Twain driver for a PC. Macintosh computer users will need to purchase a special connection kit. All of this equipment is easy to use if you are computer literate and are willing to spend some time learning a new approach to photography. A digital camera is not a simple alternative to traditional point-and-shoot 35mm or APS cameras.

If you are looking for a digital camera that will deliver good-quality images capable of modest (by film standards) enlargement, you can expect to pay in the range of $10,000 to $25,000 (1999) for the basic camera. Cameras such as the Kodak DCS-460 have been used by photojournalists in circumstances where timely transmission of a photograph to a newsroom via a telephone modem is urgent. It is probable that digital cameras will play an increasingly important role in the field of reportage.

Kodak also makes a digital camera back (the Kodak DCS-465) for a medium-format camera that can be used with a Hasselblad 500CM or Mamiya RZ67. The back will deliver a resolution of up to 2,036 x 3,060 pixels, which is sufficient to make a good-quality 8 x 10 print. The digital images can be stored as they are taken on PC-Type III hard-disk cards (170MB capacity), and a single card can accommodate up to twenty-six high-resolution images. All of the normally operative camera lenses and accessories can be used with the digital back. The ability to display the image immediately on a video monitor, edit it with computer software, and download the file directly to a print shop has proven to be useful for catalog production and other advertising applications. Digital backs for larger-format cameras are also available.

35mm Cameras

A small camera does not imply low cost; a good small camera is necessarily expensive, and a good enlarger (also expensive) is essential for fine results. Equipment in the small-camera field must be of high quality, otherwise results will be disappointing.

Facility of operation of the camera comes only with practice; manipulation of the camera in the dark or with the eyes closed will be helpful in giving the "feel" of the instrument at different settings. Even if these adjustments are roughly approximate, they save time. Such familiarity with the instrument will assure rapid basic operation and assist in capturing the fleeting scene before us.

Technical advances in photography over the past fifty years have made 35mm cameras the most popular and versatile cameras ever. The array of equipment and films available for the 35mm format is unrivaled in any other system. The incorporation of computer technology, coupled with recent advances in black-and-white and color film formulations, has resulted in cameras that are highly sophisticated and capable of producing images of consistently superb quality.

When you consider purchasing a 35mm camera, it is wise to choose a body and lens that are part of an entire camera system. Leica, Nikon, Canon, Pentax, Contax, and Minolta, for example, all produce professional-quality equipment that has stood the test of time and the marketplace. Each manufacturer offers a variety of lenses, filters, lens shades, motor drives, electronic flash units, and other accessories that are completely compatible with its camera bodies. If you acquire a camera body that is part of a system, all accessories will fit properly, and the camera ought to perform according to its specifications.

Figure 2.10: *Leica M6.*

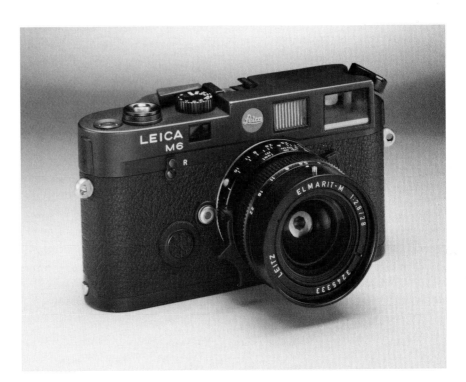

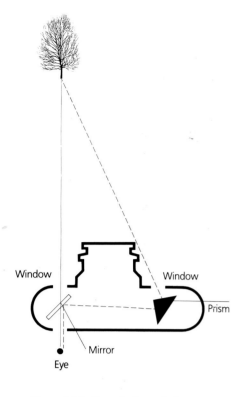

Figure 2.11: *Rangefinder optical system.* The viewfinder image, seen through the window at the left end of the camera, includes a small superimposed rangefinder area controlled by the prism at the right. The prism is coupled with the lens focus setting and rotates in such a way that the image it forms comes into alignment with the primary viewing image when the focus is correct. The greater the distance between the rangefinder windows (sometimes referred to as the rangefinder base length), the more accurate the system is likely to be.

35mm Rangefinder Cameras

Leica M6 Leica "invented" 35mm still photography with the introduction of the Leica 1 in 1925. From the beginning, the Leica sought to marry simplicity of design and operation and the finest mechanical and optical quality that was technically possible. The Leica M6 continues the Leica tradition of 35mm cameras that are unsurpassed in terms of image quality.

All 35mm cameras are classified according to which system is used to view the image being photographed. *Rangefinder cameras* have a "window" built into the camera body, which contains a framed area that approximates what the lens sees.

Leica has resisted the temptation to integrate the latest electronic controls into the design of its cameras, opting instead to maximize optical performance and mechanical operation. Its only concession to automation is the incorporation of a through-the-lens light-metering system in the camera body.

Focusing and Framing the Image The viewfinder of the Leica M6 is a window built into the top of the camera. Bright lines corresponding to the image areas covered by 28mm, 35mm, 50mm, 75mm, 90mm, and 135mm lenses appear in the window when the respective lenses are attached to the camera. In the center of the window is a small rectangle, part of the mechanical rangefinder used to determine proper focus. To focus, you rotate the lens collar until the image in the center of the screen is superimposed on the larger image in the window.

Focusing with the rangefinder on the Leica M6 is quick and precise, and Leica has designed the viewing frame so that parallax errors are minimal. (*Parallax* is the term used to describe the fact that the image seen through the viewfinder is not exactly the same as the image that is being photographed, because the viewing and taking lenses are in different locations; see figure 2.19.) For an example of parallax, look at an object about two feet away from you. Without moving your head, cover first one eye and then the other. The position of the object relative to the distant background will be quite different in the two instances.

Rangefinder cameras have at least two advantages over single lens reflex cameras: first, for wide-angle lenses, focusing tends to be more accurate with a rangefinder; second, the image in the rangefinder's viewing window is much brighter than what you see with an SLR. This is an important consideration for photography in low-light situations.

One drawback of rangefinder cameras is that since you do not see the image through the camera's lens, you cannot visually judge the depth of field. Markings on the lens will tell you what the range of acceptably sharp focus is for any lens setting, and with a little experience you will develop a feel for the effects of the various settings, but cameras in which you look through the lens to compose and focus the image have a decided advantage here.

Exposure Determination The two small light-emitting diodes (LEDs) in the viewing window of the Leica M6 are connected to a light meter built into the camera. To activate the meter, you touch the shutter-release button; then you adjust either the lens aperture or the shutter speed as needed. When both LEDs light up, the aperture/shutter speed settings correspond to a normally "correct" exposure.

A

B

Figure 2.12: *View through a rangefinder camera.* When the two superimposed images are aligned, as in figure B, the focus is correct.

Other Leica M6 Features Without a lens, the Leica M6 weighs 1¼ pounds, considerably less than the average SLR; it is small enough to fit into a jacket pocket. The fastest shutter speed is $^1/_{1000}$ second. A full complement of wide-angle and telephoto lenses are available to fit it, as is a motor-drive attachment that allows you to take up to three exposures per second.

Leica offers special seminars on the use of its cameras and publishes books and a periodical that are an excellent source of information on the use of Leica equipment.

Overall Considerations In terms of quality and performance, the Leica M6 is in a class of its own. The lenses are superb, and every mechanical aspect of the camera reflects the maker's dedication to craftsmanship. It is one of the simplest and quietest cameras to operate. (Since only the focal-plane shutter curtain moves when the exposure-release button is pressed, the camera is almost noiseless — in contrast to an SLR, whose moving mirror produces a noticeable click.) With care, a Leica will give you a lifetime of good use. The camera and lenses are at the top of the 35mm-camera price range.

Contax G2 Contax has entered the modern 35mm rangefinder field with the introduction of its G-series cameras. The Contax G2 is a highly sophisticated camera that features superb-quality interchangeable Carl Zeiss T* lenses and can be operated in either an automatic or manual mode. The handsome camera body is made of die-cast aluminum covered with a titanium outer body and its design and features reflect the extensive experience of Contax in the 35mm field. The camera integrates very sophisticated electronic features into its operating system. The electronically controlled shutter sets exposures that can range from $^1/_{6,000}$ up to 16 seconds. A photodiode provides centerweighted light readings at whatever aperture the lens is set. You can specify exposure compensation of +/− 2 steps to accommodate unusual lighting situations. Flash synchronization up to $^1/_{200}$ second is an attractive feature. Through-the-lens direct flash control automates the use of the flash unit and ensures correct exposures.

The viewfinder is a zoom telescope, and the frame area changes automatically as the focal length of the lens and focusing distance are changed. As you look through the viewfinder, an LCD displays the shutter speed, an exposure warning if there is insufficient light, flash-ready and exposure-OK symbols, and a distance scale with the autofocus readout or measured focus indications. A motor drive is available for the camera that enables you to expose up to four frames per second. A three-frame autobracketing option that can be set in full- or half-step variations is an interesting feature. The camera also has multiple exposure capabilities, a built-in self-timer, and auto film-loading.

Zeiss lenses that are available for the Contax G2 are the 16mm Hologon, the 21 and 28mm Biogon, the 35 and 45mm Planar, and the 90mm Sonnar. The quality and performance of these lenses is excellent and though they are fewer in number than those offered by Leica, they cover the range of focal lengths most likely to be used by photographers. The selling price of the Contax G2 is significantly below that of the Leica M6 and the impressive quality, capabilities, and performance of the camera have made it an "instant classic" well worth considering.

Figure 2.13: *Contax G2.* By integrating modern electronic features into a 35mm camera in the rangefinder format, Contax created a niche between the Leica and modern SLRs. The camera has a rugged titanium-clad aluminum body and offers autofocusing, automatic exposure control, shutter speeds up to $^{1}/_{6,000}$ second, and a series of superb Zeiss lenses spanning focal lengths from 16mm to 90mm.

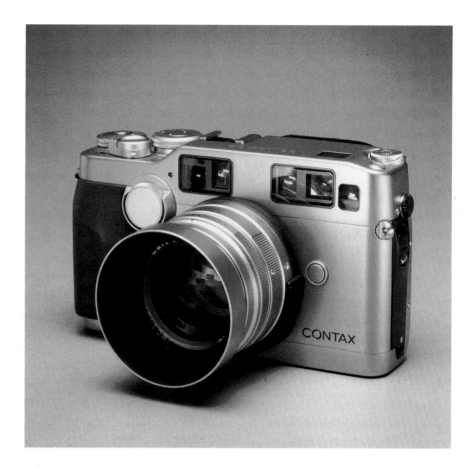

Single-Lens Reflex (SLR) Cameras

Single-lens reflex (SLR) cameras now dominate the 35mm-camera market. The viewing system is designed to let you look through the lens of the camera so that the image you see corresponds to the image that will appear on the film. This is made possible by a mirror placed behind the lens, which reflects the image onto a focusing screen at the top of the camera. When the shutter-release button is depressed, the mirror swings out of the way and the shutter opens to expose the film. The mirror then immediately returns to its original position.

To make the image as bright as possible, the lens diaphragm is automatically on the wide-open setting for focusing and framing. At the instant of exposure, the diaphragm closes down to the programmed aperture and the exposure is made.

Some cameras have *depth-of-field preview buttons* that let you see what the scene will look like at the programmed aperture. The darkened image that appears when you depress the button corresponds to what the camera will actually photograph. This feature is particularly useful in situations where the depth of field is very limited (in close-up photography of flowers or insects, for example).

Figure 2.14: *Single-lens-reflex optical system.* The mirror, located in front of the film, deflects light entering through the lens upward to a focusing screen. This image is then reflected through a prism to the eye for viewing. When the shutter-release button is pressed, the mirror swings up against the viewing screen and light passes to the film for exposure, which is controlled by a shutter located just in front of the film plane.

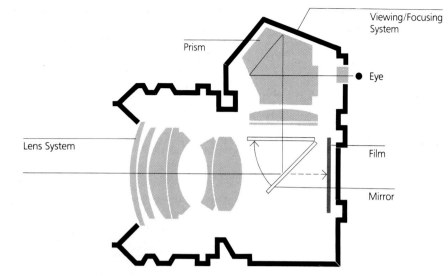

Viewing/Focusing System

Prism

Eye

Lens System

Film

Mirror

A

B

Figure 2.15: *View through a single-lens reflex camera.* The viewing field shows exactly the same image that will be photographed when the shutter-release button is pressed. The split-image circle at the center of the field functions like the superimposed image of a rangefinder: when the focus is correct, a straight line passing through the viewing field will be unbroken (as in figure B).

Focusing and Framing the Image While the more complicated viewing system makes an SLR heavier than a rangefinder, it also makes composing an image more certain. With modern 35mm cameras, lenses can be focused either manually or automatically. In the manual mode, you focus the image by rotating a collar on the lens; as you adjust it, the image you see as you look in the viewer moves into and out of focus. It is up to you to decide the proper setting.

If the camera has an electronic rangefinder, a small motor coupled to an optical sensor will focus the lens automatically when the camera is in the autofocus mode. The object in the center of the focusing screen will be the reference point for the focusing device, and that object will be placed in sharp focus. If the camera is pointed at a moving object while it is set on autofocus, the lens will keep the tracked subject in continuous sharp focus.

Some cameras also have a "freeze focus" option. In this mode you focus the lens for a specific distance and depress the shutter release button. When the subject (a racing car, for example) arrives at the preset focused position, the camera's shutter trips automatically.

Exposure Control Most modern 35mm SLR cameras incorporate a light meter into the camera body to help you determine the proper exposure for your film. Computer technology has made automatic exposure control a practical and desirable feature.

One problem in exposure determination lies in how to weight the relative brightness of objects in the center of a scene and the background. If the brightness values differ significantly, the result can be a negative in which one or the other is badly overexposed or underexposed.

In the most sophisticated 35mm SLR cameras, the light meter reads the brightness of the center circle and then measures the light level in other areas of the image. These values are relayed to a computer chip and compared to an array of preprogrammed values that define the light characteristics (for example, backlighting, sidelighting, low contrast, high contrast) of the scene. From the assembled data, a decision is made about the optimum exposure value for the scene, and this value determines the exposure settings. All of these evaluations

Figure 2.16: *Canon EOS-1N.* The Canon EOS 35mm single-lens reflex camera systems reflect decades of commitment by Canon to marry the best in optics, mechanics, and electronics in cameras that perform at the cutting edge of photographic technology. The Canon EOS-1N is a remarkably sophisticated camera that lends itself to completely automated operation or to as much personal decision making as you wish to impose. Each aspect of the camera system — lenses, flash units, interchangeable backs — is designed to allow for upgrades so that any advances in technology can be incorporated into the basic camera.

The EOS-1N has the largest selection of autofocus lenses for SLRs. Forty-two lenses span a range of focal lengths from 14mm to a remarkably fast 1,200mm f/5.6 telephoto. Most of the autofocus lenses can be focused manually as well. Seventeen zoom lenses are available, covering a broad array of focal lengths. The autofocus feature is extraordinarily accurate and functions well in extremely low-light situations, where manual focusing is very difficult with any camera. A unique depth of field option is available with the EOS-1N: to obtain the optimal depth of field, focus first on the nearest point that needs to be in sharp focus, then do the same for the farthest point. Next, compose the picture and press the shutter button, and the camera will automatically select the best intermediate focal point, aperture, and shutter speed for the image.

The exposure system for the camera divides the viewing area into a complex grid (not visible through the viewfinder), while a microprocessor-controlled metering system measures the light intensity in sixteen different regions of the scene. The reflectance of the active focusing point is weighted most heavily and the camera is programmed to calculate and deliver the "best" exposure after appropriately evaluating the overall scene. If you remain uncertain about how to expose a difficult scene, the camera can be set to provide single or continuous bracketing of exposures up to +/– three stops in ⅓- or ½-step increments. In addition to operating fully automatically, the camera can function in a *spot metering* or a *partial metering* mode that limits the metering area to the center section of the viewfinder. The camera can be operated with *aperture priority* control (you select the aperture, the camera sets the shutter speed), *shutter priority* control (you set the shutter speed, the camera selects the aperture), or in *manual* mode, where all of the decisions are yours. The fastest shutter speed is $^1/_{8,000}$ second.

The standard flash-exposure program employs through-the-lens exposure control. The camera measures the light from the flash and ambient illumination that actually strikes the film plane during exposure and terminates it at the appropriate time. The use of a fill-in flash for unusual lighting situations, which is a complex problem with most cameras, is fully automated with the Canon EOS-1N.

A nice feature of the Canon EOS-1N is a built-in motor drive that advances the film at a speed of up to three frames per second. The camera can be operated in either a single-frame or continuous-exposure mode when the shutter button is depressed. A power-drive booster is available that permits exposures up to a rate of six frames per second, which is useful when you are photographing subjects in action or motion.

Considerable thought has gone into the design and location of the controls for the camera. The body is shaped to fit comfortably in your hands, and the controls are conveniently located to operate at the touch of a finger. The body is fitted with moisture-resistant gaskets that offer considerable camera protection in messy environments. The Canon EOS-1N is an inch shorter, a pound lighter, and $1,000 less than the Nikon F-5 and is currently the most popular 35mm camera used by professional photographers.

take place the instant you begin to depress the shutter-release button, and the determinations are completed within microseconds.

With highly automated cameras, you can (1) set the camera at a specific aperture, and it will automatically determine and set the shutter speed; (2) set the camera at a specific shutter speed, and it will automatically determine and set the aperture; (3) set both the aperture and shutter speed yourself; or (4) let the camera's controls determine and set both the aperture and the shutter speed.

Many cameras also have a range of controls for an electronic flash. The flash can be used either as the sole light source for the exposure or as a "fill" to provide some additional light for an object in the foreground (see page 193).

Advantages and Limitations of 35mm Cameras

The flexibility and portability of the 35mm camera make it the camera of choice for many photographers. It is ideal for photographing people in action, for doing close-up work (such as shooting wildflowers), and for use in certain aspects of nature photography. Virtually all newspaper photographs and all images in such magazines as *National Geographic* are the product of 35mm cameras.

The variety of film available for 35mm cameras is unrivaled in any other format, and the same can be said for lenses. The cameras themselves can be adapted to other instruments ranging from microscopes to telescopes, and with the appropriate accessories they can be used underwater or in outer space. If one had to use a single word to describe the 35mm camera, it would be *versatile*.

There are two major limitations with 35mm cameras, however — one physical, the other psychological. The physical restriction is the size of the negative produced by the camera: 24 x 36 mm, or 1 x 1½ inches. Two factors that influence the quality of a photographic print are *the resolution of fine details* and the *tonality,* or how smoothly colors and tones are rendered. Because a 35mm negative needs to be enlarged substantially to make a print, the resolution and tonality can never be as good as they would be in a print made with a similar film in a larger negative format (assuming that the lens qualities are comparable).

The 35mm camera can also embody a subtle psychological pitfall that photographers need to guard against. Thirty-six exposures, automatic exposure control, automatic flash exposure at low light levels, automatic focusing, motor drives, and other "automatic" features offer enormous photographic potential. It is easy to slip into the habit of taking a picture of anything that catches your eye for a moment and hoping that a few negatives may be interesting enough to print. A state of mind can develop in which chance displaces creativity. At that point the camera controls the creativity of the photographer, rather than the other way around. Awareness and selectivity are critical characteristics of fine photography, and it is essential that "automation" not be allowed to diminish those personal qualities.

One final note of caution: *always check your camera's batteries before you use it, and keep a supply of spares in your camera case!* With most modern, highly automated 35mm cameras, the camera will cease to operate the moment the batteries run down.

Georgia O'Keeffe and Orville Cox,
Canyon de Chelly National Monument,
1937

At one rim-edge I was walking around with my Zeiss Contax and I observed O'Keeffe and Orville Cox in a breezy conversation standing on a rock slope above me. It was an inevitable picture. O'Keeffe and Cox were engaged in a bit of banter. The moment was now. If the camera was held level Cox's hat and O'Keeffe's figure would be cut into; a side tilt was necessary. Kneeling, I lowered the position of the camera, bringing more of the figures against the sky. This was intuitively and swiftly managed, and I made only one exposure.

I do not get along well with the automatic features of today's cameras, although I acknowledge that they have many advantages — superb lenses, electronic shutters, motor drives, and ingenious accessories. But I want to have complete control of lens aperture and exposure; I prefer to use a spot meter no matter what camera I am working with.

I developed the roll in Yosemite a few weeks after the picture was taken. While drying, the roll slipped out of the clothespin on the drying wire, fell to the floor, and was stepped on! The only frame out of the thirty-six that was damaged was this one, by far the best of the roll. [Note: The negative is badly scratched, and printing it requires considerable manipulation.] When I have a subject that I feel is unusual I try always to make a duplicate exposure simply because there might be an accident like this one or a defect in the image area. But if the subject is fleeting, like the facial expressions in this image, there is no way to make duplicates.

I have done considerable work with the 35mm. I stress the importance of choosing (if possible) the ideal camera and format for the problem at hand. In general, I favor a tripod-mounted view camera for static subjects that invite contemplation — or a small hand-held camera for "the decisive moment."

This photograph recalls for me the brilliant afternoon light and the gentle wind rising from the canyon below. The Southwest is O'Keeffe's land; no one else has extracted from it such style and color, or has revealed the essential forms so beautifully as she has in her paintings.

— ANSEL ADAMS

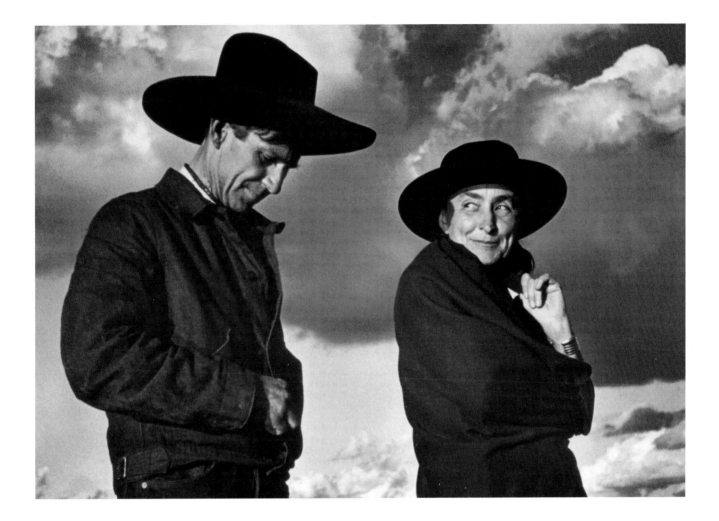

35mm Cameras: Summing Up

One often-asked question is, Can you really tell the difference between photographs taken with a good $500 35mm camera and ones shot with a camera that costs $4,000? The answer is probably, though it depends on how careful you are when you use the camera. The optical performance of a lens is a measure of its *resolving power* (the ability to separate closely spaced lines; see pages 111–115) and *contrast* (the ability to distinguish nearly identical tones of gray; see pages 111–115). Optical performance can be compromised by poor mechanical assembly or by wear or play in the threads of the focusing mechanism built into the barrel of the lens.

Assuming that everything on the two cameras is in working order and that the cameras themselves are secured on tripods to take the photographs, a critical examination of the resulting negatives or slides will probably reveal slight but perceptible differences. For hand-held shots, any differences may be eradicated by the slight motion of the camera when you take the photograph. Is the distinction between the two results important enough to warrant consideration?

The answer is again relative. If your confidence is enhanced by knowing that you are working with the finest optical instrument available, and if you respond to the challenge and opportunity it offers, the answer is yes. Remember, however, that as factors in the quality of the photographs produced, the physical properties of cameras and lenses are less limiting than the photographer's technique and imagination.

Medium-Format Cameras

The photographer who uses this format does so because he finds that the compromises involved work to his benefit. He may achieve better image quality than is possible with a 35mm camera, with greater mobility than a 4 x 5 camera permits. No one camera is suitable for all kinds of photography, but for those who confront a wide variety of subjects and working conditions, with demands for high image quality, a medium-format camera may be a logical choice.

Medium-format cameras are those that produce negatives in sizes varying from 4.5 x 6 cm (1⅝ x 2¼ inches) to 6 x 6 cm (2¼ inches square), 6 x 7 cm (2¼ x 2¾ inches), or 6 x 9 cm (2¼ x 3¼ inches). Medium-format cameras usually use roll film, but some are capable of using sheet film.

One significant advantage of larger negatives lies in the technical quality of prints or transparencies made from them; the resolution of details and the tonal gradation are notably superior to what can be achieved with the 35mm format when comparable lenses are used. The gain in negative size is achieved, however, at the expense of increased camera size and weight. As a result, medium-format cameras are slightly more cumbersome than their 35mm counterparts. By the time you pack the basic camera and a few lenses into a carrying case or bag, the total weight can easily exceed twenty pounds. If you are willing to carry that much equipment, you should give serious thought to acquiring a large-format camera instead. You will have the advantage of additional controls and the ability to use either roll or sheet film, and you will probably also have much less weight to carry. In deciding which kind of camera to buy, you should carefully consider the advantages and trade-offs.

Figure 2.17: *Mamiya C330.* This venerable twin-lens reflex camera features sturdy construction and interchangeable lenses with excellent optics; 120 and 220 roll films will produce twelve or twenty-four 2¼-inch-square negatives, respectively. While this and most other twin-lens reflex cameras have been discontinued in favor of single-lens reflex models, they can be found in excellent used condition in many camera stores at modest prices. Because of the fine lens quality and large negative size, the twin-lens reflex cameras like the Mamiya, Rolleiflex, Rolleicord, and Yashica Mat are an excellent choice for both amateur and professional photographers who want to explore possibilities beyond the 35mm format.

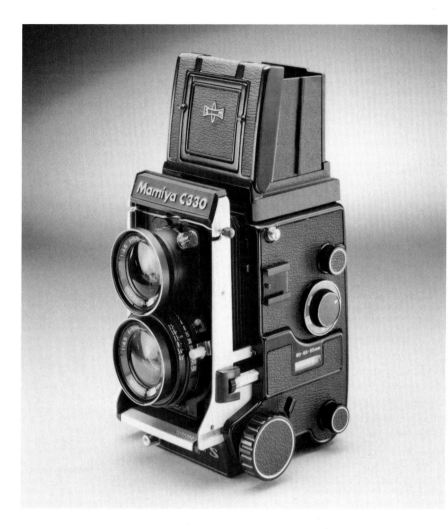

Twin-Lens Reflex (TLR) Cameras

The twin-lens reflex was for many years a standard of the photographic world. The design, developed by Rollei, became an acceptable press and documentary camera in the years when the 4 x 5 press camera was standard and the 35mm was viewed by many as too small for professional work.

Excellent results are possible with some models of this design, and they often represent the least expensive way for a photographer to begin working in medium-format.

A *twin-lens reflex (TLR) camera* is a modified box camera with a viewing lens mounted above the camera lens. The viewing lens has the same focal length as the picture-making lens and projects an image off a mirror and onto a ground-glass screen, enabling you to focus and compose the scene. The image on the screen is reversed from left to right, which is somewhat disconcerting when you first use the camera. Because the viewing lens is located a few inches above the camera lens, a small degree of parallax error is unavoidable. You can correct for parallax by composing the image with the camera mounted on a tripod, then raising the camera by the precise distance between the centers of the two lenses.

Most twin-lens reflex cameras do not have interchangeable lenses; there are attachments to modify the normal focal length of the camera to wide-angle or telephoto, but the optical quality will inevitably be compromised. Mamiya, however, makes a TLR camera with interchangeable front panels, which permits you to change both viewing and taking lenses in one simple operation. Lenses are available for this camera in focal lengths ranging from 55mm to 250mm. In addition, Mamiya offers a prism that can be attached to the viewing screen to rectify the image on the ground glass so that what your eye sees corresponds to the actual scene.

A used twin-lens reflex camera may be well worth your consideration, especially if you are looking for a second camera. For years Rollei made a TLR that set the standard in the field for superb optics and durability.

Figure 2.18: *Cross section of a twin-lens reflex camera.* With this design, separate lenses of identical focal length form the viewing and picture-making images. The two lenses are contained in a single focusing mount so that when the viewing lens focuses the subject on the ground glass, the primary lens focuses it on the film plane. The image seen on the ground glass is reversed from left to right because of the mirror. Because the viewing lens is a few inches above the taking lens, parallax is unavoidable.

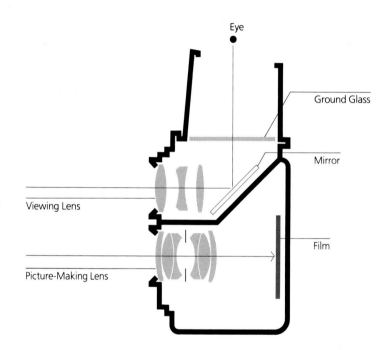

Single-Lens Reflex (SLR) Cameras

The advantages associated with viewing a scene through the camera lens led manufacturers to develop a variety of single-lens-reflex designs for medium-format cameras. Most models consist of a simple three-piece assembly of an interchangeable lens, a light-tight box, and an interchangeable film magazine. Focusing is accomplished by the rotation of a collar on the lens.

One important advantage of modular camera design is that having multiple film magazines is, in effect, equivalent to owning multiple cameras: you can load one magazine with black-and-white film, a second with color-negative film, and so forth. You can photograph the same scene with different films just by switching magazines.

With most medium-format single-lens reflex cameras, shutters are built into the lenses. During viewing, a curtain shields the film, the shutter stays open, and a mirror reflects the image onto a focusing screen, where you compose the

A

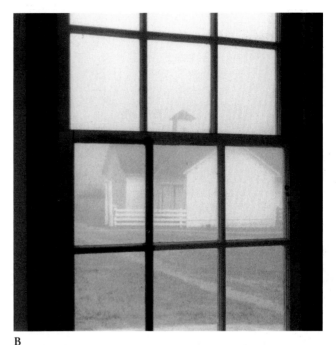

B

Figure 2.19: *Parallax.* (A) The image seen through the viewing lens of a twin-lens reflex camera. (B) The same scene as photographed by the picture-making lens of a twin-lens reflex camera.

To avoid parallax problems and ensure that the image you photograph is the same one you see through the viewing lens of your twin-lens reflex camera, after composing the image, raise the stage of your tripod by an amount corresponding to the measured distance between the viewing and picture-making lenses. (Alan Ross, *Window and Farm Building, Point Reyes National Seashore, 1987*)

image. When you depress the shutter-release button to make an exposure, the shutter closes, the curtain opens, the mirror swings up against the focusing screen, and then the shutter opens and closes, exposing the film. An advantage of this design is that an electronic flash unit will be synchronized at *all* shutter speeds, not just the small range of speeds possible with a focal-plane shutter. A disadvantage is that each lens needs its own shutter, thereby adding to its cost.

Several medium-format SLRs do have focal-plane shutters (among them the Hasselblad 2000FC). The benefit of a focal-plane shutter is that shutter speeds are independent of the lens and therefore remain consistent. Unfortunately, focal-plane shutters large enough to be used with 120 roll film are difficult and expensive to build and have not been widely used by manufacturers.

A Detailed Look at the Hasselblad 500 C/M The Hasselblad Corporation pioneered and introduced an extraordinary SLR medium-format film camera in 1948. Over the years, the company has incorporated advances in lens design and selected electronics into the basic camera system. Care, craftsmanship, and science have combined to produce one of the finest cameras ever made; it is no accident that the Hasselblad has been a part of every manned space mission the United States has undertaken.

The basic camera in the Hasselblad system is the Hasselblad 500C/M (see figure 2.20). It features interchangeable lenses and film backs and offers several options in viewfinders, some of which have built-in light meters for exposure determination. In only the moment it takes to replace the film back, you can switch from 4.5 x 6-cm to 6 x 6-cm format, or from black-and-white to color film — all without disturbing the camera itself.

The Hasselblad 500C/M has a mirror that can be locked into place (if you choose) before an exposure is made. This is a wise precaution at exposures of less

Figure 2.20: *Hasselblad 500C/M with
bellows lens shade.* Bellows extensions vary
according to the focal length of the
lens. A slot at the back of the bellows
allows gelatin filters to be inserted when
necessary.

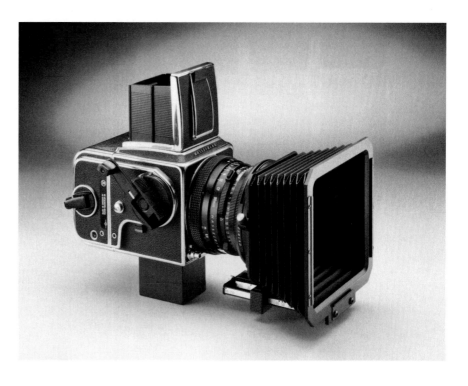

than one-thirtieth of a second because it eliminates any vibrations that might be caused by the motion of the mirror. In the Hasselblad, you view the scene directly through the lens, by looking down on a ground-glass screen. In this case the image is right-side-up but reversed from left to right. An optional prism view-finder that completely rectifies the image allows eye-level viewing.

The normal lens for the Hasselblad 500C/M is the Zeiss 80mm Planar. Also available are 30mm, 40mm, 50mm, 60mm, 100mm, 150mm, 250mm, 350mm, and 500mm lenses, as well as numerous special-purpose lenses and a 140–280mm zoom lens.

The Hasselblad family of cameras and accessories constitutes one of the most versatile and reliable camera systems ever designed. And Hasselblad's commitment to the concept of interchangeability means that newer accessories and lenses fit older-model cameras, thereby avoiding unnecessary obsolescence.

Other Medium-Format Single-Lens Reflex Cameras In introducing a number of excellent new medium-format SLRs, manufacturers have responded to the demand for cameras that can be handled with ease, incorporate all of the electronic advances that are now part of the modern 35mm camera, and produce a larger negative.

Bronica, Pentax, and Mamiya each make an SLR camera designed specifi-cally for the 4.5 x 6-cm format. All feature interchangeable lenses and mecha-nisms that permit film to be changed in midroll. Electronic exposure control and the comfortable feel and design of these cameras allow you to handle them with the same facility as a 35mm camera, but the negatives produced have nearly three times the area of a 35mm negative and can be enlarged to the traditional 8 x 10-inch size without cropping. Most important, the difference in print quality with the larger-format negative is readily apparent.

Figure 2.21: *Mamiya 645.* Several dedicated 4.5 x 6-cm medium-format camera systems offer the basic flexibility and features of high-end 35mm cameras but produce an image three times larger — a significant advantage when enlargements are being contemplated. The Mamiya M645 Pro TL offers automated exposure control, interchangeable film backs and lenses, and a motor drive.

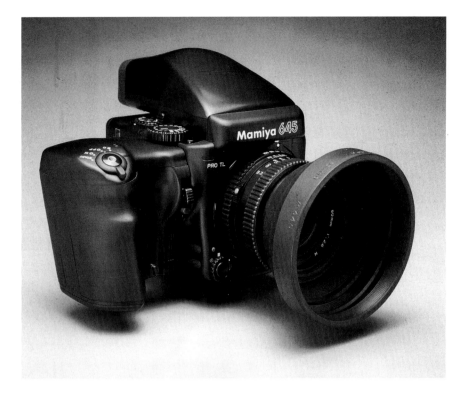

In addition to Hasselblad, both Rollei and Bronica offer single-lens reflex cameras in the square format. (The Rollei is also adaptable to the 4.5 x 6-cm format.) Both cameras incorporate modern electronic controls into their design. Rollei, for example, integrates a motor drive into the camera body. The electronic exposure metering of both has proved to be accurate and reliable.

Figure 2.22: *Cross section of a medium-format single-lens reflex camera.* The primary lens is used for both viewing and picture making. A mirror deflects the light to a ground-glass focusing screen during viewing. When the shutter-release button is pressed, the mirror swings up and a shutter, usually mounted in the lens, controls the exposure of the film.

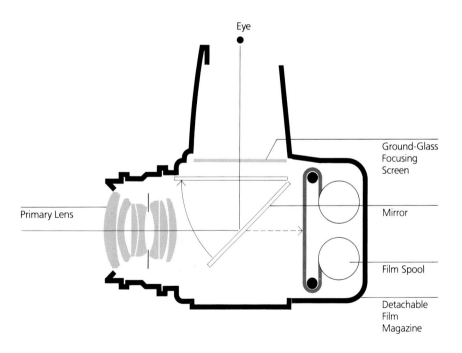

Figure 2.23: *Mamiya RZ67 Pro II.* The sophisticated electronic controls, interchangeable and rotating camera backs, broad spectrum of superb lenses, close-up focusing capability, and numerous other features make this 6 x 7-cm medium-format camera an excellent choice for both studio and fieldwork. The camera is shown with the optional AE Prism Finder attached.

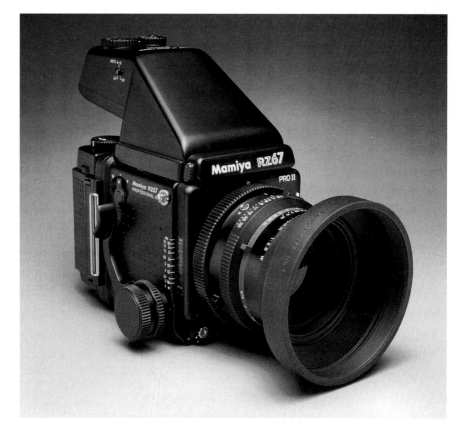

The Mamiya RB67 and RZ67. Mamiya pioneered two versions of a single-lens reflex camera in the 6 x 7-cm format and has devoted almost forty years to evolving and perfecting the RB67 and the RZ67; they differ mainly in the electronic features they employ. While the difference of 1 cm between the 6 x 7-cm and the 6 x 6-cm-square format may seem trivial, it is quite substantial in practice. Most enlarged photographs are printed in an aspect ratio of 4:5 (8 x 10, 11 x 14, 16 x 20, and 20 x 24-inch formats all equal or approximate this ratio). If a square negative is to be enlarged to 8 x 10 inches, 1.2 cm will have to be cropped from two opposing edges, whereas a 6 x 7-cm negative requires virtually no cropping. Consequently, the comparable usable area of a 6 x 7-cm negative is about 45 percent greater (6 x 7/6 x 4.8 = 42/29 = 1.45) than a 6-cm-square negative. For comparable camera lenses, the quality of an enlargement is directly dependent upon the area of the negative used; a print made from a 6 x 7-cm negative will be notably better than one made from a smaller negative size.

Because of the quality of the camera system, the versatility, and negative size, the Mamiya RB67 and RZ67 have become the medium-format cameras of choice for many professional photographers. Discussion of camera features will be confined to the Mamiya RZ67 system, though most are common to the RB67 as well.

The cameras have interchangeable rotating backs that can be used with 120, 220, and Polaroid films. The rotating back enables you to change from a horizontal to a vertical format without moving the camera. Image masking on the focusing screen changes automatically when the back is rotated.

Each lens is equipped with its own leaf shutter and provides exposure speeds in the range of $^1/_{400}$ to 8 seconds. Electronic flash is synchronized at all shutter speeds. To eliminate any vibrations during exposure, the mirror can be released before the lens shutter is tripped. The AE Prism Finder provides eye-level viewing through the lens and completely automatic exposure control with ⅙-step increments if you choose to use it. LED readouts display camera settings in the viewfinder. Virtually all accessories for the RB and RZ cameras can be used interchangeably.

Focusing utilizes a rack-and-pinion system that moves the lens out from the body of the camera for less-than-infinity focus. A large focusing knob is conveniently located next to the shutter cocking and film transport lever for fast focusing of the image. Precise focus is achieved through a fine-focus collar on the knob. A lever locks the bellows in place to prevent an inadvertent focus shift while other camera adjustments are being made. A significant advantage of the rack-and-pinion focusing system is that the closest focusing position is far less than that which can be achieved with lenses for which focusing is accomplished by rotating the lens collar to move lens elements. For example, the 90mm lens can focus to within 16 inches without any accessories. With extension tubes the 90mm lens can be focused to within 3 inches of the subject.

A wide range of optically and mechanically superb lenses is available for the camera systems. These include wide-angle (37mm fish-eye, 50mm, 65mm, and 75mm with shift capability), standard (90mm, 110mm), macro (140mm), telephoto (150mm, 180mm, 250mm), zoom (100–200mm), and APO (210mm, 250mm, 350mm, 500mm). Each lens has a depth-of-field preview lever. A mirror lock-up socket on the lens closes the lens iris and releases the mirror in the camera body. The exposure is then completed by depressing the shutter-release button on the camera. Alternatively, the camera's shutter-release button can be used to trigger the entire exposure sequence in one operation. However, for slow shutter speeds (less than $^1/_{30}$ second), it is best to use the mirror lock-up option to avoid any possibility of camera vibrations during exposure.

Figure 2.24: *Vertical and horizontal formats with the Mamiya RZ67 rotating back.* Frequently a composition can be visualized as either a horizontal or vertical photograph. The rotating back on the Mamiya RZ67 enables you to photograph a subject both ways without moving or reorienting the camera. (Alan Ross, *Horno, New Mexico, 1998*)

While the camera is easy to use and operate in handheld mode, it functions at its best as a studio or field camera, best suited for working on a tripod. The camera with the 110mm lens and a 120 roll-film holder weighs about 5 pounds (2.49 kg).

Medium-Format Rangefinder Cameras

In recent years manufacturers have introduced several high-quality medium-format rangefinder cameras. Most of these are modern variations of a design that was used and favored for much of this century but was abandoned in the face of the onslaught of 35mm cameras. They handle and function like scaled-up versions of the 35mm.

A significant advantage of the rangefinder design is that cameras that employ it tend to be smaller and easier to carry than medium-format SLRs. Medium-format rangefinder cameras generally do not have interchangeable lenses, however (the Mamiya 7 is a notable exception), so you sacrifice a little flexibility for the sake of convenience.

It is not practical to attempt to describe here all of the medium-format rangefinder cameras that are available. As with any camera choice, you should think about what kind of subjects you are most likely to want to photograph and then decide whether a particular camera can fulfill your needs.

Figure 2.25: *Mamiya 7.* This 6 x 7-cm medium-format camera offers a full range of electronic automatic- or manual-exposure controls, interchangeable lenses, and a 35mm Panoramic Adapter Kit that enables you to take 24 x 65mm images on 35mm film. The viewfinder provides full parallax correction for all but the 43mm lens. The Mamiya 7 has the versatility of a 35mm camera and produces images with superior detail and quality.

Large-Format Cameras

The small camera, held in hand, can scan the subject freely, as directed by the hand and eye, but the view camera — fixed on the tripod — "sees" only the area of the field covered by the lens within the format of the negative. Changes can be made by turning or tilting the camera on the tripod head or moving the entire assembly, but such adjustments are much more cumbersome than the free positioning of the hand camera. On the other hand, the fixed position of the view camera (and of any camera used on a tripod) leads to greater precision of composition and higher optical quality of the image. Proponents of the small hand-held camera argue that the intuitive perceptions of the eye and mind will determine the optimum point of view and select the "decisive moment" with far greater efficiency than the tripod-bound camera will. . . . Both approaches are valid within their appropriate fields.

Figure 2.26: *Roll-film holders.* Roll-film holders convert a view camera into a medium-format camera with all of the possible adjustments inherent in the former. With the Wista backs (Graflock/International–type), first compose the image on the ground-glass back, then replace the back with the film holder to make an exposure. The Calumet holder is shaped like a traditional sheet-film holder and is inserted into the camera back to make the exposure.

In reality, large-format cameras, often called *view cameras,* are the simplest and most flexible of all camera systems. They are heavy and cumbersome compared to smaller-format systems, and they almost always require a tripod, but the technical quality of the images that can be produced with them is unrivaled.

The view camera offers complete interchangeability of both lenses and films (sheet film as well as roll film), and it is the only camera system that provides the photographer with the ability to control the geometric "distortions" inherent in any lens (see figure 2.33).

With a view camera, the image on the ground-glass focusing surface is precisely what will be recorded on the film. The image appears upside-down and backward; this will seem strange when you first use the camera, but the scene's abstract nature will quickly begin to work to your advantage. This "departure from reality" will make you more aware of the basic structure and borders of the image, and that awareness will usually lead to stronger compositions.

View cameras commonly come in sizes to accommodate negatives from 2¼ x 2¾ inches up to 8 x 10 inches, and special models are also available in larger sizes (for example, 11 x 14 or 10 x 20). Calumet offers quality, budget-priced view cameras ranging from 4 x 5 to 8 x 10 inches; Linhof cameras are of unmatched quality but are very expensive.

Lenses for view cameras (see chapter 3) are available in a bewildering array of focal lengths, speeds, and prices. When you are purchasing a lens, quality should be your first consideration. Modern lenses have the finest optics ever developed; any good *anastigmatic* lens made by a reputable firm will produce images of excellent quality. Many older lenses are also superb. With testing and a suitable guarantee, such lenses are fine values and can be purchased with confidence.

One important characteristic of view-camera lenses is *covering power.* This is not an issue in other camera systems because their lenses are designed to project the image over the entire surface area of the negative. With view cameras, however, a lens designed for a 4 x 5 format camera may not cover the entire negative area if it is used on a 5 x 7 format. Always inquire about the covering power when you purchase a lens; the greater it is, the larger the range of adjustments you can make while composing the image on the ground-glass screen (see figure 3.4).

Figure 2.27: *Readyload sheet-film packets.* Several varieties of 4 x 5 sheet film are available in Readyload packets that contain two sheets of film in a light-tight packet (ten packets are sold in a box). The packet is slipped into either a Kodak holder or Polaroid sheet-film holder and the envelope is partially withdrawn just prior to exposure. After exposure, the envelope is reinserted and a second exposure can be made by turning the envelope. The substantial savings in bulk and weight make Readyloads a desirable alternative to traditional sheet-film holders for fieldwork with a view camera.

Figure2.28: *Sheet-film holders.* A sheet-film holder is a two-sided container into which individual sheets of film are inserted and held in place by thin rails. The film is protected from light by dark slides that are inserted through a felt baffle at the top of the holder. To expose a sheet of film, insert the holder into the camera back, withdraw the dark slide, make the exposure, replace the dark slide, and remove the holder. Use compressed air to remove dust from holders prior to loading sheet film. Avoid leaving sheet-film holders exposed to sunlight for prolonged periods to minimize the possibility of fogging around the edges of the film due to light leaks.

Figure 2.29: *Loading sheet-film holders.* Sheet-film holders must be loaded in total darkness. On a clean table open a box of sheet film, remove the film from its sealed pouch, and place the stack of sheets sideways in the box with the *emulsion side down* (that is, with code notches in the top-left-hand corner as you face the sheet). Fold back the flap at the bottom of the film holder, take a sheet of film from the stack, turn it *emulsion side up,* and slide it into the holder and under the raised opening of the guide rails. Use the tip of a finger to make certain that the sheet is properly positioned, then push the film gently all the way into the holder. Fold up the bottom flap of the holder and push the dark slide down until it is engaged in the slot in the flap. Swivel the arm of the locking screw at the top of the holder to prevent accidental withdrawal of the dark slide. The top edge of the dark slide is white on one side and black on the other. After an exposure is made, reinsert the dark slide with the black edge facing outward to remind yourself that the film is exposed.

Large-Format Camera Types

The most flexible of the large-format cameras is the *monorail view camera*. It consists of five basic parts: a sturdy *metal rail* that attaches to the tripod by means of a mounting bracket; the lens and *lensboard*, a board on which the lens is mounted; the *front stanchion*, which is mounted on the rail and accepts the lensboard; the *rear stanchion*, which holds the ground-glass viewing surface and the film holder; and the light-tight, flexible *bellows*, which connects the front and rear stanchions. Both stanchions can be raised, lowered, swiveled, shifted sideways, or tilted, allowing you to "correct" or distort the geometry of the object you are photographing.

A second view-camera design is the *flatbed* type. In these models the rear section is a "box" approximately three inches deep. The bottom of the box is the film holder and viewing screen. As you open the box, the lid becomes the bed that supports the front and rear stanchions. The front stanchion and the bellows are folded up inside the box and are secured to the bed by metal tracks that enable you to adjust the distance between the lens and the camera back. This ingenious arrangement enables you to carry a large camera in a very compact space.

Field cameras are view cameras that are specifically designed to be portable; they are especially suitable for hiking and can easily fit into a backpack. Both monorail and flatbed view cameras have been adapted for use in the field. For ordinary work, the choice of design is one largely of personal preference.

Figure 2.30: *Toyo monorail view camera.* The stanchions enable both the lensboard and the camera back of a monorail view camera to be raised, lowered, tilted, twisted, and shifted, thereby making this type of camera the most flexible available. Focusing is accomplished by sliding the stanchions along the monorail and adjusting the front and back of the camera.

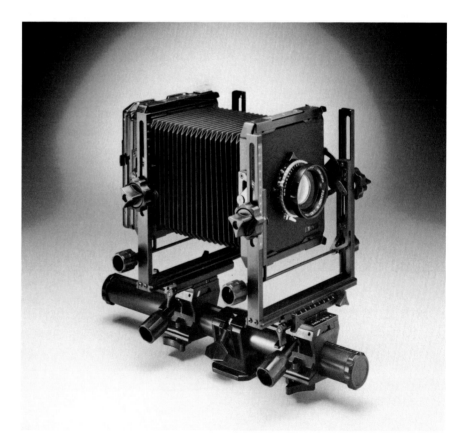

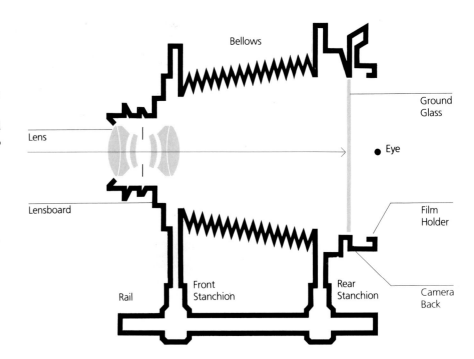

Figure 2.31: *Cross section of a monorail view camera.* The lens assembly and film plane in this camera are connected by a flexible bellows. Viewing and focusing are done by examining the image projected on the ground glass at the rear of the camera. The film holder, containing the unexposed roll, pack, or sheet film, is inserted prior to exposure. The dimensions of the holder and its position in the camera are critical; the film must occupy precisely the same plane where the ground glass was located during viewing and focusing, and the holder must provide a light-tight seal with the camera back.

Press cameras are a type of medium- or large-format camera intended for handheld use. They are similar in construction to flatbed cameras, but the movements of the stanchions are more restricted. Press cameras have a viewfinder and a rangefinder to enable you to compose and focus, and a built-in ground-glass back allows you to compose the image more carefully with the camera mounted on a tripod.

For a photographer on a limited budget who wants to work with a large-format (4 x 5-inch) negative, a used press camera can be an excellent value. Crown Graphic and Speed Graphic press cameras were produced in great numbers, as was the Linhof; they are easy to find in good condition in camera stores that stock used equipment. These cameras can provide a reasonable and affordable entry into the field of view-camera photography, and with a little effort and imagination on your part, they can handle almost any photographic situation you are likely to encounter.

General Considerations for Large-Format Cameras

When you purchase a view camera, the film holders and lenses must be acquired separately; thus, each view-camera system is essentially custom-made by the user. A good view-camera system will cost no more than a good 35mm camera. Used view cameras are also widely available and can be purchased with confidence after inspection; just about the only problems you need to worry about are light leaks in the bellows and overall sturdiness of construction.

Light leaks are easy to detect by extending the bellows fully and looking inside the camera with the back removed and a lensboard in place. Any pinholes of light that you see can be fixed with opaque paint or electrical tape. Even if the bellows is badly worn, it is easy and inexpensive to replace.

A view camera must be sturdy! Lock the stanchions in place and test them for play. If the bed or the supports flex easily, look for another camera. You do not want to work with a camera that shakes in the slightest breeze.

Figure 2.32: *Canham DLC 4 x 5 view camera.* The unique design, thoughtful and rugged construction using precisely machined parts, light weight, 20-inch-long bellows extension, and wide range of both front and back adjustments make this an unsurpassed 4 x 5 view camera for both studio and fieldwork. Figure A shows the camera with bellows extended, and figure B shows the camera closed up and ready to be carried.

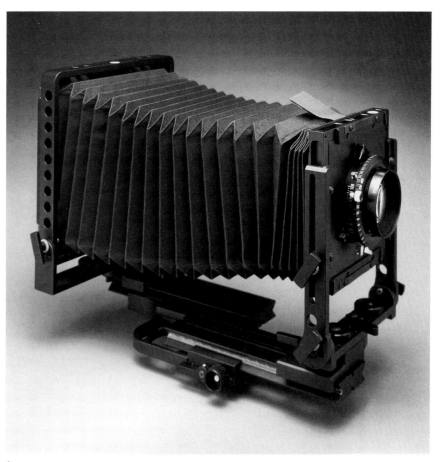

A

B

As with any camera, you need to experience the feel of a view camera before making your choice. One thing to keep in mind is that as long as it is stable and capable of making the adjustments you need, the view camera itself has absolutely no effect on the quality of your photographs. The camera is merely a box that serves as a conduit for the lens. It is the *lens* that determines image quality.

View-Camera Adjustments

Figure 2.33: The following simple view-camera adjustments enable you to change the depth of field and apparent perspective of an image and alter the shape of your subject. (*Note:* The image that you see on the ground-glass surface of a view camera is upside-down and backward.)

Image Seen on Ground Glass	Side View of Camera and Subject

(A) When the camera is pointed upward at an object (for example, a high-rise building), parallel vertical lines will converge as they recede from your viewpoint. Only one segment of the vertical face of the object will be in sharp focus.

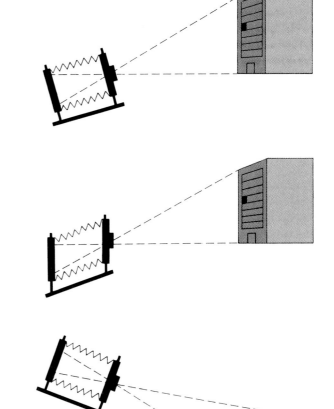

(B) The converging lines in figure A can be made to appear parallel and the entire image brought into sharp focus by tilting both the front and the rear stanchion until the lensboard and camera back are parallel to the vertical plane of the subject.

(C) When the camera is pointed downward at an object, parallel vertical lines will converge as they recede from your viewpoint.

(D) The adjustments that must be made in this instance are analogous to those made in figure B; the lensboard and camera back should both be parallel to the vertical plane. Note that the parallel *horizontal* lines still converge as they recede from the camera. While the entire plane of the front surface (the plane with the *A*) will be in sharp focus at any aperture, the lens must be stopped down to ensure that the depth of field will be sufficient for the entire *C* plane to be in sharp focus.

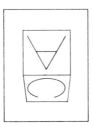

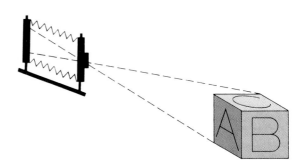

(E) When a planar surface is photographed straight on, at the same level as the camera, and the planes of the camera back and lensboard are parallel to it, the image will be undistorted.

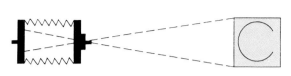

(F) Moving the camera off to the side of the subject without changing the level of the lens will alter the perspective of the image. Note that the parallel edges of the block now recede from the camera's viewpoint.

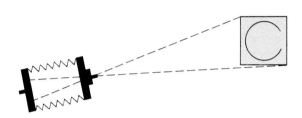

(G) Keeping the lens in the same position as in figure F and shifting and/or swinging the lensboard and back so that they are parallel to the *A* plane will restore that surface to its true shape.

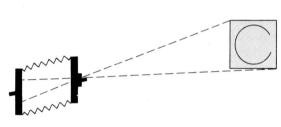

(H) This commonly encountered photographic situation is similar to that seen in figure C. Only one segment of the receding plane will be in sharp focus, and the vertical lines will converge downward.

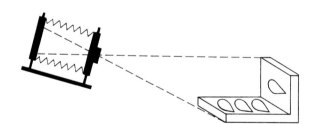

(I) If the camera back is moved to a vertical position and the tilt of the lensboard is adjusted, the geometry will be corrected and the entire image will be in sharp focus.

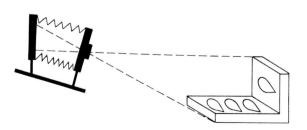

Using a Large-Format Camera

Basic cameras have no means of image control other than lenses of varying focal lengths or specialized (and expensive!) perspective-control lenses. Geometric principles result in visual distortions (such as convergence) unless the camera is directed squarely at the subject with the film plane parallel to the principal plane of the subject. For example, pointing the camera up at a building creates convergence of the vertical parallel edges of the building and the building appears to be tilting backward. While this seems natural when we look at a structure, it looks strange when we examine a photograph of the subject. Certain adjustments on view cameras can control this situation.

Similarly, depth of field can be a severe problem with an ordinary camera. A subject with near and far objects in line with each other can be brought into acceptable focus only within the limits of the characteristics of the lens (the focal length and aperture used) and with consideration of the degree of enlargement that will be required. Subjects with near and far elements — for example, an object in the foreground and a distant mountain as a backdrop — can be brought into focus by a simple back-tilt or front-tilt adjustment of the view camera. To make maximum use of the capabilities of a view camera it is necessary for the lens to have sufficient *covering power* (see pages 70–72) to project the entire image on the film when the lens axis is moved away from the center of the film. *Always use a good-quality focusing magnifier (4x–8x) to check for sharp focus of the image on the viewing screen.*

The rising or falling front The most common adjustment used with view cameras is the rising or falling front. By moving the lensboard up or down without tilting the camera, the top or bottom of the subject can often be brought into view on the focusing screen. See figure 2.34 A and B.

The sliding front or back This feature accomplishes with lateral movements what the rising or falling front does for verticals. Note that the rising, falling, and sliding adjustments move parallel with the plane of the negative and perpendicular to the lens axis. With all of the foregoing adjustments only the center of the lens axis moves to different points on the focusing screen and negative.

Back tilt Assume we are photographing a building and that after using the rising front to a maximum degree we still have not included the full facade. Furthermore, if we cannot move farther away and do not want to use a shorter focal length lens, which would require a greater degree of enlargement, we must tilt the camera upward. The image will be seen to converge on the focusing screen because the camera back no longer parallels the building facade.

If we now tilt the camera back forward until it is again in the vertical position, the converging vertical lines of the image will once again be parallel. Because the lens is much farther from the bottom of the image than from the top, the image will not be in sharp focus over the entire viewing screen. Depending upon the angle of tilt, you can achieve sharp overall focus by stopping down the lens aperture or tilting the plane of the lensboard forward or by a combination of the two. See figure 2.34 C and D.

A

B

C

D

E

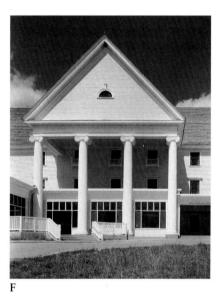

F

Figure 2.34: *View-camera adjustments.*
These six examples illustrate how a view
camera might be used to compose a
photograph in the field. (A) The camera is
set up with the lensboard centered and the
camera back in the vertical position. Too
much foreground and cutting off the top of
the building are the obvious problems. (B)
Raising the lensboard incorporates more of
the facade into the image but does not

overcome the problems mentioned in A.
(C) Tilting the camera upward brings the
building facade into full view, but the tilted
camera back causes convergence of vertical
elements. (D) Tilting the camera bed
upward and then tilting both the lensboard
and camera back into vertical positions
results in a well-composed image free from
unwanted convergence of vertical lines.

(E) Moving the camera to the front of the
facade directly opposite the far-right pillar
and making all of the adjustments cited in
D produces an image in which the vertical
lines are parallel but the horizontal lines are
skewed. (F) The convergence in E was
corrected by pivoting the camera back
around its vertical axis to correct the
distortion.

Back or front tilt for focus For objects that recede directly away from the camera it is possible to achieve sharp focus at wide apertures by tilting the camera back or front or by using a combination of the two movements. To use the back tilt, focus the camera so that the farthest object is in sharp focus at the bottom of the ground-glass screen, then tilt the camera back toward you until the near object is in sharp focus. A few further fine adjustments may be needed. Remember, however, that when you tilt the back, you are affecting the geometry of the image, and any rectilinear area in the subject will show either convergence or divergence. An advantage of using the back tilt to achieve focus is that the lens axis does not move away from the center of the negative and so, demands on the covering power of the lens are minimized.

With the camera back at the vertical position (or tilted), the front tilt can be used to achieve focus with near and far images by tilting the lensboard. This movement does displace the axis of the lens, and lens coverage must be adequate. Very little movement of the image will be seen when the lens is tilted, and no geometric change is caused by this action. See figure 2.35B.

Front and back swings These function on exactly the same principle as the back and front tilt (it would be the same as tilting the camera 90 degrees to the side). In many situations most of the possible camera adjustments may be used at the same time. You need to be careful about introducing geometric distortions into the image and be aware of the failure of the lens to properly cover the negative as a result of a combination of movements. It is important to follow a step-by-step procedure when making camera adjustments, always monitoring the position of the camera back with respect to the image planes.

For free-form natural subjects, the evidence of distortions is not nearly as apparent as with rectangular objects such as architectural structures. However, converging pine trees can be as disturbing as tilting buildings. Pay attention to horizon lines and keep them level when appropriate.

Large-Format Cameras: A Summary

An important rule to follow in all cases is *set up the camera in normal position with zero adjustment settings.* Use all of the adjustment settings as little as possible; it is easy to overadjust without thinking about what is happening! In all cases where the convergence of parallel lines in the subject must be avoided, the camera back (the focal plane) *must* be parallel to the plane of the subject. With cameras that have tilt back adjustment, before you tilt the camera up or down, try using the rising or falling front (the same for lateral movements of the sliding front or back). If it is necessary to move the camera to cover the subject, then do so — and then tilt or swing the back into parallel position.

If there are different focal planes in the field of view, you must seek the proper focus point for maximum depth of field, or use the tilting or swinging front (if the back must be kept parallel to the subject). As you swing or tilt the lens you may have serious coverage problems — look for these in the corner of the image. It is important to know the covering limits of your lenses; test them by focusing on a bright, uniformly lighted wall and check the corners of the focusing screen for visible light fall-off.

A

B

C

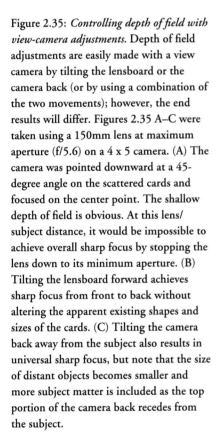

Figure 2.35: *Controlling depth of field with view-camera adjustments.* Depth of field adjustments are easily made with a view camera by tilting the lensboard or the camera back (or by using a combination of the two movements); however, the end results will differ. Figures 2.35 A–C were taken using a 150mm lens at maximum aperture (f/5.6) on a 4 x 5 camera. (A) The camera was pointed downward at a 45-degree angle on the scattered cards and focused on the center point. The shallow depth of field is obvious. At this lens/subject distance, it would be impossible to achieve overall sharp focus by stopping the lens down to its minimum aperture. (B) Tilting the lensboard forward achieves sharp focus from front to back without altering the apparent existing shapes and sizes of the cards. (C) Tilting the camera back away from the subject also results in universal sharp focus, but note that the size of distant objects becomes smaller and more subject matter is included as the top portion of the camera back recedes from the subject.

Figure 2.36: *Extreme depth-of-field control.* This extraordinary photograph was made by hanging a 4 x 5 field camera upside-down inside the tripod legs in order to place the lens about 5 inches above the asphalt. Extreme tilts of both the camera back and lensboard were required to achieve the desired perspective and focus, which is sharp from a few inches to infinity. (Alan Ross, *Banana Peel, US 285, Northern New Mexico, 1997*)

Summing Up:
It's Your Decision

The camera or cameras you choose must reflect your personal interests and circumstances. Photographic equipment can be extremely expensive, but while the camera of your heart's desire may exceed the reach of your bank balance, affordable alternatives are available. If your need to create images is great enough, you can make do with the most primitive equipment and succeed in making a strong photographic statement.

The range of camera equipment now being manufactured is impressive. The multitude of options and the persuasive advertising hype make choices even more difficult. How do you make a wise decision?

Most photographers will want to own a 35mm camera. There are subjects that it captures and circumstances that it functions under better than any other camera. If you buy a well-known brand either new or used from a reliable dealer, the probability is that it will be capable of producing fine images, and you will be satisfied with your purchase.

If you intend to make enlargements yourself, someday you will probably want to work with larger-size negatives. There simply is no substitute for a large negative if you wish to make prints with consistently high image quality. The most flexible cameras for this purpose are view cameras, and the controls you have with them cannot be duplicated in any other system. For example, with the sheet film used with a view camera, each negative can be exposed and developed individually to maximize the image quality.

If you plan your purchasing strategy well, an excellent and functional view-camera system need not be expensive. Using a view camera is the best way to learn and understand photography, but it does demand that *you* function on manual, not on automatic. The extra effort will pay substantial dividends.

One common complaint about view cameras is that they are slow and cumbersome. In photography, however, slowness is most often an advantage, not a fault. View cameras require thought. It is not unusual to see a photographer stand with his or her head under the focusing cloth of a view camera for five or ten minutes, studying and composing an image. Occasionally you will see him or her move on without making an exposure, if the image just did not work as a photograph. That is a discipline few 35mm photographers develop.

View cameras *are* cumbersome; that is a fact that not even the most avid devotee would deny. Lugging a camera, several lenses, and a heavy tripod up a mountain, through a desert, or across city streets does put your convictions about photography to a stern test. It is at moments such as these that you begin to consider the merits of compromising and acquiring a medium-format camera.

Medium-format systems are often an excellent choice for photographers. Using modern films, they come close to delivering all the quality inherent in a 4 x 5 negative, and some are almost as easy to handle as a 35mm camera. However, by the time you add several lenses to the basic camera, the weight of a medium-format camera system can be formidable. The same is true for 35mm cameras.

The real key to compromise in the field lies in what you choose to take along with you, not in which format you use. For example, if you plan a long hike and prefer to photograph with a view camera, a stripped-down Crown Graphic, two

lenses, and a film pack weigh very little and will slip easily into a day pack. It is only when you try to provide for every contingency, hauling along every lens and gadget in your photographic arsenal, that you get into trouble and begin to rue the day you took up photography. The discipline of working with a restricted range of equipment is worth cultivating, regardless of which camera system you prefer.

Whichever system you choose, spend as much time as you can familiarizing yourself with all of the camera's controls. Practice changing film and lenses so that you can do it very rapidly, especially if you use small- or medium-format equipment — you don't want the action to pass you by as you fumble around trying to load a new roll of film into the camera. With a view camera, practice setting up the camera on a tripod, and seek out situations that will enable you to use the camera's swings and tilts. By developing a thorough appreciation of a camera's capabilities, you will soon be able to handle the mechanical details of its operation on a subconscious level and give over all of your attention to capturing the image that caught your eye.

The next time you pick up a camera think of it not as an inflexible and automatic robot, but as a flexible instrument which you must understand to properly use. An electronic and optical miracle creates nothing on its own! Whatever beauty and excitement it can represent exist in your mind and spirit to begin with.

Half Dome, Cottonwood Trees,
Yosemite Valley, California,
circa 1935

Large-format cameras are heavier and more cumbersome than their smaller counterparts, and almost always require the use of a tripod. They offer a number of advantages, however, including larger negative size, full control of the position of the lens and film planes, and the ability to process each negative individually.

There is no question that using a view camera requires some physical stamina. In my earlier years I backpacked through the mountains with an 8 x 10 view camera, two lenses, twelve double film holders, tripods, filters, focusing cloth, etc. I finally resorted to using pack animals on the trails, and gradually reduced the weight and size of my equipment. Now, when asked what camera I use, I reply, "The heaviest one I can carry!" Obviously, this is not the camera equipment for casual snapshots, but I believe that the greater effort and restrictions lead to precision of seeing.

[For this image] I used a twelve-inch Dagor lens and 8 x 10 film. The camera was pointed upward slightly, and no adjustments were used to eliminate the small convergence. Theoretically, perhaps the image should have been precisely aligned, but I often find in practice that a small amount of convergence is visually effective. — ANSEL ADAMS

Chapter Three

Lenses and Accessories

There is something magical about the image formed by a lens. Surely every serious photographer stands in some awe of this miraculous device, which approaches ultimate perfection. A fine lens is evidence of a most advanced technology and craft. We must come to know intuitively what our lenses and other equipment will do for us, and how to use them. — ANSEL ADAMS

In chapter 2 a few basic terms describing the anatomy of a lens and how it works were introduced, primarily to help you understand the basic operation of a camera. A lens is really the heart of a camera, and the lens you choose and the way you use it will, to a great extent, be limiting factors in determining the quality of the photographs you produce. When you find a subject that you want to photograph, you need to make some key decisions about (1) the *focal length* of the lens, (2) the *aperture* you will use, and (3) the *shutter speed* at which the photograph is to be taken. Each of these three variables has a pronounced effect on the appearance of the image.

What a Lens Does

The simplest way to form an image is through a pinhole. Light reflected from any point on a subject will pass through a small hole, producing a slightly diffuse image (called the *image-circle*) of that point. The accumulated overlapping image-circles form the total image. Pinhole images are necessarily slightly blurred, or "diffuse," but their "soft-focus" appearance is often aesthetically pleasing.

When a ray of light strikes a curved glass surface such as a lens, it is bent and its direction changes. By controlling the shape of the glass, it is possible to bend all rays of light that emanate from a single point and strike the glass so that they are sharply focused *as a single point* (see figure 2.4). This is what a lens is designed to do.

Unlike a pinhole, a lens *sharpens* rather than *diffuses* an image. More important, since the diameter of a lens is vastly greater than the diameter of a pinhole, much more light is transmitted by a lens. The increased light intensity permitted by the lens decreases the time needed to expose the film from minutes to fractions of a second. Also, since the image created by a lens is relatively bright, it is easy to examine it through a viewfinder and to compose the scene as desired. These virtues of lenses — image sharpness and brightness — add enormous flexibility to the camera.

Figure 3.1: Ansel Adams, *Grass and Burned Tree, Sierra Nevada, California, 1935.*

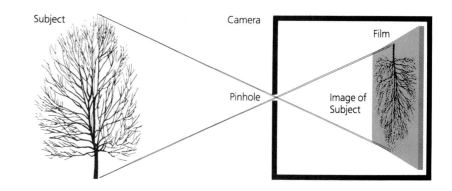

Figure 3.2: *Pinhole forming an image.* Light is reflected in all directions from each part of the subject. For each subject point, however, the pinhole restricts the light falling on the film to a small area, producing an image-circle of that point. These overlapping image-circles cumulatively form the total image.

Lens Characteristics

A magnifying glass is a simple lens that everyone is familiar with. The lens does a creditable job of forming and magnifying an image, especially toward the center of the glass. The most basic box cameras use this kind of lens.

If you examine the image produced by a simple lens, however, you will realize that it is far from perfect. For example, the image seen at the edge of the lens is not as crisply defined as that in the center, and straight lines show slight curvature. These problems can be corrected, to a degree, by using several simple lenses in combination to form a *compound lens.*

Covering Power The image produced by a lens is circular. Therefore, if the rectangular format of the film does not fit within the circle, the corners and edges of the image will be *vignetted,* or cut off. This is not a problem with 35mm and most medium-format cameras because their lenses are designed to provide a large enough image-circle to accommodate the film format.

With lenses designed for use with view cameras, however, the size of the image-circle is of critical importance since it determines how large a film format can be used *and* limits the range of camera adjustments that can be made. When purchasing a lens for a view camera, choose one with an image-circle that is at least two inches greater than its focal length, if possible; that will enable you to

Figure 3.3: *Comparison of pinhole and lens photographs.* (A) Photographs made through pinholes are slightly diffuse but can have their own pleasing aesthetic and are often remarkably informative. Pinhole photography has enormous creative possibilities and can be done with very simple equipment. (B) When the same scene is photographed with a 150mm Nikkor lens on a 4 x 5 view camera, the details are sharply defined throughout.

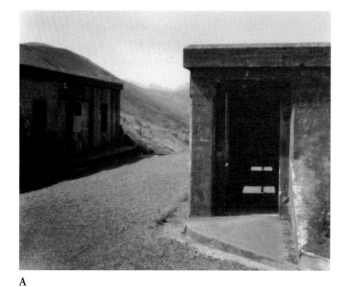

A

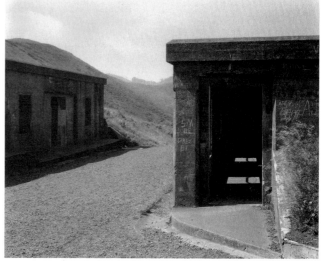

B

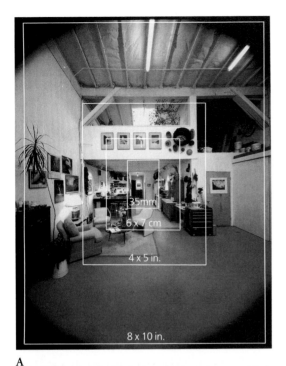

A

B

C

D

Figure 3.4. *Covering power of lenses.* These photographs were taken with different 90mm lenses, all set at f/22 and mounted on an 8 x 10 view camera. Note that although the sizes of objects pictured by each lens (a function of focal length) are identical in all cases, the area covered by the image-circle varies dramatically.

(A) Taken with a Nikkor 90mm SW. The lens nearly covers the entire 8 x 10 format, and the image is sharp out to the edge of the image-circle. The image contrast is also excellent. (B) Taken with a 90mm f/6.8 Angulon. Notice the smaller image-circle, the lower image contrast, and the loss of sharp definition toward the edge of the image-circle. (*Note:* The lens used to make this photograph is an early version of the Super Angulon; these newer lenses are far superior.) (C) Taken with a Mamiya 90mm lens for the RB67 camera. Although it is designed for the 6 x 7-cm format, the lens almost covers 4 x 5 inches. The contrast and resolution are superb. (D) Taken with a Nikkor 80–200mm zoom lens set at 90mm. The lens provides adequate coverage for the 35mm format, for which it is designed. The contrast and resolution are excellent.

make the necessary camera adjustments in most of the ordinary photographic situations you are likely to encounter. If you plan to do much architectural photography or expect to use your camera in situations where extreme "correction" of the image is routine (for example, in product photography for advertising), look for a lens that has a substantially larger image-circle. Part of the price of a view-camera lens is related to its covering power, but the additional cost will be offset by superior performance and increased usefulness.

Aberrations Although the art and science of lens-making are centuries old, lens designers continue to work to improve the quality of the images that a lens can produce. Characteristics that photographers seek in lenses include efficient *transmission* of light, excellent *resolution* of fine detail and high *image contrast* (see pages 111–115), and *accurate reproduction* of the scene. Because of some inherent properties of lenses, these goals can only be approached, never completely achieved.

Lenses produce effects such as *spherical aberration, astigmatism, chromatic aberration, linear distortion, coma,* and so forth, all of which compromise image quality. These aberrations manifest themselves in various ways. For example, chromatic aberration causes rays of different colors to focus at different points — at the edge of a white spot you may see fringes of red, green, and blue. Linear distortion results in either concave or convex curvature of straight lines (that is, they bend away from or toward the center of the image); lenses with coma convert pinpoints of light into minuscule comet shapes; lenses with astigmatism turn circular shapes into ovals, and so on.

To date it has not been possible to design a compound lens that is free of aberrations — as one defect is corrected, another is aggravated. The challenge to lens designers is to create a lens that minimizes most or all of these aberrations. With the advent of the computer, the problem of lens design has been greatly simplified.

Another major advance in lens-making occurred when manufacturers began to use *rare earth glasses.* These specialized glasses have superior properties and permit designers to produce lenses that reduce chromatic aberration and increase image contrast. Rare earth glasses are expensive, unfortunately, and their use is restricted to fine lenses.

Almost all lenses manufactured within the past decade are capable of decent optical performance. Furthermore, by stopping down almost any modern lens two or three stops (see page 86), you can render virtually all optical aberrations insignificant.

A B

Figure 3.5: *Lens flare.* (A) This image, made with an uncoated lens, shows the overall reduction in contrast caused by lens flare. The shadow areas receive additional exposure because of the scattered light. With color film, the flare can impart a color cast to the photograph, depending on the dominant colors of the scene. (B) The use of a coated lens reduces the flare and increases the overall contrast, though the difference can sometimes be quite subtle.

Lens Flare When light strikes a glass surface, a small fraction of it is reflected and scattered and causes *lens flare.* Flare is similar to the glare you experience when you try to look at an object with a bright light shining in your eyes. With a camera, lens flare results in a slight fogging of the negative image and a reduction of contrast. The potential for image degradation from lens flare is directly proportional to the number of lens elements in a lens.

If each element of the lens is *coated* (a process in which inorganic salts are deposited on the glass to produce a layer a few millionths of an inch thick), reflection and light-scattering problems are minimized. The color cast seen on the surface of a modern camera lens is due to the coating.

Flare is often a problem if there is a bright light source just outside or within the picture-taking area. Its effect can be mitigated through the use of a lens shade. Some designs serve a dual purpose by providing a slot into which filters can be inserted. In an emergency, it helps to shade the front of the lens with a card held outside the field of view.

Mechanical Considerations In addition to optical performance, you should also consider *mechanical quality* when purchasing a camera lens. Part of what you pay for in a lens is tight seals around moving parts, finely machined threads, metal rather than plastic parts for critical focusing elements, and so forth. If a lens begins to develop "play" as you use it, the image quality will probably decline. Mechanical construction is especially important in lenses of complex design, such as zooms (see page 82), which have many moving parts and in which precise spacing between lens groups is essential.

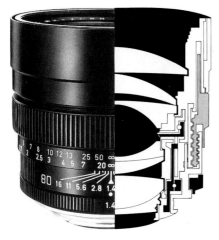

Figure 3.6: *Leica-R lens.* The Leica-R lens contains 182 individual parts. The cross-sectional view (*on right*) shows seven lens elements assembled in five groups.

What to Look For in a Lens

Shopping for a lens: The best advice in this instance is basic: Acquire the best lenses you can for the uses to which you intend to put them. Whenever possible, acquire a lens from the manufacturer through a reputable dealer. It is impossible to tell by cursory examination if a lens is slightly damaged or poorly mounted in a shutter.

A photographer should buy a lens primarily because it will efficiently meet his requirements. He may also consider a lens as an investment; a fine lens never seriously depreciates in value. This is important, for as he progresses in his work he may wish to trade in one lens for another, and a lens of high quality, in a good shutter, makes such trades more advantageous.

A high-quality lens will have the following characteristics: (1) high resolving power (the ability to separate closely spaced subject detail) at *both the center and the edge* of the image; (2) high image contrast (white and black tones distinctly separated, not muddy shades of light and dark gray); and (3) sturdy mechanical construction.

Before you begin to shop for a lens, try to find a review that includes test data on lens resolving power, lens contrast, and mechanical construction. (These reviews appear as monthly features in many photography magazines.) After you make a purchase, test your new lens by photographing a subject with a lot of fine detail and pronounced horizontal and vertical lines (a building with a lot of brickwork or a sheet of newspaper taped to a wall would work well). Use a tripod to minimize camera movement, and load the camera with a fine-grain slide film. Focus the image carefully and photograph the subject at every lens aperture; write down what aperture and shutter speed you used for each exposure. Then project the slides or look at them critically with a strong magnifier to be certain that the images produced live up to your expectations. Look for corner-to-corner sharpness, and make sure there is no pronounced curvature of lines that should be straight, no color fringes, and so forth. If the lens does not meet reasonable standards, return it and try another.

Focal Length

Light from a far-distant point will be sharply focused in a plane located a fixed distance behind the lens. *The focal length of a simple lens is defined as the distance between the lens and the plane of sharp focus under these conditions.*

Your choice of focal length can often decide the success or failure of a photograph. Figure 3.9 shows a pair of portraits; one was taken with a wide-angle lens, the other with a telephoto lens. The distortions produced by the wide-angle lens can be extremely unflattering, and it is usually not the right lens to use if you want to create a pleasing portrait. The sections that follow and the chapter on visualization will help you to make appropriate lens choices.

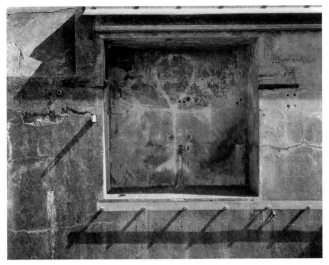

A

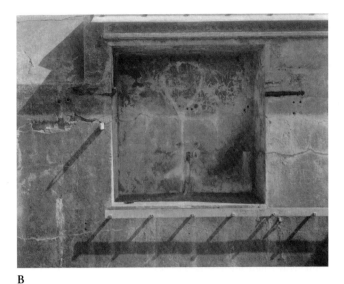

B

Figure 3.7: *Lens comparisons.* Resolving power and image contrast are two important characteristics to consider in choosing a lens. These photographs were made with a 4 x 5 camera fitted with (A) a modern 150mm Nikkor lens and (B) an older model 141mm Ross Wide Angle Anistigmat. Each lens was set at f/22. The resolving power and contrast of the older lens are far inferior to those of the Nikkor, as shown in figures C (a detail of A) and D (a detail of B).

C

D

Focusing a Lens Before you take a photograph with a lens, you must focus it. With view cameras and folding cameras, focusing is accomplished by moving the entire lens back and forth. When the image is sharply defined on the ground-glass viewing surface, it is "in focus." If the camera does not have a focusing viewfinder (and many older folding cameras do not), it may have a distance scale to indicate where you should position the lens to achieve proper focus.

Small- and medium-format cameras, on the other hand, are constructed so that the lens-to-film distance is fixed by the camera body and remains constant. The focal length of lenses for these cameras is varied by the lens-maker through expansion or contraction of the bundle of light rays within the lens itself. Focusing of the lens is achieved by rotating a lens collar to move elements within the lens barrel.

Figure 3.8: *Focal length of a lens.* When a simple lens is focused on an object, the distance between the lens and the film plane is the focal length.

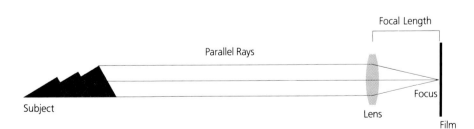

A

B

Figure 3.9: *Lenses and portraiture.* (A) Lenses with longer-than-normal focal length produce portraits that have what most people consider a natural-looking perspective (35mm camera, 105mm lens). (B) Wide-angle lenses used close to the subject often create unpleasant exaggerations of facial features and include distracting background details within the image (35mm camera, 24mm lens). (Alan Ross, *Jenna Ross, 1998*)

Focal Length and Magnification Photographers relate the focal length of a camera lens to its magnifying power: *the greater the focal length, the greater the magnifying power of the lens* (that is, a longer focal length will mean that objects will appear larger).

The size of the image recorded on the film is directly proportional to the focal length of the lens. For example, if you photograph an apple with one lens, then change to another lens with twice the focal length of the first, the image of the apple will double in size.

The size of an object on the negative does not depend on the type of camera you use or on the size of your negative; rather, image size at a fixed distance from the camera is determined solely by the focal length of the lens. If an object is photographed twice from the same position, using a 300mm lens first on a 35mm and then on a 4 x 5 camera, it will be exactly the same size on both negatives. The two negatives, however, will show very different areas of the scene — if the object fills the entire frame of the 35mm negative (about 1 x 1½ inches), it will occupy only one-fourth the height of the 4 x 5 negative.

Table 3.1

"Normal" Focal Lengths for Lenses

Negative Size	Normal Lens
35mm	50mm
4.5 x 6 cm	75mm
6 x 6 cm	80mm
6 x 7 cm	90mm
6 x 9 cm	110mm
4 x 5 inches	150mm (6 inches)
5 x 7 inches	210mm (8 inches)
8 x 10 inches	300mm (12 inches)

Note: One inch equals 2.54 cm, or 25.4mm.

Lenses of "Normal" Focal Length The lens of the human eye has an angle of view (that is, the angle of what you can see to the left and right of center as you look straight ahead) of about 50 to 55 degrees. When the focal length of a lens on any camera is approximately equal to the length of the diagonal of the film format, the angle of view through the lens corresponds closely to what your naked

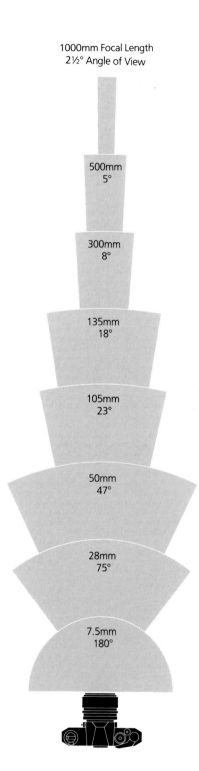

1000mm Focal Length
2½° Angle of View

500mm
5°

300mm
8°

135mm
18°

105mm
23°

50mm
47°

28mm
75°

7.5mm
180°

Figure 3.10: *Focal length and angle of view.* The greater the focal length of a lens, the smaller the angle of view and the portion of the scene covered.

eye sees as you look at a scene. A lens that meets this criterion is referred to as the *normal* lens for the camera.

"Normal" focal lengths differ greatly as a function of film format, but *the angle of view for every normal lens is the same* (approximately 50 to 55 degrees). Table 3.1 lists the "normal" focal length for each camera format.

Because the angle of view remains constant for all normal lenses, each film format will record the same scene. The normal lens for a 35mm camera is 50mm and the normal lens for a 4 x 5 is 150mm. Thus, you will see approximately the same subject area if you photograph a scene with two different cameras, a 35mm and a 4 x 5, fitted with their normal lenses (50mm and 150mm, respectively).

Normal lenses are used for "all-purpose" shooting. With 35mm cameras, the overwhelming majority of photographs are taken with lenses in the range of 40mm to 55mm. This is predominantly a consequence of the way we "see." As you expand your photographic horizons, you will begin to understand that "normal" does not always produce the most exciting images.

Lenses of Short Focal Length With any camera format, *the greater the focal length of the lens, the smaller the angle of view* — that is, when the focal length is increased, the field of view that you see through the lens is narrowed. If the focal length of the lens is decreased, the opposite happens. Lenses that produce a wider than normal viewing angle, usually 65 degrees or more, are classified as *short-focal-length lenses.* Most of those designed for small- and medium-format cameras are called *wide-angle lenses.*

Wide-angle and short-focal-length lenses often represent the only practical way of taking a photograph when you are unable to include all of the important elements in a scene using a normal lens — for example, in photographing building interiors (when space limitations restrict you) or landscapes (when you want to capture a wide panorama). Short-focal-length lenses create the visual effect of moving the scene away from the camera; with a wide-angle lens, an object will appear smaller than it would with a normal lens.

These lenses are also useful for achieving the deliberate creative effect of exaggerating the perspective of a scene by overemphasizing foreground objects, thereby adding to their visual impact.

Long-Focus Lenses Camera lenses that have an angle of view of 35 degrees or less are called *long-focus lenses;* they enlarge the image relative to that produced by a normal lens. *Telephoto lenses* are long-focus lenses designed to magnify the image to a far greater degree than the lens-to-film distance would normally dictate. Binoculars are a good example of a telephoto lens. Long-focal-length lenses for 35mm and roll-film cameras use a telephoto design.

Long-focal-length lenses come in handy for photographing distant objects or isolating small elements of complex scenes that you cannot get close to. For portraiture it is usually wise to select a lens that is approximately twice the normal focal length; this will create a pleasing perspective and avoid crowding the subject with a camera.

Lenses favored for conventional studio portraiture, known as portrait lenses, generally have a long focal length and produce a slightly "soft" image with diffuse definition of detail (spherical aberration is often designed into the lens).

Carolyn Anspacher,
San Francisco, California,
circa 1932

One evening in San Francisco in 1928, Albert Bender (my first and most significant patron) took Virginia and me to a performance of The Dybbuk. *The star, tall, strikingly handsome, and immensely gifted, was a young protégée of Albert's. From that evening Carolyn Anspacher was our lifelong friend.*

I made this photograph of her with a 4 x 5 Korona View camera and a twelve-inch Voightländer process lens. I was impressed with the results, but many were not. It was called "The Great Stone Face" and was thought by some to be a picture of a sculptured head. This actually pleased me, because at the time I had a strong conviction that the most effective photographic portrait is one that reveals the basic character of the subject in a state of repose, when the configurations of the face suggest identity and personality.

I am still of this persuasion; the usual "candid" photograph is but one moment of the subject's lifetime, a fragment usually related only to the artifact of the shutter's action. A painter can synthesize many impressions, observations, and reactions — creating a single expressive complex. The portrait photographer has only one passage of time (long or short) in which the delineation of the face is defined.

Awareness of the subject's personality enables some of us to anticipate expressive moments, not merely recognize them in passage. This requires both extensive practice and experience. — ANSEL ADAMS

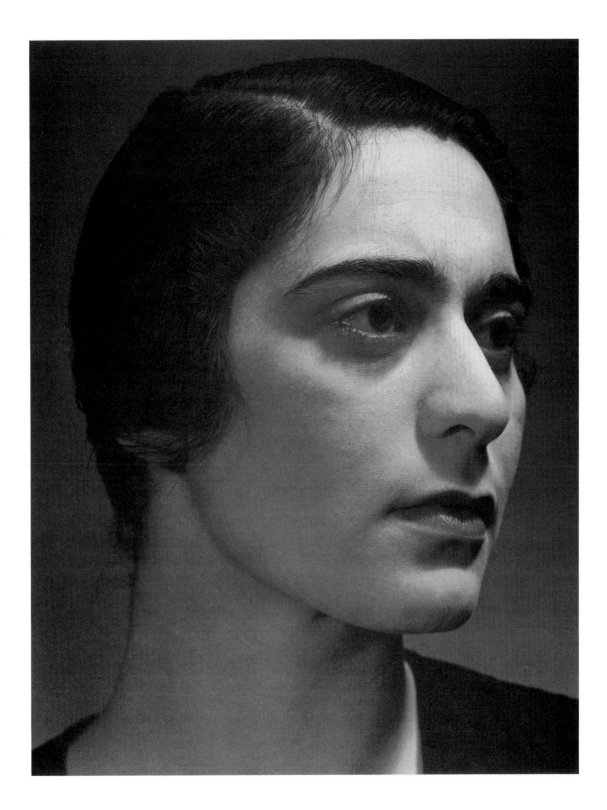

A

B

Figure 3.11: *Wide-angle lenses.*
(A) A photograph of Ansel's living room, taken with a 50mm lens on a Nikon camera. (B) Taking the same photograph from the identical position using a 24mm lens results in a fourfold increase in the area recorded by the camera, with no change of perspective.

With some older lenses (the Graf Variable, for example), the image produced is quite soft at wide apertures but very sharp when the lens is stopped down. Supplementary lenses and filters for portraits (the Hasselblad Softar, for example) scatter light and result in diffused images that, as Ansel was fond of saying, *"reduce skin texture and the benefits of time."* The Rodenstock Imagon is another example of a lens designed specifically for portraiture.

Long-focal-length lenses that are highly corrected for aberrations and designed for close-up work where extremely sharp definition is required (in copying or photoengraving, for instance) are known as *process lenses.* They have a maximum aperture of f/8 to f/11 and are not usually suited to low-light situations. Process lenses are designed to perform optimally at subject-lens distances of one to five times the focal length of the lens.

If you use a process lens as a long-focus lens for ordinary photography, you should test it for a *focus shift* that may occur when it is focused on a distant object and then stopped down (see page 86). To test the lens for a focus shift, first focus it at maximum aperture on a bright light at least fifty feet away (the reflection of the sun on a chrome car bumper will work nicely), then stop it down and see whether the spot remains in sharp focus. If it does not, you will have to correct the problem by refocusing the lens at the smaller aperture. Typical process lenses include the Nikon Apo-Nikkor, the Rodenstock Apo-Ronar, and the Schneider Repro-Claron.

Convertible Lenses View-camera lenses consisting of two components that can be used either in combination or separately are called *convertible lenses*. Each component has its own distinct focal length, and the focal length of each is longer than that of the combination. If you use a single component of a convertible lens, it should be placed behind the diaphragm. Focus shifts *almost invariably occur* when single components of these lenses are used, and you will need to correct the focus as you stop down the lens. Turner-Reich and the Zeiss Protar were popular convertible lenses and can often be found in stores that specialize in used view-camera equipment.

Enlarging Lenses Designed to be used at short working distances to project an image onto a flat field, *enlarging lenses* are lenses of "process-lens" quality.

Perspective-Control (PC) Lenses Designed for small-format cameras, *perspective-control lenses* can be raised, lowered, or shifted sideways, thereby permitting a substantial degree of *convergence control* in a photograph, much as you would have with a view camera. With a PC lens, instead of pointing the camera upward to photograph a building, for example, you hold it level and move the lens to preserve the rectangular shape of your subject. Some lenses also have a *tilting* feature that allows you to focus on a plane that is not parallel to the camera back — such as a landscape with a long, receding foreground and important subject matter in the distance.

Figure 3.12: *Composition and focal length.* This sequence of four photographs was taken without moving the camera; the only variation lay in the focal length of the lens used for each image, ranging from wide-angle to telephoto: (A) 24mm; (B) 50mm; (C) 105mm; (D) 200mm. The perspective remains the same throughout the sequence, but the area covered by each lens decreases as its focal length increases. Choosing the appropriate lens is an important part of interpreting a scene photographically.

A

B

C

D

Supplementary Lenses Single-component lenses that attach to the front of the primary lens are most often used to alter the focal length of that lens. With fixed-lens cameras (such as twin-lens reflex cameras), *supplementary lenses* can be used to convert the primary lens to a telephoto or wide-angle lens. When you use a supplementary lens, however, bear in mind that the image quality is never as good as that of the original lens, and the light transmission is usually reduced by the equivalent of one or two stops. Nonetheless, a supplementary lens can produce reasonable results and is usually a better alternative than a new camera. For best results, supplementary lenses should be used with the primary camera lens set at the highest feasible aperture.

Zoom Lenses Developed for use with single-lens reflex cameras, the *zoom lens* allows you to replace several lenses of fixed focal lengths with a single lens. With a zoom lens, the focal length can be varied over a selected range by moving a lens collar. Two popular 35mm zoom lenses offer focal lengths ranging from 28mm to 85mm and from 70mm to 200mm. To use a zoom lens, first focus the lens on the primary subject, then zoom in on the scene until you are pleased with the framing.

The big advantage of having a zoom lens is that it means you can avoid carrying the several different lenses you would need to cover the same range of focal lengths. The major pitfall of the zoom is that it can inspire haphazard visualization of a scene and encourage laziness on the part of the photographer. Very often it is too easy to stand back and achieve a "satisfactory" composition with a zoom lens, when in fact it would be preferable to move closer and become more intimately involved with the subject.

A high-quality zoom lens produces sharp images at all focal lengths and focus distances and does not require refocusing when the focal length is changed. Bargain-priced models can fall short of this standard, though, so be certain to test the lens you are considering at a broad range of settings before you purchase it.

While high-quality zoom lenses perform remarkably well, they are never as good at all of their settings as fixed-focal-length lenses. Because of their convenience, however, zoom lenses are clearly the lens of choice for ordinary "snapshooting" and for those times when you can transport only a limited amount of equipment.

Because zoom lenses often contain more than a dozen elements arranged in as many as six groups, the mechanical design and construction of the lens are *very* important. An inexpensive zoom lens may represent a serious compromise of both optical and mechanical performance, and you should be appropriately cautious about purchasing one.

Macro Lenses A *macro lens* is a lens of normal or slightly long focal length, designed for extreme-close-up photography. Most lenses for single-lens reflex cameras cannot be focused on objects closer than two to three feet away. A macro lens enables you to get within inches of the subject and achieve magnifications of up to ten times life size on the film. Some 35mm lenses are designed as and designated macro lenses and can be focused from infinity down to small subject-lens distances.

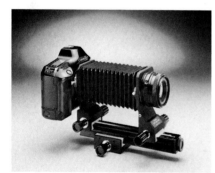

Figure 3.13: *Canon T90 with auto bellows attachment.* **A bellows attachment allows you to photograph objects within a fraction of an inch of the lens and thereby achieve great magnification in image size.**

Although most zoom lenses can be used as macro lenses by means of a collar adjustment that shifts them into a macro mode, they are not as perfectly corrected as those lenses designed primarily for close-up work.

For very high degrees of magnification, *bellows attachments* and *microscope adapters* are also available for most camera systems.

Lenses and Composition

If you examine images taken with a wide-angle lens, you will notice that the size of foreground objects is exaggerated and that objects that are slightly farther away from the camera seem very far removed. Telephoto lenses do the opposite, appearing to compress widely separated objects into a relatively narrow space. When we look at a photograph, our impression of a third dimension — that is, our sense of depth — is influenced by the lens used to make the photograph.

Perspective is determined solely by the position from which the photograph is taken. This principle is demonstrated in figures 3.15 and 3.16, photographed using normal, wide-angle, and telephoto lenses. If you study the segment of the wide-angle photograph that includes the telephoto image, you will see that they are identical and differ only in size. One effective way to exaggerate perspective and add visual impact to an image is to change both the focal length of your lens and the position from which you are photographing.

Figure 3.14: *Close-up photography.*

(A) This photograph of straight pins was made with an f/1.4 Nikkor lens set at f/5.6 with a bellows attachment. Note that while the central portion of the image is sharp, the edges are out of focus.

(B) This image, taken with a 55mm Micro Nikkor lens set at f/5.6, is clearly superior to the first. The lens is corrected to produce a flat field and can be focused to within inches of the subject without bellows attachments; it can also be used as a normal taking lens. Some zoom lenses can be shifted onto a "macro" setting and used as close-up lenses.

A

B

Perspective and Camera Position

Figure 3.15: Perspective is determined solely by the position of the camera, not by the focal length of the lens used. Figures A, B, and C were taken from the same position, using lenses with focal lengths of 105mm, 50mm, and 24mm, respectively. The field of view varies according to the focal length of the lens, but the perspective of any common portion of the image remains unchanged. Enlarging corresponding segments of the 50mm and 24mm negatives will yield two prints identical to A (figures D and E).

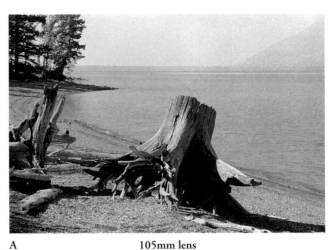

A 105mm lens

Figure 3.16: When the camera position is changed, the perspective changes as well. In figures A, B, and C, lenses with focal lengths of 105mm, 50mm, and 24mm, respectively, were used to photograph the same scene. In order to keep the size of the tree stump in the center of the scene constant, the camera was moved closer in for the 50mm photograph and closer still for the 24mm image. The backgrounds of B and C show a clear change in perspective, resulting from the altered camera position.

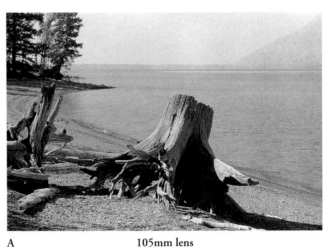

A 105mm lens

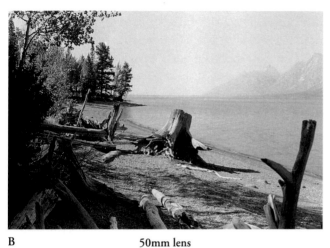

B 50mm lens

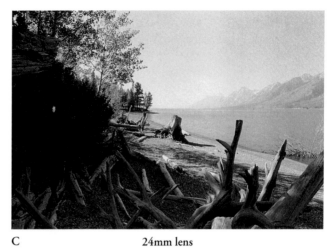

C 24mm lens

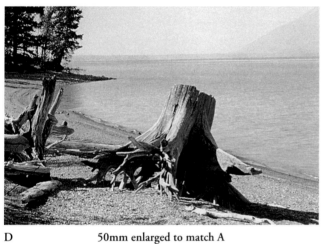

D 50mm enlarged to match A

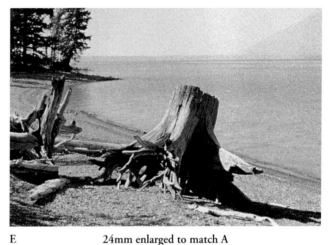

E 24mm enlarged to match A

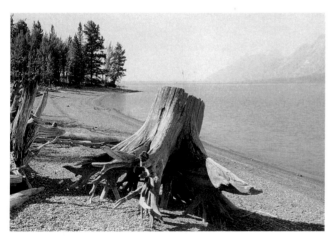

B 50mm lens

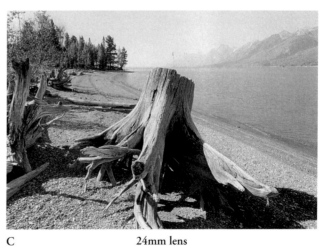

C 24mm lens

Aperture and f-stops

The amount of light passing through the camera lens can be regulated by varying the size of the lens opening, which is controlled by expanding or contracting a ring of overlapping thin metal blades. The *lens aperture* is defined as the ratio of the diameter of the lens opening to the focal length of the lens. For example, a lens measuring 1 inch in diameter with a 4-inch focal length would have a maximum aperture of ¼, which is expressed as f/4. A 200mm-focal-length lens that is 50mm in diameter would have the same maximum aperture as the 4-inch lens described above (50/200=¼=f/4), even though the diameter of the lens opening is twice as large (50mm=2 inches).

Why is it necessary to understand the concept of aperture when using a lens? The important thing to know when you take a photograph is what intensity of light is reaching the film plane. Light intensity at the film plane *decreases* as the focal length of the lens *increases*. Thus, the intensity of light striking the film is a function of both the size of the lens opening and the focal length of the lens. The equation for calculating *aperture* takes both factors into account.

All lenses set to the same aperture will transmit the same amount of light to the film plane. Light meters that are used with cameras for exposure determinations (see chapter 6) are calibrated in terms of *apertures* so that the readings they give will be independent of the focal length of the camera lens.

Aperture Settings The controls on a lens are calibrated so that *as you move from the largest to the smallest aperture, each step decreases the transmitted light intensity by half, and as you move in the opposite direction, it doubles.*

Originally, aperture was varied by the insertion of metal plates (called "stops" because they stopped a portion of the light from passing through the lens) with centered holes in front of the lens. As manufacturing techniques developed, these stops were replaced by a diaphragm, or iris, built into the barrel of the lens. However, the old terminology continues to be used, and we still talk about "stopping down" a lens.

The sequence of aperture settings engraved on a lens is usually part of the following series: f/1, f/1.4, f/2, f/2.8, f/4, f/5.6, f/8, f/11, f/16, f/22, f/32, f/45, f/64. (*Note:* This strange series of numbers is related to the formula for the area of a circle. To halve the area of a circle, you must reduce its diameter by the square root of 2 — that is, roughly 1.4. Each number in the series equals approximately 1.4 times the previous number.) Occasionally you will see a lens with a first aperture number that is *not* in this series (for example, f/3.5); it usually represents a half- or one-third-stop interval in the above series.

Lens Speed The aperture inscribed on the lens is the widest one possible with that lens on your camera; it is often referred to as the *lens speed.* If you see *50mm f/2.0* on a lens, for instance, it means that the lens has a 50mm focal length and a maximum aperture of 2.0.

For a 35mm camera, a lens with a maximum aperture in the range of f/1 to f/2 is sometimes called a "fast" lens because it is capable of taking photographs in fairly dim lighting. An f/1 lens, for example, would require only one-eighth the light intensity needed to take a photograph with an f/2.8 lens. Fast lenses cost much more than "slow" lenses because they require special glass and are more difficult to make.

Depth of Field

Varying the aperture of a lens is probably the most frequently used control in photography (other than focusing!), and it serves two purposes: it restricts the amount of light that will strike the film, thereby providing a means of exposure control, and it affects the degree to which all objects in the photograph are in sharp focus.

The region of sharp focus in a photograph is called the *depth of field*. In contrast to the pinhole, which cannot be "focused" and has an infinite depth of field, the camera lens has a *critically sharp focus* that is limited to the point or plane on which the lens is focused. Everything in front of or behind that plane of focus must necessarily be somewhat out of focus and blurred.

In practical terms, however, there is a region or field of *acceptably sharp focus* that extends in front of and behind the point of focus. The limits of this region (or once again, of the depth of field) are subjective, since the definition of sharpness is imprecise and influenced by such factors as the degree of enlargement of the negative and the distance from which the print is viewed.

Depth of field is a function of the focal length of the lens and the aperture at which the lens is used.

Depth of Field and Aperture Depth-of-field markings are engraved on the barrel of the lens, and this will help you to estimate the range of sharp focus as you vary the aperture and prepare to take a photograph. To use these scales, focus the lens on your intended subject. The mark opposite the heavy line in the center of the lens barrel will indicate how far the point of focus is from the camera. Flanking this mark is a sequence of f-stops corresponding to those built into your lens. The depth of field can be estimated by reading the two values on the distance scale opposite the appropriate f-stop numbers.

The depth of field of a lens increases as you stop it down. *Each time you double the f-stop (for instance, from f/4 to f/8), you double the depth of field.*

Figure 3.17: *Using selective focus to advantage.* One way to emphasize the center of interest is to restrict the plane of sharp focus. (A) To limit the depth of field and thereby minimize distractions in the background, a 200mm lens was used at f/4.5. Compare this to the exposure made at f/22 (figure B). (Alan Ross, *"Skipper," Pet Cemetery, Presidio, San Francisco, 1987*)

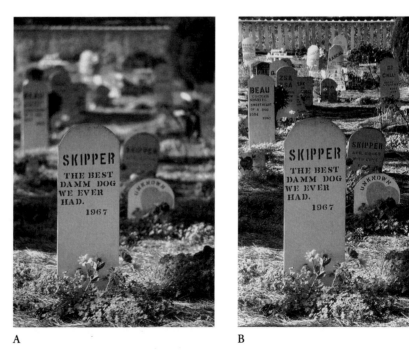

A B

Figure 3.18: *Depth-of-field scale.* The top row of numbers is the distance scale, and immediately below it is the depth-of-field scale. The aperture numbers appear in pairs on the depth-of-field scale, with one on either side of the heavy mark indicating the optimal focus. On the distance scale, the numbers that lie opposite the pair corresponding to the aperture chosen define the range within which the image will be in acceptably sharp focus. Thus, in the case shown, the optimal focus is about 3.4 feet, and at f/22 the depth of field extends from 3 feet to 4 feet.

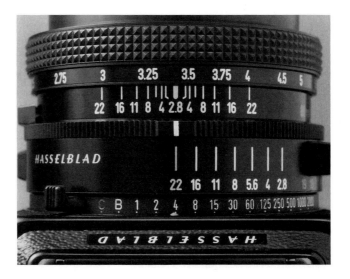

Depth of Field and Focal Length The depth of field decreases markedly as the focal length of the lens increases. Wide-angle lenses, therefore, are capable of producing images with a very large depth of field, while with telephoto lenses the depth of field is usually severely limited. The table below gives the approximate ranges of sharp focus for various lenses focused on a point five feet from the camera at an aperture of f/22.

Table 3.2

Approximate Depth of Field for Lenses Focused at 5 Feet at f/22

Focal Length of Lens	Range of Sharp Focus
20mm	1.5 feet–infinity
28mm	2.5 feet–infinity
35mm	3–20 feet
50mm	4–8 feet
85mm	4.5–5.7 feet
135mm	4.9–5.2 feet

Depth of Field and Subject Distance In addition to being controlled by the focal length and aperture of the lens, the depth of field is also a function of the camera-to-subject distance: the closer the camera is to the subject, the more limited is the depth of field. You can increase the depth of field in a scene by moving farther away from the subject. Doubling the camera-to-subject distance quadruples the depth of field because depth of field is proportional to the square of the distance between the subject and the camera. Thus, if the depth of field is 4 feet at a subject-camera distance of 10 feet, it will be 16 feet (4 x 4=16) if you increase the camera-subject distance to 20 feet.

Unfortunately, moving away from the subject also decreases the image size, and the gain you achieve in depth of field may be offset by the fact that the important part of the image will be considerably smaller on the negative. One alternative to moving away from the subject is to use a lens with a shorter focal length: by using a lens of half the focal length, for example, you can quadruple the depth of field. The effect is the same as that achieved by moving twice as far away from the subject.

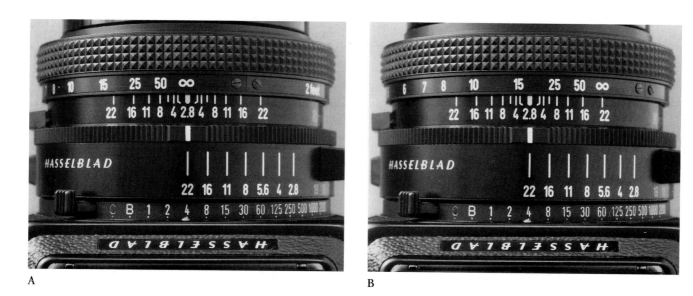

A B

Figure 3.19: *Using the depth-of-field scale to determine hyperfocal distance.* (A) The focus is set at infinity. At f/22 on the depth-of-field scale, the hyperfocal distance indicated on the distance scale is about 18 feet. (B) When the lens is refocused to 18 feet, the depth of field extends from about 9 feet (half the hyperfocal distance) to infinity, the range seen opposite the f/22 marks on the depth-of-field scale.

Hyperfocal Distance When a lens is set for focus at infinity, the nearest plane to the camera that is also in "acceptably sharp" focus is located at the *hyperfocal distance.* This value is directly related to the f-stop at which the lens is set. To locate the hyperfocal distance, set the lens on infinity focus and read the distance value on the scale opposite the f-number at which you plan to photograph. Everything between that distance (the hyperfocal distance) and infinity will be in "sharp" focus. Now reset the lens to the hyperfocal distance. Everything between that point and infinity will remain in sharp focus, but now the area from the hyperfocal plane to the new distance opposite the f-number on the scale will also be in focus.

Summing Up Decisions regarding depth of field are largely aesthetic judgments. Most landscape photographers prefer that as much detail as possible in a photograph be crisply defined. To accomplish this, they generally take photographs at small apertures. In some cases, though, a very restricted depth of field helps to isolate the point of interest: in a crowd scene, you can force the viewer's attention onto a single individual by making certain that everyone else is slightly out of focus. In order to limit the depth of field, use as wide an aperture as possible.

Figure 3.20: *Hyperfocal distance.* When the focus of a lens is set at infinity, the near limit of the depth of field is referred to as the hyperfocal distance for the aperture used. If the focus is then set at the hyperfocal distance, the depth of field will extend from one-half the hyperfocal distance to infinity. When subjects at infinity must appear sharp, focusing at the hyperfocal distance gives the maximum depth of field. The hyperfocal distance is closer to the lens when the lens is stopped down.

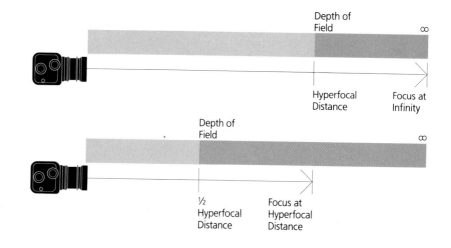

Fortunately, you do not need to memorize complex numbers or perform lengthy calculations to use a lens intelligently. With virtually all cameras used today for serious photography, you can look through the lens and see exactly what you are photographing at any aperture (though with some cameras you must press a depth-of-field preview button in order to do so). If you decide you need more depth of field, simply stop down the lens until you are satisfied with what you see. You do not need to make your photographic life any more complicated than that.

Figure 3.21: *Hyperfocal distance and depth of field.* For figure A, a 50mm lens set at f/2 was focused on the foreground; for figure B, it was focused at infinity. In both instances the depth of field is very limited. Figure C shows the effect of focusing the camera at the hyperfocal setting and stopping the lens down to f/16: the image is sharply defined throughout.

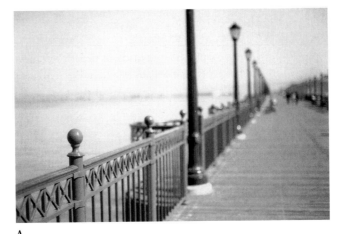

A

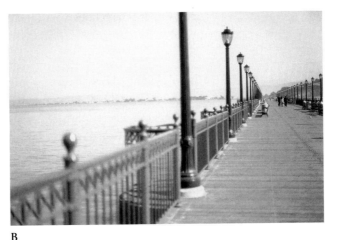

B

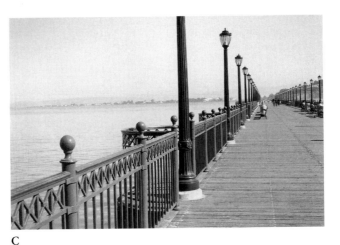

C

Combining Aperture Settings with Shutter Speeds

The amount of exposure that film receives is determined by both the *intensity* of the light that strikes it — a function of both the aperture setting on the lens and the subject's brightness — and the *duration* of the exposure, a variable controlled by the camera's shutter. This relationship is expressed in the simple equation

$$Exposure = Light\ Intensity\ x\ Time,\ \text{or}\ E = I\ x\ t$$

The proper exposure is ascertained by means of a light meter, an operation that will be detailed in chapter 6. The following briefly outlines how to manipulate the camera and lens controls to achieve the correct exposure once its value is known.

According to the formula, if the light intensity is reduced, the exposure time must be increased in order to achieve the same total exposure (and vice versa). Thus, if you cut the light intensity in half by stopping down the aperture one stop to gain greater depth of field, you must double the duration of exposure.

Shutter speeds on modern lenses and cameras are arranged in a geometric progression so that each value is either half or twice that of the adjacent setting. A typical sequence is 1 second, ½, ¼, ⅛, $^1/_{15}$, $^1/_{30}$, $^1/_{60}$, $^1/_{125}$, $^1/_{250}$, $^1/_{500}$, and so on. This geometric sequence parallels the relationship in the sequence of aperture stops, where each stop transmits either half or double the amount of light its neighbor does. As a result, certain pairs of settings will always result in the same total exposure value. For example, if an exposure of f/8 and $^1/_{60}$ is correct, then f/5.6 and $^1/_{125}$ will be equivalent (twice the light intensity, half the exposure time). Other possibilities would include f/4 and $^1/_{250}$, f/11 and $^1/_{30}$, f/16 and $^1/_{15}$, and so forth.

Choosing an Appropriate Aperture/Shutter Speed Combination

If the subject you intend to photograph is moving and you want to "freeze the action," you will need to use a fast shutter speed. Which shutter speed you should choose depends on how fast and in what direction the subject is moving. For a car driving past the camera, for example, a shutter speed of $^1/_{500}$ second may be required to produce an image in which the car is sharply defined, not blurred due to movement during exposure; if the car is driving toward the camera, on the other hand, a speed of $^1/_{125}$ second may be adequate. If you are in doubt, use the fastest practical shutter speed to freeze motion.

When your intended subject demands great depth of field, you should use the smallest aperture possible. If you want the range of focus to be narrow, however, you should select a large aperture setting.

Unfortunately, for any particular film and lighting conditions, your "ideal" shutter speed/aperture combination may be impossible to achieve. To understand why this is, study table 3.3 (see page 95).

Boards and Thistles,
San Francisco, California,
circa 1932

In the early '30s the Salon syndrome was in full flower and the Pictorialists were riding high. For anyone trained in music or the visual arts, the shallow sentimentalism of the "fuzzy-wuzzies" (as Edward Weston called them) was anathema, especially when they boasted of their importance in "Art." After about two years of growing concern over the position of creative photography, a number of us photographers formed Group f/64 in 1932. We felt the need for a stern manifesto!

There were a few sincere and creative workers among the Pictorialists whose concepts were superior even if their craft was not always adequate, and these were not included in our general excommunication. William Mortensen had an advanced grasp of practical sensitometry and produced a very informative book, The Negative. *However, the incredibly bad taste of his photographs smothered, for us, the validity of his contributions to the craft.*

Elated with the fervor of Group f/64, we sought purity of the image — sharp optical qualities, in-depth focus, and smooth papers. We were defining (we believed) a fresh aesthetic.

With youthful excitement I attacked photography with a sharp lens, 8 x 10-inch camera, and aggressive confidence. My most gratifying image was one of the first of this period; Boards and Thistles *demonstrated the application of purist principles. It is extremely sharp, since I used my 300mm Goerz Dagor at f/45 and developed the negative in pyro, and it was printed on glossy paper.*

Looking back fifty years I am both pleased and perplexed at some of the work accomplished in those days of dedication and brashness. The composition of Boards and Thistles *is quite sophisticated. While I avoid directly relating visual experiences to music, I feel that in this case the organization and texture of the image might have some intangible relationship to musical structure and values. I can say that this photograph reveals quite convincingly what I saw and felt at the moment of exposure.*

— ANSEL ADAMS

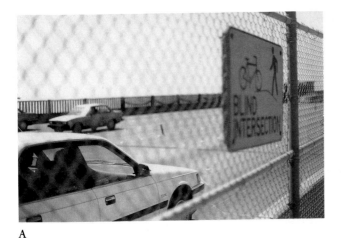

A

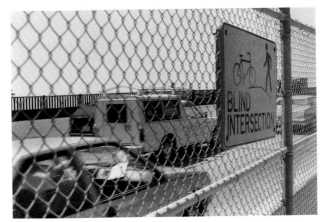

B

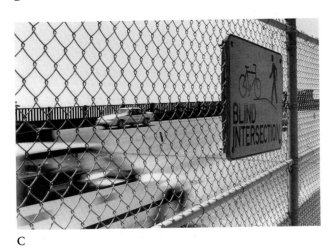

C

Shutter Speed: Aperture: Depth of Field:

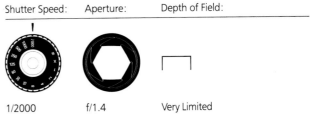

1/2000 f/1.4 Very Limited

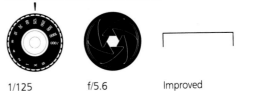

1/125 f/5.6 Improved

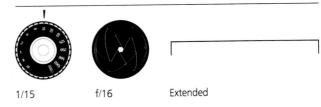

1/15 f/16 Extended

Figure 3.22: *Aperture/shutter speed trade-offs.* (A) At a shutter speed of $^1/_{2000}$ second, the moving traffic in this scene appears to be frozen in place, but the wide aperture necessary to accommodate the exposure (f/1.4) results in a very limited depth of field.

(B) A shutter speed of $^1/_{125}$ second at f/5.6 is not adequate to freeze the motion of the cars, but the depth of field has improved substantially, with only the part of the fence closest to the camera still being slightly out of focus.

(C) At a shutter speed of $^1/_{15}$ second at f/16, the depth of field extends from the nearby fence to infinity, but moving objects are blurred. If you are faced with a situation in which you want to stop the action and also have great depth of field, you will need to use a high-speed film and accept a grainy image.

Table 3.3

**Equivalent Aperture/
Shutter Speed Pairs**

Aperture	Shutter Speed
f/2	1/500[a]
f/2.8	1/250
f/4	1/125
f/5.6	1/60[b]
f/8	1/30
f/11	1/15
f/16	1/8[c]

[a] Little depth of field, shutter speed will freeze action
[b] Moderate depth of field, shutter speed will freeze slight movement of subject
[c] Great depth of field, shutter speed will not freeze motion of subject, and camera
 cannot be hand-held

If you want the greatest possible depth of field (f/16), you will have to use a slow shutter speed (⅛ second). Alternatively, if you want to use a fast shutter speed ($^1/_{500}$ second), you will have to use the lens at its widest aperture (f/2) and settle for a modest depth of field. Usually one of the intermediate pairings will represent an acceptable compromise. When the situation demands both a fast shutter speed *and* great depth of field, your only recourse is to select and use a "fast film," one that has greater light sensitivity than the film in the example above (see chapter 4 for a discussion of films).

Photographic Accessories

Figure 3.23: *Tripod.*

It has been said that photographic equipment represents one long chain of semi-frustrations, and the tripod is one of the significant links! Use of the view camera demands an adequate tripod, and with all cameras we frequently have occasion to use tripods of different kinds — from the simple monopod (a single "leg" to which the camera is attached — helpful with small cameras since it allows a certain amount of freedom while giving stability) to the most complicated and massive studio camera stands.

Tripods

Next to the camera and the lens, the tripod is the photographer's most important accessory. Unless the camera is absolutely stable during the moment of exposure, the image will be blurred, no matter how good the camera and lens may be. The single most significant mechanical step most photographers can take to improve their photographs is to use a tripod.

A tripod basically consists of three legs supporting a platform to which the camera is attached. Most tripods are now made of metal and are designed to provide maximum strength with minimum weight. The legs are constructed of either tubular or channeled metal and telescoping sections that allow them to be extended or shortened. A center post attached to the platform can also be raised and lowered.

The most essential characteristic of a tripod is rigidity. It must be stable in the wind and must resist vibration, and it must also suit its purpose: a tripod with thin legs will not be strong enough for a view camera. To test the tripod's stability, extend its legs fully and mount a camera on it. Tap one leg and see whether the

assembly shakes. If you have any doubts about its rigidity, continue shopping. Inexpensive tripods are a very poor investment.

On many models, the legs of the tripod are stabilized by a series of braces attached to the center post. The legs themselves terminate in spikes, with extendable rubber pads. The spikes should be used outdoors to prevent the tripod from slipping; the rubber pads will keep it steady on smooth surfaces.

The tripod platform must be large enough to support your camera securely. Some tripods will accept a "stage," a piece of hardware that can be attached to the bottom of the camera. When the tripod is set in place, you slide the stage onto the platform and secure it by means of a simple latch. This design makes the tripod much easier and faster to use in the field.

Various devices (usually rods that you loosen or tighten by twisting) allow you to tilt the platform forward and backward and from side to side. You should be certain that any adjustable components are firmly locked in place and that the camera is secure. Few experiences are more painful than watching your camera tilt forward in the midst of a long exposure, or having your fingers pinched by a slumping camera.

A good tripod will be almost indestructible if you give it reasonable care. Lubricate the joints periodically and make sure that no dirt or dust works its way into the collars of the telescoping legs, as grit will cause the legs to jam. Bear in mind that salt water corrodes most metals. If the legs of your tripod come into contact with it, rinse them thoroughly in tap water as soon as you can, dry them, and finally wipe them down with an oiled rag.

Figure 3.24: *Bogen Ball tripod head.* This convenient device replaces the traditional tripod platform, which requires two separate adjustments for tilt corrections. To adjust the camera position, you simply squeeze the pistol grip, swivel the camera into place, and then release the grip. A level is built into the base of the head, and a quick-release stage allows you to clamp the camera onto the tripod in an instant. The Bogen Ball tripod head is sturdy enough to be used with any camera up to the 4 x 5 format.

Figure 3.25: *Tripod quick release.* Any tripod can be made more convenient with the addition of a quick-release mechanism. The stage is attached to the camera body and remains there; to mount the camera on the tripod, you set the stage in place and release the retaining clamp.

Figure 3.26: *Lens shade vignetting.* When you use the full range of adjustments on a view camera you need to check the final image carefully on the ground glass to make certain that the lens shade is not cutting off a portion of the image (see figure A). A useful technique is to look at the lens through the cut-off corners of the ground-glass back; if the image is vignetted, it will be quite apparent.

A B

Figure 3.27: *Light reflection off lens elements.* When a bright light is in or just outside the picture frame, each surface of a compound lens will reflect a percentage of the light striking it. Reflections off the lens elements may project the outlines of the diaphragm blades on the film, spoiling the image. This problem can usually be prevented by the use of an appropriate lens shade. (Alan Ross, *Horseshoe Bay, British Columbia, 1972*)

Lens Shades

With the advent of optical coating, lens reflections were greatly reduced and the effects of flare from random light striking the lens likewise minimized. However, the direct rays of the sun falling upon the lens and/or bright diffuse light from brilliant surroundings will produce flare unless the surface of the lens is protected by a suitable shield. The outer edge or rim of the lens barrel can also catch sunlight and cause trouble.

Hence, the first "rule" is that the direct sun be shielded from the entire front surface of the lens.

Unwanted reflections, a frequent cause of photographic problems, can often be easily eliminated with a *lens shade.* The simplest variety is designed to screw into the front of the lens barrel. It is important that the shade be suited to the focal length of the lens on which it is being used; if it does not fit properly, part of the image may be cut off, or "vignetted." If, for example, you use a lens shade designed for a normal 50mm lens on a 28mm wide-angle lens, the image's corners will be rounded off by the edge of the shade.

Bellows lens shades are more versatile in that they can be expanded or contracted for use with lenses of any focal length (see figure 2.20). Some also have a slot into which a filter can be inserted. These shades can be attached directly to the lens with a mount or suspended over it by means of an extension arm.

Lens shades are usually not practical with large-format cameras because they may inhibit the adjustments you can make with the lens and camera front. Shade the lens by using the dark slide or a sheet of cardboard to cast a shadow over it or use a clip-on barn-door shade (figure 3.28). If you opt for a lens shade, look through the cut corners of the ground-glass back to make certain that there is no vignetting taking place (figure 3.26).

Camera Cases and Bags

Figure 3.28: *Clip-on lens shade/gel filter holder.* To avoid the vignetting problem or restriction of view-camera adjustments that sometimes arises with the use of traditional lens shades, use a clip-on lens shade. This accessory attaches to the lens barrel, and the "barn doors" can be rotated and positioned to shade the lens from unwanted light. A slot accepts 4-inch-square gel filters. Proper placement of the card outside the field of view will cast a shadow over the front of the lens and eliminate most of the flare. Alternatively, you can handhold a gray card or the dark slide to shield the lens.

I recall previous summer trips in the Sierra where my camera cases and their contents became alarmingly hot in direct sunlight. The ambient air temperature was tolerable, but the heat generated within the black or dark-colored cases was severe. An experiment confirmed the value of white protective paint, white fabric, or aluminum. I had two identical black fiber cases, one of which I painted white. These were placed in direct sunlight with a thermometer in each. In fifteen minutes the painted case gained only ten degrees Fahrenheit; the unpainted case soared to 125 degrees — and this on a mild, sunny afternoon in San Francisco! I could imagine how hot the black case could become in the blistering desert. Manufacturers continue to produce dark cases and bags, and focusing cloths with both sides dark. Obviously, their designers have never worked in the desert!

Using a camera case or a well-cushioned bag is one of the best ways of safeguarding your investment in equipment. Aluminum cases with well-made hinges and clasps and tightly fitting joints are both strong and light and offer excellent protection. Lined with firm foam rubber, these cases can be easily compartmentalized to accommodate camera bodies, lenses, and accessories — but do make certain there is an ample layer of foam rubber along every wall of the case to protect your equipment against shock.

There are a large number of over-the-shoulder bags on the market; the best ones are light, sturdy, and well insulated with foam. A more comfortable alternative is a knapsack. If you store each lens and camera body in a suitable leather case, box, or pouch, everything will fit into and be quite safe in a backpack.

If you have a large amount of equipment and work out of a car or van, you may want to consider adapting a large toolbox to transport your equipment. Partition it with plywood, line the inside with outdoor carpet and foam, and paint it white. This arrangement works well on trips and is an inexpensive alternative to purchasing several costly aluminum cases.

Avoid buying a black camera case if possible. They absorb heat very efficiently and, if left in the sun, will roast your equipment. An aluminum case or a case with a white enamel surface would be a more sensible choice.

Miscellaneous Items

The great variety and volume of [photographic] equipment produced, advertised, and sold in recent years has been both bewildering and confusing to the photographer. No one has time to fully evaluate the many cameras, lenses, exposure meters, enlargers, and general accessories. . . .

The photographer must therefore reject the obviously inadequate or inappropriate items, investigate more or less generalized kinds of things, make the best selection he can (often with conflicting advice from friends, colleagues, advertisements, and dealers) and proceed to master the operation of final selections. . . .

Figure 3.29: *Camera field kit.* Every photographer has a stable of accessories that are useful or necessary additions to the camera case. Typical items are spare batteries, cable releases, flashlight, calculator, tape measure, lens cleaner, lens brush and tissues, multifunctional pocket knife, screwdrivers, focusing loupe, assorted filters, marking pen, peelable tape, notebook, lens shade/filter holder, compressed gas, and a light meter. Prepare a checklist of items you need and review it before going out on field trips.

There is a great illusion among photographers that creative work depends *upon equipment. On the contrary, equipment is something to be selected for a specific purpose.*

Every photographer develops a list of accessories that are useful to have on hand during a photographic field trip. Some items you may wish to include in your list are described below.

Basic camera tools include a *penknife*, a *set of small screwdrivers, pliers,* and *scissors.* These will enable you to deal with almost any equipment snarl you are likely to encounter and want to try to correct in the field. *Filament tape* is useful for holding things together on a makeshift basis.

Cable releases are used to trip the camera's shutter and have a habit of disappearing just when you most need them. Since they are both invaluable and inexpensive, it is worthwhile to purchase an assortment and store them in a plastic bag with your camera equipment. Avoid cable releases that are stiff and inflexible, since they could cause you to jostle the camera during exposure. When you buy a cable release, make certain that the plunger extends far enough to trigger your camera's shutter; cable releases for view cameras often require a longer plunger extension than those used for other types of cameras.

Figure 3.30: Cedric Wright, *Ansel Adams photographing in Yosemite Valley, 1944.*

Spare batteries are essential to have on hand at all times because much modern camera equipment depends upon battery power. Always carry a spare set of all of the batteries you might need. Between sessions, store them in the freezer — they keep fresh much longer that way.

Lens cleaners should include a *soft-bristled brush* to remove dust from the lens surface and a *syringe bulb* that will produce a blast of air when squeezed. *Soft tissues* and *lens-cleaning fluid* often come in handy but should be used with caution to avoid damaging the lens coating, which is only a few microns thick.

Pocket data guides such as those published by Kodak are full of helpful information about films, filters, and exposure factors, and supply answers to a variety of questions that may arise in the field or the darkroom. A pocket data guide makes a useful companion on any field trip.

A small *notebook* and *several pencils* are essential items for every photographer's equipment list. In fact, it is a good idea to write out a checklist of important equipment on the first page of the notebook; then you can use the list as a guide before you embark on a field trip. Few things are more frustrating than arriving at a distant place and discovering that you have left behind some vital piece of equipment.

The fastest way to learn how to take good/better/best photographs and avoid making horrible mistakes more than once is to keep detailed notes on each photograph you take. Write down such details as the reading on your light meter, the aperture and shutter-speed settings, the filters used (if any), processing conditions, and so forth. These data will help you to analyze how you might have improved the photograph if it falls short of your expectations. *Exposure-record forms* (see page 202) provide a convenient way of keeping notes when you photograph.

A small *flashlight* is helpful to have on hand, especially toward the end of the day. Camera settings become more difficult to see as it gets darker, and in the rush to take a photograph, you can easily misplace filters, cable releases, and so forth.

Plastic refrigerator-storage bags that can be tightly lock-sealed are ideal for protecting lenses, filters, film and film holders, cable releases, lens brushes, and so on against moisture and dust.

Foam ice chests are convenient for transporting film and keeping it cool. A pack of frozen and sealed artificial ice will keep the inside of the chest chilled and avoid the danger of your film's getting wet from melting ice cubes. As an added precaution, always seal packets of film in plastic refrigerator bags before placing them in an ice chest.

A *measuring tape* is an important accessory if you use a view camera. For close work, the bellows of the camera must be extended to bring the subject into focus. These adjustments require a change in exposure as well, and you will need to be able to measure the amount of extension to apply the *bellows-extension factor* (discussed in detail in chapter 6).

A *magnifier* is also indispensable for view-camera work. It is difficult to achieve critical focus of the image with the unaided eye, and a magnifier is particularly useful for scanning the corners of the ground-glass focusing surface. A magnifier that folds into a pouch is easy to carry in the field; to avoid losing it, you can punch a hole through the pouch, run a string through, and wear it around your neck. If you wear reading glasses, a retaining band will keep you from misplacing them while you are setting up and focusing your equipment.

A roll of *white paper tape* is helpful for labeling film and film holders after exposure. You will often need to adjust the development conditions for certain batches of film, and unless they are clearly labeled, you are likely to confuse them when they are ready to be processed.

Opaque black tape can be valuable in an emergency, whether to make a quick repair to a bellows with a light leak or to hold an odd piece of equipment in place when your hands are busy elsewhere.

As you gain experience, you will want to add to this list or discard items that do not fit in with your style of working. What is indispensable to one photographer may seem worthless to another. Photography is a field in which gadgets abound; some are extremely useful, while others may be best classified as interesting curiosities. In general, it is wise to buy the best-quality equipment you can afford and to strive to keep what you carry down to a minimum.

Caring For
Your Equipment

Cameras and lenses are delicate instruments. They contain sensitive springs and gears, electronic components, and fragile glass, and they need to be finely tuned to deliver optimum performance. They should be treated with care and respect. Dirt, dust, moisture, and physical abuse can spell ruin for any equipment.

(CAUTION: Cleaning the glass surface of a lens always carries with it some risk of scratching the glass or the lens coating, so avoid unnecessary lens cleaning. A speck of surface dust will not distort the image.)

Figure 3.31: Ansel Adams, *Cathedral Rocks, Yosemite Valley, California, c. 1949.*

Equipment should always be carefully cleaned when you have finished using it; this is especially important if it has been subjected to a wet or sandy environment. Dirt can work its way between moving parts and abrade the components of photographic equipment, so be sure to wipe all parts clean with a soft cloth, use a cotton swab for hard-to-reach corners, and dislodge any dirt and dust with a gentle stream of air. Make it a point to have your camera professionally cleaned every few years, or more often if you use it in a damp or dirty environment where sand or grit is a factor. If you get into the habit of cleaning and caring for your equipment after every photo session, it will always be ready for you to use the next time.

If you are going to store your equipment for more than a month, remove the batteries. When batteries are spent, they often begin to corrode and can quickly ruin the contacts on the camera. If you live in a damp climate, carry some *silica gel* in your camera case to keep it dry.

For storage, cap your lenses at both ends and seal them in a pouch, a lens case, or a case with foam-rubber compartments. Organize accessories such as filters into appropriate groups and sizes and keep them in resealable plastic bags or pouches.

Simple maintenance will assure that your equipment will always perform to your expectations — and it will be less likely to need expensive repairs.

Chapter Four

Black-and-White Film

The key to the satisfactory application of visualization lies in getting the appropriate information on the negative. This can be compared to the writing of a musical score, or the preparation of architectural designs and plans for a structure. We know that musicianship is not merely rendering notes accurately, but performing them with appropriate sensitivity and imaginative communication. The performance of a piece of music, like the printing of a negative, may be of great variety and yet retain the essential concepts. — ANSEL ADAMS

Film is the material on which the language of photography is written. After the image you visualize is recorded on the film, it is refined and altered through the processes of developing and printing. The eloquence of a photograph's statement, however, is ultimately limited by the contents of the negative.

When photography was in its infancy, practitioners of the art had to create their own "film" on glass plates. The sheer variety of films available today, in contrast, is extraordinary. You can buy black-and-white films in a great variety of types and in formats ranging from 35mm rolls to 8 x 10-inch sheets in any good photo store. More unusual sizes can be special-ordered.

In black-and-white photography alone there are more than fifty roll and sheet films for you to choose from. If you add color-transparency and color-negative films to the list, the number exceeds one hundred. Each of these films serves a different purpose, although there is considerable overlap. To make an intelligent choice, you need to understand something about the fundamental characteristics of film.

The Composition of Film

Figure 4.1: Ansel Adams, *Unicorn Peak and Thunderclouds, Yosemite National Park, c. 1967.*

The manufacture of modern film involves highly sophisticated technology. First, very pure gelatin and water are heated, and precise quantities of potassium bromide and potassium iodide are dissolved in the mixture. Silver nitrate is then added to form a milky suspension of microscopic crystalline particles of *silver halides*. These silver-halide crystals are sensitive to blue and ultraviolet light. If specific dyes are added to the silver-halide mixture (commonly referred to as the *emulsion*), it can be sensitive to other colors in the light spectrum.

Other additives are included to stabilize the emulsion, which is then carefully aged. During the aging process, the silver-halide particles assume distinct crystalline shapes and sizes. The shape and size of the silver-halide crystals in the emulsion are the primary determinants of how a film will respond to

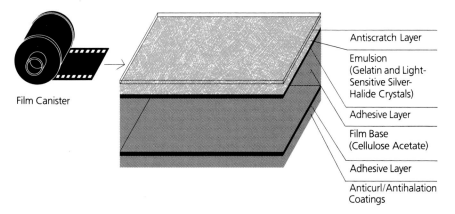

exposure and how the print you make from a negative will look. For example, an emulsion with large crystals of silver halides will generally result in a film that requires less light for exposure (a so-called high-speed film) and may produce "grainy" prints. Conversely, very small silver-halide crystals will result in a "slow" film and very fine grain.

The aged emulsion is eventually applied to a base of tough transparent plastic. In the case of color film, the base may need to be coated with as many as a dozen different layers. Because the precise composition and method of manufacturing of a film emulsion are what determine the film's special properties, those details are kept confidential by film manufacturers.

How an Image Is Recorded on Film: The Latent Image For reasons that are not fully understood, when light strikes film, it alters the sensitive silver-halide particles in the emulsion, producing an invisible or *latent image* that cannot be seen until the film is developed. During development, the chemicals that constitute the developer convert the latent image to black metallic silver. The deposits of silver embedded in the emulsion act as a very fine mosaic of silver grains patterned to form the negative image. The developed film is called a *negative* because its tonal values are the opposite of those of the scene photographed. Thus, the brightest areas of the scene correspond to the regions of greatest exposure to light and are, therefore, darkest on the negative.

Characteristics of Black-and-White Film

The characteristics of a negative are directly related to the properties of the film and, to a lesser degree, the developer used. With black-and-white films, photographers must consider several factors (often interrelated) when trying to choose among the many varieties available.

Film Speed

For a silver-halide crystal to be classified as "exposed" — and therefore for a latent image to be created — a threshold level of exposure to light must be exceeded. Crystals that have received sufficient exposure will be converted to silver during development; those that have not will be unaffected by the developer. *Film speed,* a numerical value that you set on your exposure meter, is a measure of a film's

threshold sensitivity to light. If you know the film speed and you use a light meter to measure the light intensity, or brightness, of the scene you are photographing, you will have all the information you need to make your exposure settings.

Manufacturers determine film speeds at carefully controlled laboratory conditions and assign each type or batch of film an ASA (American Standards Association), DIN (Deutsche Industrie Norm), or ISO (International Standards Organization) number. ASA and ISO numbers are identical and are used almost universally today.

For each doubling of the ASA or ISO number, the film speed is doubled, thus reducing the exposure required for a particular scene by one-half, corresponding to one stop. For example, if your light meter indicates that a proper exposure is $1/60$ second at f/8 with an ISO 50 film, appropriate settings for an ISO 100 film could be $1/60$ second at f/11, or $1/125$ second at f/8. For an ISO 400 film, the settings could be $1/60$ second at f/22, $1/125$ second at f/16, $1/125$ second at f/11, or $1/500$ second at f/8.

The manufacturer's ASA or ISO number should be used as a guide only until you have enough experience to assign your own film speed (we will call this your *exposure index,* or *EI*) based on how the film responds to your equipment and your way of processing and printing the film. Your camera may have lenses with poorer light-transmission characteristics than are indicated on the dial, or slower shutter speeds than those used by the manufacturer, and your darkroom procedures may differ substantially from theirs; all of these factors may make your effective film speed different from the speed given by the manufacturer. Through experience or actual testing, you will learn how to adjust recommended ASA or ISO values to arrive at an exposure index appropriate to your equipment and techniques. (See chapter 6 for further details on film speed.)

While all films are categorized according to their film speed, speed itself is not an independent variable. It is related to grain size and shape, which in turn affect the ability of a negative to resolve fine detail, such as closely spaced lines. Film speed is also linked to a film's ability to convey *tonality,* or the transition from a light tone to a darker one. Before choosing a film, you need to appreciate the importance of these factors from both an aesthetic and a practical viewpoint.

If you are photographing a sporting event such as a car race or a basketball game, you will probably want to choose a "high-speed" film — that is, one with an ASA or ISO rating of 400 or higher. Because high-speed films require relatively little light to create a latent image, you will be able to use the short exposure times necessary to freeze the action. For example, if you determine that an aperture of f/11 is required to give you adequate depth of field for the subject you wish to photograph, your light meter may indicate that on a slightly over-cast day with a film of ISO 25, you should use a shutter speed of $1/15$ second. However, this shutter speed is too slow to enable you to record a fast-moving object without blurring. By switching to a film with an ISO rating of 400, you could use an exposure of $1/250$ second at f/11 for the same lighting conditions, which will probably be fast enough to freeze any motion.

If you think that an even faster shutter speed is necessary, you have two choices: use a film with a still higher speed, or change to a wider aperture on the lens. In either case, you will be forced to make a trade-off. Choosing the combination f/8 and $1/500$ second will give you an equivalent exposure, but you

A

B

Figure 4.3: *Comparison of grain in slow and fast films.* **This still life was photographed using (A) Kodak T-Max 100, a moderate-speed, fine-grained film, and (B) Kodak T-Max 3200, a fast, coarse-grained film. Note that with the faster film there is an obvious increase in grain and a lessening of the smooth tonal transitions made possible by the slower film. (Alan Ross,** *Two Glasses, 1987*)

will sacrifice some depth of field to achieve the faster shutter speed. Selecting a faster film, with an ASA or ISO rating of 1000 or above, will let you use a faster shutter speed at the same aperture, but the negative will be substantially grainier and fine details will not be as well resolved. Each of these factors is discussed below in detail.

For still-life photographs and relatively static subjects (for example, portrait and studio photography, landscapes, architectural subjects, and so on), slower films, with speeds in the range of ISO 25 to 125, are usually more suitable than faster films. The success of such photographs depends on the resolution of fine details and on print tones that have continuity and are pleasing to the eye; the mosaic effect that can be a byproduct of a high-speed, grainy film would not be acceptable. Because enlargement increases grain size as a general rule, with small-format negatives (that is, from 35mm and other roll-film cameras), it is wise to use the slowest film consistent with your ability to freeze the action of the subject or to keep camera motion to a minimum.

Grain Size

If you look closely at a negative with a strong magnifier or microscope, you will see that it is composed of a large number of tiny specks, which are grains of silver. In the darker portions of the negative, the specks of silver are concentrated and tightly packed. Conversely, in the lighter areas, the grains are farther apart. The *distribution* of the silver grains corresponds to the exposure the film received, while the *size* of the grains is primarily determined by the process used to make the film, and is a consequence of the characteristics of the silver-halide particles in the film's emulsion. Thus, a coarse-grained film invariably leads to a coarse-grained negative, although the developer can moderate the grain to some extent.

The size of the silver grains in the developed negative generally correlates with both *film speed* and *image resolution.* Slow-speed films (ASA or ISO 25 to 100) usually produce fine-grained negatives in which details are clearly resolved. With faster films, grain size increases and resolution decreases. When you are choosing a film, speed and grain are two of the major considerations you need to balance.

To understand the role of grain in a black-and-white photograph, think about the photographic image at a microscopic level. A photograph is like a piece of graph paper with a grid too small to be seen by the eye alone. Any point on its surface can be either black (if there is a developed grain of silver at that spot) or white (if there is no silver present); there is no other alternative. A gray tone is produced when a large number of black dots are close together but separated by white space. When the dot size and spacings are small and close, the eye sees the area as a uniform gray tone. When there are more dots than there is space, the area looks dark gray; when there is more white space than there are black dots, the region appears light gray.

If you study the reproduction of a photograph in a newspaper or in this book with a magnifier, you will see that the image consists of a grid of dots. From a distance it will seem to have varying tones, but in fact it is a mosaic of black

Figure 4.4: *Film grain.* High-speed films such as Kodak T-Max 3200 (up to ISO 3200) result in images with pronounced grain. In many instances, grain has a strong aesthetic appeal. (Alan Ross, *Tulip, 1987*)

ink spots on a white surface. Similarly, a photographic negative is a mosaic of silver grains that form a grid, though the individual particles are generally too small and too closely spaced to be distinguished by the unaided eye. When light is projected through the negative and onto an emulsion-coated paper, a positive image is produced, in the form of a photographic print. The opaque grains of silver prevent light from passing through the negative, with the result that dark areas on the negative correspond to light areas on the print (because in those parts of the image where no light passes through the negative, the print remains unexposed, and the paper stays white after it is developed). Light does pass through the clear areas of the negative to the printing paper, exposing its emulsion and causing it to darken when the paper is developed. Thus, the light values of the negative are reversed in the print, and the negative mosaic is converted to a positive one in the printing process.

Whether or not you can see the mosaic pattern in a print depends upon the inherent graininess of the negative you began with, the degree of magnification you used if you printed the negative by projection and enlargement, and how close you stand to the print when viewing it. Grain is most noticeable in areas of the print where the tone is a uniform middle-gray value. It is an aesthetic issue for many photographers. In a landscape featuring a light-gray sky, for example, a print speckled with grain prominent enough to resemble a hailstorm may not give quite the effect you had visualized.

There are two ways to avoid prominent grain in photographs. The simplest method is to use a large film format to reduce the degree of enlargement required for printing. Enlarging a negative involves increasing the size not only of the silver grains themselves but also of the spaces between the grains, which generate the black "specks" you see on the photographic paper. (These black specks are what photographers usually refer to as "grain," even though it is actually the white areas that represent the positive image of silver grains in the negative.) Making an 8 x 10 print from a 4 x 5 negative means magnifying each grain twofold; the same print from a 35mm negative requires an eightfold enlargement. Grain invisible in the former case may be overwhelming in the latter.

If you do not have the luxury of using a larger-format negative, a second grain-minimizing strategy is to choose a fine-grain film along with an appropriate developer (see chapter 7). For modest degrees of enlargement (up to tenfold), this method works well.

Grain can be either accentuated or toned down somewhat through your choice of light source for printing. Used in combination with fine-grain developers, enlargers with diffuse light sources can help to offset a film's inherent graininess.

Pronounced grain in a print is not always detrimental; it can often add to the impact of a photograph. In some landscapes, grain may be an asset. In a photograph in which sand dominates the scene, for example, sharply defined grain may well convey a more forceful impression than grain that makes the sand look as smooth as whipped cream. If you want to explore the use of grain as a creative tool, consider such films as Kodak Royal-X Pan (ISO 1250) or Kodak 2475 Recording Film (ISO 1000 to 4000).

Negative Contrast

When a scene is photographed with black-and-white film and the film is developed, the negative is a two-dimensional version of the scene, in which the light values are reversed. By using your light meter to measure the *luminance,* or brightness, of each element within the scene, rather than the overall average luminance, you can define the *subject brightness range,* or *SBR.* For a simple subject such as three cards that are black, gray, and white, respectively, the relative luminances may be 1:4:16. The SBR, a measure of the extremes of luminance as you go from black to white, would be 1:16. A negative of the scene would show an image of the three cards with their brightness values reversed.

The *opacity* of the negative, a measure of its ability to transmit light, is directly proportional to the amount of silver that has been deposited in the emulsion as a result of exposure and development. Instruments called *densitometers* can be used to measure the opacity of film; the readouts are given in units of film *density.** The greater the density, the blacker the film.

Measurement of the density of the three different areas of the film corresponding to the black, gray, and white cards defines the negative's density range. For a properly exposed film and any given SBR, the density range of a negative is determined by the developer and the time and temperature used for development. Manufacturers usually recommend development times that result in a negative whose density range is considerably less than the SBR, thereby making it easier to produce a "realistic" representation of subject luminance values on modern photographic printing papers.

While contrast can be defined in mathematical terms as the ratio of luminance values to densities, this definition is of little use or importance to the practicing photographer. Instead, qualitative descriptions of contrast are part of the everyday vocabulary of photographers. If the densities of two areas of a negative differ by only a small amount, yet the luminances of the subject in these same regions were vastly different, the negative is said to be one of "low contrast," a result of underdevelopment. If, on the other hand, the densities of two areas of the negative differ greatly although the luminances of the subject were nearly the same, the negative is said to be of "high contrast." A high-contrast negative is a consequence of overdevelopment.

Fine-grained film is developed much more rapidly than coarse-grained film. The greater total surface area of silver halides available to the developer in a fine-grained emulsion allows swift development of the latent image, and only a short development time is required to bring a negative of a slow-speed, fine-grained film to an appropriate contrast level. The amount of time it takes a film to reach normal contrast values upon development indicates its level of *inherent contrast.* Slow-speed films generally have a high inherent contrast, and conversely, high-speed, coarse-grained films have a low inherent contrast.

**Opacity, transmission,* and *density* are mathematical terms used in the science of sensitometry. If ten units of light are directed at a uniformly exposed and developed sheet of film, and only one unit passes through, the *transmission* is $^1/_{10}$ or 0.1, the *opacity* is the reciprocal of the transmission, or 10, and the *density* is the logarithm (base 10) of the opacity, or 1.0. Density is used as the common measure of opacity because the numbers are smaller when a logarithmic scale is used.

Still Life,
San Francisco, California,
circa 1932

This photograph was not made for any commercial purpose; it was a simple arrangement of objects assembled and photographed with aesthetic intent. As the years passed I had a better concept of the difference between the contrived (arranged) composition, which is a synthetic *creation in that it involves putting together elements to make an agreeable arrangement, and a composition from the external world, created by an* analytic *process in that we select and manage the elements of the photograph in the existing surround.*

Arrangements like this one are achieved both by actual construction of the subject and by refinements observed and managed on the ground glass of the camera. Making a close picture of this type convinces the photographer that there is a profound difference between what the eye sees and what the camera "sees." The nearer the subject is to the lens, the more important it is to evaluate it from a position very close to the lens, or — ideally — by composing directly on the ground glass or through a reflex finder. Adjustments of both subject arrangement and camera position were critical here to achieve the desired effect.

The photograph was made on Kodak 8 x 10 Commercial Panchromatic film. I had no way of evaluating basic film properties in those days; we found out by experience that some films had "longer scale" than others, and some required shorter or longer development. Actually, we did not know just what was taking place physically and chemically, and much of our work was fortuitous approximation refined by bracketing exposures and developing times. — ANSEL ADAMS

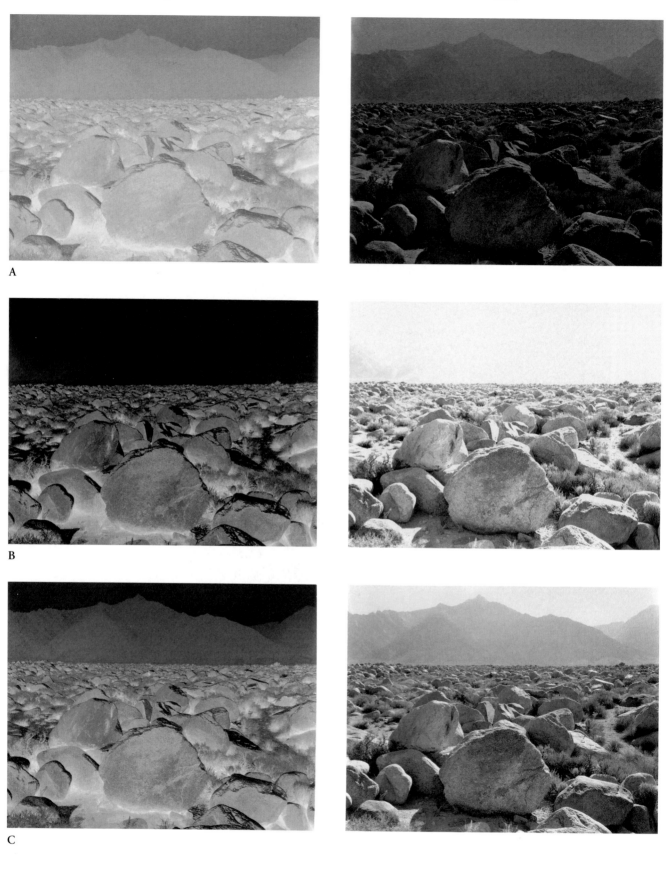

A

B

C

Figure 4.5: *Negative density and development time.* Figures A, B, and C show three separate negatives of the same scene, each paired with a corresponding black-and-white print. All three negatives were normally exposed, but each was developed differently. The negative in figure A was developed for 5 minutes (underdeveloped), resulting in low contrast in the negative itself and a lack of adequate detail in the shadow areas of the print. Figure B was developed for 16 minutes (overdeveloped), leading to high contrast in the negative and a loss of detail in the lighter print tones. Figure C was developed for 9 minutes (normally developed); the result is a negative with normal contrast and a subsequent print in which both shadows and highlights can be easily interpreted.

If you want to photograph a scene with an extensive subject brightness range (for example, an outdoor scene with deeply shaded areas, with an SBR of 1:250), you can most easily record the range of light values on a fast film (with low inherent contrast), using a shortened development time. Alternatively, for a scene with a very restricted SBR (for example, a scene in the shade, with an SBR of 1:4), you can increase the apparent contrast by using a slow-speed film with a longer development time. (Procedures for controlling negative contrast will be discussed in detail in chapter 7.)

Resolving Power

The *resolving power* of a film, measured in units of lines per millimeter, is an index of its ability to record as distinct entities closely spaced lines on a test chart at precisely defined conditions. The resolving power therefore indicates how well a film will reveal fine details in a scene. As you might expect, slow, fine-grained films have significantly greater resolving power than fast, coarse-grained films.

Acutance *Acutance,* a measure of the contrast at sharply delineated boundaries of light and dark tones, is related to a film's resolving power. Unlike grain, which is an inherent film characteristic, acutance depends upon the type of developer used. A negative that exhibits high acutance will feature well-defined boundaries and have a "crisp" appearance; a print from a negative with low acutance will look fuzzy. High-acutance developers emphasize grain structure and should usually be restricted to fine-grained films.

A final note is in order about resolution and acutance. If your camera moves even slightly during exposure, no amount of tinkering during development will produce a crisp and sharp image. If clearly defined details are important for the success of your photograph, and if recording the image requires either a long exposure (slow shutter speed) or a telephoto lens — both of which magnify camera movement — be certain to use a sturdy tripod and a cable release, and in an SLR camera, lock up the mirror.

How a Film Responds to Exposure and Development

The density of any section of a negative is a result of the amount of exposure it has received, the development process, and the fundamental characteristics of the film's emulsion. If negative density is charted as a function of exposure, it will indicate how film responds to various subject brightnesses for a particular developer. Such a graph is called the *characteristic curve.*

The Characteristic Curve A typical characteristic curve looks like a tilted *S.* The left side of the curve illustrates the film's response to the low light levels you would encounter in the shadow areas of the negative. This section of the curve is referred to as the *toe.* The middle part of the curve, called the *straight-line section,* records the film's response to the middle-gray tones of a subject. The top portion, where the slope decreases, is called the *shoulder* of the curve. The brightest values of a subject can fall in this region, although with most modern films, densities of this magnitude (greater than 2.0) are seldom reached during normal photographic applications.

A B

Figure 4.6: *Contraction of negative contrast.* (A) The subject brightness range of this scene was too great to record both shadow and highlight details on the negative in a range that would result in a suitable print. (B) By increasing the exposure and reducing the development time a second negative was obtained that was easy to print and showed excellent detail throughout the image. (Alan Ross, *Windows, Point Reyes National Seashore, 1987*)

The technical literature that the manufacturer provides with a film usually includes a characteristic curve. If you take the time to learn how to read and analyze them, characteristic curves can give you a vast amount of information about how a film will react to various lighting conditions and development. For example, the characteristic curve for Kodak Plus-X Pan Professional Film 2147 shows that the film is less sensitive to tonal differences in the shadow areas than it is to middle tones or highlights. Thus, in a photograph made with this film, you will see very little contrast in the shadow areas but a clear stepwise progression of grays in the middle tones and highlights. The characteristic curve for such a film is said to have a *long toe.*

If you intend to photograph a scene with a limited subject brightness range — for example, a landscape on an overcast day — and you want distinct tonal separations, do not choose a film with a long toe. One with a short toe and a long straight-line section (such as Ilford Pan F, or Agfapan 25) would be more satisfactory.

Does this mean that your choice of black-and-white film must depend on what the light conditions happen to be? In short, the answer is no. General-purpose films work very well for a variety of lighting conditions, and if it proves to be necessary, there are adjustments you can make while developing and printing the negative to compensate for the subtle differences between films. However, if the majority of your work involves a specific type of photography, such as studio portraiture, you would probably be wise to choose a film whose characteristic curve is ideally suited for that application (in this case, Kodak Plus-X Pan Professional Film 2147).

How Black-and-White Films Respond to Colors

Different films can have quite different responses to the various colors of the spectrum. Early emulsions were sensitive only to blue light, and as a result, most nineteenth-century landscape photographs show a blank white sky. The blue of the sky was overexposed during the long exposure times required to record the landscape itself, and therefore the sky printed as pure white. Some

early photographers overcame the problem by maintaining a separate stock of cloud negatives, which they deftly printed in on the otherwise blank skies of their landscapes. It is always a surprise to see the same clouds appear in a number of different landscapes, with the clouds often lighted by the sun at different angles from the landscape itself!

White light is a mixture of colors in wavelengths ranging from the ultraviolet (very short wavelengths, not visible to the eye) to the infrared (very long wavelengths, also not visible to the eye). In between these two extremes is the visible light spectrum, from red (long wavelength) to violet (short wavelength). Early films were sensitive only to blue light; later, dyes were added to the emulsion to make the film sensitive to both blue and green light but not to red. Such film is called *orthochromatic.*

Orthochromatic ("ortho") films are still available and are widely used for copy work (for example, photographing black-and-white line drawings for graphic-arts purposes) and scientific applications. Some portrait photographers also prefer ortho films for rendering skin tones. One big advantage of these films is that they can be handled and processed under a fairly bright red or yellow safelight (see chapter 8).

With further research, the light response of film was extended to include red. These films, described as *panchromatic,* are sensitive — though not equally so — to all wavelengths of the visible spectrum. Most panchromatic films are slightly less responsive to green than to other colors.

Most general-purpose films sold today are panchromatic, or "pan." Pan films' sensitivity to all visible light has two major consequences: (1) during development, the films must be handled in complete darkness; and (2) the films themselves are color-blind. For example, a bright-red apple in the midst of green leaves provides a sharp contrast for the eye, but on pan film the fruit and leaves will be recorded as having the same tone. (Ortho film would produce a print in which the same apple was dark gray, and the leaves a very light gray.) Because it

Figure 4.7: *Characteristic curve.* A characteristic curve is a graphic display of the relationship between film exposure and negative density. Units of exposure form the horizontal axis, and negative densities make up the vertical axis. Moving from left to right on the exposure scale, each unit corresponds to one stop of additional exposure. Film speed is defined by the exposure necessary to produce a negative density of 0.10 unit above the film-base density. The term *toe* is used to describe the portion of the curve that results from exposures of the shadow areas; the *straight-line section* represents the middle- and light-gray regions; and the *shoulder* of the curve, or the upper end of the straight-line section, charts the highlights.

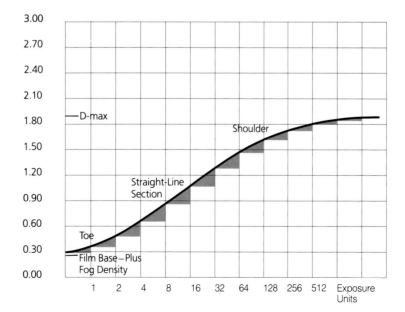

Figure 4.8: Minor White, untitled, 1955, from *Rural Cathedrals/Sequence 10.* An example of a print made from infrared film.

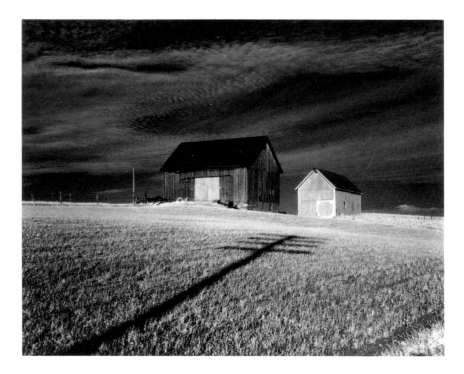

is color-blind, pan film responds to light *intensity,* not to the emotional brilliance of a color. Separating the visual impression of a vibrant color from the luminance, or light intensity, of the object is a special challenge that photographers who choose to work with black-and-white film must recognize. (See page 150 and figure 10.5 for the use of the Wratten #90 filter as an aid to visualizing black-and-white print tones.)

Infrared film is sensitized to both the visible and the infrared (invisible to the human eye) portions of the spectrum. Infrared film "sees through" the atmosphere and senses heat, making visible details that normally go undetected. For instance, green foliage, which is a strong emitter of infrared energy, is rendered as a brilliant white by black-and-white infrared film, an effect that can be dramatic and startling.

Choosing the Right Black-and-White Film for Your Purpose

Given the range of choices available, how do you select a black-and-white film? Most photographers find that one slow- or medium- and one fast-speed film can provide them with enough flexibility to deal with virtually any situation they are likely to encounter. Which film you should use in a given situation will usually be determined by the lighting conditions. The Kodak T-Max films are proving to be excellent and come in both ISO 100 and 400 speeds. Kodak Tri-X and Kodak Plus-X are suitable alternative combinations. If other brands of films with similar ISO ratings are available to you, do not hesitate to use them; Ilford, Agfa, and Fuji are all superb. All major brands of black-and-white films can produce high-quality negatives. Once you have settled on a film, use it until you gain enough experience to appreciate its virtues and limitations.

Table 4.1

Some Common Black-and-White Films

Film	ISO	Grain/Resolution
Konica Infrared	8	Fine/High
Kodak Technical Pan	25	Ultra-fine/Ultra-high
Agfapan 25	25	Extremely fine/Very high
Ilford Pan F	50	Extremely fine/Very high
Kodak High-Speed Infrared	80	Fine/Medium
Ilford Delta	100	Extremely fine/Very high
Kodak T-Max 100	100	Extremely fine/Very high
Agfapan 100	100	Extremely fine/High
Ilford FP4	125	Extremely fine/High
Kodak Plus-X	125	Very fine/High
Kodak Verichrome Pan	125	Very fine/High
Agfapan Scala[1]	200	Very fine/High
Ilford SFX[2]	200	Very fine/High
Kodak Tri-X Professional	320	Fine/High
Kodak Tri-X	400	Fine/High
Ilford Delta 400	400	Fine/High
Ilford XP-2	400	Fine/High
Kodak T-Max 400	400	Fine/High
Kodak TMX-400CN[3]	400	Fine/High
Fuji Neopan	400	Fine/High
Ilford HP5	400	Fine/High
Agfapan 400	400	Fine/High
Kodak TMZ-3200	3200	Medium/Medium

Notes: These films are not offered in all formats. Sheet films are generally available in 4 x 5, 5 x 7, and 8 x 10 sizes and can frequently be obtained in smaller or larger sizes or by special order from the manufacturer.

(1) Agfapan Scala is a black-and-white *positive film* that must be sent away for laboratory processing.

(2) Ilford SFX film has extended red sensitivity that approaches the near infrared.

(3) This film requires the same processing that is used for color negative film.

Using Filters in Black-and-White Photography

Contrast Filters

Color filters called *contrast filters* fit over the lens and enable the photographer who works in black and white to selectively alter tonal relationships in the negative, based on the color of the subject. Filters used with black-and-white films transmit light waves of the same color and absorb those of the complementary, or "opposite," color (that is, the color that, when mixed with the first, results in black). A red filter, for example, will absorb blue light. Used in a landscape photograph, a red filter will reduce the intensity of the light reaching the film from the blue sky, thereby darkening the sky's normal tonal value. (*Note:* Dark-red filters have a stronger effect than light-red ones.)

A filter can often heighten the drama of a scene. However, it is easy to become enamored with the impact of white cumulus clouds against a deep-black sky and to overdo the use of filters. Experiment freely, but practice restraint.

Good glass filters are expensive. As you accumulate a set of lenses, the probability of your having a single set of filters to fit all of them approaches zero.

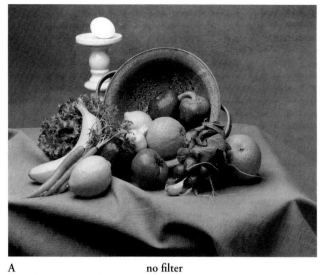

A no filter

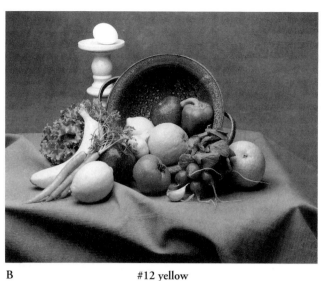

B #12 yellow

C #25 red

'D #58 green

Figure 4.9: *The effects of contrast filters on black-and-white film.* The exposures were made with: (A) no filter; (B) a #12 filter (yellow); (C) a #25 filter (red); (D) a #58 filter (green); (E) a #47B filter (blue). Note the dramatic differences in the tones of the various fruits and vegetables when filters of the same or a complementary color are used.

E #47B blue

Table 4.2

**Contrast Filters
for Black-and-White
Photography,
with Approximate
Filter Factors**

Filter	Comments	Filter Factor*
#6 #8	Yellow filters that moderately darken blue sky and shadows illuminated by blue skylight. The #8 filter (formerly designated K2) is frequently considered to be a correction filter, giving approximately "normal" visual rendering of daylight-illuminated colors for panchromatic films.	2 (+1 stop)
#12 #15	Deeper yellow filters with correspondingly greater effect than the #6 and #8. The #12 filter is "minus blue," meaning that it absorbs virtually all light of blue wavelengths. The #15 filter absorbs some green light as well as all blue light.	2.5 (+1⅓ stops)
#11 #13 #58	The #11 is a light yellow-green filter; #13 is similar but stronger; and the #58 is a strong tricolor green filter. All darken blue sky values and shadows as well as red subjects, and they also lighten foliage somewhat (though green filters in general may have less effect on foliage than expected, partly because of the reduced sensitivity of panchromatic films to green). The #11 filter is considered to provide "correction" when used with panchromatic film under tungsten illumination, and the #13 does the same, to a somewhat greater degree.	#11: 4 (+2 stops); #13: 5 (+2⅓ stops); #58: 8 (+3 stops)
#23a #25 #29	Red filters that tend to darken blue sky and sky-illuminated shadows considerably and produce strong contrast effects. They also darken diffuse reflection from foliage. The #23a is red-orange but has about the same effect on landscape subjects as the #25. The #29 (a deep, sharp-cutting tricolor red filter) gives maximum contrast in landscape and other situations.	#23a: 6 (+2⅔ stops); #25: 8 (+3 stops); #29: 20 (+4⅓ stops)
#47	A blue filter (tricolor) that lightens the sky and darkens green foliage and trees. The use of a blue filter exaggerates atmospheric effects.	6 (+2⅔ stops)
#44	A cyan filter that does not transmit red light and, when used with a panchromatic emulsion, simulates the effect of orthochromatic film, emphasizing blue and green.	8 (+3 stops)
Polarizer	Eliminates reflections and glare from water and nonmetallic surfaces and darkens blue sky (the effect depends upon the angle of the sun).	2.5 (+1⅓ stops)

*See page 122.

One strategy is to buy a set of filters in the largest size you are apt to need, along with a set of step-down rings; these will enable you to use the same filters on any of your lenses. You could also purchase a set of gels (thin sheets made of a material that resembles plastic) and an adapter or lens shade with a slot to hold them. Gels are slightly less expensive than glass filters of comparable quality, but they tear and crease easily and are heat-sensitive.

Table 4.2 summarizes the properties of filters that can be useful in black-and-white photography.

The Filter Factor

Filters seldom reduce the intensity of only one color in a scene. Thus, when using a filter, you will usually need to compensate for the overall reduction in light intensity by adjusting the exposure according to a *filter factor* recommended by the manufacturer. Filter factors depend upon the light source illuminating the subject. For example, with a normal subject in daylight, the filter factor for a #25 (red) filter is 8. This means that you should increase the exposure by three additional stops (2 x 2 x 2 = 8) over the exposure indicated by your light meter. If you forget to adjust your exposure, the scene will be drastically underexposed!

To take another example, if you use a #25 filter indoors on a subject illuminated by ordinary tungsten light bulbs, the filter factor will be 5, and you will need about 2⅓ stops of additional exposure. The #25 filter factor is lower under these conditions because tungsten light is "redder" than daylight, and a greater percentage of the light from the scene passes freely through the filter.

Filters are transparent to light of their own color. Thus, while the print tones of a red apple and green leaves in a black-and-white photograph taken with pan film *without* a filter will be similar, a red filter (with *no* filter factor applied) will produce a print in which the print tone of the apple remains the same but the leaves appear black. The same scene photographed with a green filter (again, with no filter factor applied) will achieve the opposite result: gray leaves, black apple.

Determining Filter Factors Filter factors are calibrated by manufacturers and apply to daylight conditions at noon and near sea level. If the light conditions differ significantly from these, the filter factor may also be different. For example, at high altitudes such as you would encounter in a mountain range, light is bluer, and a yellow filter will increase a scene's contrast more than it would at sea level. You may need to increase the normal exposure factor by a half-stop or more to compensate for the change in light characteristics.

The only certain way of determining the filter factor for unusual atmospheric or lighting conditions is by trial. Polaroid film is ideal for these tests. Begin by photographing a *Kodak Gray Card* (see page 171), or any other subject with a uniform tone, without a filter and recording the exposure necessary for a perfectly exposed photograph. Next, attach the contrast filter to the lens, change the exposure by increasing the aperture of the lens by the recommended filter factor, make a second exposure, and compare the print to the first one. If the "filtered" print is too dark, it is underexposed, meaning that the filter factor you used was too low and must be increased; if the print is too light, the opposite is true. Make another exposure, increasing (or decreasing, as appropriate) the

aperture until the tone of the filtered print matches that of the unfiltered print. The difference in aperture settings between the unfiltered and filtered prints will give you the correct filter factor for those particular atmospheric conditions. For example, if you carried out the above procedure in the mountains with a #8 filter (whose normal factor is 2.0) and found that a two-step difference in aperture was necessary to match the gray tones, the increase in exposure and correct filter factor would be 4.

Light meters typically do not see all colors the same way film does, and if you are using a filter on a camera with a through-the-lens light meter, it may give readings that result in incorrect exposures. To use filters with a through-the-lens metering system, take and note an exposure reading with no filter in place using a gray or white surface as a subject. Next, place a filter over the lens, take a new reading, and compare it to the value calculated by applying the standard filter factor recommended by the manufacturer. If the values do not match, adjust the film speed setting or exposure compensation dial until you reach the calculated value, then use this "correction factor" every time you use that filter.

Special-Purpose Filters

Polarizers While the *polarizer* is not a filter in the strict sense of the word, it is used in the same way as a filter and likewise selectively alters tonal values. Light can be thought of as a bundle of waves that vibrate in every direction; when it strikes a surface, often only those light waves that are oriented in a specific direction will be reflected or transmitted. Imagine trying to slip a sheet of paper through a venetian blind: you can do it only if the edge of the paper is parallel to the slats. A *polarizer* acts like an optical venetian blind and transmits only those light rays that are oriented, or *polarized,* on a particular plane.

Polarizers can be extremely useful for eliminating glare or reflections from smooth surfaces such as windows or pools of water. To use a polarizer, you attach it to the lens of an SLR and simply rotate it until unwanted reflections and glare are minimized. If your camera does not have through-the-lens viewing, hold the

Figure 4.10: *Polarized light.* Ordinary light can be thought of as a bundle of waves, each of which vibrates in a distinct plane, like a plucked string. A polarizer filters out all but those light rays that are oriented in a specific direction.

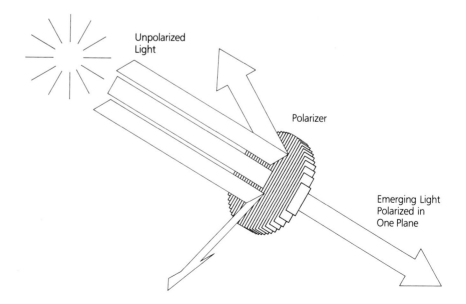

A B

Figure 4.11: *Polarizing filters.* (A) Surfaces such as glass or water often produce distracting reflections that can be removed by placing a polarizing filter over the camera lens. (B) The same scene photographed with a polarizer. The filter was rotated until the reflections disappeared.

polarizer up to your eye and rotate it until you obtain the desired effect. Note the filter's orientation at that point, attach it to the camera lens, and turn it until its orientation is the same as when you looked through it. When you make an exposure, the effect you saw will be recorded on the film. The filter factor for a polarizer is 2.5, regardless of its orientation.

You must observe the effect of the polarizer very carefully when the scene you are photographing includes the sky. Skylight is strongly polarized, with the degree of polarization reaching a maximum at an angle of 90 degrees from the sun. If you are employing a wide-angle lens with a polarizer, you may see a sky that varies from light to dark blue as you move from one side of the picture frame to the other — possibly resulting in a strange-looking photograph! This aberration cannot be corrected, so it is generally wise to avoid using a polarizer for black-and-white or color photographs that include much sky.

Skylight and Ultraviolet Filters *Skylight* and *ultraviolet (UV) filters* can minimize the effects of haze as well as other atmospheric conditions that tend to give a faint blue cast to daylight. This blue cast is especially problematic in color photography, where it can lend a distinct blue tint to color transparencies. Many photographers keep one of these filters permanently attached to the lens as a protective measure, since the filter factor is negligible for both. This practice may result in some degradation of the optical characteristics of a fine lens, however, and it is not a good idea unless you are photographing in adverse conditions involving blowing sand, sea spray, or the like.

Neutral-Density Filters *Neutral-density (ND) filters* are gray in color and serve to decrease the intensity of the light passing through the filter without altering its color balance. They are useful in both black-and-white and color

photography. ND filters are manufactured in unit increments of 0.1 ND, which corresponds to one-third of a lens stop or a comparable decrease in exposure time. A 0.3 ND filter is equivalent to one full exposure stop. Neutral-density filter effects are additive. Thus, a 0.3 ND filter used with a 0.1 ND filter reduces exposure by 1⅓ stops (1 + ⅓ = 1⅓).

A neutral-density filter can come in handy in a situation where the lighting conditions are bright but you want to use a large aperture to limit the depth of field — for example, if you are taking a portrait in full sunlight. Such conditions would normally require you to use a small aperture and a fast shutter speed, but with a 0.9 ND filter you will need to increase the aperture by three stops in order to achieve the correct exposure — while you decrease the depth of field.

An ND filter can also be helpful when you are using a flash attachment as a source of fill-in light in relatively bright surroundings. If you want to use an electronic flash as a secondary light source in outdoor photography (to lighten a face shaded by a hat, for example), you may have to use a neutral-density filter. Most 35mm cameras require you to set the shutter at a speed of $^1/_{60}$ second or less to synchronize with the electronic flash. For an ISO 400 film in bright sunlight, the normal exposure may be $^1/_{250}$ second at f/22, the smallest aperture available on your lens; an ND filter (with a value of 0.6 or greater) would decrease the light intensity so that you could photograph the scene at an achievable lens aperture and a usable shutter speed ($^1/_{60}$ second) with your flash unit.

Figure 4.12: Alan Ross, *Golden Gate Bridge, Sunglint, 1989.* A neutral-density filter was used to "erase" the traffic in this midday photograph of the Golden Gate Bridge. The filter allowed an exposure time of several seconds, with the result that virtually all moving cars and pedestrians are unrecorded and only the stationary subject is seen.

Figure 4.13: *Polaroid sheet and pack film holders.* Polaroid manufactures a variety of holders, enabling their black-and-white and color films to be used with most cameras.

ND filters can also be used to eliminate moving objects from a scene by making very long exposures. For instance, if you want to photograph a building that has a constant stream of people passing by it, and you do not wish to include the people in the photograph, you can put a 3.0 ND filter over the lens. This will increase the normal exposure by a factor of 10 stops (making it 1,024 times as long!). Thus, an exposure that normally requires one second will now take seventeen minutes, and any person or object that is not stationary for at least several minutes will not be recorded during the exposure.

Using Filters in Combination

At times you may wish to use filters in combination — for example, a red filter and a polarizer. When you use filters in combination, their effects are additive, but you must *multiply* their filter factors to arrive at the correct exposure. Thus, a #25 filter (factor 8) used with a polarizer (factor 2.5) will result in a combined filter factor of 20 (8 x 2.5), equivalent to 4⅓ additional stops of exposure.

Polaroid Films

Figure 4.14: Martin S. Silverman, *Converso Duo, Florence, Italy, 1997.* When printed in color, Polaroid's new sepia prints have a rich sienna brown tonal range whose scale and color depend upon exposure, and the time and temperature for development. The Polaroid process uses a monochrome dye to generate the print color. With overexposure creamy whites and light brown hues are produced, while with underexposure the darker tones intensify to a prominent brown/black with terra-cotta mid-tones.

The films developed by the Polaroid Corporation can play an important role in your black-and-white or color photography. Polaroid's great innovation was to include the processing chemistry in its film packs. After the film is exposed, it is passed between rollers that burst and spread a pod of chemicals over the surface of the negative and/or print. Development proceeds automatically, and the final image appears after a few seconds or minutes, depending on which film you choose. In essence, the development and fixing of the image are combined into one-step, automatic processing.

Special film holders allow you to use Polaroid "peel-apart" films with most cameras. Negative and print films are available either in film packs or in individual sheets. A wonderful feature of Polaroid photography is that it provides you with "instant feedback" and quality images. In the field, an "instant print" in your hand can call immediate attention to such problems as exposure errors or stray objects that you may have overlooked on the viewing screen of your camera. Discovering a mistake while you can still remedy it is considerably less painful than receiving a nasty surprise in the darkroom, when it is too late. Polaroid films, cameras, and accessories can thus hasten the photographic learning process. Table 4.3 summarizes the characteristics of some currently available Polaroid black-and-white films.

With care and appropriate sensitivity, Polaroid films can produce memorable photographs. Two portfolios of outstanding Polaroid photographs by Ansel Adams and others have been published under the titles *Singular Images* and *Polaroid Land Photography.*

Prints produced by the Polaroid process have a unique "presence," and their tonal values are quite unlike those in prints obtained by traditional enlarging or contact-printing processes. Because Polaroid materials produce only one print from each exposure (with the exception of Type 55, which produces a negative that can be used to make multiple prints), they are the modern equivalent of the daguerreotype.

Type 55 P/N film produces a fine-grained negative from which excellent enlargements can be made. After developing, the negative must be soaked in a

strong solution of sodium sulfite and then washed thoroughly in running water. If you wish, you can remove the exposed film from the Polaroid film holder and delay processing it until you have access to a darkroom, but this will force you to sacrifice the element of instant feedback in the field. Field processing is perfectly feasible if you are prepared to carry and store jars of solutions in the trunk of your car.

Table 4.3

Polaroid Sheet Films

Polaroid Film	ASA or ISO	Comments
Type 51	320	Produces black-and-white prints (no negatives) that are high-contrast (black or white, no middle-gray tones). Useful for scientific applications, copying of line drawings, and creative special effects. If the film is exposed using a tungsten light source, an ISO value of 125 should be used.
Polapan Type 52	400	A high-speed, continuous-tone material that produces black-and-white prints. Prints have beautiful tonal gradations and provide superb detail.
Type 53	800	Produces a medium-contrast print that does not require coating. Type 803 is an identical product in 8 x 10 format.
Type 54	100	Produces a medium-contrast print with a wide tonal range. No coating required. Primarily intended for use by professional photographers to "proof" scene setups. Type 804 is an identical product in 8 x 10 format.
Type 55	50	Produces both a black-and-white negative and a black-and-white print. If you want the negative to make additional prints, increased exposure may be required; some additional processing is needed to insure the negative's permanence.
Type 56	200	Produces a medium-contrast sepia-tone print with lovely tonal qualities.
Type 57	3000	A continuous-tone black-and-white material that produces prints only. Excellent for use in low-light situations. Type 107 is similar and made for the film-pack format. Type 667 is a film-pack product that does not require coating of the print.

Note: This table describes the major Polaroid film types. The pack films with 100 and 600 series numbers measure 3¼ x 4¼. The 80 series films measure 3¼ x 3⅜ inches. All films with the same last digit are similar.

Calla Lily,
San Francisco,
circa 1955

When photographing very light objects, especially such delicately valued subjects as flowers, one must strive to hold a semblance of texture throughout. If placed too high on the scale, the high values will burn out; if too low, they may appear drab and gray. The key values of the flower are almost white, and the eye and mind read the other values as appropriate. The background values become very subtle, and the passages of value in the flower are satisfying without being dramatic. The photograph was done using [Polaroid] Type 52 film, in natural light near a garden wall, illuminated from skylight coming mostly from the left.

A film's ability to reproduce a range of subject brightness levels (luminances) is one of its critical characteristics. Polaroid films have a shorter scale than conventional black-and-white negatives and are comparable in exposure range to color transparency films; however, some recent Polaroid print films show longer exposure ranges than earlier films. As with transparencies, the exposure decision, or placement, is made for the high values of the Polaroid print.

The Polaroid Land films most widely used by professional and advanced amateur photographers are the 4 x 5-format materials. Until the 4 x 5 Land films and film holder appeared in 1957, the Polaroid process was considered primarily a snapshot medium. The ingenious and compact system that was developed for using 4 x 5-inch Polaroid films with standard view and press cameras has greatly expanded the professional and technical applications of "instant" photography. — ANSEL ADAMS

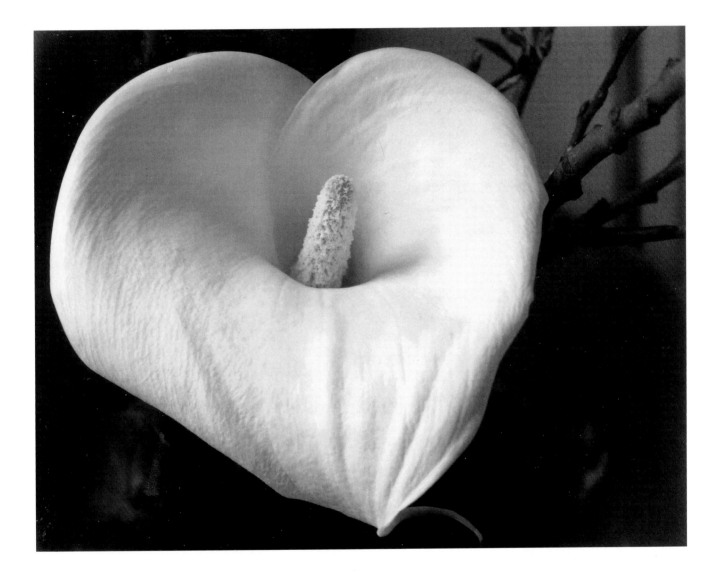

Chapter Five

Visualization: The Art of Seeing a Photograph

Figure 5.1: Ansel Adams, *Church and Road, Bodega, California, c. 1953.*

The steps in making a photograph may be simply outlined as follows:

1. Need, *or* desire, *to photograph. This attitude is obviously essential. Sometimes just going out with the camera can excite perceptive interest and the desire to work. An assignment — a* purpose *— can be the greatest stimulus for functional or creative work.*

2. Discovery *of the subject, or* recognition *of its essential aspects, will evoke the concept of the image. This leads to the* exploration *of the subject and the optimum point of view.*

3. Visualization *of the final picture is essential in whatever medium is used. The term* seeing *can be used for* visualization, *but the latter term is more precise in that it relates to the final picture — its scale, composition, tonal and textural values, etc. Just as a musician "hears" notes and chords in his mind's ear, so can the trained photographer "see" certain values, textures, and arrangements in his mind's eye.*

Visualization, and the conscious application of fundamental techniques, does not *inhibit the creative-intuitive faculties; it protects and augments them. The creative-intuitive forces must dominate from the start in all expressive work. If not, the whole concept of photography as a creative medium would be invalid. But a sloppy performance of a photograph is as obnoxious as a sloppy performance of music. Subject alone — or any mere simulation of reality — cannot support a work of art in any medium.* — ANSEL ADAMS

Photography is a visual language. Languages are a means of communicating thoughts or emotions through abstract symbols. Photographs often look so "realistic" that it is easy to forget they are not: three dimensions have been compressed into two, color is absent in a black-and-white photograph, and the tones of the actual subject and of a photographic print may be entirely different. Yet an effective photograph creates its own reality.

Together, a camera and film transform light and form into a photograph. The task of a photographer is to look at a scene and then translate it into a photograph. In any language, translation is not simply the act of converting one set of words into another; if the spirit of a phrase is lost in the process, the translation is inadequate. Fine photographs are those that capture the spirit as well as the light and form of their subject.

To progress in photography, you must cultivate the habit of *looking* at a scene and *seeing* it in the photographic symbols of lines, tones, textures, shapes, and color. The mental process of interpreting the reality of a scene and translating it into photographic symbols is called *visualization*. For the viewer of your prints, the symbols you create will in turn be transformed into an emotional response, and the strength of that response will be one measure of how well you have been able to visualize and interpret a scene.

The first step in learning how to communicate through photography is to understand the strengths and limitations of the language. In discussing the process of visualization, we will emphasize the black-and-white print as the basic medium for making a photographic statement (even the most technically advanced color materials available today are based on black-and-white technology and begin as black-and-white images). Later, in chapters 10 and 11, we will see how color can add to and modify what is being communicated.

Because the goal of this book is to explore photography as a means of creative expression, both the mechanical aspects of taking and making a photograph and the aesthetic issues must be considered. During the course of this exploration, you will sense that there are guidelines you will want to evaluate — and apply, when appropriate — as you begin to photograph. These discussions are intended to provoke you into thinking about photography and its processes; they do *not* aim to provide you with a firm set of rules and regulations that you must follow in order to make great photographs.

Visualization of a Photograph

Art takes wing from the platform of reality. We observe reality; we may or may not feel *anything about it. If we do feel something, we may have a moment of* recognition *of the imperative subject and its qualities in terms of a photograph. In a sense this is a mystical experience, a revelation of the world that transcends fact and reaches into the spirit.*

Once we recognize a potential photograph, we begin to "see" in our mind the image that will convey the visual-emotional experience of the subject to the maximum degree — that is, we visualize *an image. Our visualization starts with the subject but takes into account the characteristics of the medium itself and of the specific equipment and materials we are using.*

There are three basic stages in every creative process: (1) generating the concept; (2) deciding how to achieve the concept in practice; and (3) executing the concept. In photography, these stages usually correspond to (1) seeing a subject that you want to photograph; (2) setting up your equipment and making the decisions that will produce the photograph you want; and (3) making the photograph. Steps 1 and 2 of this process are the essence of visualization.

Characteristics of a Photograph

To reiterate, when you choose to work in a medium, you must understand its ordinary strengths and limitations. A photograph is a two-dimensional representation of a three-dimensional scene, as recorded by a camera through the eye of a lens. In a black-and-white photograph, everything is reduced to two elements: *form* and *tone* (shades of gray, with black and white representing the extreme values of a spectrum of gray tones). In color photography, colors comparable to those of the subject are substituted for the gray tones in black-and-white photographs. Both form and tone can be controlled by the photographer.

Composition refers to the structural relationships that are created between objects, tones, and colors as you frame a scene in the camera's viewfinder. Spatial relationships between objects, and even the apparent shapes of the objects themselves, can be varied by the placement of the camera and your choice of lens. Colors and tones in the photograph itself are influenced by the exposure you select and by the way you process your film and paper. *Visualization* is the word Ansel used to describe the rational and emotional process by which he arrived at his photographic compositions.

Volumes have been written about the rules of composition, but while most of these generalities are reasonable, rules are made to be broken. Creative photographers are not driven by rules, although they freely make use of them whenever they serve to strengthen or reinforce the visual message. Rules can be useful, but they must never stifle creativity, which is of primary importance.

The ability to visualize a scene as a photograph is one distinction between a "snapshooter" and an accomplished photographer. Once you visualize the composition of the image that you want to capture, the remaining tasks involved in making a photograph are primarily a series of mechanical operations, some of which may require considerable skill, but all of which can be mastered without too much difficulty.

One way to learn about the process of visualization is to compare photographs of some familiar scenes with the scenes themselves. In looking carefully at the pictures, you will begin to understand how the scene translates into a photograph. Analyzing photographs is also a good way to gain a sense of what you can control when you make and print a photograph.

Visual versus Photographic Images

As with all art, the photographer's objective is not the duplication of visual reality. Photographic images cannot avoid being accurate optically, as lenses are used. However, they depart from reality in direct relation to the placement of the camera before the subject, the lens chosen, the film and filters,

the exposure indicated, the related development and printing; all, of course, relating to what the photographer visualizes.

Photography is an analytical medium. Painting is a synthetic medium (in the best sense of the term). Photography is primarily an act of discovery and recognition. . . . The photographer cannot escape the world around him. The image of the lens is a dominant factor. His viewpoint, his visualization of the final image (print or transparency), and the particular technical procedures necessary to make this visualization valid and effective — these are the essential elements of photography.

Although both the eye and the camera lens form images, the images are not always the same. With a camera we have the luxury of changing the focal length of the lens, while with our eye the focal length is a constant. One of the first things a photographer needs to understand is how "seeing" with a camera lens differs from seeing with an eye.

If we look at parallel lines receding into the distance (as with railroad tracks or a ribbon of highway), normal perspective makes it appear that the lines eventually converge. A photograph of the scene will convey the same impression. In contrast, if we gaze up at a group of tall buildings, we "see" them as parallel towers rising up perpendicular to the ground, even though a photograph taken from the same place will show them leaning toward the center. In the case of the buildings, our brain alters our visual impression, and we "see" the buildings as we instinctively "know them to be."

If you were to look carefully at the buildings through your camera viewfinder, you would see that they really do appear to lean inward and converge. Most people simply do not notice this phenomenon because it is not what they expect to see. Remember: the progress you make as a photographer will depend upon your making the transition from *looking* to *seeing*. *Looking* is simply a gathering of visual impressions. *Seeing* results from analyzing what you are looking at; it is equivalent to understanding your visual impressions.

Some viewers might find a photograph of "tilting buildings" jarring, even though it represents the reality of what the eye or a camera lens actually "sees" in those circumstances. You can "correct" the tilt when you print the negative, or you can avoid it altogether by using either a view camera with appropriate adjustments or a 35mm camera with a special perspective-control lens. A photographer must be aware that if the back of the camera is not perpendicular to the level ground, vertical lines will converge. If the camera is pointed upward, the lines will converge toward the top of the photograph; if it is pointed down, the opposite will occur.

Another notable difference between the eye and a camera lens is that the eye can focus sharply only on one object at a time, although brain-retina reflexes make both near and far objects *seem* sharp. With a camera lens, on the other hand, the depth of field can be controlled by varying the aperture (see page 87), which gives you the option of either selectively focusing on a specific element within a scene or placing the entire image in sharp focus (within limits). It is up to you to make a decision based on which composition seems stronger to you.

A

B

Figure 5.2: *Using cropping L's.* Cardboard
borders cut into the shape of an L are a
useful tool for making decisions regarding
image cropping. (A) One of Ansel's
photographs in an uncropped state, with
cropping L's alongside. (B) Using the L's
to determine what portion of the image
will be enlarged to make the final print.
(C) Ansel Adams, *Moon and Half Dome,
Yosemite National Park, 1960.* Cropped
version.

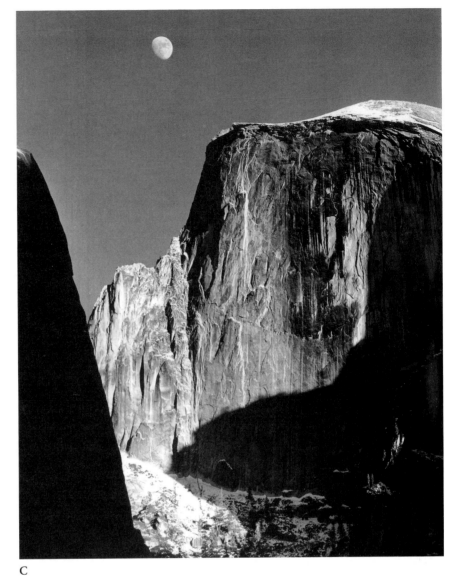

C

The most important lesson here is that you can control the form of the
image through the way you use your camera and the lens you choose. You must
be aware of the various possibilities and then select the approach that will result
in an image that reflects your thoughts and feelings on the subject.

Improving Your Skill at Composition

One tool that can help you evaluate photographic composition consists of a pair
of cardboard *cropping L's* about one inch wide, with arms long enough to frame
your usual photographic prints. You can use these to create frames of variable
sizes as you study photographs. As an exercise, take a set of snapshots (use
someone else's if you can — it will be easier for you to be detached and ruthless
about editing them) and crop each until you think you have arrived at the
"strongest image." The choice of a "strongest image" is a subjective judgment,
since there are no unique answers in photographic composition. You will quickly
realize that most of the snapshots could have been improved substantially if the

A

B

C

Figure 5.3: *A viewing card as a visualization aid.* (Alan Ross, *Fence and Farm Buildings, Point Reyes National Seashore, 1987*) (A) An attractive scene with the potential for many interesting photographs.

(B) A quick scan of the scene with a viewing card isolated this section and revealed its photographic possibilities.

(C) A photograph taken from the same position with a lens with a long focal length. Without a viewing card, this image would have been easy to overlook.

photographer had given more thought to zeroing in on the subject before tripping the camera's shutter.

Make it a practice to go through the same exercise with your own photographs. Your sense of how to approach and photograph a subject will soon improve, and the quality of your images will benefit greatly. Additionally, you will find these cropping L's very useful for composing your print in the darkroom as you prepare to enlarge an image.

An Aid to Composing in the Field Another simple device can help you sharpen your seeing and organizing skills when you are out photographing in the field. Find a piece of cardboard that will fit into your camera case. Cut a rectangle out of the center that is the same size as the film format you use: 2¼ inches square; 2¼ x 2¾ inches for a 6 x 7; 2¼ x 3¼ inches for a 6 x 9; 4 x 5 or 5 x 7 inches for view cameras; and so on. For a 35mm camera, it is best to use a rectangle that measures 2 x 3 inches (the same proportion but twice the size) so that you will not need to hold it too close to your eye. Be sure to leave at least a 2-inch border around the cut-out rectangle.

By using the card as a frame when you study a scene, you can quickly isolate various elements and consider them without other visual distractions. You can go from "wide-angle" to "telephoto" simply by extending your arm. The viewing card can also make it easier to decide which lens to use: the distance between your eye and the card will roughly correspond to the focal length of the appropriate lens. If you need to know the measurement in millimeters, just multiply the number of inches by 25. For example, if your 4 x 5 frame is 8 inches from your eye when the subject is organized in a way that you like, you will want an 8-inch, or 200mm (8 x 25 = 200), lens on the camera. (If you use a 2 x 3-inch rectangle for a 35mm camera, you will have to divide the eye-to-card distance in half in order to estimate the focal length of the correct lens. You can also use a 4 x 5-inch frame for an 8 x 10 camera: simply double the eye-to-card distance to estimate the focal length.)

Using a viewing frame before you set up your camera and tripod will save you a lot of time and is a guaranteed shortcut to taking better pictures.

Choosing What to Include in Your Photograph

The best way to learn about photographic composition is to *think* about your images before you take them and *analyze* them after you make a print. The feedback will soon inspire you to compose images in more creative ways. You will quickly begin to realize that the two most basic (interrelated) factors are (1) where you place the camera, and (2) what you include within the borders of the photograph.

Point of View

When you photograph a scene, the single most important question is usually, What is the best location for taking a photograph? A slight shift of the camera to the side or a raising or lowering of your point of view can have a significant impact on the visual impression your photograph will make on the viewer. You want to

be certain that the viewpoint you choose will result in the most effective photograph possible.

Many places have extraordinary visual appeal. The question of how to best photograph a scene, regardless of its complexity, must be reduced to *selecting*, *organizing*, and *imagining* those elements of the scene that will translate an emotional response into an effective photograph. These steps may require considerable thought and some experimentation, but as you gain experience, you will develop a feel for what "works." The problem is one that Ansel particularly appreciated.

> *The eye has enormous selective power. For example, consider a deer in an expanse of meadow; our interest and excitement in the subject compels our full attention on the deer; it fills the field of our attention. Without thinking, we point the camera in the direction of the deer and expose. We find that our lens does not share our excitement and selectivity; it merely records — with faithful observance of the geometric rules of perspective, image size, etc. — the deer as a small and inconsequential object in a large area of meadow! Once we are aware of the deer, we must visualize the* picture of *the deer — not just the deer itself as seen by the eye. Based on this visualization, we then change our position (moving toward the deer — who may not appreciate our proximity!) and/or use a lens of long focal length. If we cannot move in, and we do not have such a lens, we may approximate our*

Figure 5.4: Ansel Adams, *Barn, Cape Cod, Massachusetts, 1939.* Ansel carefully chose where to place the camera to make this photograph. If the camera had been a little lower, the top of the fence pickets would have merged with the buildings behind. As your eye reaches the far left of the fence, the pickets direct your vision to the darker outbuildings, whose lines carry your gaze on to the brilliant image of the barn. At the extreme right of the frame, another building is visible in the background. Its shape mirrors the geometry of the barn. The opening at the right of the fence is psychologically important to the success of the image: try covering the right-hand edge so that the photograph ends with the last picket, and note how the image changes. Imagine how it would look if the camera were moved farther to the right so that the fence line ended below one of the barn doors; if you cover a portion of the right end of the fence, you will find that the entire photograph falls out of balance. Often a variation of a few inches in camera placement can make or break a photograph.

visualization by resorting to great enlargement of the negative (probably with loss of image quality). Through visualization we learn how to create pictures, and we discover what cameras can and cannot do!

Where you choose to stand relative to the subject is a critical part of composition. Your first instinct will be to scan and frame an image from the point at which it caught your eye, but if you settle for that point of view, you may lose some of your photograph's potential.

Powerful photographs, especially those of the natural world, are like "big game" — they need to be carefully stalked. When you find a subject that attracts you, pause for a few minutes to enjoy the scene. Clear your mind of distractions, and let the environment work on you. Enter into the spirit of the place. Then begin to examine what you see.

Should you move in closer or try a different lens? How would the image change if you moved to the right or the left? Are the light and shadows appropriate for the subject at this time of day, or would a photograph taken earlier or later be better? What is the best height for the camera? Would placing it closer to the ground increase the dramatic impact of the photograph? Are there objects in the foreground or the background that you want to exclude from or include in the photograph?

The above questions are not meant to be a checklist for you to tick off as you prepare to photograph. Instead, questions such as these should become part of your natural and instinctive thought processes as you use your camera. With conscious practice, these choices, considerations, and possibilities will become second nature to you.

Framing the Image

Once you have determined the best place to locate your camera for a photograph, you must decide what fraction of the scene you want to record on film. When you think about "framing a scene," you need to consider both the *borders* of the image and what appears in the *background*.

The viewfinder of the camera (and your viewing card, which you should have in hand when you are scouting a scene) will define the horizontal and vertical borders of the photograph; the choice of an appropriate background is up to you.

Horizontal or Vertical Format? One of the first framing choices you must make is whether the image should be composed in a *horizontal* or a *vertical* format. Which seems most pleasing aesthetically? For the photograph *Church and Road, Bodega, California* (figure 5.1), Ansel chose a vertical format. The road that leads our eyes to the church reinforces the upward thrust of the windows and steeple. Try covering the bottom two-thirds of the image, thereby converting the photograph to a horizontal format, and notice how its visual impact is altered. When you encounter a scene that you want to photograph, give some thought to whether a horizontal or a vertical image would be more appropriate, and set up your camera accordingly.

Frozen Lake and Cliffs,
Sierra Nevada, Sequoia National Park,
1932

In my early days I frequently assisted in leading Sierra Club hikes in Yosemite and the High Sierra. I made this photograph while on the annual outing in the Kaweah Gap and Kern River watersheds, in many ways the most spectacular region of the Sierra. Precipice Lake was partially frozen and snowbanks rested in the recesses of the cliffs. I was impressed with the solemn beauty of the scene and saw the image quite clearly in my mind. I was becoming confident of my seeing and had considerably developed my craft.

I was using a 4 x 5 Korona View camera with a 19-inch lens, which gave me precisely the composition I visualized. It was a complicated exposure problem: the deeply shadowed recesses of the cliffs contrasted with the blinding sunlit snow, taxing my intuition and the range of the film as well. I was fortunate with my exposure: I had no way to measure the specific luminances of the distant subject with my early Weston meter, so I gave one lens stop more exposure than average and hoped for the best.

I am interested in why I see certain events in the world about me that others do not see. On the day that this photograph was made there were several other photographers nearby, some very good ones who were then far more technically advanced than I. The scene was before us all, but no one else responded with creative interest. Cedric Wright, close friend, violinist, and photographer from Berkeley, observed what I was doing and, half in jest, set his camera up in my location. I saw his print later; he did not have a lens of appropriate focal length and he overexposed his negative. On seeing my print he exclaimed, "Jeez! Why didn't I see that!" I have seen some of his prints that have evoked the same comment from myself.

With all art expression, when something is seen, it is a vivid experience, sudden, compelling, and inevitable. The visualization is complete, a seemingly instant review of all the mental and imaginative resources called forth by some miracle of the mind-computer that we do not comprehend. For me this resource is not of things consciously seen or transcriptions of musical recollections; it is, perhaps, a summation of total experience and instinct. Nothing modifies or replaces it. — ANSEL ADAMS

Aspect Ratio The *aspect ratio*, or the relative proportion of the short to the long side of the frame, varies according to camera format. For a 35mm camera, the aspect ratio is 1:1.5, while for a 4 x 5 view camera it is 1:1.2. Nature does not always arrange itself to accommodate your camera's film format. If the image you want to photograph does not have the same rectangular shape that you see through the viewfinder or on the ground-glass focusing surface — for example, if the composition you see is a square shape and you have a 35mm camera in hand — you must be prepared to crop off part of the image when you make a print.

A Note on Cropping While cropping can be a useful technique in print-making, it is essential that you do as much mental "cropping" as possible before you take the picture. This approach is important because the technical qualities of a print are directly proportional to the size of the negative you use (see chapter 4). Thus, if you use only 10 percent of a negative when you make a print, the image sharpness and smoothness of tone will suffer, and the image as a whole may have a "grainy" appearance.

If you discover in the darkroom that what really caught your eye when you took a photograph was a small segment of the scene in the center of the negative, the next time you encounter a similar situation, remember to move in closer to the subject or to use a lens with a longer focal length to get the photograph you want. The need for excessive cropping is usually an indication of inadequate visualization of the image when the photograph was being taken. Each time you prepare to take a photograph, you must ask yourself, What is it about this scene that moves me to capture it on film? When you arrive at your answer, the next step is to *frame that part of the scene as tightly as is practical in the camera's viewfinder.* Following this simple rule will guarantee an enormous improvement in the quality of your photographs. Cropping should not be relied upon to salvage images that were poorly visualized in the first place.

Organizing the Image within the Frame

When you have found a subject that interests you and determined whether the scene should be photographed as a horizontal or a vertical image, you have to think about how to "organize" it within the frame. There are two variables that you must consider: *position* and *lighting*. If you are working in a setting where you have complete control (for example, photographing an arranged still life), you can organize the lighting and placement of subjects almost at will. In the natural scene, however, your choices are usually limited to camera placement and time of day.

The purpose of framing a subject in the camera's viewfinder is to optimize the impact of the photograph you visualize. The following are some factors you should consider.

Choosing the Center(s) of Interest

Where is/are the center or centers of interest in the scene? The natural tendency of most photographers is to locate the center of interest (which is usually a region, not a point) in the center of the frame. This practice is encouraged by the camera

Figure 5.5: Ansel Adams, *Trailer Camp Children, Richmond, California, 1944.* This 35mm photograph has a structure that many Renaissance painters would envy. Each face forms a distinct center of interest, but it is the baby's eyes that make contact with us. The curves of hands, arms, even the curve of the oldest child's collar, bring our eyes back to our contact point. The image is not posed and represents a passing moment that Ansel was able to visualize and compose in the span of a few seconds.

manufacturers' placement of the focusing circle in the exact center of the viewing screen in all hand-held cameras. Unfortunately, this arrangement rarely produces an exciting image.

Once you have identified the center of photographic interest, move the viewing card or your camera and viewing screen, positioning the center in various parts of the frame. Choose the position that creates the most visual interest — your instincts will guide you. If you are uncertain about which alternative works best, do not hesitate to make several exposures, with the center of interest in different locations within the frame. After you make prints, tack them to a wall and study them carefully; one composition will eventually emerge as the strongest. Exercises such as this will help you with future choices, and soon you will be composing images instinctively.

Figure 5.6: Ansel Adams, *Spanish-American Woman, near Chimayo, New Mexico, 1937.* The woman's face is the center of interest in this image, and our eyes are immediately drawn to it. If you cover the right half of the photograph, you will see that although the image remains interesting, it is now nothing out of the ordinary. The texture and tone of the light-gray wooden post are echoed in the woman's face and serve to balance the image. If the post were the same dark tone as the background, the composition of this photograph would strike us as awkward.

When there is more than one center of interest in a photograph, what becomes important is the centers' relationship to each other. Usually one center should dominate, to avoid confusion as to what the image is about. The use of lines, curves, and angles can help to link separate elements, directing the viewer's attention to important centers.

Placing the Horizon Line

Pay attention to the placement of the horizon line: unless you are striving for a special effect, it should be level! When it runs through the middle of a photograph, the horizon often creates two competing pictures. Decide which is the more important element in a particular landscape, the sky or the land, and tilt your camera up or down accordingly. On the other hand, if you are photographing a vast plain where the sky and the land seem to merge, you may conclude that the horizon ought to be across the middle of the photograph. Your message should always dictate the form you choose for expression.

Establishing Near-Far Relationships

A photograph's success will often depend upon your ability to "organize" the subject so that the viewer will experience an immediate sense of intimacy with the image. A successful photograph draws you into the scene at once. Your eyes awaken your sense of touch; you can almost reach out and feel substance in elements of the image, and your awareness of the photograph's margins virtually disappears.

Monument Valley, Arizona is a wonderful example of this. The sunlit monolith that dominates the foreground immediately captures our attention. Its surface, shaped by erosion, is smooth yet scarred by the experience of time, wind, and weather. We sense that the three distant temples of stone that rise a thousand

feet and more above the valley floor have similar surfaces, products of the same elements. A dirt road in the picture's center seems to dwindle into nothingness. The grandeur and desolation of Monument Valley are driven home.

Ansel's photograph was taken alongside the road, just a few hundred feet beyond the entrance to the valley. Yet rarely does anyone stop at this point to look or to take his or her own photograph of the scene. Why?

Because the "monolith" in the foreground is a rock only a few feet high. If you move a little to the right or the left, you will have virtually the same view of the three peaks, but with a featureless foreground. *Monument Valley* is a superb example of an image in which a near-far relationship serves to arrest the viewer's attention. (See page 361 for Ansel's color photograph of Monument Valley.)

If the subject you are photographing is far away and you cannot approach it, think about creating some foreground interest. Make certain that it complements, and does not obscure, the object of your photograph. You may find the foreground *so* interesting that you reduce whatever it was that originally caught your eye to a mere backdrop.

Figure 5.7: Ansel Adams, *Monument Valley, Arizona, 1958.*

Time, Timing, and Visualization

Questions of time and timing are key to many photographic opportunities. The issues that you need to consider in this regard involve the best time of day to take a photograph of a particular subject, the "decisive moment" when an exposure should be made, and the duration of the exposure itself. Each of these variables forms an important part of visualization.

Time of Day

The quality of light changes dramatically throughout the day and also varies with the time of year. A scene that is spectacular at sunset may not be worth photographing at high noon. With landscapes in particular, choosing *what time of day* to photograph can be as important as choosing *what* to photograph.

In the hours shortly after sunrise and before sunset, the sun is at its steepest angles, causing landscape features to cast significant shadows. If used skillfully, these shadows can help to build an impression of a third dimension in the two-dimensional world of a photographic print.

The hours near midday are wonderful for looking at the natural world, but they are seldom ideal for photographing large land areas. The brilliant sunlight illuminates everything in sight, but if you look carefully, you will see that the quality of light is relatively flat, shadows and "dimension" are at a minimum, and, as a result, scenes have little depth or definition.

Tourists are often disappointed when they arrive at a roadside scenic viewpoint, the site of some great landscape photograph that they have seen in books, in magazines, or on postcards. While the scene may be spectacular, it just does not look as dramatic as it does in the photograph. The difference between the reality and the photographic image of the scene often lies in the time of day or the weather conditions. If you want to make dramatic landscape photographs, especially in the absence of stunning cloud formations, plan to photograph either early or late in the day. As you make photographs at different times, you will

Figure 5.8: Ansel Adams, *Ghost Ranch Hills, Chama Valley, Northern New Mexico, 1937.* Note how the grazing morning light emphasizes every crack and wrinkle in the mud hills. The larger shadow areas define the overall shape of larger features within the landscape and provide visual clues about their relative positions. If this photograph had been taken at noon, the shadow areas would all be brightly lit, and the photograph would be dull and difficult to read.

Figure 5.9: Henri Cartier-Bresson, *Behind the Saint-Lazare Station, Paris, 1933.* This photograph is a splendid example of a photographer's capturing the "decisive moment." If the photograph had been taken a fraction of a second sooner, we might have been left with the optimism that the jumper felt when he launched himself. A thousandth of a second later, and the image would have recorded the indignity of failed ambition. As it is, we see the picture and smile, knowing what the future forever holds in store.

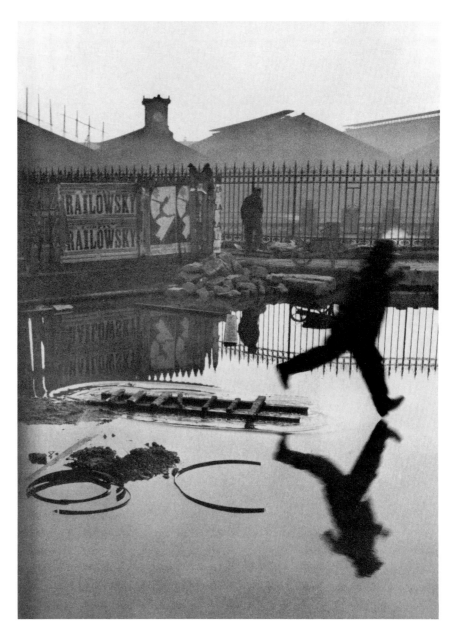

notice that postdawn light is often very different in character from twilight. This is because wind and human activity stir up dust, and the haze that gathers during the day can enhance the quality of light (for the purposes of photography only!) in the twilight hours.

The "Decisive Moment"

Ansel believed that *"anticipation is [a] prime element of creative art and essential to visualization."* In many photographic situations, there is one and only one "right" instant to trip the camera's shutter. Henri Cartier-Bresson refers to the critical time for making the exposure as the "decisive moment." It is that fraction of a second when a high-jumper is just clearing the bar, when emotions reach a breaking point, when time and place combine to provide a unique photographic opportunity. You photograph these situations by instinct, composing, focusing, and exposing faster than it is possible to think consciously.

Photography that relies on capturing the decisive moment for its visual impact is extremely difficult. The action and the setting must be instantly visualized by the photographer in the context of a photographic image; successful images of the decisive moment are the result of careful observation, a sense of anticipation, camera readiness, and a willingness to intrude on others in order to take a photograph — in short, a marriage of camera, mind, and eye.

If you ever have the pleasure of watching a photojournalist at work, you will notice that he or she is constantly resetting the camera and lens to accommodate changing light conditions and unfolding events. A good photojournalist continually scans the surroundings for possible photographic opportunities, and is ready to spring into action at any time. For a photojournalist, visualization is a continuous process.

Regardless of which photographic pursuits appeal to you, you should practice this process yourself, even when you are not carrying a camera. Think about the quality of light, and figure out what aperture and shutter speeds you might use to photograph your surroundings. Try to evaluate scenes or events quickly and make snap judgments about where the best point to photograph from might be. These exercises will heighten your visual awareness and help to integrate your camera into your subconscious. You will be surprised by what you discover — and by what you will want to return to and photograph.

Figure 5.10: Wynn Bullock, *Sea Palms, 1968.* Sea palms grow in shallow water and are washed over constantly by the breaking surf. With an exposure of several minutes' duration, the surf is "averaged out" and looks like fog. Segments of the plant that are normally below the water line can be seen in the photograph since they are exposed momentarily whenever the waves recede. Bullock was a master at visualizing how the passage of time would influence a scene in which motion was an important element.

A B C

Figure 5.11: *Shutter speeds and moving water.* This fountain was photographed using shutter speeds of (A) ½ second; (B) ¹/₃₀ second; and (C) ¹/₅₀₀ second. The shutter speed you choose when photographing subjects in motion can have dramatic aesthetic implications.

Duration of Exposure

The amount of time allowed for an exposure, particularly when motion is involved, can affect the translation of a scene into a photograph. For example, if you photograph a running stream at $1/60$ second or less, droplets and ripples will usually be clearly delineated, while at $1/10$ second, turbulent water will appear as streaks, with well-defined structural features. Exposures of longer duration will result in a milky and featureless rendition of the water. Each alternative has aesthetic appeal. When you visualize a scene that has moving objects, you must decide what sort of effect you want to capture on film. Polaroid sheet films are especially useful in these circumstances and will help you to evaluate the various possibilities.

One significant difference between the eye and the camera lies in the ability of the camera and the film to capture and store light gathered by the lens over a long time period. Because our eyes automatically adjust to differing light levels and produce only momentary impressions of what we see, we must leave it to our minds to visualize the creative possibilities of long exposures.

Visualization of Tones

In photographs, shapes convey information about the physical characteristics of that which is visible to the eye. The light and shadows that define shapes can also be used to create a mood and penetrate the spirit of your subject. Learning how to use light to express what you feel about a subject is by far the most difficult aspect of photography.

In everyday life, we use colors and tones to convey our emotions and feelings. White generally symbolizes purity, black is associated with death, and red may suggest danger, adventure, or excitement. In photography, colors and tones have the power to communicate to the viewer your emotional response to a subject.

A large percentage of photographers who pursue art choose to work in black and white rather than color. Their choice reflects both aesthetic and technical concerns. In black and white, images can achieve a unique balance between the

literal and the abstract; the drama of deep, rich blacks adds power to a photographic statement, and silky white tones lend a lyrical quality. In the hands of a master, these elements can be blended into a memorable message.

In black-and-white photography, tones are relatively easy to control. One way to alter the tones of the natural scene is to use a filter (see chapter 4). Sky tones, usually an important factor in establishing the mood for a photograph, are especially easy to manipulate. In the absence of a filter, a blue sky will be rendered in a very light gray tone by black-and-white film; yellow and green filters will produce a "natural-looking" sky of middle gray tone, and a red filter will lower the tone of a deep-blue sky to pure black.

Your choice of film can affect both the tone and the texture of the image. Some films are designed to produce images of extremely high contrast, meaning that objects are either black or white, with no gray tones at all. These stark images may be appropriate for some scenes. Other films generate extremely grainy-looking images, which have creative possibilities that you may wish to explore (see chapter 4).

Other common ways of altering or controlling print tones include manipulating the exposure and development of the negative (see chapters 4 and 7) and selecting appropriate papers when printing the negative (see chapters 8 and 9).

The Wratten #90 Viewing Filter: An Aid to Visualizing Tones

In black-and-white photography, you need to visualize the tonal relationships between various elements within a scene. Most black-and-white films are almost "color-blind" and respond not to the color of an object but to its *luminance*, or brightness.

The problem of merging tones in an image can lead to many disappointments when you begin to photograph. While you might assume that objects of different colors separated by a considerable distance would be easy to distinguish in a photograph, this is not always the case; in fact, the tones that result from different colors are often identical. As mentioned earlier, a red apple against a background of green leaves presents a clear color contrast to the human eye, but in a straightforward black-and-white photograph (with no filter used), the apple and the leaves will be almost indistinguishable from each other in tone. Therefore, when looking at a scene and trying to visualize it as a black-and-white photograph, you must train yourself to evaluate the luminance of objects (as measured with a light meter — see chapter 6), not their color. In color photography, tonal relationships are not a problem because the color negative (or transparency) records a scene much as you see with your eye.

The Wratten #90 filter, which is deep brown, is effectively able to neutralize colors and instead transmit primarily subject luminance. If you look at a scene and then hold the filter up to your eye, you will get an excellent impression of how it will appear in a black-and-white print. (If you continue to stare through the filter, however, your eye will begin to compensate and you will start to notice colors again.) Used judiciously, the #90 filter can help you to visualize black-and-white tones in the natural world (see figure 10.5).

Polaroid Black-and-White Films as an Aid to Visualization

An inexpensive Polaroid camera loaded with a packet of black-and-white film is an excellent tool for analyzing problems of all kinds in the field. It will provide you with instant feedback and can be an important shortcut to learning the technique of visualization.

You can make effective use of a Polaroid camera as a learning tool by taking it on a trial field trip. Seek out a variety of settings with different color patterns to photograph. Practice looking, seeing, organizing, and visualizing, then take

Figure 5.12: Michael Kenna, *Night Walk, Surrey, England, 1983.* The flare from the streetlamps and the pronounced grain of the film give substance to the atmosphere and enhance the mysterious mood of this image.

Monolith,
The Face of Half Dome,
Yosemite National Park, 1927

At dawn, on a chill April 17 in 1927, my fiancée, Virginia, two friends, and I drove from our home to Happy Isles and began an eventful day of climbing and photographing. I had my 6½ x 8½ Korona View camera, with two lenses, two filters, a rather heavy wooden tripod, and twelve Wratten Panchromatic glass plates.

When we arrived about noon, the face of Half Dome was in full shadow. In early mid-afternoon, while the sun was creeping upon it, I set up and composed my image. I was using a slightly wide-angle Tessar-formula lens of about 8½-inch focal length. I did not have much space to move about in: an abyss was on my left, rocks and brush on my right. I made my first exposure [of this scene] with plate number eleven, using a Wratten No. 8 (K2) yellow filter. As I replaced the slide I realized that the image would not carry the qualities I was aware of when I made the exposure. The majesty of the sculptural shape of the Dome in the solemn effect of half sunlight and half shadow would not, I thought, be properly conveyed using the K2 filter. I had only one plate left, and was aware of my poverty.

I saw the photograph as a brooding form, with deep shadows and a distant sharp white peak against a dark sky. The only way I could represent this adequately was to use my deep red Wratten No. 29 filter, hoping it would produce the effect I visualized. With the Wratten Panchromatic plate I was using, this filter reduced the exposure by a factor of 16. I attached the filter with great care, inserted the plate holder, set the shutter, and pulled the slide. I knew I had an exceptional possibility in my grasp. I checked everything again, then pressed the shutter release for the 5-second exposure at f/22. I carefully inserted the slide and wrapped the plate holders in my focusing cloth for protection against the roughness of the long hike home.

This photograph represents my first conscious visualization; in my mind's eye I saw (with reasonable completeness) the final image as made with the red filter. I knew little of "controls." My exposures were based on experience, and I followed the usual basic information on lenses, filter factors, and development times. The red filter did what I expected it to do. I was fortunate that I had that twelfth plate left!

I can still recall the excitement of seeing the visualization "come true" when I removed the plate from the fixing bath for examination. The desired values were all there in their beautiful negative interpretation. This was one of the most exciting moments of my photographic career. — ANSEL ADAMS

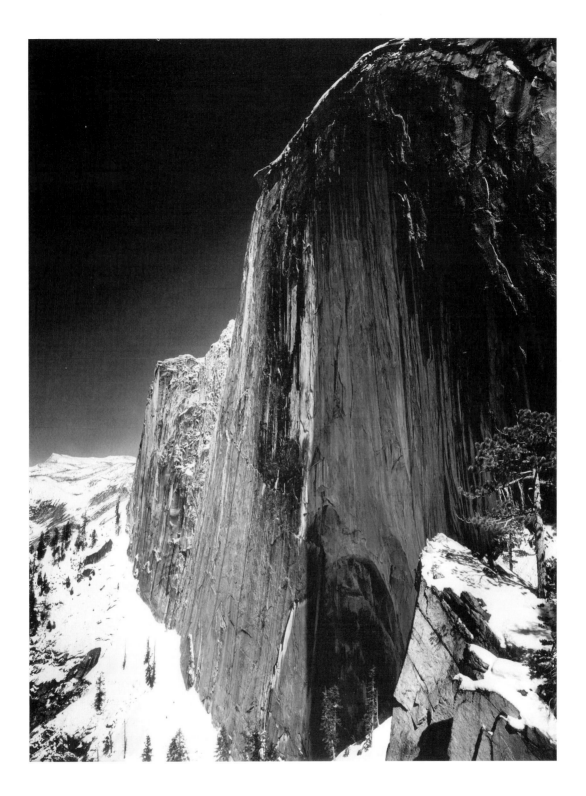

and develop an "instant" photograph. Compare it carefully to the scene before you, and notice how the scene is translated into a black-and-white photograph. Keep detailed notes on how various colors are transposed into tones so you can review the results at your leisure. Use your light meter (see chapter 6) to measure the luminance of important elements in the scene, and note what tones of gray these elements produce in the print.

Comparing Color Transparencies and Black-and-White Prints

If you have access to two 35mm cameras, you can perform the same exercise described above for a Polaroid camera, though it will take longer for you to get feedback. Load one camera with ordinary panchromatic black-and-white film and the other with color slide film (slides are preferable to color prints since prints from color negative film can vary widely in color from the actual scene). Take a field trip and photograph each scene you select with both cameras, then have the two rolls of film processed and compare the results. As always, make careful notes when you take a photograph so that your analysis of your prints or slides will be meaningful.

Using either a Polaroid or two 35mm cameras in the field will hasten the development of your visualization skills. Either one of these approaches should help you begin to see in black and white.

Visualizing Forms and Tones

In Ansel's photograph *Saint Francis Church, Ranchos de Taos, New Mexico,* the church is portrayed as an almost abstract assembly of massive blocks, slabs, and spheres that generate a large number of interesting geometrical shapes. A sense of strength and endurance is conveyed by its stalwart presence. The brilliant sunlight characteristic of northern New Mexico is evident in the almost-white sky; the shadowed areas differ only slightly in tone from the surfaces that are in direct sunlight, reinforcing the mood of enveloping light.

Look closely at the structure of the image. The camera was carefully placed so that the shadowed edge of the far buttressing element on the left side of the photograph would be just visible. Consequently, instead of being silhouetted directly against the sky, the relatively light surface of the near buttress is provided with a sharply defined border. If the camera had been positioned a little farther back, the roof beam jutting into the sky would have visually merged with the edge of the roofline to the left of it. Cover the foreground of the picture with a sheet of paper, and notice how the quality of the image changes when the texture supplied by the sand is eliminated. Try to imagine how the photograph would look if it had been taken from farther away: the church would appear to be a short, squat object, and the visual impact would be quite different.

These thoughts are typical of what should go through a photographer's mind as he or she visualizes an image. Visualization is an interactive process, a mental and emotional dialogue between photographer and subject; other photographers looking at the same subject would make totally different decisions based on their own individual visualizations.

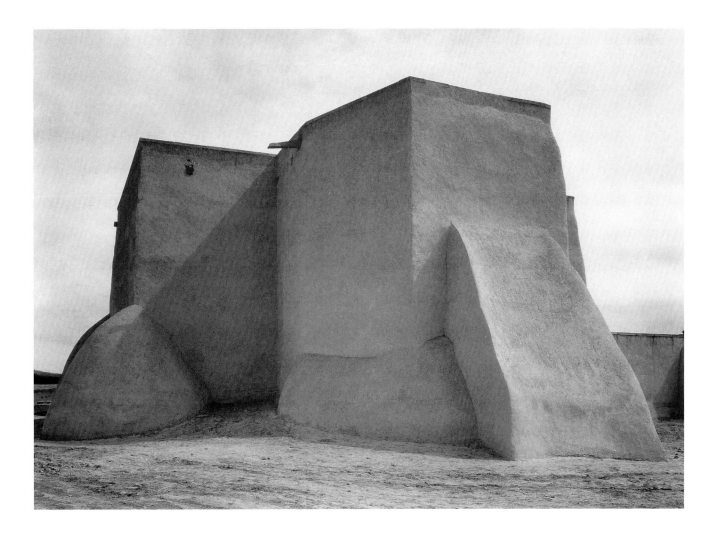

Figure 5.13: Ansel Adams, *Saint Francis Church, Ranchos de Taos, New Mexico, c. 1929.*

Figure 5.14: Paul Strand, *Saint Francis Church, Ranchos de Taos, New Mexico, 1931.* This photograph illustrates another visualization of the same building shown in figure 5.13. Each of us has a distinctive way of responding to visual experiences, and this is reflected in the photographs we make.

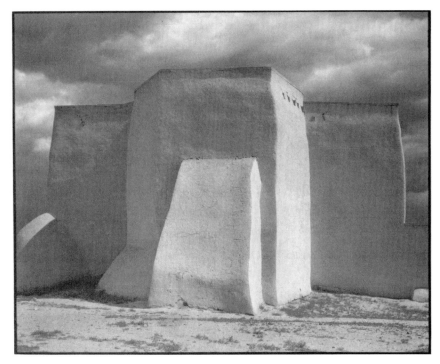

In the case of *Saint Francis Church,* after a careful consideration of the subject, Ansel formed a mental image of the photograph. He then moved the camera into position, chose the appropriate lens, and adjusted the camera to achieve the desired composition on the focusing screen. The positioning of the camera, the choice of lens, and the framing of the image determined the elements of *form* in the photograph. A second set of decisions — which film, filters (if any), and exposure to use, how to develop the film, and how to print the negative — was also made before the photograph was taken. The latter choices determined the *tonal* elements of the photograph.

In *Penitente Morada, Coyote, New Mexico,* the clear sky is a near black tone, and the brilliant sunshine creates contrasts that seem almost harsh. Why should this photograph, taken not too far from Taos, be so different in feeling from the bright and airy image of the church? *Penitente Morada* is clearly more than just a record of an adobe building on a sun-filled afternoon.

The Penitentes are members of a secret religious society who live in an impoverished region of the mountains in northern New Mexico. Their religious rites, especially during Holy Week, include flagellation, suffering, and crucifixion. Few outsiders have been permitted to observe these events. The photograph is as harsh as their lives.

To achieve this image, the camera was positioned to maximize the impression of a two-dimensional world. The angle of the sun emphasizes the cracks in the wall, and the pebbles and stones in the foreground are sharply defined. Neither the door nor the window invites approach. The structural forms are all rectangles within rectangles. Film, exposure (a deep-red filter was used), development, and printing of the negative were all calculated to produce subject tones that would reflect Ansel's visualization of the subject.

Compare this photograph to the previous one. Both images are assemblies of simple geometric forms. The photograph of the church in Taos is a pleasing composition of a variety of shapes; *Penitente Morada* uses a single form. The sky in the Taos image is bright, and details in the shadows are clearly visible; in *Penitente Morada,* the black sky sits on the roof of the building like a lid, and shadow details can barely be made out. There are no important middle-gray tones in the second photograph; objects are either black (or close to it) or white.

Could Ansel have photographed both subjects from the identical positions at the same times and reversed the tonal values of *Penitente Morada* and *Saint Francis Church*? The answer is yes, very easily. And if he had, each photograph would have differed radically in mood from his original visualization of the image. *Penitente Morada* reflects not only the physical scene that confronted Ansel but also his emotional reaction to the subject.

Helping you to learn how to control tonal values through (1) selection of film, (2) the use of filters, (3) exposure, (4) film development, and (5) printing papers and techniques is one of the primary goals of this book, and each of these topics will be explored in detail in subsequent chapters. For the moment, it is sufficient to stress that tones should be visualized and controlled with the same degree of care you use in selecting a subject and deciding how to deal with it physically.

Figure 5.15: Ansel Adams, *Penitente Morada, Coyote, New Mexico, c. 1950.*

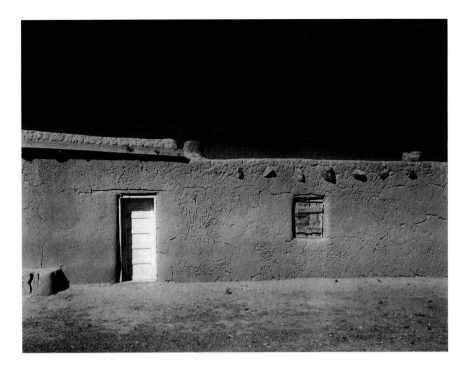

Learning from Other People's Photographs

Beginning photographers often think that because a master photographer photographed a subject in a certain way, that is the way it should always be photographed. In fact, nothing could be further from the truth. The extraordinary thing about life is that each of us sees the world differently, and there are many "right ways" to do things. Photographers are constantly reexploring the same subjects, and each generation brings forth its own visions of the world. Those visions that are most deeply expressive will endure.

Figures 5.16, 5.17, and 5.18 are photographs of Mission San Xavier del Bac, taken independently by three separate photographers over a span of twenty years. Their cameras were all set up within twenty feet of each other, yet the images are very different, and each has a beauty all its own. Although you may be tempted to ask, "Well, which is best?," that is not a legitimate question in the world of art. Each image must stand or fall on its own, and each has its own validity.

Studying the works of fine photographers is a worthwhile pursuit for all photographers. It is comparable to reading the books of accomplished authors if you want to be a writer, or copying masterpieces of painting if you want to paint. The object is not to imitate their works but rather to understand the techniques they used to achieve their results. A useful way to practice visualization at home is to look at a photograph and try to visualize the scene that the photographer actually saw. Try to analyze why he or she chose that particular camera angle and field of view. This exercise will help you when you go out into the field to photograph images of your own.

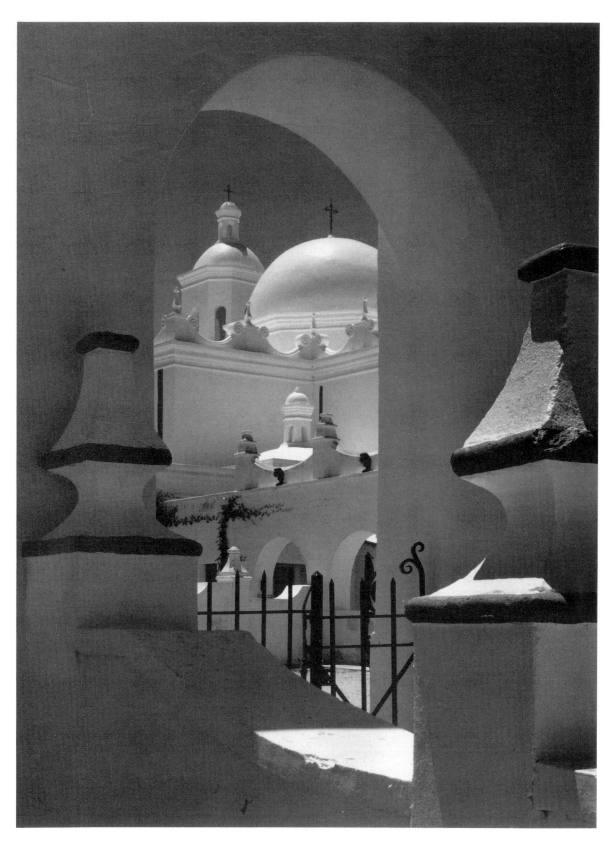

Figure 5.16: John P. Schaefer, *Dome through Arch, Mission San Xavier del Bac, Tucson, Arizona, 1977.*

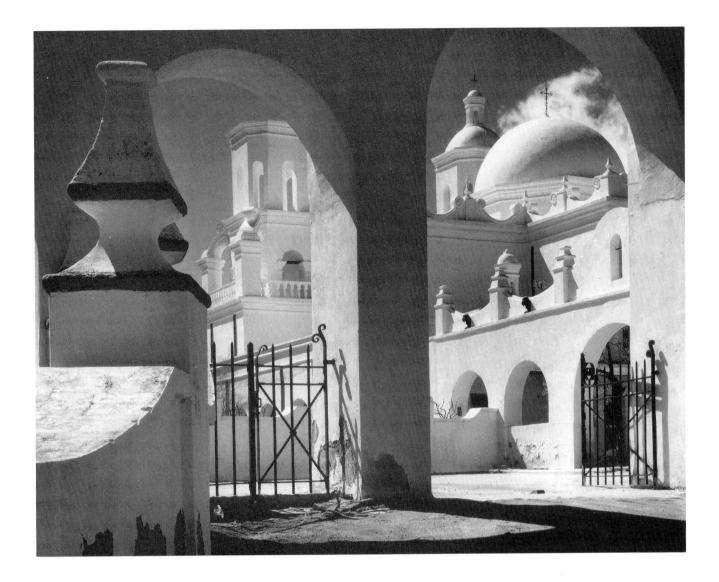

Figure 5.17: Ansel Adams, *Arches, North Court, Mission San Xavier del Bac, Tucson, Arizona, 1968.*

Figure 5.18: Dick Arentz, *Mission San Xavier del Bac, Tucson, Arizona, 1987.*

Practicing Photographic Seeing

I remember seeing, in about 1919, an exciting vista from Baker Beach: a mass of dark cliffs gathering above the shore with a small segment of the ocean horizon beyond. I had no camera but my eye, and no reference to time but the slow passage of the sun. The scene has remained brilliantly fixed in my mind. I often returned with my camera in a futile search for that elusive experience, with hopes for a moment that would justify a photograph. It has taken me a lifetime to recognize when I should not *feel obligated to make a photograph. If I do not "see" an image in terms of the subject and its creative potential at the time, I no longer contest my instincts. In these early years there were glimmers in my mind, such as that experience at Baker Beach, of what a photograph could be.*

Just reading a book about photography will not make you an accomplished photographer. You must practice at every opportunity and refine your craft through trial and error. The most that any text can do is provide you with some useful guidelines that will point you in the right direction and help you solve problems intelligently as they arise — and arise they will!

Figure 5.19: Ansel Adams, *Rock, Merced River, Autumn, Yosemite Valley, California, c. 1962.*

The most effective way of developing your photographic skills is to come up with a project for yourself that will result in a photo essay. Select a subject that you are interested in and that will be easily accessible over the course of several months or, preferably, a year. Possible subjects may include a group of people whom you know well, a school, unusual buildings in your neighborhood, a local park, a forest, or the waterfront — it doesn't really matter what your subject is, so long as it interests you.

Set yourself an objective of creating a portfolio *for yourself* of about two dozen prints that together tell a complete story. Plan to photograph your subject under as many different conditions as possible. Take photographs at various times of day and times of year, do close-ups and distance shots, employ available and artificial lighting, and generally make use of any circumstances that happen to arise. If you find that you have messed up a photograph, go back and try it again until you make a print that matches your visualization of the scene.

By limiting yourself to a particular subject, you will force yourself to think seriously about it and to probe beneath its obvious surface features. Adopting the *project* approach is a vastly superior alternative to wandering around the countryside looking for the occasional inspiring photograph to practice on. The latter usually results in a much longer learning cycle and leads to a series of only marginally satisfying photographs. A self-designed project is a superb means of acquiring useful experience and a technical foundation that you can apply to other settings. In time you will begin to recognize that your photographic skills have evolved, and that you are no longer merely recording the world with a camera but are instead interpreting it sensitively, with the eye of an artist.

Visualization: A Summation

The visualization of a photograph involves the intuitive search for meaning, shape, form, texture, and the projection of the image-format on the subject. The image forms in the mind — is visualized — and another part of the mind calculates the physical processes involved in determining the exposure and development of the negative and anticipates the qualities of the final print. The creative artist is constantly roving the worlds without, and creating new worlds within.

The following sequence breaks down the artistic and craft operations of photography and clarifies their function in visualization. With practice, the entire sequence should become intuitive and quite immediate.

1. Experience the subject and recognize its expressive or illustrative potentials.

2. Try to visualize, or "see," an image, and formulate a general impression of its composition within the format used.

3. Select the appropriate lens by considering the desired image size; if your visualization includes a change of perspective or relative scale, you may have to move toward or away from the subject, or otherwise change camera position.

4. Using a tripod, when appropriate, place the camera in optimum position and compose the visualized image on the ground glass or in the viewfinder.

5. Carefully scan the image *for mergers of line, edge, and texture. Check its borders and corners for possible distracting elements.*

6. Check the image for "readability." Are the important areas of the subject clearly revealed? Do the adjacent values merge, or are they distinctly separate? (Note: In black-and-white photography, two different colors of the same reflective value may blend into the same gray tonality. To check for tonal separation, view the scene through a Wratten #90 viewing filter. This filter will suggest visually how an unfiltered black-and-white panchromatic film will "see" your subject, and what values may merge in a photographic rendering.)

This practice sequence need not involve making an exposure, but should include visualizing the desired black-to-white tonal range of the finished print.

A good photographer develops an ability to look at a subject and recognize which aspects of it might make an interesting photograph. As adults, we usually glance at our surroundings as if we were flipping through a magazine, hoping for an interesting picture or story to catch our eye. Headline writers spend their days trying to compose intriguing phrases that will slow us down and capture our attention even for a moment.

Except for a few scenic lookout points along our highways, the natural world does not advertise its countless wonders. One reason to pursue photography is to create visual headlines, photographs that will catch people's eyes and make them read your story.

The first step in visualization is to *look* carefully at your surroundings and let yourself respond emotionally. You must make a conscious transition from *looking* to *seeing*.

Next, *select* those visual elements that are the heart of the scene. Use a *viewing card* to isolate the essence of what you want to photograph, and measure the distance between the viewing card and your eye to determine what the focal length of your lens should be. Think about which filter — if any — might enhance the tonal qualities of the photograph.

Decide whether the place where you are standing provides the best point of view for the subject. If it does not, consider your alternatives. Be sure your position allows you to *organize* your subject into an interesting visual pattern. Look carefully at the background of the scene, and make certain that in your enthusiasm over the primary subject you have not overlooked any distracting features that will be prominent in a print.

In composing and *visualizing* a photograph, remember to consider the quality of the light and shadows. Try to visualize how the colors and tones of the subject will translate into photographic tones. If you sense that two objects have similar tonal values, even if they are separated by some distance, you may need to move so that their tones will not merge in your photograph.

If near-far relationships or lines, curves, or angles will add to the structural impact of the photograph you are trying to realize, do not hesitate to use them.

When you have made your basic choices about framing the image and decided which lens, filters, and film to use, set up your camera and tripod (when possible) and compose and focus the image on the viewing screen. Look carefully

at the image on the focusing surface and imagine it as a photograph. Make the measurements and decisions necessary to expose the film, and at the decisive moment, trip the shutter. If all has gone well, your visualization will have been completed and a fine photograph will be just a few steps away.

Look, see, select, organize, and visualize, and the rest is simple mechanics — well, almost. These five steps are the most important and most difficult part of photography. If you make a serious mistake at this stage, anything you can do in the darkroom as you develop and print the negative will be merely repair work. It will seldom salvage your image.

The creation of art is the struggle to express emotion effectively and with originality. It is an exploration of the mind, with no map to guide you and a destination that only *you* may recognize when you reach it. Ansel kept the following quote of Albert Einstein's under the blotter on his desk: "Where the world ceases to be the scene of our personal hopes and wishes, where we face it as free beings admiring, asking and observing, there we enter the realm of Art and Science. If what is seen and experienced is portrayed in the language of logic, we are engaged in science. If it is communicated through forms whose connections are not accessible to the conscious mind but are recognized intuitively as meaningful, then we are engaged in art. Common to both is the loving devotion to that which transcends personal concerns and volition."

In creative photography, you must control your camera (and not let it control you) while remaining emotionally receptive and free to respond to your environment. *Control* and *freedom* are clearly opposites, but as you gain experience, the mechanical "control" aspects of photography will become second nature to you and will cease to intrude on your creative process. When you reach this stage, your only concern will be with what you have to say to the world with your camera.

Chapter Six

Determining Film Exposure

Although modern equipment is of remarkable accuracy, the process of determining the ideal camera exposure will always involve a considerable degree of judgment. I can recall seeing Edward Weston, who was not particularly of scientific persuasion, using his meter in rather unorthodox ways. He would point it in several directions, take a reading from each, and fiddle with the dial with a thoughtful expression. "It says one-quarter second at f/32, I'll give one second." His approach was empirical, based on long experience combined with deep sensitivity and intuition, and his extraordinary results speak for themselves. My own approach relies on experience and intuition for the visualization of the image, but I prefer a more methodical system for executing the visualized photograph.

— ANSEL ADAMS

Once you have found a scene that you want to photograph and used the techniques of visualization to isolate an image, you must expose and develop the film. Deciding what aperture to set the lens at, what shutter speed to use, and how to develop the film so that you will obtain a properly exposed negative is not always easy; the decisions you make will manifest themselves in the final print, and your choices must be consistent with your visualization of the scene.

Your first objective in photography should be to create a negative that will lead to an expressive print. Most negatives should have the following characteristics: adequate detail in the *shadow areas* (the darkest tonal values in the print) and *highlights* (the lightest tonal values), and a *gradation* of tonal values corresponding to the *contrast* of tones that you visualized for the print. The latter point is especially important because the success of a print often depends more on the gradation, or continuity, of the middle tones than on the presence of any "pure white" or "pure black."

Negative detail in the shadow areas is controlled almost exclusively by film exposure. *Highlight detail* and *contrast* are controlled by development of the negative and can be further modified during printing.

When you visualize a print, you should give some thought to the exposure, development, and printing of the film. A successful photograph, however, must begin with a negative in which all of the important details of a scene are recorded in such a way that they can be translated into the print you visualized. Minor mistakes in film exposure or small procedural errors in developing can usually be

Figure 6.1: Ansel Adams, *Leaves, Mount Rainier National Park, Washington, c. 1942.*

compensated for during printing, but significant deviations from the "ideal" will result in an unsatisfactory negative, from which it may be impossible to wring a satisfactory print. The key to making negatives of consistently high quality lies in learning how to use a light meter intelligently.

Light Meters

To know what aperture and shutter speed will result in a properly exposed negative, you need to determine the luminosity of the subject you intend to photograph. A light meter (often referred to as an "exposure meter") is a device that enables you to measure light intensity. Photographers have a wide range of models to choose from, from simple to highly sophisticated, but remember: no light meter, however advanced its design, can *think* for you!

The *only* thing a light meter can do is measure the *actual brightness* of an object; it can make *no* assessment of whether the object is light or dark, in deep shade or in bright sun. It is up to you to evaluate and interpret the nature of your subject according to the information provided by the meter. By understanding how light meters work and are calibrated, you will be better able to use them to determine the appropriate exposure for a scene.

Setting Up and Reading a Light Meter

The first step in using a light meter is to key in your film speed. When you purchase film, the ISO, ASA, or DIN value that is printed on the box or included in the insert is the film speed recommended by the manufacturer; as you gain experience, you may find it necessary to modify film-speed values to reflect the characteristics of your particular equipment and your working habits (see chapter 4). With most light meters, you rotate a dial until the appropriate film

Figure 6.2: *Types of Light Meters.* Left to right: The Zone VI Spot Meter, a meter that reads a 1-degree circle. When you input the film speed and shutter speed you wish to use, the readout will indicate the aperture that corresponds to a middle-gray exposure setting. The Luna-Pro digital F meter is a wide-angle light meter featuring a sensitive silicon blue cell that measures the average reflectance over a wide area. The Sekonic Zoom Master L-508 can function as either a spot meter, an incident light meter, or an electronic flash exposure meter and delivers a digital readout with suggested aperture and shutter-speed settings.

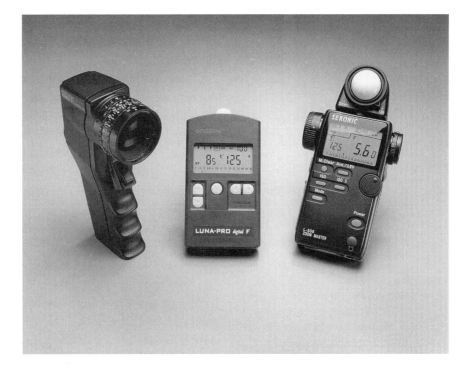

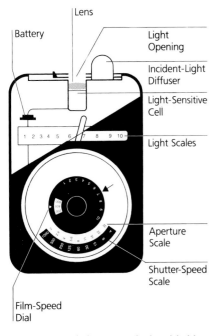

Figure 6.3: *A light meter.* The hand-held meter illustrated here measures the intensity of reflected light. If the domed diffuser is placed over the photocell, the meter can also be used to measure incident light. To make a measurement, you must first input the film speed by rotating the dial until the appropriate value appears in the window. Turn on the meter and point it directly at the object whose brightness you wish to measure; the needle will move across the scale to the corresponding value. Rotate the outer dial so that the arrow lines up with the number indicated by the needle. Any of the matched pairs of aperture/shutter speed will give an appropriate exposure for middle gray. Many meters also display EV numbers in another window, as well as a scale of zones that can serve as a useful reference.

Figure 6.4: *A gray scale.* The patches of tones that make up the gray scale represent the transition from black to white. The tone of each patch differs from that of its nearest neighbors by one stop more or less exposure.

In the illustration, labels read: Battery, Lens, Light Opening, Incident-Light Diffuser, Light-Sensitive Cell, Light Scales, Aperture Scale, Shutter-Speed Scale, Film-Speed Dial.

speed appears in a window or opposite an arrow; with a digital meter, you enter the film speed as a number on a keypad.

A light meter's readout generally consists of a group of aperture/shutter speed pairings of equivalent exposure value, from which you can choose any desired combination. In figure 6.3, the combinations are f/2 and $^1/_{1000}$; f/2.8 and $^1/_{500}$; f/4 and $^1/_{250}$; f/5.6 and $^1/_{125}$; f/8 and $^1/_{60}$; f/11 and $^1/_{30}$; f/16 and $^1/_{15}$; f/22 and ⅛; f/32 and ¼. The total amount of light transmitted by any camera lens would be the same for each of these aperture/shutter speed pairs.

Alternatively, the readout may be an *exposure value*, or *EV*, that you key into your camera lens to lock in the appropriate aperture/shutter speed combinations. In this system, each unit difference in light intensity represents either a doubling or a halving of the adjacent value. For example, an EV reading of 14 indicates a subject brightness twice that of 13 and eight times that of 11 (2 x 2 x 2 = 8). The numbers therefore correspond to stop changes on your camera lens.

The "Middle-Gray" Standard

If you assemble a large and roughly equal number of light and dark objects, the average of all the tones will be *middle gray*. The technical name for this middle-gray tone is *18-percent gray*, since it reflects 18 percent of the light that falls on it. Middle gray, or 18-percent reflectance, is used as a standard in photography and is a key reference point, much as the tone A in music serves as a standard for tuning instruments.

A photographic light meter is calibrated to assume that anything it is pointed at is middle gray. If you set the light meter for the correct film speed and point it at a scene that "averages out" to middle gray, the readout will be an exposure that is *usually* appropriate. The assumption that the "average" tone of an "average" scene—in color or in black and white—will be approximately middle gray is in fact remarkably valid.

The purpose of this book, however, is not to teach you how to make "average" photographs. A light meter should be used as a tool to interpret a scene, not just to measure its average luminosity. What happens, for example, if you point your meter toward a scene that is clearly not "average," such as a snowscape in bright sunlight, or moss in deep shade? In either case, the light meter will indicate an incorrect exposure, since it is programmed to assume that the subject is middle gray. If you take the meter reading at face value, the snow scene will be underexposed and the moss will be overexposed. In the case of the snowscape, the basic assumption that the average of the scene is middle gray is clearly wrong since the average brightness of the snow will be two or three stops greater than

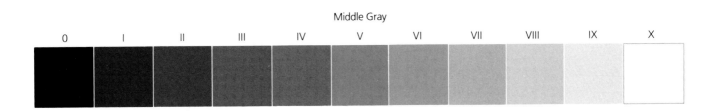

Middle Gray

| 0 | I | II | III | IV | V | VI | VII | VIII | IX | X |

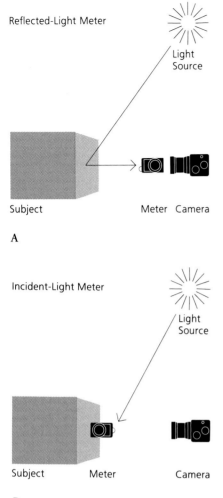

Figure 6.5: *Reflected and incident light.*

(A) The light reflected by a subject is measured with a reflected-light meter, which is directed toward the subject from the direction of the camera. Since reflected light is what we actually see and photograph, such measurements can be more informative and accurate than incident-light readings, provided that metering procedures and pitfalls are fully understood.

(B) Incident light is the light that falls on the subject from one or more light sources. It is measured with an incident-light meter, which is held near the subject and directed toward the camera.

that of a gray card placed in that setting. However, the meter is programmed to respond as if the scene were middle gray, and the indicated exposure will be two or three stops less than it should be. The opposite will be true in the instance of a dark subject in dim lighting. The evaluation and appropriate photographic interpretation of these situations are one concern of this chapter.

Types of Light Meters

There are two basic types of light meters: those that measure *reflected light* and those that measure *incident light.* Each has its own particular uses, detailed below.

Reflected-Light Meters Reflected-light meters are designed to be pointed at the scene from the approximate camera position; they measure the amount of light actually reflected or given off by the subject. Reflected-light meters are far more commonly used in photography than incident-light meters. All meters built into cameras are of the reflected-light type, and all hand-held meters can measure reflected light, though on some this is an option.

Spot meters also measure reflected light, but rather than responding to the average brightness of a large area, they read the brightness of small segments (usually a cone of light covering 1 degree) within the scene. These meters permit you to evaluate the entire range of brightness of a scene. Using one intelligently is the best way to ensure that you expose your film correctly.

Incident-Light Meters Incident-light meters measure the intensity of the light falling on the subject (the incident light). They are available only as an off-camera, hand-held instrument. To use an incident-light meter, you move to or near the site of the subject and, while standing in the same light as it, point the meter in the direction of the camera. (When photographing a distant scene, you cannot use an incident meter to estimate the appropriate exposure unless you are able to find a position in which the lighting is identical to that falling on the subject.) A translucent hemispherical bulb covers the light-sensitive photocell; when light strikes the bulb, it is uniformly dispersed over its surface. The photocell then measures the intensity of the light, and the readout indicates what exposure value you should use.

Since incident-light meters calculate exposure values solely on the basis of the intensity of light falling on the subject, the indicated exposure will be appropriate regardless of whether the subject is sunlit snow or moss in deep shade. The only limitation is that the entire scene must be lit by the *same* source of light. Incident-light meters can be extremely useful in situations where the light can be controlled (in the studio, for example) or the subject is uniformly illuminated. However, for scenes with complex lighting (such as those that are backlit or partly in the sun and partly shaded), incident-light meters are useless.

Some incident-light meters are made to respond to the peak of an electronic flash; these can be especially useful if you take many flash photographs. The readout for this kind of meter will indicate what aperture you should use for the flash exposure.

Estimating Film Exposure

Using the Manufacturer's Guidelines

When you purchase film, the package often includes an insert like the following for Kodak Plus-X Pan Professional Film (ISO/ASA 125):

KODAK PLUS-X Pan Film		
Load and unload your camera in subdued light.		
DAYLIGHT EXPOSURE: Set your camera or meter (marked for ISO or ASA speeds) at 125/22°, or use the exposures given in the table below.		
Bright or Hazy Sun on Light Sand or Snow	1/250	f/16
Bright or Hazy Sun (Distinct Shadows)	1/250	f/11*
Weak, Hazy Sun (Soft Shadows)	1/250	f/8
Cloudy Bright (No Shadows)	1/250	f/5.6
Heavy Overcast or Open Shade†	1/250	f/4

*Use f/5.6 for backlighted close-up subjects.
†Subject shaded from the sun but lighted by a large area of sky.

Figure 6.6: *Using an incident-light meter.* In a scene with contrasting sunlight and shadows, an incident-light meter can give misleading and erroneous readings, as can be seen in figures A and B. In each of the following examples, the photographs were made using the indicated exposure values.

(A) When the meter was placed in an unshaded area, the exposure indicated was $^{1}/_{30}$ second at f/16. At this setting, the negative is slightly underexposed.

(B) A reading taken with the meter placed in a fully shaded portion of the door indicated an exposure of $^{1}/_{30}$ second at f/4. The resulting negative is clearly overexposed.

(C) A reading made in lightly spotted sunlight suggested an exposure of $^{1}/_{30}$ second at an aperture halfway between f/11 and f/16. This is a satisfactory exposure.

(D) A reflected-light reading using the camera's built-in meter indicated the same exposure used in figure C.

These recommendations reflect the experience of decades of use of the film by photographers. *Take the insert along with you whenever you photograph.* These simple guidelines provide a useful check on your light-meter readings and can be extremely helpful if the battery in your light meter fails. If you are photographing outdoors and calculate an exposure that is *very* different from what appears on the film insert, be sure to *recheck* your meter reading — you probably made a mistake somewhere along the way. While using the manufacturer's guidelines for exposure estimation might be considered the most "primitive" means of exposure control, it nonetheless works remarkably well.

A Useful Rule of Thumb

A rule that every photographer should commit to memory is that *in bright sunlight, the normal exposure of a film at f/16 is 1/ISO.* For example, for Kodak Plus-X film (ISO 125), the normal correct exposure in full sunlight should be $^{1}/_{125}$ second at f/16 (or any of the equivalent pairs of camera settings). This rule is a helpful check and can come in handy if you find yourself without a light meter.

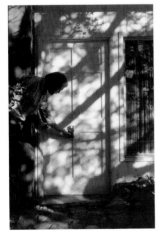

A

B

C

D

Figure 6.7: *Lens markings on a Hasselblad lens.* (a) Distance markings at focal point. (b) Depth-of-field scales. (c) Aperture control ring and settings. (d) Shutter speed control ring. (e) EV numbers.

Hasselblad lenses allow you to rotate either the shutter-speed or the aperture ring to set the lens at the EV indicated by your light meter. The aperture and shutter-speed rings are locked together so that increasing the aperture *automatically* decreases the exposure time (or vice versa), enabling you to select any appropriate aperture/shutter speed pairing in one motion.

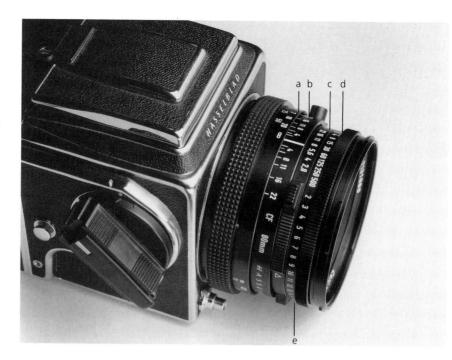

Automatic Exposure Control

Most handheld cameras now feature automatic exposure control, which lets the camera make all the exposure decisions for you. Some photographers argue that automation is the antithesis of creativity and that thinking through exposure decisions is an important process that the photographer cannot afford to neglect. Others maintain, with equal fervor, that allowing the camera's electronic circuitry to make exposure decisions frees the photographer to concentrate on composition. Both arguments have merit.

If you examine a number of photographs taken with the aid of automatic exposure control, you will find that the cameras' electronic circuits have made the correct exposure decisions in the vast majority of cases. Many models now have an electronic chip containing a "library" of more than a hundred different types of lighting conditions. When the camera's lens is focused on a scene, the meter notes both the characteristics and the intensity of the light distribution, compares these to situations in its library of exposures, and programs the appropriate exposure value into the camera's shutter and/or aperture setting(s).

Automatic exposure control is perfectly suitable for the majority of color photographs taken with either transparency or color-negative film. The photographer has very little flexibility in processing these films, so film exposure becomes the key variable in the creation of a fine photograph. In black-and-white photography, however, you will often want to choose exposures and development conditions that vary from the norm so that you will be able to exert control over the *contrast* and *tonal range* of the negative and the print. When control of contrast and tone is important, it may be necessary to use an exposure that deviates from that indicated by the camera's metering system (see pages 179–181).

Using a Reflected-Light Meter

As we chatted, Meg [Margaret Bourke-White] told me that her working method, whenever possible, was to set the shutter at ¹/₁₀₀ second and make exposures with every lens stop from f/4.5 to f/22; one was certain to be perfect! We continued discussing technical shoptalk, though her experience was with the camera, not in the darkroom. Photojournalists rarely do their own negative processing or printing. They are field people, and their basic craft is concentrated on mastering their subjects and applying the sharp visual reporter's eye. For them, photographic image content is the dominant consideration, print quality a distant second.

While package inserts, rules of thumb, and automatic exposure control can be useful, knowledge of how to use a handheld exposure meter is critical to your progress as a photographer. Memorable photographs, especially landscapes, are often the result of lighting conditions that are distinctly "not average." Under these unusual circumstances, normal rules and automation will probably fail to produce the fine, expressive photograph you have visualized.

Reading Middle Gray with Your Light Meter

Since light meters are calibrated to provide readouts corresponding to the reproduction of a middle-gray tone in a print, the easiest way to estimate the proper exposure of a scene is to place a Kodak Gray Card (a card whose surface has 18-percent reflectance) in its midst. If you measure the reflectance of the surface of the gray card with your light meter, the readout will indicate what exposure you should use in most cases. Using a gray card this way is equivalent to and produces the same result as measuring the brightness of the scene with an incident-light meter.

For scenes that have an "average" distribution of light and dark tones, the readout you will obtain if you use a typical wide-angle reflected-light meter to measure the average brightness of the scene will be the same as the exposure value determined by means of the gray card. Since there are times when it is not practical to use a gray card, however (for example, when you are photographing a distant landscape), you should learn how to meter a scene directly to estimate exposure.

There is one distinct advantage in using a gray card with your light meter: the meter will not be influenced by unusually bright or dark areas in the scene that shift the *overall average reflectance* of the scene away from middle gray. If you use the readout from a gray card to determine exposure values, the light and dark areas will automatically be recorded on the film at appropriate density values for reproduction in the print as light and dark tones.

Conversely, the disadvantage of limiting your light-meter readings to a gray card is that there will be times when it will not be effective — for example, when there is backlighting or uneven illumination. When a scene's subject brightness range exceeds seven stops or is very limited (two or three stops), it may be desirable to alter the normal exposure values and development to obtain a suitable negative (see pages 198–201). The surest way to create a negative that will lead to an expressive print is to measure the subject brightness range (SBR) of a scene and base your exposure and development decisions on those values.

When Reflected-Light Readings Will Lead You Astray

Imagine that you are photographing a large checkerboard mosaic pattern of black and white squares. If the mosaic has an equal number of black squares and white squares, the average reflectance will correspond to middle gray. If you were to step far enough away so that your eye could not isolate the individual squares, you would see a uniform gray surface of 18-percent reflectance.

A reflected-light meter reading of the entire mosaic area would average the black and white tones and would be exactly the same as a reading taken from a

A

B

C

D

E

F

G

Figure 6.8: *Using a reflected-light meter.* This sequence of photographs demonstrates the importance of analyzing the characteristics of a subject when using a reflected-light meter and not simply relying on the meter reading. All of the following photographs were made under the same lighting conditions.

(A) This exposure was based directly on the meter reading. The subject averages "middle gray," and the meter reading therefore gives the correct exposure value.

(B) The subject was altered to give a preponderance of black checkers. The exposure was identical to that used for figure A, and the image tones of the two prints are identical.

(C) The reflectance of the subject was measured again, and a second exposure was based on that value. The lower subject reflectance results in a meter reading that leads to *overexposure* — note the loss of highlight detail in the white checkers.

(D) The printing time for the over-exposed negative from figure C was increased, and the background tone was matched to that of figures A and B. The resulting print is indistinguishable from figure B. A small degree of overexposure can often be compensated for during printing of the negative.

(E) The subject was altered once again, this time to give a preponderance of white checkers, and the exposure used for figure A

was repeated. The white, gray, and black tones have the same values as in figure A.

(F) The reflectance of the subject was measured once more, and a second exposure was based on that value. The higher subject reflectance results in a meter reading that leads to *underexposure* — note the complete loss of detail in the black checkers.

(G) The printing time for the under-exposed negative in figure F was decreased, and the background tone was matched to that of figures A and B. While the tonal value of the white checkers is acceptable, the black checkers show no useful tonality. Serious underexposure cannot be compensated for during printing of the negative.

gray card held against the mosaic. An exposure based on either reading would result in a negative that when printed would reproduce the checkerboard pattern of alternating black and white tones.

If the pattern of the mosaic were altered so that there were many more black squares than white ones (with no corresponding change in lighting), the average reflectance of the surface would decrease in proportion to the number of black squares added. A reflected-light meter would give a lower reading (based on an accurate observation and measurement), indicating that you should increase the exposure for the mosaic. This increase, however, would clearly be wrong, since the reflectance of individual squares within the mosaic would not have changed, and the exposure should be independent of the number and distribution of tones among neighboring squares. A negative exposed with settings based on a reflected-light reading of the newly patterned, disproportionately black mosaic would be overexposed, with the black squares appearing as gray tones.

If you were to take a reading from a gray card placed before the new mosaic, on the other hand, you would find that the suggested exposure settings would be the same as they were in the first case. A negative exposed with the same settings as before would produce a print that mirrored the new scene.

If you reversed the experiment and arranged the mosaic so that there were far more white squares than black ones, a reflected-light meter would indicate that the average reflectance of the mosaic had increased (which would be true) and that you should allow less exposure. That conclusion would also be wrong, since the reflectance of the individual black and white squares would, once again, remain the same. If you were to use the exposure settings indicated by the meter, your negative would be seriously underexposed. A gray-card reading would confirm that the intensity of illumination had not changed, and that the exposure should again be the same as in the first example.

The point of this discussion is to reemphasize that a light meter *always* assumes that it is reading an average subject, with a reflectance of 18 percent, and that the print you want will average out to a middle gray. If the *distribution* of tones within a scene is not average, the meter will not compensate, and your judgment must come into play.

A Closer Look at Print Tones: The Zone System

The Zone System is a framework for understanding exposure and development and visualizing their effect in advance. Areas of different luminance in the subject are related to exposure zones, *and these in turn to appropriate* values *of gray in the final print. Thus careful exposure and development procedures permit the photographer to control the negative densities and corresponding print values that will represent specific areas, in accordance with the visualized final image.*

If you think about the implications of the experiment with the black-and-white checkerboard, you will be forced to conclude that the only sure way to use your light meter to determine proper exposure is to consider individual print tones. For convenience, the standard gray card clearly serves as a useful reference.

Shortly after light meters became readily available to photographers, in the 1930s, Ansel began to experiment with ways of using them to obtain negatives

that captured the images he had visualized. Recognizing that negative densities (and, therefore, print tones) were controlled by both film exposure and film development times, Ansel worked out a method of exposure and development control that came to be known as the *Zone System*. In Ansel's hands the Zone System became a tool that helped him to create many of his most memorable images.

> *Experience enhances intuition, and if the intuition is strong and bravely realized, the artist is in a most favorable situation. The price of trial-and-error training is high in time and energy. In my own experience I worked on an uncertain empirical basis until I began teaching and developed the Zone System. But Stieglitz, Edward Weston, Brett Weston, and most of the photographers in history progressed most handsomely without the system. I am convinced that if such a technical approach had been available in their time, their craft problems would have been simplified. No one will ever know. As Brett [Weston] states, "I am a primitive. Ansel is a scientist." This is an overgeneralization. I am not a scientist. I consider myself an artist who employs certain techniques to free my vision.*

There are three closely linked and basic parts of the Zone System: (1) measuring the subject brightness range; (2) determining the exposure; (3) developing the film for the appropriate duration. To understand the principles behind the Zone System, you must first take a closer look at the relationships between subject brightness, film exposure, development time, negative densities, and print tones.

Negative Densities and Print Tones

When you expose and develop film, you are left with a negative image of the subject — that is, an image in which the light and dark values are the reverse of those in the scene that you photographed. When you make a print of the negative (see chapter 8), the image is reversed once again, so that the tonal values of the print correspond to those of the original scene. The relationship between the print tones and the luminosity of various parts of the original scene will depend upon (1) the characteristics of the printing paper you use; (2) how the negative is printed; and (3) how the film has been exposed and developed.

In order to eliminate the first two variables, all of the prints discussed below were made on the same type of printing paper and were printed in the same way. The following experiment is one that you should try yourself. You will need a camera, a light meter, and a notebook and pencil.

Find an evenly lighted surface with a slight texture, such as a concrete wall, a closely woven fabric, or a section of screen with a gray backing. Use your light meter to measure its reflectance: move close to the subject and point your meter directly at it, but be sure not to cast a shadow on the area you are metering. Affix your camera to a tripod, focus the lens on the surface you metered, set the camera controls to one of the indicated aperture/shutter speed pairings, and make an exposure. In your notebook, create a chart similar to table 6.1 and write in the aperture and shutter speed you used opposite Zone V.

Next, advance the film and reduce the exposure by one stop at a time, making exposures that correspond to Zones IV, III, II, I, and O and recording the aperture and shutter speeds for each. Now proceed with increased exposures, beginning with Zone VI (one stop more than the Zone V exposure) and continuing through Zone X. To span the range from Zone O to Zone X, you may need to vary both shutter speed and aperture. A typical series of exposures will resemble the sequence recorded in table 6.1. (Your particular values will depend on the subject brightness and your film speed.)

Figure 6.9: *A textured surface exposed on Zones O through X.*

O

I

II

III

IV

V

VI

VII

VIII

IX

X

Table 6.1

**The Zone System:
Sample Exposure Series**

Zone	Shutter Speed	Aperture
O	$^1/_{1000}$	f/8
I	$^1/_{500}$	f/8
II	$^1/_{250}$	f/8
III	$^1/_{125}$	f/8
IV	$^1/_{60}$	f/8
V	$^1/_{30}$	f/8
VI	$^1/_{15}$	f/8
VII	$^1/_8$	f/8
VIII	$^1/_4$	f/8
IX	$^1/_2$	f/8
X	1	f/8

Note: In this data set, the aperture was kept constant and shutter speeds were varied. It is important to expose the film over a range of shutter speeds where reciprocity failure (see page 195) does not occur (see the film insert for this information). Another way of generating the same data set is to keep the shutter speeds confined to a narrow range and vary the lens aperture.

The exposed film was developed following the procedure recommended by the manufacturer (see chapter 7 for details on how to develop film). The exposure time for printing the negatives was adjusted so that the print tone for the Zone V negative would correspond to middle gray. All of the other negatives were then printed under the same conditions. A set of typical results is illustrated in figure 6.9.

To recapitulate, a light meter is calibrated to assume that whatever it is pointed toward is middle gray. The subject was metered, the exposure that we identified as Zone V was based upon the meter reading, and the film was exposed and developed to produce a negative. The Zone V negative was then printed to match the tone of a gray card. For the purposes of this experiment, we assumed that the film speed and development time recommended by the manufacturer were correct. By metering an object as a Zone V brightness value and subsequently printing it as middle gray, we fixed the tonal scale of the entire array.

The Scale of Zones　The group of prints shown in figure 6.9 contains a good deal of information about exposure and print tones. It is obvious from an inspection of the prints that *reducing exposure of the film produces a darker print value* (note print value IV) and that *increasing exposure results in a lighter print value* (note print value VI).

Once a Zone V exposure has been fixed, we define a one-stop exposure change as a change of one zone on the exposure scale, and the resulting gray of the print is considered to be one *value* higher or lower on the print scale. Thus, metering a subject and then reducing the exposure by one stop will give a Zone IV exposure and a Value IV print tone. Conversely, increasing the exposure by one stop will result in a Zone VI exposure and a Value VI print tone.

Dynamic and Textural Range　In figure 6.9, the scale of print values is centered around Value V, which matches the 18-percent-reflectance gray card. If

you look closely at Values IV and III, you will see that the texture and details are clearly visible. In Value II a sense of "substance" remains, but structural details are no longer obvious. Value I is nearly full black, with almost no impression of substance or texture, and Value O is the maximum black the printing paper can produce: no detail or texture is present.

A similar progression can be observed for the lighter print values. Values VI and VII show well-defined texture and details. Value VIII is quite light but still has a slight sense of texture and substance, while Value IX is nearly pure white. Value X exhibits the pure white of the paper base.

Ansel subdivided the total range of exposures that can be printed into three categories. The *full range* of tones from black to white is represented by Zones O to X. Within this span lies the *dynamic range*, consisting of the effective values for conveying "information" (Zone I through Zone IX). Zones II through VIII convey qualities of texture and substance and are called the *textural range*.

Zone:	O	I	II	III	IV	V	VI	VII	VIII	IX	X

◄·················· full range, pure black to pure white ······················►

◄·························· dynamic range ·························►

◄················ textural range ··················►

Ansel considered the negative density obtained with a Zone I exposure to be the lowest *useful* density for making a print. It is possible to see and measure slightly lower negative densities on film, but they have no practical value since they result in tones that cannot be distinguished from pure black in the print. Negative densities for zones higher than X (XI, XII, XIII, and so forth) can be recorded on film and often show considerable tonal separation on the negative. These special situations require unusual negative processing and/or printing techniques if the values are to be represented as distinct tones in a print.

Print Tones and Subject Brightness In conventional photographic situations, the subject is not a surface with a single luminance value but a scene containing a range of brightness values. To understand how the experiment described above relates to typical photographic subjects, consider the following.

In the procedure illustrated by figure 6.9, the negatives were made by photographing one subject and varying the exposure of the film by altering the exposure time (or, equivalently, altering the aperture). It follows from the exposure formula, also called the reciprocity law —

Exposure = Light Intensity x Time

— that the identical results could have been achieved by using a single aperture/shutter speed combination and varying the intensity of the light reflected from the subject's surface.

To demonstrate this, you could control the intensity of an artificial light source by means of a voltage regulator (essentially the same thing as a light dimmer control) and make a series of stepped exposures in which the light intensity is doubled for each new photograph. The Zone V exposure should correspond to a light intensity near the middle of the range you can achieve. A

typical data set from this kind of experiment would look like that in the chart below. If you were to develop the film and print the negatives so that the print value of the Zone V exposure was middle gray (and assuming that you used the same printing conditions for all of the other negatives), the array of prints would be identical to that shown in figure 6.9!*

Relative Brightness:	½	1	2	4	8	16	32	64	128	256	512
Zone Designation:	0	I	II	III	IV	V	VI	VII	VIII	IX	X
Print Tone:		Almost Black				Middle Gray				Almost White	

From an examination of the sequences in this chart, it is apparent that Zone VI is twice as bright as Zone V ($32/16 = 2$). Similarly, Zone VII is four times as bright as Zone V ($64/16 = 4$), Zone IX sixteen times as bright as Zone V ($256/16 = 16$), and Zone II is one-eighth as bright as Zone V ($2/16 = 1/8$). Note how this sequence once again parallels the controls on your camera lens for both shutter speed and aperture.

What this and the previous experiment show is the following: once you have decided which reflectance level in a scene is your Zone V exposure, the negative densities (and, therefore, the subsequent print tones) of all other reflectances will fall into place relative to Zone V.

Reference Print Tones of Typical Subjects

If you analyze black-and-white prints, you will usually find that most commonly recognizable objects have distinctive print tones that fall within a relatively narrow range of values. For example, most photographers will print average sunlit Caucasian skin as a Zone VI tonal value, average dark foliage as a Zone IV tonal value, textured snow in sunlight as a Zone VIII tonal value, dark but textured surfaces as Zone III values, and so forth.

Table 6.2, a summary of how typical subjects normally appear as print tones, can serve as a useful guide when you begin to work with a spot meter.

Using a Tone Other Than Middle Gray As a Reference

Since negative densities and print tones in a photograph correspond to the relative reflectance of elements in the scene that was photographed, the moment you fix middle gray (Zone V) — or any other single tonal value — all of the other tones in the scene will fall into place according to their *relative* brightness. An alternative — *and the soundest* — approach to metering a scene is to decide, as you visualize the image, what tone a specific object within the scene should have in a print, and then use that tone to calculate your exposure.

*If you want to try this experiment, connect a floodlamp to a voltage-regulating device and measure the reflectance of the subject with the lamp at its brightest setting. Use the voltage control and reduce the light intensity until the reflected-light meter reading is *five* stops less than the value shown at the lamp's brightest intensity; use that value for your Zone V exposure. Next, vary the exposure by halving or doubling the light intensity (the aperture and shutter speed should remain constant) until you have covered the range from Zone O to Zone X. For the set of figures labeled "Relative Brightness," Zone I has been set at one unit of illumination, corresponding to the minimum level of exposure necessary for the film.

Table 6.2

**The Zone System:
Print Values and Tones**

Print Value Range	Zone	Description of Print Tone
Low Values	0	Total black in print. No useful density in the negative other than film base plus fog
	I	Effective threshold. First step above complete black in print, with slight tonality but no texture
	II	First suggestion of texture. Deep tonalities, representing darkest part of image where some slight detail is required
	III	Average dark materials and low values showing adequate texture
Middle Values	IV	Average dark foliage, dark stone, or landscape shadow. Normal shadow value for Caucasian skin in sunlight
	V	Middle gray (18-percent reflectance). Clear north sky near sea level as rendered by panchromatic film, dark skin, gray stone, average weathered wood
	VI	Average Caucasian skin value in sunlight or artificial light. Light stone, shadows on snow in sunlit landscapes
High Values	VII	Very light skin, light-gray objects; average snow with acute sidelighting
	VIII	Whites with texture and delicate values; textured snow; highlights on Caucasian skin
	IX	White without texture approaching pure white, thus comparable to Zone I in its slight tonality without true texture. Snow in flat sunlight
	X	Pure white of the printing-paper base; specular glare or light sources in the picture area

Suppose, for example, you were photographing some weathered wood that you visualized as a dark but fully textured print tone, equivalent to a Zone III value. You could take a meter reading of the wood, keeping in mind that the suggested exposure would correspond to a Zone V *placement* of the subject brightness because a meter always assumes that the object it is pointed at is middle gray (Zone V). Since a Zone III tone is two steps darker than a Zone V tone, you would decrease your exposure to two stops below that indicated by your light meter, thereby lowering the density values of the negative and the consequent tonal values in the print by two steps.

To take another example, if you were photographing a snow scene, you would probably visualize the snow as a barely textured white, comparable to a Zone VIII print value. If you metered the scene, your light meter would give you

the exposure required to render the snow as a middle gray (again, corresponding to a Zone V placement). You would then need to increase that exposure by three steps to ensure that the snow would be printed at a Zone VIII print value. The reason so many snow and beach scenes look "gray" is that the photographer accepted the meter reading at face value and underexposed the film.

Keep in mind that whenever light or dark values in a scene are used to determine the exposure, all of the other values will fall relative to their relationship to the reflectance of the placed value.

Print Tones and the Use of a Spot Meter

Silverton, Colorado is an example of a print with a full range of print tones from black to white. In the illustration the tonal scale of print values is analyzed in terms of spot-meter readings made at the scene. If you had been standing next to the place where the camera was set up with a spot meter in your hand, it would have been easy to take readings of selected elements within the scene. If you had used the distant forest as a reference reading — that is, if you had placed the reflectance of the forest on Zone V — and then measured the reflectance of the white church in the foreground, your meter would have indicated a two-stop difference in settings, corresponding to the two-zone difference in subject brightness. Similarly, if you had measured the brightness of an average area of the foreground fence, you would have found that it was two stops darker than the forest, or two zones lower. You could have gone on to measure the brightness values of all of the important areas of the scene in the same way. At some point you would have realized that the exposure value indicated by your light meter when you spotted it on the distant forest would be an appropriate one to use, since that would necessarily place the negative density of the forest on Zone V. It would also mean that the facade of the church would fall on Zone VII and that the fence would fall on Zone III, resulting in suitable print tones for those elements of the subject. As soon as you *place* one element of a scene on any zone, the other elements will automatically *fall* on the zones appropriate to their relative brightness.

Another way to approach the exposure determination for this scene would have been as follows. The facade of the church is a very light gray; you would visualize it as a Zone VII value in a print. To find the proper exposure, you would take a meter reading of the church (this will now correspond to a Zone V exposure value, since meters treat everything as middle gray) and then give an additional two stops of exposure above the settings indicated by the meter to place the facade on Zone VII. The exposure value and camera settings would be identical to those obtained by measuring the reflectance of the forest and letting it correspond to a Zone V value.

Still another alternative would have been to measure the reflectance of the fence (considered to be a middle gray by your meter), assign it a Zone III print value, and reduce the exposure setting indicated by the meter by two stops. Each of the three metering procedures described would have led you to exactly the same exposure value (aperture and shutter-speed settings) for the scene.

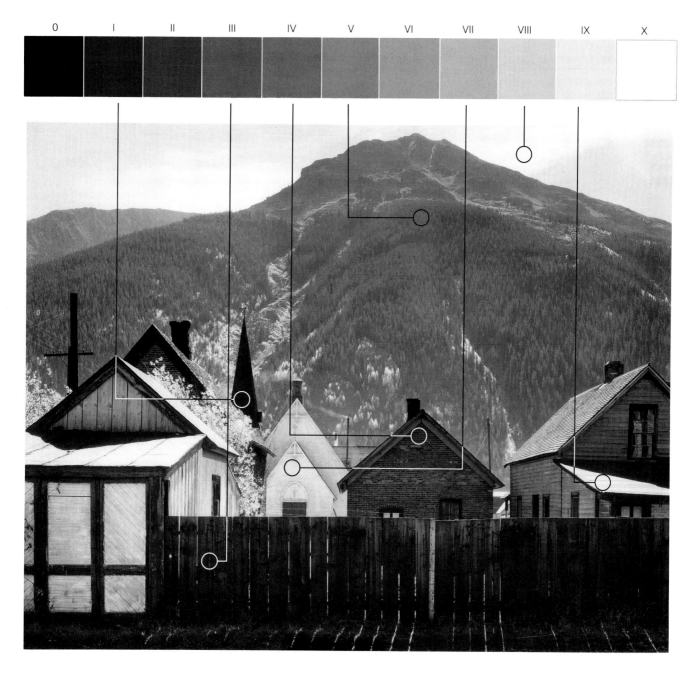

Figure 6.10: Ansel Adams, *Silverton, Colorado, 1951*. A useful illustration of exposure zones and their corresponding print tones.

When you visualize a scene in terms of print tones, it is a relatively simple matter to determine the correct exposure, since once you measure the reflectance of any tone in the scene and assign it to a particular zone, all of the other tones will automatically be fixed in relation to it.

If you had used a wide-area handheld meter to measure the average light intensity for *Silverton, Colorado,* would it have indicated the same exposure value? Maybe or maybe not! The sky is very bright; if the meter had picked up too much skylight, you could easily have underexposed the scene by one or two stops. The result would have been a negative that failed to record any details of the fence or darker surfaces of the scene.

El Capitan, Winter Sunrise, Yosemite National Park, 1968

Getting up at dawn on a winter morning and driving around Yosemite is a chilly but wonderful experience. Arriving at the classic El Capitan viewpoint, I found the subject tremendously exciting. The snow was deep under foot, and it is not easy to get the tripod securely placed in such conditions; if the legs are not pressed through the snow to the ground or firm lower levels of snow and ice, they may slowly settle and move the camera out of position.

The clouds were swift-moving, and I made a series of exposures. There is no way one can anticipate accurately the positions of such wreathing vapors; one situation appears worthy of an exposure — and then appears another situation that seems even better. I made about six exposures on the film remaining in a Kodak Tri-X pack, then turned to the Polaroid Type 55 P/N material. I made several more exposures, feeling that I had really accomplished something. After processing, I found that all the exposures were acceptable, but two were of exceptional moments of the ever-changing scene.

The mood of the scene was dramatic and called for a deep-valued image — a literal rendition of values would not do at all! While the illumination was less contrasty than such a scene usually is, it was decidedly not soft. The Polaroid Type 55 negative has a shorter exposure scale than conventional film, and therefore higher effective image contrast. There is no control in processing, and only preexposure will help reduce contrast under certain conditions. The image reproduced here is from a Polaroid negative, which had the best cloud-cliff relationship and fine tonal values.

A viewer once asked me about the values: "Don't you think the trees are rather dark?" Black-and-white photography gives us opportunity for value interpretation and control. In this instance, were the trees lighter in value, the glow of light on the cliff would, for me, be far less expressive. However, other photographers might well make quite different images. I would not like anyone to think I believe this image to be the only one possible, but it fulfills my visualization at the time of exposure. In an overpowering area such as Yosemite Valley it is difficult for anyone not to make photographs that appear derivative of past work. The subjects are definite and recognizable, and the viewpoints are limited. It is therefore all the more important to strive for individual and strong visualizations.

— ANSEL ADAMS

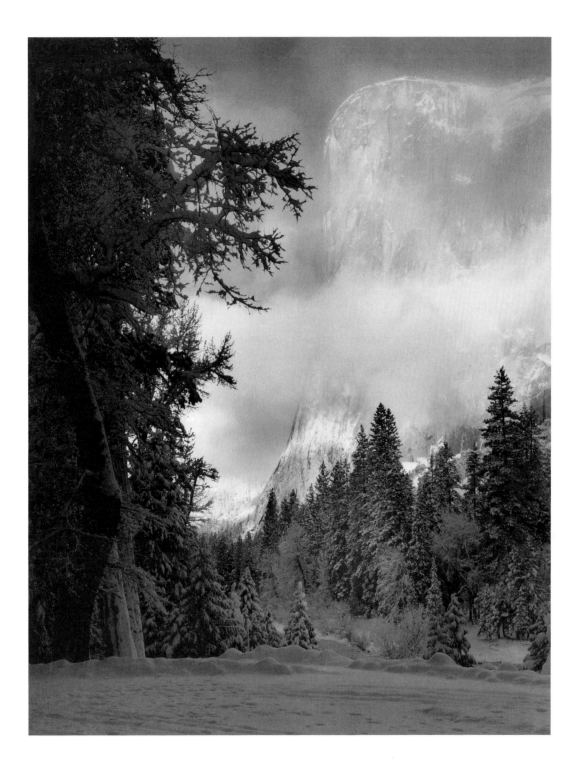

Light Characteristics and Metering Problems

Photography was conceived in natural light. Our visual reactions to the world about us are tied inexorably to the experience of the ages; by the process of evolution and adaptation our eyes have come to serve as instruments of perception and in some measure of interpretation, strengthening by association the other sensory impressions. Not only are objects perceived by daylight, but they are interpreted according to the direction, the intensity, and the color of the light. Hence the perceptual realities of the world largely depend upon the qualities of natural light.

Photography is a language, and light is its vocabulary. A photographer's task is to interpret the world in symbols of light. These symbols are combined into messages that are read and recorded on film, then shared through the photographic print or transparency.

Light has an extraordinary ability to create "moods." Dark, overcast days are characterized as dreary or depressing, while a brilliant, sun-filled morning makes us eager to get out and greet the world. Displays of light during spectacular thunderstorms are awesome. With no lightning — just thunder and rain — storms might still be impressive, but much of their fascination would disappear.

To create an expressive photograph, you must do more than simply record the light your camera sees. You need to be aware of the quality of the light around you, and you need to interpret it through exposure and development controls so that your photograph will convey the mood of the scene that helped to shape your visualization.

Types of Lighting and Their Effects

Beyond performing the obvious task of illuminating a subject, light also plays a more subtle role in helping the eye to define shape and texture. Try these simple experiments.

Figure 6.11: Ansel Adams, *Metamorphic Rock and Summer Grass, Foothills, the Sierra Nevada, California, 1945.* An example of front lighting.

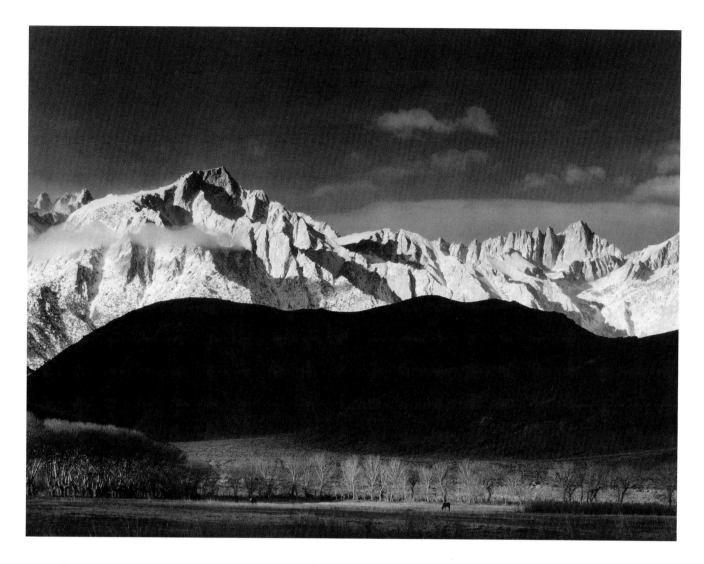

Figure 6.12: Ansel Adams, *Winter Sunrise, The Sierra Nevada, from Lone Pine, California, 1944.* An example of side-lighting.

Front Lighting Turn your back to a light source such as a tungsten or fluorescent light. Extend your arm and let the light fall full on the palm of your hand. Allow your fingers to curl a bit. You will see lots of surface detail, but you will get little sense of texture. Shape is defined mainly by outline because shadows are minimal. This type of lighting is referred to as *axial* or *front lighting*.

Front lighting is often characterized as being "flat"; it has the quality of being informative but unemotional. Photographs taken with a flash attachment frequently fall prey to this criticism. Flash photography can create a stark mood that is unintentional, especially when the negative is overexposed.

Scenes featuring axial or front lighting are simple to meter for exposure because their subject brightness range, or SBR, can be easily recorded on your film and printed on normal-contrast paper. A reading taken with a gray card or a wide-area reflected-light meter will usually result in a satisfactory exposure.

When a curved surface is illuminated and photographed with front lighting, the edges of the object will appear to be darker because most of the light is reflected away from the lens axis. This is known as the "limb effect." Consequently, a white object such as an egg photographed against a white background will be clearly visible. Edward Weston put the "limb effect" — no pun intended — to creative use when photographing nudes on white beach sand.

Figure 6.13: Alan Ross, *Egg in axis light, 1998.* This was taken with afternoon sun on the camera axis; the shadow of the camera was within about 1 inch of the base of the egg. The background was white mounting board of almost similar brightness value. Contrast was exaggerated by reduced exposure and prolonged development.

Forms are revealed by a variation of line and surface reflections rather than by variations of light and shade. The "limb effect" can be enhanced by reduced exposure and prolonged development of the negative.

Sidelighting Now make a quarter turn of your body so that your hand is lit from the side. Slowly rotate your wrist and watch how the shadows help to define the lines and folds of your skin. Note how the gradations of shade add dimension to the shape of your fingers, bringing their edges into sharper focus. This relationship between light source and subject is referred to as *oblique lighting* or *sidelighting.*

Sidelighting usually enhances the visual impact of a subject. Morning or evening light glancing across a scene at a severe angle often creates a mood that is lacking in the flat light of midday. Much of the visual appeal of figure 6.12, Ansel's photograph *Winter Sunrise*, would have been lost if the sun had been directly behind the camera, thereby removing all shadows from the distant snow-covered peaks.

Scenes with strongly contrasting lighting can present metering problems: the subject brightness range will require careful placement of the shadow areas to ensure that all important details are recorded on the negative. You may also have to adjust the development conditions for the film to avoid ending up with unmanageably dense highlight areas in the negative.

Backlighting Next, face the light and move your hand until it shields your eyes from the light source. The outline of your hand will be sharply defined. Unless there is a considerable amount of reflected light, you will be unable to make out surface details. Any hair on your hand or arm will seem to "glow" like a halo. This is known as *backlighting.*

Backlit scenes are usually dramatic, but they also present a challenge for the photographer. If you base the exposure on the shaded surfaces of objects in the foreground, the background will be grossly overexposed and may print as pure white. Conversely, if you meter the background to determine your exposure, it is likely that the shaded surfaces will be underexposed and will appear as silhouetted objects in a print. You must decide whether to choose one extreme and interpret the scene in that way (rather than trying to capture the exaggerated SBR on film) or to strike a compromise and sacrifice a bit of texture at both ends of the exposure scale in order to obtain an effective photograph.

In circumstances where it is important to capture details in both the foreground and the background (for example, in an indoor portrait that features a window providing outside light), it is generally better to use a fill-in light to build up brightness in the foreground than to resort to unusual exposure or development conditions. If the former alternative is not possible, you will need to give the scene one or more stops more exposure than "normal" and develop the film for a shorter-than-normal time (see the following section).

Figure 6.14: Alan Ross, *Pampas Grass, 1979*. An example of backlighting. The exposure was determined by placing the illuminated grass on Zone VII–VIII and letting the background fall to approximately Zone I–II. Normal development was given and slightly higher-than-normal contrast filtration was used to print the image.

Diffuse Lighting There is one other type of lighting that you will often encounter. On an overcast day, in a patch of fog, or in a typical modern office lit by banks of fluorescent lights, the light is directionless and enveloping, and shadows are minimal. This is termed *diffuse lighting*.

Diffuse lighting minimizes the problems of metering and making exposure determinations. Measurement of either the reflectance of a gray card or the average reflectance of the scene will usually result in appropriate exposure settings. The major difficulty with diffuse lighting is that prints can look drab because of the low contrast. If you increase the contrast of the print by developing the negative for a longer-than-normal time, you can add a rewarding brilliance to an image that might otherwise escape notice.

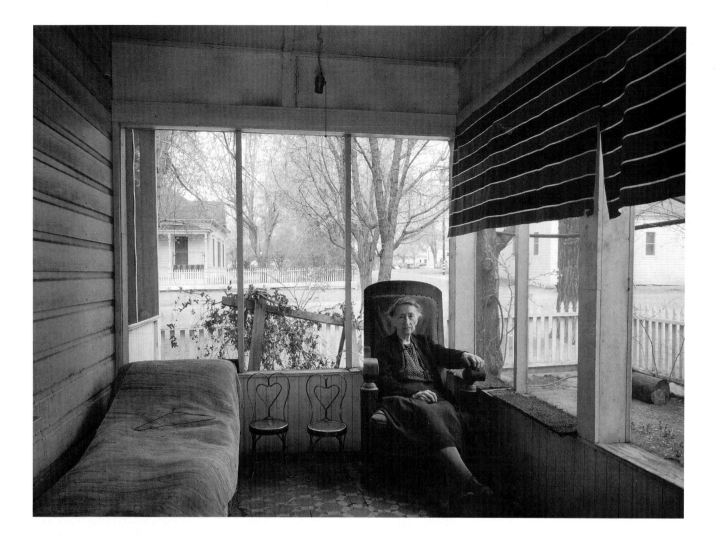

Subject Contrast and Exposure Considerations

Figure 6.15: Ansel Adams, *Mrs. Gunn on Porch, Independence, California, 1944.* This is an example of an image with an extended subject brightness range. To hold the values in both the shadows and the highlights, the negative was exposed to favor the shadows and processed using reduced development.

Low-Contrast Subjects

Scenes with low contrast (that is, a subject brightness range limited to four zones or less) pose the fewest exposure-determination problems for the photographer. *Leaves, Mount Rainier National Park, Washington* (figure 6.1) illustrates a subject with a limited SBR, typical of the range you will encounter in shade or with flat lighting.

For subjects with a narrow subject brightness range, several different exposures could be used without sacrificing shadow detail or separation of tonal values. For example, for a subject in deep shade, such as *Leaves*, if you used a wide-area meter to measure the overall brightness of the scene, the indicated reading would result in a negative containing all of the desired details. If you photographed the same scene using one stop less exposure, there would probably still be enough detail on the negative that a print made from it would be virtually indistinguishable from the first. If, alternatively, you gave the film one or two stops more exposure, in either case the negative would produce a print that would also be comparable to the "correctly" exposed negative. You would merely have to adjust the printing time to accommodate the overall density changes in the negatives.

Low-contrast subjects with limited SBRs offer considerable latitude for exposure variation and error. However, *in order to obtain optimum image quality, you should use the minimum exposure necessary to record all important shadow details.*

High-Contrast Subjects

With high-contrast subjects, there is *no* exposure latitude; both underexposure and overexposure will produce an unsatisfactory negative. *Pohono Bridge* (figure 6.16) illustrates a scene with a wide subject brightness range; meter readings of the extremes of shadow and sunlight indicated a range of seven zones. In such a situation, if you were to place the shadow area on Zone III to ensure adequate representation of details, the lightest part of the image would fall on Zone X and would print with no detail at all. If you placed the brightest areas on Zone VIII or slightly less, the shadowed regions would fall on Zone I or less and would also

Figure 6.16: Alan Ross, *Pohono Bridge, Yosemite National Park, 1993.* Scenes with deep shadows and strong highlights are among the most difficult to photograph and print. Less-than-normal development was used to reduce negative contrast, and the photograph was printed using the lowest-possible contrast filtration with Ilford Multigrade paper. Significant burning-in of the bright sunlit patches was required.

A B

Figure 6.17: Ansel Adams, *Two Trees, Yosemite Valley.* These examples show the effect of preexposure. (A) The tree trunks were placed on Zone III, and the earth in the foreground fell on about Zone V. (B) Preexposure was given on Zone III. The low values of the tree trunks are definitely improved. The middle values, with complex textures, appear somewhat lighter, mostly because the small dark areas within them are affected by the preexposure.

be devoid of detail. Neither of these interpretations of the scene would be pleasing. The solution to this exposure problem is to place the important shaded areas on Zone II and then to control the density range of the negative as best you can through reduced development (see chapter 7).

Preexposure

When you are photographing a high-contrast subject, the normal procedure is to reduce the development time in order to compress the scale of negative densities. In some cases, however, shortened development will result in very poor separation of tones in the shadow areas. *Preexposure* is a simple method of selectively enhancing the density of the shadow values so that they will appear in a print as textured areas rather than as black and empty shadows.

To preexpose your film, follow this procedure. Use your light meter on a gray card to determine the exposure you will need for a Zone II placement of the card. (The meter reading will indicate the settings for a Zone V placement; just adjust the shutter speed or aperture setting until it corresponds to three stops less exposure than that value.) Next, focus the camera lens at infinity, hold the gray card a few inches away from the lens so that it will be completely out of focus, and

make an exposure. Do not advance the film. Now expose the same frame or sheet of film by photographing the high-contrast scene as you normally would. The chart below summarizes what happens to the total exposure of the film as a result of this procedure.

Zone:	I	II	III	IV	V	VI	VII	VIII	IX
Basic Units of Exposure:	1	2	4	8	16	32	64	128	256
Added Units of Preexposure:	2	2	2	2	2	2	2	2	2
Total Units of Exposure:	3	4	6	10	18	34	66	130	258

Zones correspond to units of relative brightness, and each increase of a zone number in turn corresponds to a doubling of the film exposure. If you photograph a gray card placed on Zone II, it is equivalent to adding 2 units of exposure to the film. If you now photograph a scene on the same piece of film (creating a double exposure in which the first exposure was of a blank card), the *total* exposure the film receives will be that recorded along the bottom line of the chart. Note that the percentage change in exposure is large for the lower zones (200-percent increase for Zone I, 50-percent increase for Zone III, 25-percent increase for Zone IV), but negligible for the higher zones.

Figure 6.17 illustrates the effect of preexposure on a high-contrast scene. The procedure works best for increasing the visible detail in places that are in deep shadow; if there are large dark areas, the false tones achieved by preexposure will not look natural.

Bellows Extension Factor

Just as the intensity of a flashlight beam shining on a wall decreases as you move the flashlight farther away, so the intensity of light passing through a lens and striking the film decreases as the distance between the lens and the film increases. The aperture settings given by a light meter are based on the assumption that the distance between the lens and the film is approximately equal to the focal length of the lens. If you are using either a view camera or a 35mm camera with a bellows extension for close-up photography, you must give the film more exposure than indicated by the light meter in order to compensate for the consequent fall-off in light intensity.

The increase in exposure you will need to give is calculated by the following formula:

Bellows Extension Factor = (Bellows Extension) 2/(Focal Length) 2

(To use the formula, you need to measure the distance between the lensboard and the film plane after you have focused on the subject.) Thus, if you are using a 6-inch lens and the distance between the lensboard and the film plane is 8½ inches, the bellows extension factor will be $(8.5)^2/(6)^2 = 72.25/36 = 2$. This means that you should either double the indicated exposure time or open the lens by one f-stop. If you forget to apply the bellows extension factor under these circumstances, the film will be underexposed by one stop.

A note of caution: if your camera has through-the-lens metering, the built-in light meter will indicate the correct exposure, and no lens extension factor should be applied.

Exposure with Flash

Flash units are available for all cameras and serve as a source of "packaged light." Electronic flash units are inexpensive and reliable and have rendered flash bulbs virtually obsolete. Most modern cameras and electronic flash units allow for automatic exposure control, which in turn has made the flash units themselves much easier to operate.

The chief difficulty in using flash lies in the visualization of the effect of light on the subject — the modeling of curves and shadows, the effect on highlights, and so on. Studio photographers use "modeling lights" (which are actually light bulbs built into the flash head) to get an accurate sense of the effects of the position of a flash lamp.

The most common flash setup is a single light either attached to or held near the camera. Unfortunately, this is probably the worst kind of lighting to use for a photograph; it produces harsh lighting and tends to wash out textures. Direct reflections off the subject can result in "hot spots," and with color film, "red-eye" (a red reflection from the retina of the subject's eye) is a frequent occurrence. (You can avoid the latter effect by moving the flash unit away from the camera body and lens.)

You can reduce the harshness of the light emanating from a flash unit by "bouncing" it off a reflective surface such as the ceiling or a white umbrella. You will have to compensate for the reduction in light intensity, however, unless you have an automatic electronic flash unit that will monitor the amount of light reaching the camera and control the exposure accordingly. You must also consider the shadow patterns that will result from a bounce flash. For example, if you are taking a portrait and you bounce the light off the ceiling directly over the subject's head, you may inadvertently produce deep shadows around his or her eye sockets.

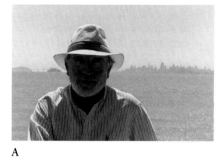

A

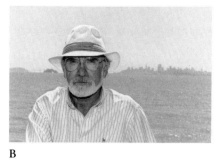

B

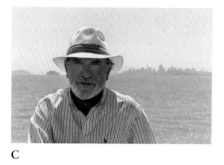

C

Figure 6.18: *Flash-fill.* Shaded areas of a photograph in the vicinity of the camera can be lightened through the use of a flash attachment to "fill in" the shadows with supplemental lighting. A "flash-fill" reduces the harsh shadows that often accompany outdoor portraits. Figure A is an example of a portrait taken in available light; figure B shows the effect of using a flash at an intensity one stop below normal daylight exposure, resulting in a flash-fill that is too bright; thus the portrait does not maintain a natural appearance. In figure C the flash was set at the equivalent of two stops below normal.

"Bare-bulb" flash units have no reflectors and bounce light off the entire surrounding environment and onto the subject. This type of flash fills in shadows more effectively than other types, but the bulb itself has an extremely small light source, resulting in sharply defined shadow edges where the light has *not* been filled in. Bare-bulb units are especially useful with wide-angle lenses, since ordinary flash units with reflectors can seldom cover their whole field of view.

Estimating Exposure with Flash

Flash units are rated according to the intensity of their light output. A *guide number* that is a function of film speed is used to characterize the light source. *To calculate what lens aperture to use with a flash unit, divide the guide number by the flash-to-subject distance in feet.* With automatic flash units, a sensor will interrupt the flash when sufficient light has been reflected off the subject to correspond to a normal exposure.

When you use a flash unit with a camera that has a focal-plane shutter, remember that the shutter is synchronized to work with the flash at only a few selected shutter speeds (usually $\frac{1}{60}$ second or less).

Fill-in Flash

When used outdoors, flash can illuminate shaded areas of a subject while having little effect on the brighter surroundings. The problem lies in how to control the intensity of the supplemental light so that the scene will maintain a natural appearance.

The following is an effective procedure for estimating exposure with fill-in flash. First, use the guide number of the unit to calculate what aperture you would normally need to expose the film. Now set the aperture one or two stops below this value and then set the shutter speed to give a normal daylight exposure at the final aperture setting. An aperture that is one stop less than that indicated by the guide-number calculation is equivalent to a Zone IV exposure, while one two stops less corresponds to Zone III. Consider what level of intensity would be most appropriate for the fill light: if a reduction is necessary, cover the flash with a layer or two of white cloth (a handkerchief will work nicely). It is important for you to experiment with flash-fill so you can fully appreciate its capabilities and its limitations.

The Reciprocity Effect

Chapter 3 discussed the normal exposure relationship, in which film exposure is expressed as a product of light intensity and duration of exposure, or

$$Exposure = Light\ Intensity \times Time$$

This formula, which holds true for most of the shutter speeds and aperture settings commonly used under ordinary lighting conditions, is known as the *reciprocity law.*

At shutter speeds of more than 1 second or less than $1/1{,}000$ second, however, for many films the law is often invalid, and this so-called failure of the reciprocity law will result in negatives that are incorrectly exposed and developed unless corrections are applied before you expose and process the film. Film manufacturers provide data detailing the nature of these corrections. The required adjustments differ for each film, and data sheets will suggest the changes that need to be made. For some of the new tabular-grain films (e.g., Kodak T-Max) reciprocity effects are minimal but with others they are substantial. Remember to consider these reciprocity effects when photographing in very dim light, where long exposures are required, or when using electronic flash where the duration of the flash may be less than $1/50{,}000$ second.

Table 6.3

Reciprocity Effect Adjustments*

If Indicated Exposure Time (Seconds) Is	Use		And, in Either Case, Use This Development Time Adjustment from Normal
	Either This Lens Aperture Adjustment	Or This Adjusted Exposure Time (Seconds)	
$1/100{,}000$	+1 stop	No Adjustment	+20%
$1/10{,}000$	+½ stop	No Adjustment	+15%
$1/1{,}000$	None	No Adjustment	+10%
$1/100$	None	No Adjustment	None
$1/10$	None	No Adjustment	None
1	+1 stop	2	-10%
10	+2 stops	50	-20%
100	+3 stops	1200	-30%

*From Kodak Plus-X insert

Figure 6.19: *Reciprocity failure.* These photographs of four brown eggs and one white egg demonstrate the effect of reciprocity failure as a consequence of long exposures. In both instances, Kodak T-Max 100 film was used and the exposure was determined by placing the reflectance of the white egg on Zone VIII. "Equivalent" exposures were used by exposing image A for 2 seconds at f/5.6–8 and image B for 4 minutes at f/45–64 (plus 0.30 ND filter — comparable to one additional step less exposure). Both sheets of film were given normal development, and the negative densities of the white eggs are the same. Both prints were made on the same contrast grade paper. Note that the shadow values in B are significantly lower than in A and that the overall contrast of the image is greater. Departures from the reciprocity law can be used deliberately to increase the normal contrast of a scene. You can compensate for the effect by increasing exposure even further and reducing the normal development time accordingly.

A

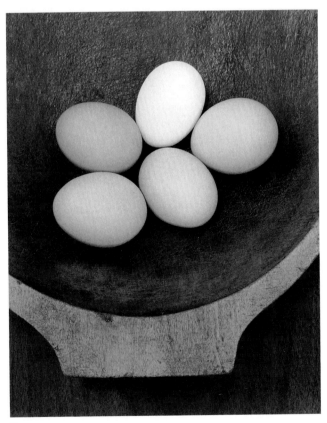

B

Itinerant,
Merced, California, 1936

The light was quite harsh. More exposure, together with less development, would have helped with the two problems that exist with this negative: it is difficult to print the shadowed face because of its generally low density, and the high sodium sulfite content of the developer (Kodak D-23) tended to "block" the high values.

It will help the student appreciate the importance of careful exposure if he knows the perils of over- and underexposure. Of the two errors, underexposure is certainly the more dangerous. The reason is that if a scene is underexposed, dark areas within the subject may not record at all on the film, and no amount of development modification or printing virtuosity will provide detail where none exists on the negative. Overexposure, on the other hand, leads to other problems such as loss of resolution, increased graininess, and reduced separation within the high values. The loss of high-value detail with overexposure corresponds to the loss of shadow detail with underexposure, except that the latter tends to be absolute: underexposed shadow areas soon lose all *detail, while the high values of an overexposed negative usually will retain* some *detail and subtle variations that may (or may not) be successfully printed. The guideline that most photographers follow is that it is better to overexpose* slightly *than to underexpose. I assume here the use of a black-and-white or color negative material; with positive materials such as transparency films the situation is reversed, and a slight underexposure is usually less harmful than overexposure.*

— ANSEL ADAMS

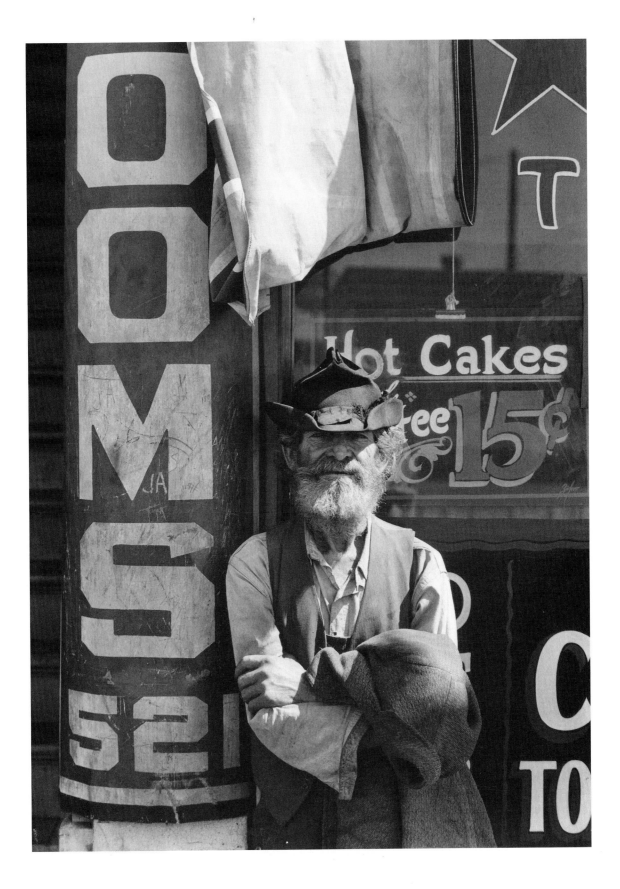

Coupling Lighting Conditions with Development Times

All of the previous discussion of film exposure has been based on the assumption that the relationship between *exposure zones* and *print values* is fixed. Print values always correspond directly to exposure zones, but the contrast between gray tones on a given grade of printing paper is determined by how you develop the film.

Increasing the duration of development increases negative contrast; decreasing development decreases contrast. This fact provides you with one of the most important creative controls available to the photographer: it enables you to expand or contract the density range of the negative.

The effect of changing the development time is almost negligible for exposure zones 0 to III; the pronounced changes in density begin to occur in

Figure 6.20: Ansel Adams, *Dogwood Blossoms, Yosemite National Park, 1938.*

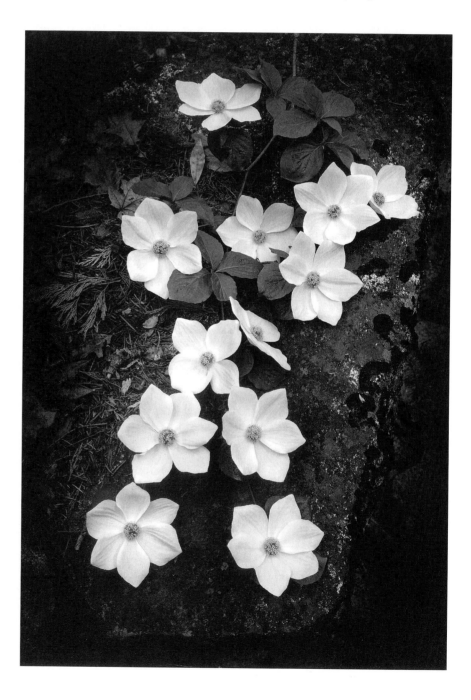

Figure 6.21: Ansel Adams, *Winter Forest, Yosemite National Park, 1949.*

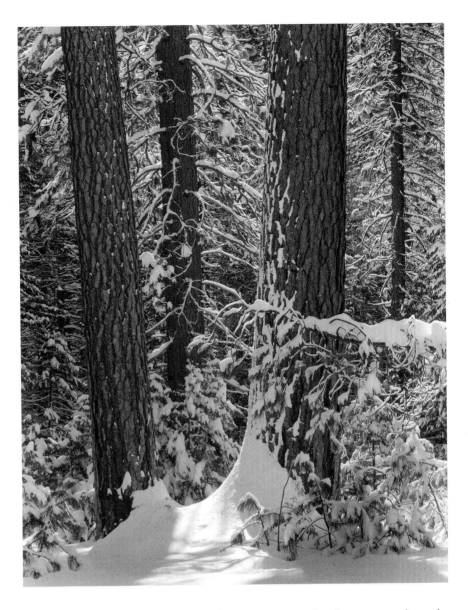

Zone IV (and higher). If you want them to show any detail, you must always be sure that the darker areas of a scene receive enough exposure to place them on Zone III; you can control the tonal values of the higher zones through your choice of development time.

A few examples of how to make use of these facts may be instructive. In *Dogwood Blossoms,* the subject was in complete shade, the only source of light being the open sky. The blossoms, a waxy white, were placed a half stop above Zone VI. A spot-meter reading of the background rock and leaves indicated that they fell primarily on Zones II and III, with some of the foliage and the rock surface approaching Zone V. Normal development would have yielded a print that looked "muddy," with little contrast between the textured white of the petals and the dark background surfaces; greater-than-normal development raised the negative density of the petals and enabled Ansel to print them as brilliant whites.

In *Winter Forest,* Ansel had to cope with an extreme range of subject brightness. When the shadowed tree trunks in the foreground were placed on Zone V, the brightest area of snow between the two trees fell on Zone X. Given

normal development, the snow would have shown no signs of texture and would have printed as a blank white region. With a development time approximately one-third shorter than normal, however, the tonal values were compressed, and the key areas of the scene are thereby represented in the print with appropriately brilliant tones and textures.

Negative Expansion and Contraction: Practical Considerations

The ability to alter the contrast of a negative by controlling its development can also be useful when you are faced with lighting conditions that are not consistent with your visualization of an image. To realize the full potential of *negative expansion and contraction*, you need to do careful tests for every film-and-developer combination you use; later, as you gain skill as a photographer, you may wish to do this, but when you are just starting out, the most satisfying and productive way for you to spend your time is to take photographs and print them in the darkroom. To that end, here are a few basic rules of thumb.

When you encounter a lighting situation that calls for the expansion of a negative by one zone (for example, Zones I to VII expanded to the equivalent of Zones I to VIII), *increase the development time of your film by about 30 percent.*

Alternatively, if you want to contract the range of your negative by one zone (for instance, Zones I to IX contracted to the equivalent of Zones I to VIII), *reduce the development time to two-thirds of the normal development time.*

Tests on a sizable number of films and developers have indicated that these guidelines are reasonable development conditions for you to try when you first attempt to expand or contract a negative. As you begin to gain a feel for what to expect, you can begin to modify the development conditions to suit your preferred film and developer.

One consequence of increasing the development time of a negative is that the *grain* is also increased. With large-format films the difference is usually not significant, but with 35mm films the increase in grain may compromise the quality of an enlargement to the point where the advantages gained by expansion will be offset by the loss in print quality. You need to weigh the gains and losses yourself.

Shortened development time decreases the grain in a negative, but you must be certain that the film has been adequately exposed — if it has not, you may find that there is insufficient detail in the shadow areas. If you plan to contract a negative, it is generally prudent to give one additional stop of exposure.

Negative expansion and contraction are especially practical with sheet films since each negative can be developed individually. For cameras that use roll film, you can reserve different film backs for normal development, contraction, and expansion. If limitations of equipment make it impractical for you to explore the potential of negative expansion and contraction, you will have to rely on the different contrast grades of printing papers in order to deal with unusual lighting problems.

You may wonder why you would want to bother with negative expansion or contraction if you can achieve similar results by changing the contrast of your printing paper. One reason is that papers cannot always accommodate the extreme densities that can result from a normally processed negative made under

unusual lighting conditions. Another is that the tonal relationships in, for example, a print made from a high-contrast negative on a low-contrast printing paper may be quite different from those in a print made from a normal-contrast negative of the same scene on a normal-contrast printing paper. Flexibility is the key here, and when you control the contrast of your negatives through exposure and development, you retain a maximum degree of flexibility for subsequent printing.

Film Speed

In all of the foregoing discussion, we have assumed that the film speed indicated by the manufacturer could be used with confidence as a constant that you programmed into your light meter. However, the ASA or ISO number included with your film should serve only as a guide; you may need to use another value for your film speed if you find that your negatives are consistently overexposed or underexposed.

The key to film speed lies in the shadow areas of your negative. If a normal exposure and development are not generating sufficient detail in Zone II to produce texture, you need to lower the rated speed of your film. To determine the appropriate film speed for your equipment, film, and developer combination, perform the following experiment.

Locate a scene with shadow areas that fall on Zones I, II, and III when you compare their brightness to that of a Kodak Gray Card (Zone V) in the same setting. Meter specific areas of the scene so that you will know exactly how bright they were compared to your gray card. Write down the exposure values that you measure for each part of the scene, as well as the exposure value for the gray card. Photograph the scene with the gray card in a prominent position, using the exposure setting indicated by the Kodak Gray Card, and then take photographs with one and two stops less exposure and one and two stops more exposure. Develop the negatives normally and print all five so that the tone of the gray card in the print matches that of the actual Kodak Gray Card. (If your camera has the appropriate controls, you may wish to refine the experiment further by using half-stop increments of exposure.) Now, arrange the prints in sequence and look closely at the Zone II brightness region of each. Note which print shows the first clear sign of texture in this area; that print will correspond to the negative that was exposed at the proper film speed for your equipment. It will usually be within one stop of the manufacturer's stated ISO value. If your negative required one stop more exposure than indicated by your light meter, then the film speed you programmed into the meter was too high; divide the stated ISO value in half and use that new number as your film speed when programming your light meter (for example, film labeled ISO 100 should be used at ISO 50). If you needed two additional stops, divide the ISO value by four. Conversely, if you required less exposure, you should double or quadruple the ISO value.

In estimating film speed, it is best to err on the low side. If you use a film speed that is too high, your negatives will be consistently underexposed, and underexposure is the one negative defect from which there is no recovery. When there are no details in the shadow areas of a negative, no amount of darkroom magic can put them there in the print.

Using a Light Meter in the Field: Summing Up

To use a light meter with maximum effectiveness, you should take along a Kodak Gray Card, a notebook with exposure-record forms, and a pencil when you go into the field. When you see a scene that you want to photograph, visualize and frame it in your camera's viewfinder. You are now ready to determine the appropriate exposure for your film by following the procedure summarized below.

1. Set the film-speed indicator on your meter to the appropriate value (either the manufacturer's ISO, ASA, or DIN value or a modified value that you have determined on the basis of personal tests or experience).

2. Face the scene and place or hold a gray card so that it is facing the camera. Check to see that there are no reflections bouncing off the surface of the card. If the scene is shaded, be sure that the card is also in the shade. Point your light meter at the card and read its brightness. (If you are using a wide-area reflected-light meter, be certain to hold it close enough to the card that it will not be confused by background lighting.) Be careful not to cast a shadow on the card while you are using the meter.

Figure 6.22: *Ansel Adams' exposure-record form.*

Figure 6.22: *Ansel Adams' exposure-record form.*

3. Select an appropriate aperture/shutter speed combination for the subject, weighing the relative importance of depth-of-field (which increases as aperture decreases) and shutter speed (which determines your ability to "freeze" action). Make a note of your choice.

4. Meter the shadow areas of the scene and note the zones on which they would fall relative to the gray card. Meter the lighter areas and note where they would fall. Remember: any element of a scene that is to print as a textured surface must fall in the range from Zone II to Zone VIII. Record the zones on which various important elements in the scene fall on your exposure-record forms or in your notebook; these data will be useful later on, when you analyze a print. (Figure 6.22 shows the exposure-record form that Ansel used.)

If the range of brightness is especially limited (that is, if there are only two or three zones between the darkest and brightest elements) or wide (if there are six or more zones), consider altering your exposure and film development to expand or contract the density range of the negative.

5. Make an exposure when you are ready, and then develop the film according to either the manufacturer's instructions or the alternative times and temperatures you have worked out for yourself.

In the vast majority of cases, this procedure will give you a negative from which you can make a straightforward print. If you do not have a Kodak Gray Card with you, you can meter any aspect of the scene, set it on the zone you visualize it as corresponding to, and determine the exposure that way.

Although estimating the proper exposure involves operating a mechanical instrument — a light meter — it is also important that you make use of the experience you gain over time taking photographs. By cultivating the habit of looking at a scene and noting the quality of light, and by keeping careful notes on the exposure and development decisions you make, you will build up a library of experiences that will suggest to you when you should depart from the norm. The tools that science makes available to simplify the practice of photography are useful, but it is ultimately the photographer's sensibility that creates memorable images.

Chapter Seven

Developing the Negative

After the creative visualization of the image, photography is a continuous chain of controls involving adjustment of the camera position and other image-management considerations, the evaluation of the luminances of the subject and the placement of these luminances on the exposure scale of the negative, appropriate development of the negative, and the making of the print.

— ANSEL ADAMS

A camera, a lens, a light meter, and your imagination: together they transform ideas and moments into latent images on film. In the darkroom, through chemistry, these images become negatives or transparencies that can be printed, producing a physical record of your visualization.

Photography is a linked series of creative decisions. The moment you visualize a photograph, you must begin to think about the most effective way of transforming what you see into the photograph you imagined. The camera, lens, film, and exposure you choose represent basic mechanical controls and play an integral part in the making of a photograph. The development of exposed film, to convert the latent image into a negative, and the subsequent printing of the negative itself are simple chemical processes.

Every negative is unique, a separate universe of photographic possibilities that you can create through exposure and development control. Visual feedback, the elation or disappointment you feel in looking at a freshly developed negative, can teach you a great deal about the consequences of all the decisions you make, correct as well as incorrect, from exposure through processing.

In order to produce consistently good photographs, you must first understand the effects of such variables as film exposure and processing conditions. When you have acquired that knowledge, you can use it to control the characteristics of your negatives.

A negative (or a color slide, often called a *transparency*) is the fundamental visual record that you retain of any photographic event. The quality of a print is usually limited by the characteristics of the negative; since the latter can be controlled with certainty only when you process film yourself, developing is an important skill for you to learn if your objective is to produce high-quality prints. Fortunately, the techniques are easy to master and do not require elaborate or expensive equipment.

Figure 7.1: Ansel Adams, *Old Faithful Geyser, Yellowstone National Park, Wyoming, 1942.*

Film Development: An Overview

Photographic film is made in absolute darkness, where a complex coating of light-sensitive silver salts and dyes is deposited on a transparent plastic base. When you expose the film in your camera, those microscopic crystals of silver salts that are struck by light are activated. No apparent change occurs in the film, but a *latent image* is formed. In order for this latent image to become visible, the film must be developed.

Since any further exposure to light will result in additional exposure of the film, *all* handling of it must be done in complete darkness. Special light-tight tanks for roll films enable you to process the film in a lighted room once it has been wound onto a reel and placed inside the tank. Loading exposed film into a developing tank is the first step in processing.

The exposed film is then immersed in a solution of developer for a prescribed *time* and at a specified *temperature,* with intermittent *agitation.* Developer can be purchased in most camera stores, either as a powder or as a solution that you dilute with water according to the accompanying instructions.

The developer converts the latent image to an actual image of black metallic silver. The *density* of a negative is a measure of the opaqueness caused by the black silver deposit: those areas of the film that received the most light will appear black, while those that received the least will be almost clear. Negative density is directly proportional to the *amount of exposure* the film was given in the camera and the *duration of development.*

When you are ready, you stop development by pouring out the developer and adding a dilute solution of acetic acid to the tank. If you open the tank and look at the film at this stage of the process (not usually done!), you will see the negative image against a milky-white, opaque background. This white background consists of undeveloped silver salts that need to be removed to complete the processing of the negative; a silver-salt solvent (a thiosulfate solution, commonly called hypo) is required for this step, termed *fixing.*

You complete processing by thoroughly washing the negative and drying it. The entire cycle, excluding drying of the negative, takes approximately twenty minutes. If you are careful and consistent, you should find it easy to achieve predictable results.

Development Chemistry: General Considerations

Choosing a Developer

What developers, then, can be recommended? . . . It has been said that Metol-hydroquinone, in various combinations and concentrations, can duplicate the effect of practically any other developer. A pyro man will object strenuously to this statement, an Amidol man will protest, and a "Migrain 967" man will smile knowingly. The truth is that any standard formula will give satisfactory results if properly used in relation to the problem at hand.

The first time you wander through the section of your local camera store where processing chemicals are on display, you may be bewildered by the impressive array of developers stacked on the shelves. Some will promise *fine grain,* others will advertise their *compensating action,* and a third group will offer the lure of

Figure 7.2: *Agitation and film development.*
These three negatives were exposed
identically and developed in Kodak D-23 at
normal strength for 8 minutes, as follows:
Figure A was given intermittent agitation,
with the tray being rocked every 10
seconds; figure B was given no agitation;
and figure C was given constant agitation.
The three negatives were printed under
identical conditions. Figure A is by far the
best negative to print; figures B and C
could produce better prints with effort, but
the quality would not be as high as that of a
print made from negative A.

A

B

C

high film speed. Since you may not know what these terms mean, how can you even begin to make a choice?

Many photographers pick a film and developer, find themselves disappointed by the prints they produce, and change to another combination. They convince themselves that as soon as they discover the perfect film-and-developer combination, they will begin to create beautiful photographs. This is self-delusion, as the shortcomings of our photographs can seldom be attributed to our equipment or our film, developer, printing paper, and so on. The simple truth is that photographic science has progressed dramatically over the past fifty years, and virtually any film or developer made by a reputable manufacturer is now capable of producing consistently superior results.

Processing film is an experiment in chemistry, and the basic rule in any experiment is to minimize the variables you need to control. Begin your film-developing education by choosing any general-purpose developer that is readily available to you and making a commitment to try nothing else for at least a year. (Kodak D-76, Kodak HC-110, Ilfotech HC, Ilford ID-11 Plus, and Edwal FG7 are all excellent products.) Only when you know, through acquired experience, how a general-purpose developer performs with your film under various lighting conditions, how sensitive the negative is to underdevelopment or overdevelopment, how much enlargement is possible before the grain of the film becomes objectionable in the print, how sharply defined objects are in the negative, and so on will you have the visual and mental references necessary for you to appreciate the capabilities of special-purpose developers.

One factor to consider in choosing a developer is convenience. Some are packaged as powders, others as liquid concentrates. With either Kodak D-76 or Ilford ID-11 Plus, you must stir the powder into a prescribed amount of warm water and store it in an airtight bottle. Kodak HC-110 and Ilfotech HC are syrups with the consistency of honey; you dilute them to make a stock solution that you then dilute further when you are ready to develop a roll of film. Edwal FG7 is sold as a liquid concentrate that you dilute immediately before use.

Developer solutions seldom have a shelf life of more than six months. Air causes them to oxidize, changing their color from clear or light tan to brown. You may get satisfactory results using a partially oxidized developer, but you will do much better with a fresh supply. If you have doubts about the quality of your developer — if it has turned dark brown, or if it has been on the shelf for the better part of a year — *throw it out and mix a new batch.* Developers are inexpensive and far less valuable than the time you took to expose the film that you are now so anxious to develop. (If you develop film only once or twice a month, you should probably opt for a liquid concentrate from which you can prepare a developer solution on an as-needed basis.)

Since air reduces the lifetime of a photographic developer, you should always store your solution in an airtight container. Plastic soft-drink bottles work very well. I personally do not like the opaque brown plastic storage bottles sold by camera shops — you cannot see what the solutions stored in them look like. Furthermore, since I keep my chemicals in the darkroom and the lights are usually out, I have no need for opaque bottles or containers. To inhibit oxidation of developers, use any of the compressed gas dusting products on the market to displace the air in the storage container just before you reseal the bottle.

Never contaminate the developer solution with any other darkroom chemical. If you accidentally touch the film before development with fingers that are wet with stop bath or fixer, you will leave prominent marks; similarly, if these or other chemicals splash into your developer, the results can be disastrous.

One-Shot Development or Replenishment?

Developers can be used in either of two ways. In *one-shot development,* the simplest procedure, you (1) dilute a portion of concentrated stock solution to obtain the required volume, (2) use the solution to develop the film, and then (3) pour the spent developer down the drain. The main virtue of this approach is consistency: the tenth roll of film will have the same qualities as the first. However, it does waste developer, since only a small percentage of the chemicals in the developer is used up with each roll of film. Kodak HC-110 and Edwal FG7 should both be used as one-shot developers.

In the second method, called *replenishment,* you formulate the developer to its proper strength and then pour it back into the bottle when the development cycle is complete. To develop another batch of film in the same solution, you either increase the development time or add a small amount of concentrated developer to compensate for the loss of activity caused by the development of the first film. Instructions for both procedures are included with the developer. After you have replenished a developer a few dozen times, you should discard it.

Replenished developers "ripen" with use, picking up small quantities of silver salts and other byproducts of film development. These byproducts often favorably alter the quality of subsequent negatives, a fact that has inspired a substantial number of photographers to champion the cause of replenishment. This approach is also much more economical than one-shot development, a factor you may want to consider if you process a large amount of film. Kodak D-76 and Ilford ID-11 Plus both favor use with replenishment.

Both one-shot and replenished developers work well; the choice of one over the other is strictly a matter of personal preference.

Developer Components

All developers used today can be formulated from less than a dozen different chemicals, and most are slight variations on a simple combination of four or five ingredients. The essential components include one or more reducing agents, an accelerator, a preservative, a restrainer, and water.

Water is the major component of any photographic developer. "Pure" water is water that is free of significant concentrations of salts and is chemically "neutral" — that is, neither *acidic* nor *basic.* (The acidity of a solution is indicated by its *pH,* which can be measured with a special meter or a paper treated with dyes that serve as indicators. Pure water has a pH of 7; solutions with a pH of less than 7 are called acidic, while those with a pH of more than 7 are termed basic, or alkaline.) Almost all tap water falls into the pH range of 6–8, which is considered "neutral."

Most drinking water is suitable for use in mixing your developer solution. If you have doubts about the quality of your water and suspect that it may be

decidedly acidic or basic (a rare occurrence), purchase purified water and use it to mix and to dilute your developer. Purified water can be found at most supermarkets and is both neutral and virtually mineral-free.

Reducing agents convert the silver salts that have been activated by exposure to light (that is, the latent image) to metallic silver. Most developers contain a combination of a high- and a low-energy reducing agent. The former favors development of the highly exposed portions of the film, while the latter works on developing detail in the shadows.

Since reducing agents used for photographic chemistry are active only in alkaline solutions, an *accelerator* consisting of a simple compound such as borax, sodium carbonate, or lye must be added to the developer to make it mildly alkaline. The concentration of the accelerator is controlled to allow development of the film within about five to ten minutes.

The *preservative,* usually sodium sulfite, protects the reducing agent from undue oxidation by the air and also helps to regulate the alkalinity of the developer.

The *restrainer* is incorporated into the developer in minute quantities to exert microscopic control over the film during development; it serves to retard chemical "fogging," or the unwanted development of unexposed areas of the negative.

The Time-and-Temperature Development Method

If you cannot look at the film when it is developing, how will you know when to stop? The instructions provided with your developer and/or film will include a table telling you how long it will take to develop a particular film in a particular developer at various temperatures. You will note that as the processing temperature increases, the total development time decreases. If you rate your film at the speed recommended by the manufacturer and develop it for the time suggested for a given temperature, the chances are very good that you will obtain a negative that will be easy to print with a specified type of enlarger. This is often called a *normal negative.*

Table 7.1

Developing Times in Minutes*

Temperature	65° F	68° F	70° F	72° F	75° F
	18.5° C	20° C	21° C	22° C	24° C
Developer					
HC-110 (Dilution B)	6	5	4.5	4	3.5
D-76	6.5	5.5	5	4.5	3.75
D-76 (1:1 dilution)	8	7	6.5	6	5
Microdol-X	8	7	6.5	6	5.5
Microdol-X (1:3 dilution)	–	–	11	10	9.5

*For Kodak Plus-X Pan Professional Film PXP120
Note: These data are for development of film in a small tank with agitation at 30-second intervals. Times are those suggested for printing a negative with a diffusion-type enlarger or for contact printing. For negatives to be printed with a condenser enlarger, development times should be reduced by approximately 10 percent.

As you gain experience, you may find that your negatives are consistently overdeveloped or underdeveloped (that is, they have either too much or too little contrast between the shadow and the highlight areas), and you may need to adjust your development times accordingly. For the time being, however, when you are just beginning to process film, follow the instructions carefully. Later chapters will discuss how to fine-tune processing conditions.

Stop Bath

When development of the latent image has proceeded to the appropriate stage, you want to stop it from going further — immediately! You do this by pouring out the developer and replacing it with a water-based solution consisting of 1 percent acetic acid.

Acetic acid is the essential component of vinegar (which is actually a 5-percent acetic acid solution, with some impurities); for darkroom work it can be purchased in pure form (as glacial acetic acid) or as a 28-percent concentrate. In either form it has a pungent smell and will cause your skin to blister if you spill it on yourself and do not quickly rinse it off with water. However, neither form is dangerous to handle if you exercise reasonable caution. To prepare a 1-percent solution, dilute 1 part of the glacial *or* 4 parts of the 28-percent acid with 100 parts of water. Acetic acid is inexpensive, so you can wash the unused portion of the solution down the sink.

Some photographers use only water as a stop bath, but there are two disadvantages to this practice. While water alone will dilute any residual developer in the tank to the point of inactivity, it will not stop the developer that has already been absorbed by the emulsion of the film, which will keep on acting until it is spent. The effect on the negative is usually slight, since fixing should

Figure 7.3: *Zone VI Compensating Developing Timer.* Where ambient conditions make it difficult to work at 68° F (18° C) or to maintain a constant temperature during film or print processing, a compensating developer timer is an ideal accessory. The probe is inserted into the tray or tank and the controller is started at the beginning of development. The lapsed time is displayed in a window. If the temperature differs from 68° F (18° C) or drifts during processing, the timer speeds up or slows down as appropriate to compensate for the differing processing conditions.

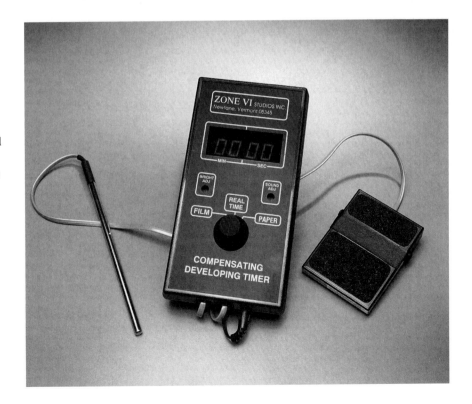

follow immediately in any case. The second, more serious problem with using a plain-water stop bath is that it will allow small amounts of alkali from the developer to be carried over into the fixer, thus hastening the fixer's degradation. While neither of these effects is catastrophic, you can avoid them altogether by using an acidic stop bath.

Fixers

Fixers, often called *hypo,* are chemicals — usually sodium thiosulfate or ammonium thiosulfate solutions — that dissolve the undeveloped silver salts on the film, which are then removed by washing. Fixers are often combined with other chemicals that harden the emulsion of the film or paper during the fixing process, thus increasing its resistance to abrasion. Ammonium thiosulfate fixers act considerably more quickly than sodium thiosulfate solutions and have become the fixer of choice for most photographers. They are easier to wash out of papers and films, simplify archival processing, and reduce washing times.

Kodak Fixer is sold as a measured, premixed powder of sodium thiosulfate containing alum, a hardening agent. To prepare the solution, empty the contents of an envelope of fixer into the prescribed amount of water and stir until the powder is completely dissolved. Do this either outdoors or in a well-ventilated area, since hypo dust is astringent, and it is the last thing you want to have floating around your darkroom. The solution will appear milky at first but will clear upon standing; it can be used immediately after preparation. Do not use the same batch of fixer for both film and prints.

Liquid concentrates of ammonium thiosulfate are available from Ilford, Kodak, and other suppliers (Rapid Fix, Kodafix, Universal Fixer, etc.). To make a working solution, dilute the concentrate according to the directions and, if desired, add the prescribed amount of hardener. *Exercise caution when handling the hardening agents — many are highly corrosive!*

Washing Aids

The key to negative (and print) permanence lies in the removal of hypo when fixing is complete. Soaking of the negative in a concentrated salt solution promotes the rapid elimination of fixer from the emulsion. These salt solutions, called *washing aids,* are available in either powder or liquid form; both work extremely well. For best results, you should mix the solution according to the directions and then soak the film in the clearing bath for approximately two minutes. By following this procedure, you can reduce the overall washing time from twenty minutes to five minutes, thereby saving both water and time while insuring that your film has the least possible amount of residual hypo in its emulsion.

Wetting Agents

Wetting agents are chemicals that retard the creation of water spots on the negative by lowering the surface tension of the water and thus inhibiting droplet formation. To use a wetting agent, add a few drops to the final rinse water and allow the film to soak for a minute before you hang it up to dry.

Sleeving and Storing Negatives

After negatives have been processed they should be stored in archival polypropylene or Mylar sleeves (a full spectrum of negative storage products is offered by Light Impressions). Transparent sleeves enable you to examine negatives with a magnifying loupe and protect them from scratching. Clear plastic sleeves simplify the handling of roll films so you can make a contact print of an entire roll of film on a single sheet of paper. Sleeved sheets of 35mm or 120 and 220 roll film can be kept in a loose-leaf notebook. Sheet films should be placed in a Mylar folder, inserted into an archival envelope, and stored in an appropriate file drawer or archival storage box. Get into the habit of writing dates, subject titles, and pertinent data on storage sleeves and envelopes and work out an indexing system to help you retrieve negatives — you will be amazed at how many you will accumulate over the years.

Processing Roll Film

Equipment

To process roll film, you will need the following equipment:

developing tank	can opener (for cassette film)
thermometer	washing hose
graduated cylinders	distilled or purified water
timing device	film clips or clothespins
widemouthed jars (4)	squeegee or sponge
pans (2)	film sleeves
scissors	notebook and pen or pencil
funnel	

A word about some of these items is in order.

Developing Tank A *developing tank* is simply a can with a light-tight lid and a vent, fitted with a reel to hold the film during processing. The primary difference among various developing tanks lies in the type of reel used: it can be either self-feeding plastic or a metal spiral. The former type is less expensive, far easier to use, and strongly recommended for beginners; Patterson Super System Four tanks have plastic reels and are well constructed, durable, and practical. Plastic reels are adjustable and can accommodate 35mm or 120 or 220 roll film. Up to four rolls can be processed in a single tank at one time.

Metal tanks with spiral reels are carefully machined equipment. They are durable and easy to clean, but it requires considerable skill to load one without damaging the film. Professional photographers prefer this type of tank (though

for reasons that are not very compelling), and for color-film development, where cross-contamination of solutions can be a serious problem, its ease of cleaning gives metal an advantage over plastic.

A set of good metal tanks, reels, and accessories can cost well over $100, while plastic tanks cost only a small fraction of that. You must decide whether the difference is worth it to you or whether you would be wiser to spend your money on a better camera or lens.

Thermometer A good-quality *thermometer* is absolutely essential for dark-room work. The modern dial thermometer and the Kodak Process Thermom-eter are both excellent and reliable. Do not be tempted by an inexpensive thermometer unless you are certain it will deliver rapid, accurate readings: too much of your darkroom activity depends upon accurate temperature measure-ment for you to risk going astray.

While film is being processed, it is important that the temperatures of all solutions be kept within one degree of each other. Variations of several degrees among the developer, the stop bath, and the fixer can cause an increase in the graininess of the negative, and variations of more than 10 degrees can cause

Figure 7.4: *Equipment for developing roll film.* (a) Graduated cylinders. (b) Interval timers. (c) Plastic developing tank. (d) Spiral reel. (e) Light-tight funnel cap. (f) Spool for spiral reel. (g) Tank cap. (h) Precision bulb thermometer. (i) Dial thermometer. (j) Bottle opener. (k) Scissors. (l) Stainless steel tank. (m) Spiral reels. (n) Tank cap. (o) Vent cap. (p) Labeled containers for solutions. (q) Deep tray for constant-temperature bath. (r) Funnel. (s) Flexible hose for washing film. (t) Film washer. (u) Squeegee. (v) Clothespins for hanging film to dry. (w) Notebook and pen. (x) Plastic sleeves for storing processed film.

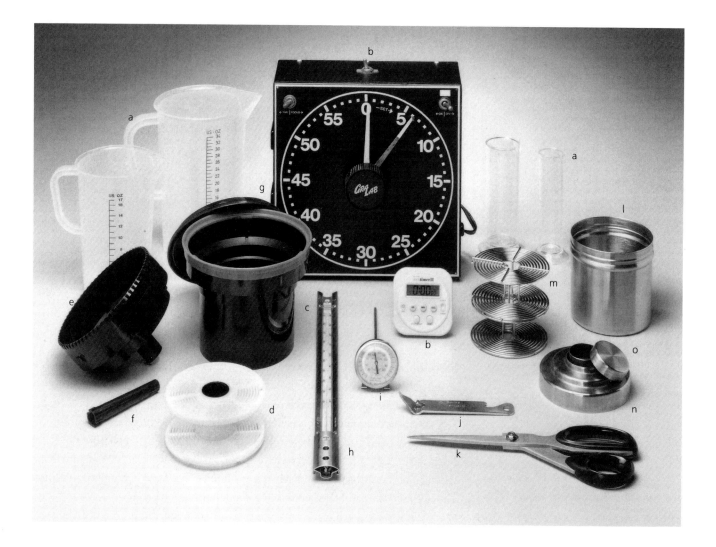

reticulation, a fragmentation of the actual emulsion. Fortunately, it is easy to maintain constant temperatures with a water bath (see "Containers," below).

Graduated Cylinders Glass, plastic, or stainless steel *graduated cylinders* are a necessity for accurate measurement and mixing of solutions.

Stainless steel cylinders are an excellent choice because they are easily cleaned and stand up to hard use, but you must pay a premium for their quality.

Glass cylinders are easy to clean, precisely calibrated, and breakable. Despite your best intentions, you will inevitably drop and break them, but they remain the best alternative for accurately measuring small volumes of solutions. If you purchase glass cylinders in 10ml, 25ml, and 100ml sizes, they will satisfy most of your darkroom needs.

Plastic cylinders have the advantage of being both unbreakable and inexpensive. You can purchase them in either a photographic supply store or a supermarket. Cylinders with capacities of 250ml, 500ml, 1 liter, and 2 liters are useful for mixing and diluting solutions, and their calibrations are precise enough for most darkroom work.

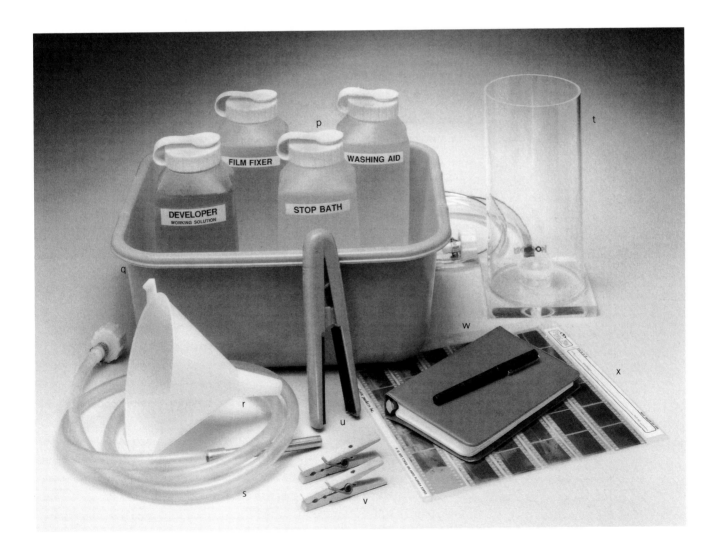

Timer Development is a chemical reaction. As with cooking, you need to time the process to know when the dish — in this case, the film — is "done." Any *interval timer* will do, but you should be sure to purchase one that is versatile: for example, many electronic and digital models can be connected to an enlarger or safelights and used during printmaking. If possible, you should buy a timer with an LCD readout that you can see clearly in the dark. Timers that make a noise at the end of a cycle provide useful "prompts" to remind you to proceed to the next step.

Containers It is critical that you be able to control the temperatures of all the solutions you use during development. If the temperature of the developer drops significantly during the cycle, the negative will be underdeveloped; conversely, if it rises, the negative will be overdeveloped. Fortunately, you can regulate the temperatures of your solutions by placing them, and the developing tank, in a large *water bath,* also known as a *constant-temperature bath.* Several gallons of water kept at or near room temperature will serve superbly well to insure a constant temperature for all of your solutions.

To prepare a water bath, purchase four widemouthed plastic jars and two plastic dish pans (available in the kitchen-supply section of your supermarket). The illustrated step-by-step procedure on pages 219–224 shows how these items should be used during film development.

Solutions Before beginning the procedure for developing roll film, prepare your chemical solutions as follows and store them in clearly marked containers. Be sure to carefully monitor the temperatures of all solutions.

Developer: Dilute the developer stock solution or mix the powder according to the instructions on the package.

Stop Bath: To make stop bath, add 1½ ounces (about 40 milliliters) of 28-percent acetic acid, or 10 milliliters of glacial acetic acid, to 1 quart or liter of water. **Caution: Always add the acid to the water, not the other way around.** If the stop bath contains much more than the recommended strength of acid, there is a danger that the film emulsion may blister.

Fixer: Measure out enough fixer to fill the developing tank, or mix the powder according to the instructions on the package.

Water Bath: Fill a pan with water to serve as a constant-temperature bath. If the temperature of your tap water does not correspond to the temperature at which you will be processing your film, adjust it by adding either warm water or ice cubes until the desired temperature is attained.

Washing Aid: Measure out enough washing aid to fill the developing tank and set it aside.

For each solution, you should prepare at least enough liquid to fill the development tank. Many tanks have the number of milliliters or ounces of solution required per roll of 35mm or 120 film inscribed on the tank, but if you are uncertain about the volume you will need, place an empty reel or reels in your tank, pour in sufficient water to cover the top of the reel(s) by at least one-quarter of an inch, and then pour out the water into a graduated cylinder to measure its volume. That volume will correspond to the amount you will need of each

Figure 7.5: *Darkroom floor plan.* The positioning of equipment on the "wet" and "dry" sides of your darkroom should relate to a logical flow of activity. After loading your roll film into a development tank or removing your sheet film from a holder, you should be able to proceed across the aisle for processing and continue in a straight line to the washing sink. Similarly, during printing, the negative should be loaded in the carrier and the paper exposed in the enlarger on the "dry" side, with processing carried out on the "wet" side. (See chapter 8 for further information on setting up a darkroom and printing.)

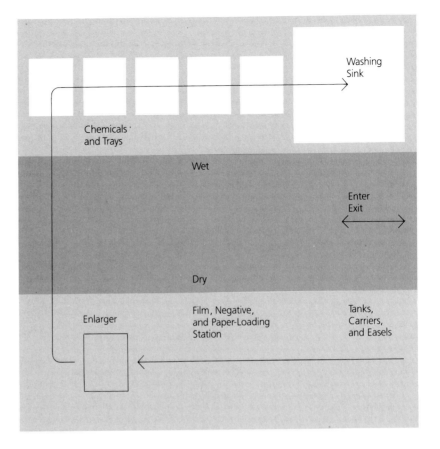

solution. Be sure to *dry the reels thoroughly* before loading them with film; moisture will cause the film emulsion to swell and stick to the reel during loading.

It is a good idea to practice loading the film onto the reel with the lights on, using an expendable roll of film. Practice first with your eyes open, then with them closed, and finally in the dark. Outdated film can be purchased cheaply from almost any photo store and is ideal for this purpose. Putting in a few practice sessions is a much better alternative than ruining a valuable roll of film in your first encounter with unfamiliar equipment in total darkness.

It should be noted that some photographers like to soak the film in water before introducing the developer. This has the advantage of minimizing the possibility that air bubbles will form on the surface of the film and leave marks on the negative. Presoaking the negative in water will necessitate a slight increase in development time (about 30 additional seconds) since the developer will take a little longer to diffuse through the expanded emulsion before it can begin to work on the grains of silver salts. With proper agitation, air bubbles should not be a problem.

Developer, stop bath, and fixer can often be used more than once. Certain types of developer and stop bath can be replenished and used again according to the directions on the package; fixer can be reused until it is "exhausted," or no longer efficiently clearing the film of undissolved silver salts. High-speed films such as Kodak Tri-X take much longer to fix than low-speed films such as Kodak Plus-X. Kodak T-Max films fix very slowly in sodium thiosulfate fixers —

ammonium thiosulfate fixers work much better. Fixing times are generally twice as long as the fixing time for conventional films like Kodak Tri-X or Ilford HP5. Observe the fixing process; if the film has not yet cleared when half the manufacturer's total recommended fixing time has passed, the fixer should be replaced. If you are pouring a solution back into a bottle, use a funnel to minimize spillage and splashing.

Figure 7.6: Ansel Adams, *El Capitan, Winter, Yosemite National Park, c. 1948.* The delicate tonal qualities of scenes such as these are most favorably rendered by the use of a large-format camera. In this case, an 8 x 10 camera was used.

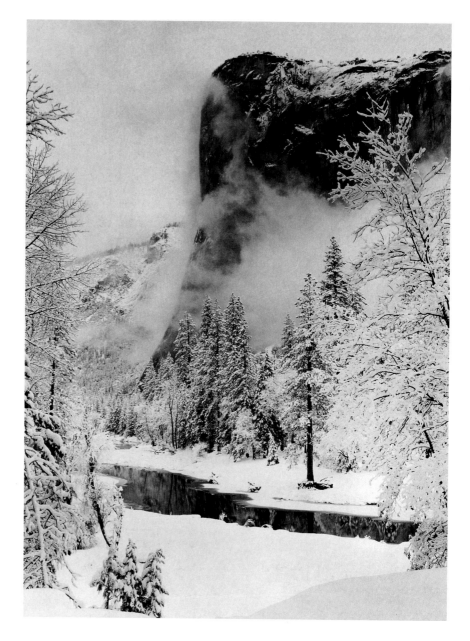

Procedure for Developing Roll Film

The key to producing negatives of consistently high quality (assuming that the negatives have been properly exposed) lies in paying attention to details and standardizing your processing procedure. What follows is a detailed description of how to develop roll film. As you gain experience, you may wish to modify the approach to suit your personal work habits and equipment.

1 Place your prepared developer, stop bath, and fixer in the pan of water that will serve as your constant-temperature bath. Make sure that the level of water in the pan is no higher than the level of the solutions in the containers; the water's buoyancy will make it easy for the jars to tip over if this precaution is not taken. Stir the solutions occasionally to hasten temperature equilibration between them and the water bath. Measure the temperature of each solution, but be careful to rinse the thermometer as you move from one solution to the next. You should have your prepared washing-aid solution at hand, but it need not be in the water bath.

2 Make certain that you will not be interrupted while you are loading film into the developing tank. On a clean, dry table, arrange the disassembled development tank, the film, a pair of scissors, and, if you are developing cassette film, a can opener. Your hands and the equipment must be *absolutely clean and dry.* Fix a firm image in your mind of where each article is located on the table, and then **turn out the lights.** The room must be completely dark during the next steps.

3a If you are working with *cassette film,* pry off the top of the cassette with the can opener and slip the spool out of the metal jacket.

3b If you are using *roll film* secured by paper wrapping, break the tape seal, unwind the paper, and allow the film to curl into a cylinder in the palm of one hand as you roll back the paper with the other. The end of the film is attached to the paper roll and must be gently separated from the film and cut off with scissors. **Always hold any film or negative only by its edges. Be careful not to kink the film while you are handling it, and never place your finger against the emulsion side of the film. Improper handling will leave marks on the developed film that cannot be removed.**

4 Use the scissors to square off the end of the film and round or taper the corners to prepare them for loading onto the reel. ◄

5 Slip the leading edge of the film into the mouth of the plastic spiral and carefully pull it through until it is about an inch past the ball bearings. ►

6 Grasp the ends of the reel with both hands and begin to ratchet them back and forth. The film will automatically feed into the spiral. If it snags toward the end, a gentle ratcheting motion will usually suffice to complete the loading of the spiral. (This problem tends to occur only with thirty-six-exposure cassette film.)

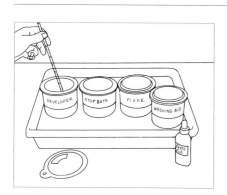

7 Load the reel onto the spool and place it inside the tank. ◄

8 Screw the vented lid on. Now you can **turn the room lights on.** ►

9 Recheck the temperature of your solutions and make adjustments if necessary. ◄

10 Set the timer for the correct development time for your film, then pour the developer into the tank. ►

11 Place the cap over the vent and start the timer. Give the bottom of the developer tank one firm rap against a tabletop or sink. This will free any air bubbles on the surface of the film.

12 Begin agitation by inverting and righting the tank with a twisting motion of your wrist. Turn the tank completely upside down, then reverse the process. Continue this sequence of inversions for the first 30 seconds. ◄

13 Place the tank in the water bath and let it sit for 30 seconds. ▶

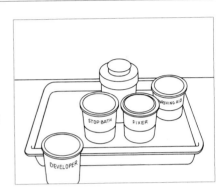

14 Pick up the tank, invert it and right it again three times using the same twisting action as before, and then return it to the water bath for another 30 seconds. Repeat this sequence (agitate three times, rest 30 seconds) until development is complete.

15 Approximately 15 seconds before the end of the development cycle, remove the *vent cap* so that you will be ready to pour out the developer. **Do not remove the cover of the tank.**

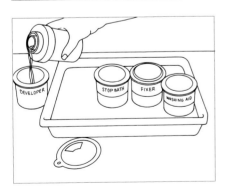

16 When the timer indicates that the development cycle is complete, pour out the developer, either into the sink or back into the bottle if you plan to replenish or reuse it.

17 Quickly pour the stop bath into the tank and recap the vent. Agitate the tank with a series of constant inversions for approximately 30 seconds. The exact timing is not critical, since neutralization of the developer is instantaneous.

18 Uncap the vent and discard the stop bath. ◀

19 Set the timer for the fixing time suggested by the manufacturer, refill the tank with fixer, and replace the cap on the vent. Start the timer immediately. ▶

20 Agitate the film for 30 seconds by continuously inverting and righting the tank. Continue to agitate the film for a minimum of 10 seconds out of every minute throughout the fixing cycle. (More agitation won't hurt, but less can result in streaking due to incomplete fixing.) If you are feeling curious, you can unscrew the top and look at the film after 2 minutes. The milky residue on the surface of the film is due to undissolved silver salts. The rule of thumb here is that fixing should continue for twice the time it takes to clear the film. At the end of the fixing cycle, either discard the solution or pour it back into the bottle if you plan to reuse it.

21 Rinse the tank twice with fresh water to remove excess fixer. You can use the water in your constant-temperature bath for this, provided it has not been contaminated by other chemicals during processing. ◀

22 Fill the tank with washing aid and agitate it for 30 seconds. Let the tank sit for 2 minutes (a longer time will not harm the film) before you discard the solution. ▶

23 Check the temperature of your tap water.

24a If the temperature is within the range of 65–75° F and varies no more than a few degrees from the temperature you used for processing, slowly fill the tank with a gentle trickle of water from the tap. When the tank is full, connect a washing hose to the faucet and insert the other end into the center of the reel. Adjust the water's rate of flow so that there will be the equivalent of a dozen or so changes of water over a 5-minute period. Wash the film for at least as long as the manufacturer recommends; do not rush the process.

24b If your tap water's temperature is significantly different from the processing temperature, adjust the temperature of a gallon of tap water, using either warm water or ice cubes as needed. Fill the tank with the water and let the film soak for 2 minutes; move the reel occasionally to provide some agitation. Pour out the water and refill the tank. When you have repeated this cycle 10 times, the film should be thoroughly washed.

25 When washing is complete, fill a container with distilled or purified water and add 2 drops of wetting agent. Pour the prepared solution into the tank and agitate the film by raising and lowering the reel several times, then allow it to soak for 1 minute.

26 After the final soak, attach a film clip or clothespin to the end of the film and unwind it from the reel. Be careful not to let the end touch the floor. ◄

27 Hang the film from a hook in a dust-free corner of your darkroom. To keep the film from curling up on itself as it dries, attach a clip to the other end as well. ►

28 Carefully wipe the excess water off both sides of the film with a squeegee or a soft, clean sponge that you use only for this purpose. Be sure not to abrade the film emulsion, which is soft and fragile when wet. Hold the film firmly while you wipe it off, but do not apply so much tension that you pull it free of the clamp. The drying time for your film will depend on the temperature and relative humidity of your darkroom and can vary from 30 minutes to several hours. You can hasten the process with a blow dryer, but you must be careful not to stir up any dust that may then adhere to the surface of the film.

When the negative is completely dry, cut it into convenient lengths. Place the segments in clear plastic sleeves or glassine envelopes made specifically for storing and protecting negatives (available from your photo dealer). Clean your darkroom and equipment thoroughly and then write down in your notebook all pertinent information about the procedures you used. Important items include the date, the developer used, developer concentration, the time-and-temperature combination chosen, and a cursory evaluation of the negative's characteristics—you might note, for example, whether it was normally developed, underdeveloped, or overdeveloped, well exposed, underexposed, or overexposed, and so on. (The process of evaluating the quality of a negative is discussed in detail on page 237.) You will add to these written notes later, when you begin to make prints from the negatives.

Processing Sheet Film

The chemistry used for developing sheet film is identical to that used for developing roll film, but the procedure followed differs because of the physical difference in the film. The simplest way to process sheet film is in trays; the individual sheets are shuffled, somewhat like playing cards, in the various solutions. Ridged rather than flat-bottomed trays are recommended since the ridges make it easier to pick up the sheets. You must be careful not to scratch the negatives and to use a consistent pattern of agitation, but the latter is not difficult to master.

The trays you use should be free of any rough spots on their surfaces that might scratch the film, and they should be at least one size larger than the sheets being processed. With 4 x 5 film, for example, you should use a 5 x 7 tray, provided that it is capable of holding the volume of developer you will require for processing. The volume needed is directly proportional to the surface area of the film being processed. A roll of thirty-six-exposure 35mm film or a 120 roll film has about 80 square inches of emulsion, which is equivalent to four sheets of 4 x 5 film, two sheets of 5 x 7 film, or a single sheet of 8 x 10 film. As a rule of thumb, you will need at least 100 milliliters of developer for each sheet of 4 x 5 film you develop. Thus, if you plan to develop eight sheets of 4 x 5 film, you should prepare at least 800 milliliters of developer. The same volume of solution would suffice to process four sheets of 5 x 7 film or two sheets of 8 x 10 film.

Figure 7.7: *Equipment for developing sheet film.* (a) Graduated cylinders. (b) Interval timer. (c) Trays with ridged bottoms. (d) Kodak universal film racks. (e) Dial thermometer. (f) Precision bulb thermometer. (g) Squeegee. (h) Clothespins for hanging film to dry. (i) Notebook and pen.

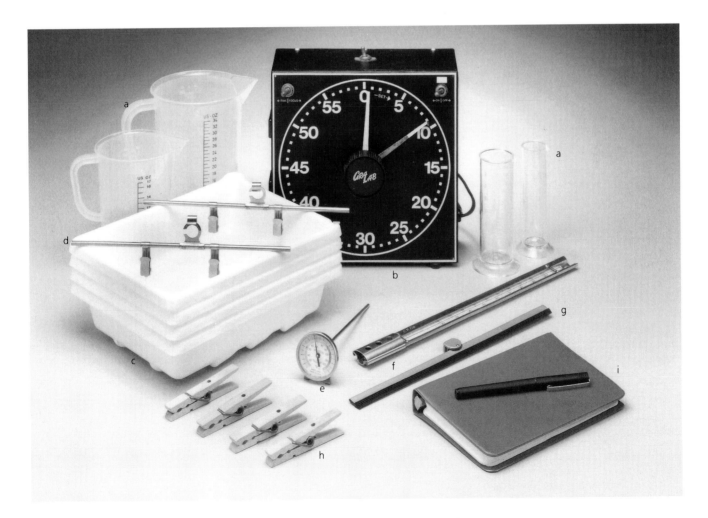

Early Morning, Merced River, Autumn, Yosemite National Park, circa 1950

This serene subject is only about one hundred feet from the highway; I have passed it hundreds of times, and I retain many "corner of the eye" memories of it at all times of the year. The shapes were always beautiful, but the lighting conditions usually were impossible. On this morning I observed a situation I could not resist; a glance was enough to command me to stop, park my car, and carry my equipment to the scene. My eye enjoyed a wonderful impression of light in all areas, but it was a very high contrast subject for the film, and I recognized this problem as I was setting up the camera.

With normal development the subject luminance range would have been excessive, and hence Normal-minus-one developing time [about 25 percent less than normal] seemed appropriate. The image was correctly exposed, but with minus development the texture-contrast of the low values was weakened. Fortunately, when I think I have an exceptional image, I make two identical exposures.

With the second negative I used the water-bath process. I should have realized from the start that water-bath development was indicated to better support the shadow values. The water-bath process holds the high values but also sustains the contrast of the low (shadow) values, giving an impression closer to the visual experience. Today, with modern thin-emulsion films, a highly dilute developer solution or the two-solution process seems about equally effective, and both approach the control that was once so rewarding with the water-bath process. — ANSEL ADAMS

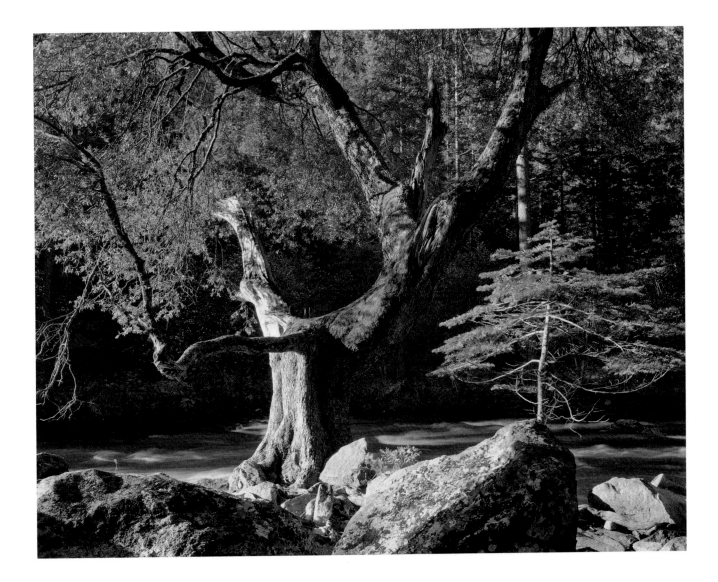

No harm can come from using an excess of developer. On the other hand, stinting on the quantity can lead to exhaustion of the developer during the developing cycle, resulting in underdeveloped negatives. *Or* it can have the opposite effect: if you use small amounts of developer, the heat given off by your fingers may warm the solution during processing, thereby increasing the rate of development and producing negatives that are overdeveloped. While it is foolish to squander developer needlessly, it is utter folly to risk ruining a potentially fine photograph by trying to save a few pennies' worth of developer.

In addition to the various solutions used for development, you will need the following equipment to process sheet film:

graduated cylinders	film washer (optional)
widemouthed jars (5)	wetting agent
a large pan	distilled or purified water
thermometer	film clips or clothespins
trays with ridged bottoms (4)	squeegee or sponge
timing device	notebook and pen or pencil

Although a professional film washer is not required equipment, it is a worthwhile addition to any darkroom. (One extremely efficient washer is manufactured by Gravity Works. With this model, the sheets are slipped into a rack, which is then placed in a tank; the tank is filled and drained once every minute by automatic syphoning, and washing is complete in five minutes. The unit costs approximately $100). Film washers can also be used for roll film.

Figure 7.8: *Loading a sheet-film rack.* Sheet film can also be developed in deep tanks, using film racks to secure and manipulate the film. After the hinged top of the sheet-film rack is folded back, the film is inserted into the slotted frame and the top is closed. During processing, the rack is lowered into the tanks, which contain the various processing solutions. Agitation is accomplished by lifting and lowering the racks in the tanks at 30-second intervals.

Procedure for Developing Sheet Film

The processing of sheet film must be carried out in complete darkness and requires extensive handling of both dry and wet film. To familiarize yourself with the details of the process, go through the following procedure with the lights on, using several sheets of outdated film. At first, limit yourself to processing only two sheets of film at a time. When you have become more familiar with the procedure, you will be able to handle up to eight sheets of film at a time. This is as much film as you will want to deal with in any one cycle.

1 Prepare the developer, stop-bath, fixer, and washing-aid solutions as you would if you were processing roll film and bring them, as well as an extra jar filled with plain water, to the desired temperature in the water bath (see page 217). Note that the time and temperature recommendations will be different for roll and sheet film of the same film type. Use only the data sheet that was included with the film you are processing.

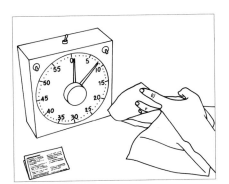

2 When the solutions have reached the appropriate temperature, fill the four trays with the various solutions and arrange them from left to right in the following order: plain water; developer; stop bath; fixer. If you have enough equipment, place each tray in a larger tray that will serve as a water jacket. The temperature of the water in the water jacket should be the same as that of the processing solutions.

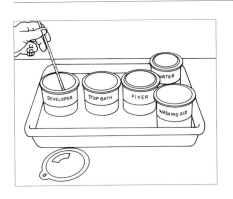

3 Determine the development time using the table provided with the film. Add 30 seconds to the recommended time to compensate for the presoaking procedure we will use, and set the timer. *Dry your hands thoroughly.*

4 On a clean, dry table, arrange the film holders in an orderly stack, with the dark slide of each holder facing up. Establish in your mind what you must do in order to walk from your present location at the table to a position in front of the water-filled tray. Practice this movement with your eyes closed until you are confident that you will be able to repeat it in the dark. Make certain that you will not be interrupted and then **turn off the room lights.**

5 Unload the film from the holders by pulling up the top (dark) slide and removing the film. ◄

Feel for the sheets' code notches and arrange them so that all the notches are in the upper-left-hand corner. Stack the sheets in a pile on the table. ▶

6 When you have removed all the film from the holders, carefully take the pile in your left hand and arrange the sheets in a fan shape.

7 Walk over to where your processing trays are arranged and locate the water-filled tray, using the hand that is not holding the film. *Do not touch the water.* Stand before the tray and remove the top sheet of film from the fan stack with your right hand. Keeping the code notches in the upper-left-hand corner, place the sheet of film in the water bath and gently push it beneath the surface of the water with the tip of your finger. It is extremely important that you keep your left hand dry so as to avoid getting any water between two sheets of dry film (see note below). Remove the next sheet from the fan and submerge it the same way. Repeat the process until all of the film is in the water bath. Let it remain in this presoak for about 1 minute (the exact time is not critical).

NOTE: Just one drop of water in between two sheets of film will immediately bind them together. If you encounter this problem, submerge both sheets in the presoak water bath, keeping as much of the film surfaces as possible separated while you do this. Allow them to soak for a few minutes. After you put the remainder of the film in the bath, spread the stuck films apart slightly so that the water can diffuse between them. Make no effort to pry them apart, as that would be certain to ruin at least one of the sheets. As water seeps into the emulsion and wets it thoroughly, the films will slowly separate; with luck, they will be undamaged. Stuck-together sheets happen to almost everyone who works with sheet film; the experience is trying enough that most people take care not to go through it twice.

One way to avoid the problem altogether is to develop your sheet film on a dry table and place the entire stack (again, with the notches in the upper-left-hand corner) on a clean piece of paper located in front of the tray of water. Pick up the top sheet with one hand, grasp it with the other hand, and submerge it in the water as described above. Repeat the sequence, picking up one sheet of film at a time with your dry hand and passing it to your wet hand, until all the sheets have been transferred to the tray of water. By keeping one hand dry and handling no more than one sheet of film at a time, you will minimize your chances of having to deal with stuck-together sheets.

8 When you have put all the sheets of film into the presoak tray, check to make sure that the entire stack is arranged so that the code notches are located in the upper-left-hand corner. Now carefully rotate the top sheet 180 degrees so that its code notches are in the lower-right-hand corner. This sheet will serve as a marker throughout the remaining processing steps.

9 Begin the agitation process by reaching under the entire stack of film with one finger and lifting the stack slightly at one end. Using the fingers of your other hand, slide out the bottom sheet of film. Keeping the code notches in the upper left, place this sheet on top of the stack with a downward "wiping" action. Submerge each sheet by gently pressing it beneath the surface with the tips of your fingers, taking care not to let any edge or corner of the film dig into or scratch the film below it. Continue this process until you reach the marker film — the sheet with the code notches in the lower-right-hand corner. The stack will now be in the same order as when you began the agitation cycle.

10 Start the timer and transfer the sheets of film, one at a time, into the developer, beginning at the top of the pile and working down. Do this as quickly as you can, but be careful not to scratch the film.

11a Begin agitation immediately, as described above, keeping careful track of your film by monitoring the code notches. Continue repeating the cycle until development is complete. Work on establishing a rhythm that will enable you to shuffle through a stack of film at a steady, reproducible pace. With 6 to 8 sheets in a batch, the shuffling of one sheet of film every 3 to 5 seconds will produce a good agitation/rest interval for each sheet; with a smaller number of sheets, you may choose to run through an agitation cycle and then let the film sit undisturbed in the tray for 15 seconds before you begin the next cycle. The important thing is to develop a consistent pattern so that your results will be constant from one batch of film to the next.

11b Some photographers prefer to divide the developer into two separate trays and agitate the negatives by transferring them from one tray to the other and then reversing the process. If you find this approach easier, do not hesitate to use it.

12 When the timer indicates that development is complete, finish the agitation cycle so that the stack will be back in its original order. Transfer the sheets, one at a time, to the stop bath, following the procedure described in step 10.

13 Rotate the film through two complete cycles of agitation. Now transfer the film to the fixer, one sheet at a time, first allowing any excess stop bath to drain off into the stop-bath tray. ◄

14 Set the timer for the recommended fixing time and begin the agitation cycle. After half the fixing time has passed, you can **turn on the room lights.** Continue agitating the film until fixing is complete.

15 Pour the contents of the trays containing the presoak (water), developer, and stop bath down the drain (unless you plan to replenish or reuse the developer). Rinse the trays thoroughly and fill two of them with water and the third with the washing-aid solution. Remove the sheets from the fixer one at a time, allowing the excess fixer to drain off into the fixer tray. Place the sheets in one of the trays of water and rinse the film by putting it through two complete cycles of agitation.

16 Remove the sheets from the rinse, one at a time, and place them in the washing-aid tray. Set the timer for 2 minutes and agitate the film continuously during this interval. ◄

17 Remove the sheets from the washing aid, allowing them to drain into the tray, and place them in the other tray of water. Agitate the film for one cycle. The sheets are now ready for washing; if you do not have a film washer, use one of the methods described in step 18.

18a Keeping the sheets separate, place them, one at a time, in a tray filled with fresh water. Run a gentle stream of water through the tray, turning the film occasionally. Make sure not to let the sheets bump into or slide over each other. The emulsion is still delicate at this stage, and it is easy to scratch the negative. ◄

18b An alternative method is to use several trays filled with fresh water, allowing a few sheets of film (which must be kept separated) to soak for 3 to 5 minutes in each. In all, about a dozen changes of water will be needed to ensure complete washing.

19 After washing, fill a tray with distilled or purified water, add 2 or 3 drops of wetting agent, and transfer the sheets to the tray. Agitate the film through one cycle and allow the sheets to soak for an additional minute.

20 Remove the film from the wetting-agent tray, attach a film clip or clothespin to a corner of each sheet, and hang it up to dry in a dust-free environment. If you find you have difficulty with water spots on your negatives, gently wipe any excess water off the surface with a squeegee or a clean sponge that you use only for this purpose. The film will curl at first, then straighten. *Do not place the negatives too close together when they are drying.* If two sheets should happen to come into contact with each other while they are still damp, they will stick together and be impossible to separate without damage.

Store the dried negatives in film sleeves of the appropriate size. Clean your darkroom and equipment thoroughly and enter any appropriate data regarding processing conditions and results in your notebook.

Rotary Processing of Film

JOBO makes a series of processors that automate film and photographic paper development. The units consist of drums that are rotated by a motor and a water bath that controls the temperature of all solutions (see page 354). Either roll or sheet films can be accommodated. These desktop units are simple to operate and enable you to carry out all processing operations with the lights on once the film has been loaded into a drum. The major advantages of rotary processing are that film development is consistent and uniform across the entire surface of the sheet of film (uneven development can sometimes be a problem with tray development of sheet film) and processing faults such as film scratching are minimized. Because constant agitation is used, *development times are usually slightly shorter than those recommended by the film manufacturer.* For high-volume processing and for color photography, the JOBO units are highly desirable accessories in the darkroom.

Film Processing: A Summary

Action or Process	Time	Procedure and Comments
1. Prepare chemicals	—	Mix solutions of developer, fixer, and washing aid. Prepare a stop bath. Bring all solutions to processing temperature and set timer for desired development time.
2. Set up processing trays or developing tank and other necessary equipment (scissors, thermometer, can opener, and so on)	—	*Developing tank and reels must be absolutely dry.* Sheet film must be unloaded from film holders on dry surface.
3. **Turn out lights**	—	Exposing the film to room light will ruin it.
4. Prepare for development		For roll film, thread film on reel, place in developing tank, cover and cap tank, and **turn on lights.**
		For sheet film, unload film holders and stack sheets of film on a dry surface. Orient code notches for identification. Transfer sheets *one at a time* into presoak bath. Sheet film must be processed in total darkness: **do not turn on lights!**
5. Development	Varies as a function of film used, developer type, temperature, and dilution. Consult instructions provided with film and developer.	Start timer as soon as developer is added to tank *or* first sheet is transferred to developer tray.
		With a developing tank, agitate continuously for 30 seconds, then for 5 seconds every 30 seconds until development is complete. Pour developer out through vent cap. *Do not remove cover of tank!*
		With sheet film, use a consistent rhythm, slowly shuffling film throughout development.
6. Stop bath	30 seconds	With a development tank, pour in stop bath and agitate tank constantly to neutralize developer.
		For sheet film, begin to transfer sheets one at a time to stop bath upon completion of development cycle. Agitate film through two cycles of shuffling in stop bath.
7. Fixing	5–10 minutes, depending upon film	With tank processing, agitate constantly for first 30 seconds, then agitate for at least 5 seconds every 30 seconds throughout cycle.
		With sheet film, agitate continuously for twice the time it takes for the film to clear. You may **turn on room lights** halfway through fixing cycle.

Action or Process	Time	Procedure and Comments
8. Water rinse	Approximately 30 seconds	Use two changes of water with agitation (for tank) or agitate for two cycles (for sheet film) to wash off surplus fixer.
9. Washing aid	2 minutes	Soak and/or agitate film for a total of 2 minutes.
10. Wash film	5 minutes	Adjust flow of water so there will be at least a dozen changes of water during wash cycle.
11. Wetting agent	1 minute	Add a few drops of wetting agent to purified or distilled water for last rinse. Soak and drain film.
12. Dry film	Variable	Dry film in a dust-free space.
13. Store negatives	—	Use film sleeves to protect and store negatives. Label them for identification.

A

B

Figure 7.9: *Effect of selenium intensification.* Although normally used for printing papers, selenium toner can also provide intensification of the negative by increasing the negative density. The negatives in figures A and B were printed identically, but the negative used to produce figure B received selenium intensification. The white wall in figure B is higher in value than the wall in figure A, and the leaves have more brilliance and better separation of values.

Evaluating
a Negative

What constitutes a "good" negative, and how do you know when you have produced one? The answer, which is not intended to be cryptic, is that a good negative is one that contains all of the information you need to produce an excellent print on the paper you normally use. In practice, a wide range of negatives can meet this criterion. Except in scenes with high contrast, small degrees of underexposure, overexposure, underdevelopment, or overdevelopment can be compensated for during the printing process with little loss of quality.

If you find that the negatives you obtain using the development times recommended by the manufacturer are consistently overdeveloped or underdeveloped, either decrease or increase the development time by 10 percent and see what happens. There is nothing sacred about the manufacturers' recommendations; they reflect the results of laboratory experiments carried out at carefully controlled conditions, and thus may not be applicable to your darkroom, equipment, and work habits. However, they generally provide an excellent starting point.

Photography is a mixture of science and art. With practice, the laboratory aspect of photography becomes a simple routine; the artistic aspect of photography, manifested by an ability to judge the outcome of your darkroom efforts, is what you must work to improve. As you gain experience in printing negatives, you will be in a position to alter the exposure and development conditions for your film, which in turn will enable you to produce the images you visualize.

The illustrations in figure 7.10, showing a series of prints from three separate sets of negatives of a landscape, will help you in analyzing typical negative merits and defects. The negatives were underexposed by two stops, exposed normally, and overexposed by two stops, respectively; then each was developed for two-thirds of the recommended time, the recommended time, or one-and-a-half times the recommended time.

The most striking lesson to be learned from the illustrations in figure 7.10 concerns the forgiving nature of the photographic process. You can often make significant errors in exposure and processing conditions and still end up with a negative from which you can salvage an acceptable image. Nonetheless, it would be imprudent for you to conclude that you can be casual about exposure and processing and simply rely on the flexibility of printing papers to cover your mistakes; there are situations (high-contrast scenes, for example) where precise exposure and negative development are crucial. You should work toward the goal of making a "perfect negative" each time you photograph — that way you will maximize your chances of recovering from any inadvertent errors.

Figure 7.10: *Contrast variation through the use of exposure/development controls.* These nine prints illustrate the effects of various exposure/development combinations. The prints were all made on a normal contrast grade of paper, and the print exposure times were kept constant in each case. It should be noted that excellent prints could easily be made from the negatives corresponding to C, E, and G, and that "acceptable" prints might be salvaged from some of the others, though the latter would clearly be inferior in quality.

(A) Underexposure, underdevelopment: very low contrast, absence of shadow detail.

(B) Normal exposure, underdevelopment: low contrast, loss of some detail in deep shadow areas.

(C) Overexposure, underdevelopment: low contrast, excellent detail in both highlights and shadow areas.

(D) Underexposure, normal development: normal contrast, serious lack of detail in shadow areas.

(E) Normal exposure, normal development: normal contrast, excellent detail in both highlights and shadow areas.

(F) Overexposure, normal development: normal contrast, excellent shadow detail but "blocked" highlights.

(G) Underexposure, overdevelopment: high contrast, adequate detail in all but the darkest shadow areas.

(H) Normal exposure, overdevelopment: high contrast, excellent shadow detail but "blocked" highlights.

(I) Overexposure, overdevelopment: high contrast, brighter areas of the scene completely "blocked."

A

B

C

D

G

E

H

F

I

The Golden Gate before the Bridge, San Francisco, California, 1932

One beautiful storm-clearing morning I looked out the window of our San Francisco home and saw magnificent clouds rolling from the north over the Golden Gate. I grabbed the 8 x 10 equipment, drove to the end of 32nd Avenue, dashed along the old Cliff House railroad bed for a short distance, then down to the crest of a promontory. From there a grand view of the Golden Gate commanded me to set up the heavy tripod, attach the camera and lens, and focus on the wonderful evolving landscape of clouds.

I do not think I had an exposure meter at the time, but instead depended upon experience, which sometimes treated me well. I confess that in those days I did much bracketing of exposures (making negatives with more and less than the exposure believed to be correct, for security). This was expensive, but psychologically rewarding at the time. For most work I was using Kodak Super-Panchromatic film and a pyro or pyro-metol developer. I would grasp at any formula I heard about; in fact, I made some beautiful negatives with amidol (which is generally used for print developing).

In those days I used normal development — a certain time at a given temperature — and hoped for the best. Occasionally, when I knew the image might be a bit flat, I gave more development time, and when I had a subject of high contrast I gave less time. I trusted the latitude of the negative material and the flexibility of the printing procedures. I had no concept of the subtle Zone System controls, but I made many photographs that have held up well over the years, and this is one of them.

— ANSEL ADAMS

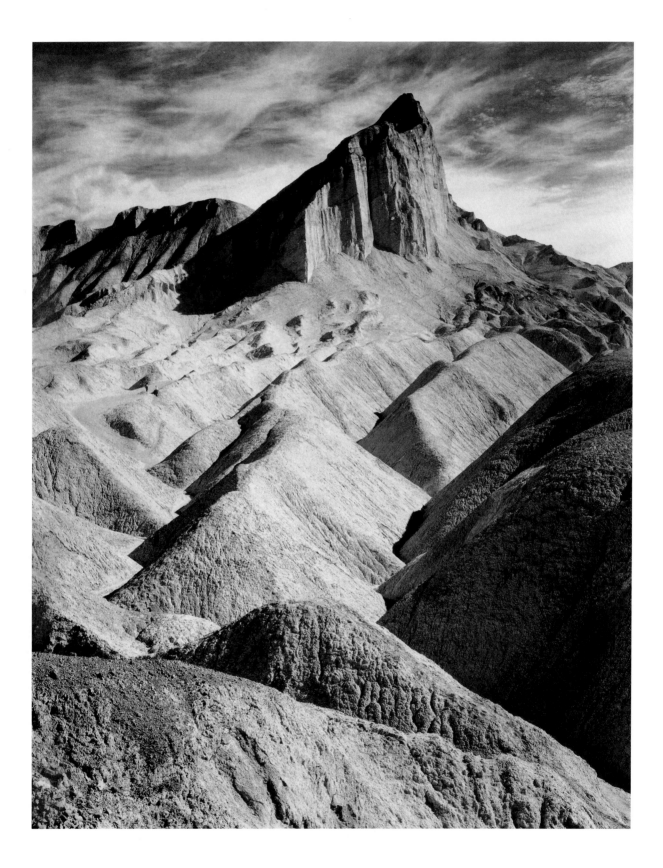

Chapter Eight

Introduction to Basic Printing

A negative is only an intermediate step toward the finished print, and means little as an object in itself. Much effort and control usually go into the making of the negative, not for the negative's own sake, but in order to have the best possible raw material for the final printing.

The making of a print is a unique combination of mechanical execution and creative activity. . . . The basis of the final work is determined by the content of the negative.

Printing is both a carrying-to-completion of the visualized image and a fresh creative activity in itself. As with other creative processes, understanding craft and controlling the materials are vital to the quality of the final result.

You will find it a continuing delight to watch prints emerge in the developer and see that your original visualization has been realized, or in many cases enhanced by subtle variations in value.

You should strive to remember the visualization — what you saw *and* felt *— at the moment of making the exposure.* — ANSEL ADAMS

Ansel was fond of remarking that the negative corresponds to the score in music, and the print to its performance. You have the opportunity to be creative at two points during the photographic process. Visualizing a fragment of the world as a photograph and organizing it within the confines of the camera frame constitute a creative act, one that marks the beginning of communicating through images: a message has been received by you, the viewer and photographer. The print, the visual expression of your thoughts and emotions, is your communication with your audience.

The operations and processes that must take place between the moment you snap the shutter and the time you turn your attention to printmaking are mechanical and, with practice, easy to master; the development of negatives does not require complex manipulations. Similarly, the procedures, equipment, and supplies used in making a print are not particularly complicated: you can become a competent printer after only a brief learning period. Mastery of the art of printing negatives, however — *and it is an art!* — depends upon your aesthetic sensibility, a sense that expands with experience.

Figure 8.1: Ansel Adams, *Manly Beacon, Death Valley National Monument, c. 1952.*

This chapter deals with the straightforward process of making a basic photographic print — a simple record of the information contained in the negative. Chapter 9 is concerned with refining these first efforts and working toward an image that interprets the negative and expresses the emotion of what you visualized. The latter is often called a *fine print.*

The Printing Process

The basic steps in making a photographic print are essentially the same as those followed in making a negative. Sensitized paper (corresponding to the negative) is exposed by light passing through the negative (corresponding to the scene); a latent image is formed. The latent image is then developed following the same procedure used for processing film, but with one significant exception: since black-and-white photographic papers are orthochromatic (sensitive primarily to blue light), you can handle and develop them in trays under dim red or yellow lights rather than in complete darkness or in a developing tank. You can even use the same solutions to process the paper, though in practice slightly different formulations are more efficient.

The simplest way to make a print is to place a sheet of photographic paper on a flat surface, lay the negative on the paper, cover both with a piece of plate glass, and expose the paper by turning on a light. Prints made with this technique are called *proof sheets* or *contact prints;* the procedure, described in detail on pages 272–275, is used to obtain proof sheets of negatives and fine prints from large negatives. Contact printing is also used for nonsilver photographic processes such as *cyanotypes, platinum* and *palladium* prints, and prints made with *printing-out papers,* or *POPs* (which allow an image to print out in sunlight, without chemical development).

With contact printing, the image produced is the same size as the negative. To overcome this limitation, most photographic prints are made with a device

Figure 8.2: *Equipment for printing and enlarging.* (a) Safelight. (b) Timer. (c) Focusing magnifier. (d) Compressed air. (e) Level. (f) Mini-mag flashlight and safelight filters. (g) Metronome. (h) Antistatic brush. (i) Contrast filters.

A

called an *enlarger*. An enlarger is a special camera that illuminates the negative and projects its image onto a sheet of photographic paper during exposure, just as a slide projector enlarges an image and throws it onto a wall or screen. Almost any degree of magnification or reduction of image size is possible.

Equipment for Printing and Enlarging

To create a photograph from a negative, you will need printing paper, the appropriate chemicals, and some basic equipment. The following items are either necessary or useful in making photographic prints.

contact printing frame	antistatic brush
enlarger	compressed-air blower
safelight	flashlight with safelight filter
contrast filter	dodging and burning devices
easel	print tongs
focusing magnifier	rubber gloves
timer	paper towels
processing trays	bucket
print washer	notebook and pen or pencil
hypo test kit	color enlarger*
drying screen	color enlarger head*
paper trimmer	color filters*
	color processor*

*Necessary only if you intend to make color prints. See chapter 11.

Contact Printing Frame The simplest device for contact printing consists of some foam rubber and a piece of quarter-inch plate glass large enough to handle at least one complete roll of thirty-six-exposure 35mm film (approximately

Figure 8.3: *Equipment for developing prints.* (a) Trays. (b) Rubber gloves. (c) Print tongs. (d) Paper towels.

A

B

Figure 8.4: *Contact printing frames.* (A) Hinged (*top*) and spring-backed (*bottom*) printing frames for making contact prints. (B) With a spring-backed printing frame, half of the frame can be lifted up while the other half remains in place. For printing processes in which a visible image is formed by the action of light alone, this allows you to monitor the progress of development while insuring that the negative and printing paper will remain in precise registration when the back is reclosed.

8 x 10 inches). A 12 x 16-inch sheet of glass will suffice for paper sizes up to 11 x 14 inches. To make a contact print, lay a piece of soft foam rubber on a flat surface, position a sheet of printing paper over it, set the negative(s) in place on top of the paper, and cover the stack with the plate glass. Window glass can often be used instead, but it may not be heavy enough to press the negatives firmly into contact with the printing paper.

On a simple commercial contact printing frame, the foam and glass components are joined at one end by a hinge. The printing paper and negative(s) are placed on the foam, and then the glass overlay is lowered over the sandwich and clamped tight.

A second type of frame is made like a frame for a photograph, with a back that is hinged in the middle. The negative is positioned on the glass surface and covered with the printing paper, and then the hinged back is set in place and clamped tight. These frames are versatile and especially convenient for use with printing-out papers, as they allow you to check the degree of development by swinging back half the frame and inspecting the image.

Enlargers An enlarger is really a camera used in reverse. It consists of a light source, a condenser (optional), a lens, a negative carrier, a baseboard, and a support system. Each of these features needs to be evaluated when you are considering a purchase. Figure 8.5 is a schematic drawing of a typical enlarger.

The light source, condenser, lens, and negative carrier are all part of the *enlarger head,* which is connected to a post and can be raised or lowered to magnify or reduce the size of the projected image. Each component of the head serves a specific purpose.

Light sources: The lamp in the enlarger head illuminates the negative and exposes the printing paper. The light source has an effect on the quality of the print produced.

A very small, bright light used in conjunction with *condenser lenses* (which concentrate the lightbeam; see below) is referred to as *point-source illumination.* It functions as a spotlight and projects the sharpest image possible, with maximum contrast; unfortunately, it also reveals every flaw in the negative and exaggerates the grain of the film. Point-source enlargers are most useful for projecting line drawings and microfilm documents.

When the light source consists of a large frosted bulb located above two condenser lenses, the enlarger is referred to as a *simple condenser enlarger.* These enlargers project bright, contrasty images, but they also expose negative defects such as scratches, dust particles, and grain (though not to the same degree as point-source enlargers). The easiest way to minimize these minor negative defects is to use a *diffuse light source,* which can be created by inserting either a piece of milk glass or a translucent white plastic plate in the enlarger head, directly above the negative. The light from the lamp is projected onto the white plate, which then becomes a secondary, diffuse source of light for the negative — and, unfortunately, also greatly reduces the light intensity. Many older condenser enlargers come with a diffusing device as an accessory. Condenser lenses are not necessary in this type of arrangement, but since they increase the overall

Figure 8.5: *Schematic drawing of a typical enlarger.* (**Figure 11.5, on page 366, shows a color enlarger head.**)

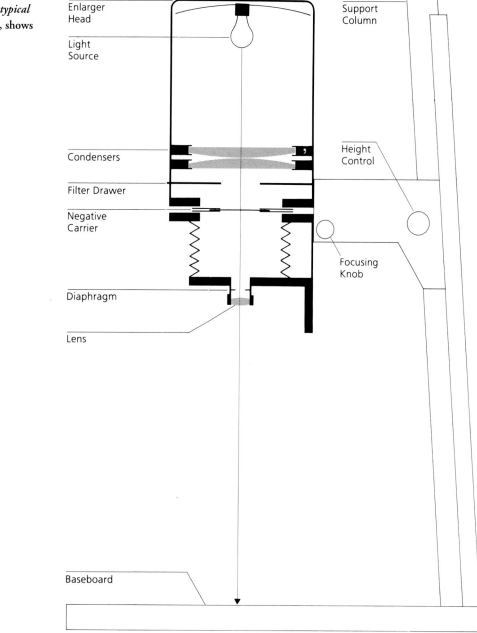

Enlarger Head

Light Source

Condensers

Filter Drawer

Negative Carrier

Diaphragm

Lens

Support Column

Height Control

Focusing Knob

Baseboard

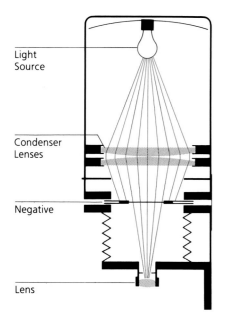

Figure 8.6: *Simple condenser enlarger head.*
In a condenser enlarger, a pair of lenses
immediately below the light source
concentrate and increase the intensity of
the light passing through the negative,
making the projected image much brighter
and therefore reducing the required
exposure time. One disadvantage of
condenser enlargers is that they emphasize
negative grain and flaws.

Light
Source

Condenser
Lenses

Negative

Lens

intensity of light reaching the negative, they can be used to reduce the exposure time. (*A note of caution:* Since tungsten bulbs generate considerable heat, it is important to make sure the enlarger head is well ventilated to avoid damage to the negative; most condenser enlargers also have a sheet of heat-absorbing glass that is placed above the negative to minimize heating.)

A more efficient way to convert an ordinary enlarger into a diffusion enlarger is to replace the lamp with a *cold light head,* an array of fluorescent tubes located behind a diffusion plate. Cold lights provide soft, even illumination that is excellent for enlarging and results in a print quality that many believe cannot be approached by any other system. For some time they were the light source of choice for photographers who strive to produce fine black-and-white prints, but with the emergence of modern variable-contrast papers, they are no longer as useful.

For anyone acquiring a new or used enlarger, the purchase of a *dichroic or variable-contrast head* is strongly recommended (see page 365). Dichroic and variable-contrast heads generate cyan, magenta, and yellow light, and blend them in a mixing box. The color spectrum of the light controls the contrast of the variable-contrast papers now on the market (see chapter 9 for a detailed discussion). Simply by changing the ratio of yellow and magenta (or blue and green), the paper contrast can be made to vary from Grade 1 or less to Grade 5. The convenience of being able to purchase a single box of paper rather than a series with different fixed contrasts and not having to use a series of variable-contrast (and image-degrading) filters far outweighs the additional cost of the head. These heads work equally well with graded papers.

Condensers: The condensers are a pair of convex lenses that focus the light from the light source on the negative. By concentrating the light, they serve to substantially increase the level of illumination.

Negative Carrier: During enlarging, the negative must be held in place in a flat and level plane; if it tilts or buckles, the projected image will not be in sharp focus. Negative carriers are metal frames that secure the negative by clamping it along its edges. After the negative is inserted in the carrier, the whole assembly is slipped into the lamp housing.

Some negative carriers consist of two glass plates that hold the negative absolutely flat. There are disadvantages to glass carriers: they attract dust, and they give rise to *Newton rings,* rainbowlike optical-interference patterns that show up on enlargements. You can avoid the latter problem by adding very thin spacers between the negative and the glass to minimize their surface contact, but unless you are working with large negatives that cannot easily be kept flat, you will be better off with glassless negative carriers.

Enlarging Lens: An enlarger should be used with a lens designed specifically for enlarging. Enlarging lenses maximize optical performance at close working distances and are optically corrected to project the image in a flat plane, unlike a typical camera lens. You should buy the best-quality enlarging lens you can afford. A poor lens will produce an image that is not sharp at the corners and edges, and this can compromise the investment you have made in your camera equipment.

High-quality enlarging lenses are coated to minimize lens flare and thereby enhance image contrast. For color enlarging, it is important that your lens be *color-corrected;* otherwise, light rays of different colors will not focus in the same plane. A lens that is not properly corrected will produce a photograph with poorly resolved edges at the junction of such colors as red and blue.

When you buy an enlarging lens, make certain that it has sufficient covering power to project the entire negative image with minimal fall-off of light intensity at the corners. It is generally wise to use as long a focal length as practical when enlarging; this insures reliance on the central part of the lens, where resolution is highest. However, lenses of long focal length require greater bellows extension on the enlarger and increase the distance needed between the enlarger head and the printing paper. These are often limiting factors in the choice of an enlarging lens. Table 8.1 gives suggested focal lengths according to negative format.

Table 8.1

Recommended Focal Lengths for Enlarging Lenses

Negative Format	Focal Length
35mm	50mm
2¼ x 2¼ inches	80mm
2¼ x 2¾ inches	90–100mm
2¼ x 3¼ inches	105mm
4 x 5 inches	150mm
5 x 7 inches	210mm
8 x 10 inches	300mm

Figure 8.7: *Negative carriers.* (A) Devices to clamp the negative in position in the enlarger are provided by the enlarger manufacturer. Some carriers have glass plates that sandwich the negative and prevent it from buckling. (B) After thoroughly cleaning both the negative and the carrier, place the negative between the guides and clamp it in place by lowering the hinged top of the carrier.

Like camera lenses, enlarging lenses project the sharpest image with the greatest contrast when set at two or three stops below their maximum aperture.

General Considerations: Most enlargers can accommodate only a limited number of negative sizes — for example, a typical brand will normally accept negatives from 35mm up to 6 x 6 cm (2¼ inches square). A 4 x 5 enlarger can be used for any negative up to and including 4 x 5 inches. Although you can purchase an enlarger made specifically for the 35mm format, if you later decide to move up to a medium- or large-format camera system, you will have to buy

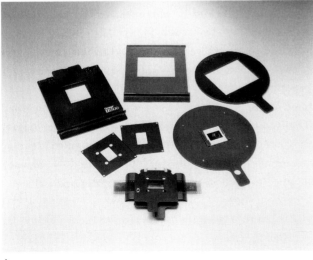

A

B

a new enlarger as well. It makes more sense for you to get an enlarger for a bigger format in the first place if there is any possibility of your scaling up in the foreseeable future.

With any enlarger, physical stability is a primary concern. Make certain that the center post is sturdy, or that the supporting struts are strong. The enlarger head should be firmly mounted on its support. You can check this by placing a negative in the carrier, turning on the enlarger light, and then tapping the lamp housing with your finger. If the projected image vibrates excessively, tighten the appropriate screws and nuts. If this does not solve the problem, look for another enlarger.

If your enlarger rests on top of a table or bench when you use it, be sure the support itself is steady. If passing traffic or footsteps cause the enlarger to vibrate, your prints will not be sharp. Stiff rubber padding placed under the enlarger will help to dampen any vibrations.

Another important quality is ease of adjustment. The lamp housing should move freely up and down the supporting frame, and it should be easy to make fine adjustments in the position of the head and in the lens-focusing mechanism.

When the enlarger is assembled, it is imperative that the planes of the lens mount, the negative carrier, and the baseboard be parallel. Significant deviations can create focusing difficulties or distort the shape of the image. Use a small carpenter's level to check the alignment of the planes.

Static electricity acts like a magnet for dust and is a particular problem when the humidity is low. By grounding your enlarger, you will avoid a buildup of static electricity.

Safelights Most graded photographic papers are sensitive to blue light, not yellow or red. This allows you to light your darkroom with red or yellow *safelights* and do all of your black-and-white printing in reasonably well-lit surroundings. Two types of safelights work well. The simplest and least expensive kind consists of a lamp housing that accepts Kodak's or other brands of safelight filters. The lamps are designed to be used with a 15-watt tungsten light bulb and should be located at least four feet away from the paper. A couple of lamps — one near your enlarger, one near your developing trays — will generate a pleasantly lit working environment to which your eyes will quickly accommodate.

A very high level of illumination can be obtained with another type of safelight, a sodium vapor lamp designed especially for the darkroom. The lamp is hung from the ceiling, and its bright yellow light is directed upward and reflected. These lamps can *fog,* or partially expose, some papers, though, so you will need to test each paper before printing (see pages 278–279).

If you use variable-contrast papers, *be sure to follow the manufacturer's recommendation* on safelights; lights that are suitable for use with graded papers (e.g., sodium vapor lamps) will often completely fog a variable-contrast paper. Do not be tempted to save money by using colored cellophane or gels — safelight filters are specifically designed to keep you from wasting printing paper!

Contrast Filters Variable-contrast printing papers require the use of special filters to control the contrast of the image. If your papers need filters, insert them *above* the negative if at all possible, not below. Filters located immediately above

A

B

Figure 8.8: *Enlarging easels.* (A) The Saunders four-bladed easel (*top*) enables you to set the location and width of each print margin individually. The edges of a single-size easel (*bottom*) form a nonadjustable border for the print. (B) To load a single-size easel, insert the printing paper into the slot at either end.

or below the enlarging lens can cause sufficient distortion of the projected image to degrade the effective quality of the lens itself. When placed above the negative, on the other hand, filters have no effect on the focus or the optical characteristics of the image. High-quality thin gel filters are best for this purpose and cause minimal distortion of the image. In any case, be sure to focus your image on the surface of the *easel* (see below) with the filters in place, as they can cause a significant shift in the focal plane. As mentioned above, a dichroic or variable-contrast enlarger head does away with the need for contrast filters and accomplishes the same objective far more easily.

Easels The easel is a piece of equipment used to hold the printing paper in place on the baseboard of the enlarger during exposure. The best easels have adjustable blades that serve as a framing device and enable you to mask off parts of the image and define the edges of the photographic print you will ultimately make. When purchasing an easel, you should check the blades at several settings to make certain that they meet at right angles; take a square or a large sheet of graph paper along with you to test this before you buy.

Four-bladed easels are the most versatile kind because they allow each blade to be adjusted independently, meaning that the width of each border on the print can be individually set. Saunders and Kostiner are two companies that produce high-quality easels of this type.

Two-bladed easels, which have two fixed and two adjustable margins, are less expensive than four-bladed models but force you to work with at least two thin margins of ¼ inch each. Wider margins offer greater protection to the print surface and are frequently desirable for aesthetic reasons.

Single-size easels such as the Speed Ez-El are available in sizes from 4 x 5 to 16 x 20. The major disadvantage of these is that they allow no cropping of the image unless you are prepared to trim the photograph to size after enlarging. Moreover, for the larger sizes, the curl of the enlarging paper can make it difficult to insert it into the easel.

The surface of any easel should be painted either yellow or black to reduce the possibility of back reflection and fogging with single-weight papers. Alternatively, you could use a thin sheet of dark paper and insert it beneath a single-weight sheet of enlarging paper.

Figure 8.9: *Focusing magnifiers.* Magnifiers that focus on the projected grain of a negative help to ensure sharp enlargements.

Focusing Magnifier The most effective way to ensure that the image projected onto the easel will be sharply focused is to use a *focusing magnifier,* an optical device whose design resembles that of a microscope. The magnifier is placed on the easel, and a mirror reflects the image from the enlarger back into an eyepiece that you look through to see the grain in the negative. The geometry of the magnifier is such that when the grain is crisply defined, the image will be in sharp focus.

To use a magnifier, focus the projected image in a zone approximately one-third of the way out from the center. If you focus this area of the image and then stop down the enlarging lens one or more stops, the entire image should be in sharp focus. If the magnifier indicates otherwise, check the lens and the negative carrier for possible problems (for instance, a buckled negative, improper alignment, or a poor-quality lens) and take corrective action.

The major difference among various enlarging magnifiers lies in how close they allow you to get to the edge of the projected image you are inspecting. The Omega Micromega is a fine instrument with a long mirror and a tilting eyepiece; it costs as much as a good camera lens, but with appropriate adjustments, it will permit you to examine the far corners of the enlarged image for sharpness of focus and thus achieve critical enlarger alignment. With most less expensive magnifiers, you cannot see beyond the central two-thirds of the projection (though this is not a serious limitation).

Timers Accurate timing of exposures during printing and development is essential if your trial exposures are to be useful and if you want to make several prints that are identical. Digital timers are far more accurate than mechanical or electric interval timers and are capable of reproducing exposure times to within $1/10$ second. The more sophisticated digital timers can be configured to turn off safelights during exposure and to time the development of prints (the latter can

also be accomplished with the interval timer with which you monitor film development).

A problem with using a timer to control print exposure is that operations such as burning and dodging are difficult to monitor unless you reprogram the timer for each step — and this quickly gets to be a nuisance. A more serious concern is that accurate timing is important only if you can be confident that the light intensity emanating from the enlarger is constant throughout the exposure and your printing session — which is more often the exception rather than the rule. Unless the enlarger head is warm, the light intensity in a cold darkroom can increase dramatically as the lamp heats up during an exposure. One solution to the problem of variable light intensity is to turn the enlarger light on well before you begin to work and leave the enlarger light on during the entire printing session. Expose the print by removing the lens cap while shielding the paper with a sheet of cardboard, then move the cardboard aside to expose the paper. Terminate the exposure by reversing the steps.

An elegant way to achieve reproducible exposures is to insert a light sensor into the enlarger head to measure and control the enlarger's *total light output.* Redlight Enterprises (Star Route 228, Santa Barbara, CA 93105;1999 price $175) manufactures a device that does this. *Units of light (lux)* are keyed into a box that looks and operates like a digital timer but monitors exposure units instead of time. In another mode the unit also functions as a traditional timer. It is a worthwhile investment if you intend to do much black-and-white or color printing.

Figure 8.10: *Metrolux*™ *II enlarger lamp monitor.* The light intensity emitted by most enlargers will vary dramatically as a function of bulb temperature. The Metrolux™ II is used in place of a timer and consists of a probe, inserted directly into the enlarger lamp housing, that constantly monitors light intensity and controls the specified *quantity of light (lux)* delivered by the enlarger rather than the number of seconds of exposure. The device ensures that all of your exposures will be consistent from print to print.

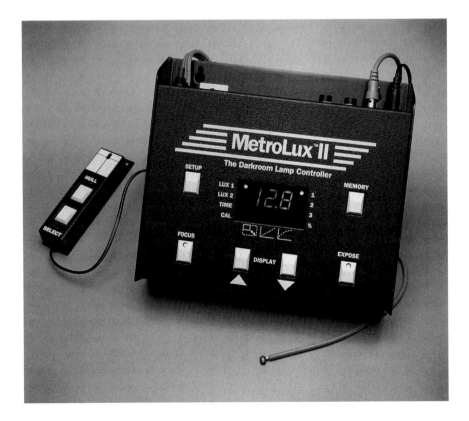

Metronomes In this age of digital controls the metronome remains a highly useful monitoring device for printing. An inexpensive audible metronome can be purchased at any music supply store. Set it to one beat per second and you will be free from the necessity of watching a clock dial or repeatedly pressing timer buttons as you expose, dodge, and burn a print. It does require that you count the beats when you make test strips and during exposure of the image — a practice that will soon become second nature to you. After the basic exposure and dodging of the paper has been completed, "burn in" areas of the print that require additional exposure, then cover and cap the enlarger lens. A simple sketch of the photograph on a sheet of paper with notes can be used as a record of the burning and dodging pattern needed. A metronome has the virtue of making basic exposure, dodging, and burning operations easily controllable and repeatable.

Processing Trays Black-and-white photographic paper can be conveniently processed in trays made especially for this purpose. Plastic trays are inexpensive, impervious to chemicals used in the darkroom, and easy to clean; many have ridges or troughs on the bottom that make it easier to pick up prints and negatives. You should acquire several sets for use with various print sizes.

It is important that you get into the habit of cleaning your trays and the inside of the sink thoroughly when you finish working. With the possible exception of the fixer, you should discard all solutions at the end of a printing session: the few cents you might save by recycling them cannot justify the risk of a print's being flawed by chemical contamination. One sound procedure is to pour the developer out into the sink, empty the stop bath into the developer tray, and then rinse each tray with hot water and stand it on end to drain and dry.

Stainless steel trays are excellent and virtually indestructible, but very expensive. Kitchen-supply stores often carry used stainless hot trays that are suitable for darkroom use.

Print Washer Washing prints after processing is one of the most critical steps in printmaking: if you fail to remove the excess fixer, the image will fade over time. Because nothing visible happens during the wash cycle, it is easy to lull yourself into complacency, but what you don't see may come back to haunt you if your washing is not thorough.

There are two basic kinds of equipment that you can use to wash prints. The least expensive and least satisfactory device consists of a *tray and siphon.* A Kodak tray siphon clips to the side of a tray and is connected to your faucet by means of a hose; when you turn the faucet on, the tray fills with water, then drains. The stream of water provides some agitation as it enters the tray, but unless you are prepared to shuffle prints every few minutes, you should not attempt to wash more than one at a time. Prints that stick together in the wash water will not be adequately cleared of hypo. If you are developing several prints you will probably find it easier to place each in a separate tray and change the water every five minutes until a test with *Residual Hypo Testing Solution (HT-2)* is negative. (A kit for this solution can be purchased from Photographer's Formulary at P.O. Box 950, Condon, MT 59826; 800-922-5255 or 406-754-2891. Test a print by cutting off a small corner of the margin, blotting its surface, and, in subdued light, putting a small drop of HT-2 on the emulsion. If a brown or yellow stain forms immediately, further washing is necessary.)

Figure 8.11: *Archival print washers.* The washers shown here are designed to keep the prints separated throughout washing, so that fresh water can reach all areas of the print simultaneously.

A much better alternative is an *archival print washer.* There are many models available, varying in price from modest to expensive. The best print washers hold each print in a separate compartment or slot in a vertical tank; water flows in one end, over the surface of the prints, and then out the other side or the bottom. Archival washers are highly efficient and produce hypo-free prints with minimal waste of water. If you are printing with an eye to permanence, the purchase of an archival print washer should be high on your list of priorities. Consider it a capital investment — an item that you will use for years, just like a good camera.

Drying Screen After prints have been processed and washed, they must be dried. The simplest and safest way to do this is to place the drained print facedown on a clean plastic-mesh screen. You can have screens made to your specifications at most hardware stores. A convenient size is 22 x 44 inches; this will accommodate two 16 x 20-inch prints or up to ten 8 x 10 prints. Several screens separated by spacers will handle as many prints as you are likely to make in a single darkroom session. The screens should be washed occasionally with a brush and soap and water to insure that they remain absolutely clean.

Figure 8.12: *Print drying rack.* This homemade print drying rack consists of plastic screens that are slipped into slots. The Formica-covered plywood that is resting on the rack is easy to keep clean and makes a convenient worktable.

Paper Trimmer Various types of trimmers are available and suitable for darkroom use. Rotating-wheel trimmers are the safest kind and are excellent for trimming photographic paper, prints, and dry-mount tissue, though they are not sturdy enough to cut through mounting board. Heavy-duty blade trimmers can serve both purposes, but you must beware of poorly constructed models, which will cause prints to "creep" while you are trimming, making it almost impossible for you to cut a clean edge or a straight line.

Kutrimmer and Dahle trimmers are both well made, and each includes a pressure bar that clamps the paper or mat along its entire edge to prevent "creeping." On any trimmer, the pressure bar should be wide and padded underneath to avoid leaving any indentations and to hold the paper firmly in place. Before you begin to cut anything, always check the pad to make certain that it is free of any grit that might mar the surface of a print — dents are highly visible and cannot be repaired.

Miscellaneous Items As you gain experience in the darkroom, you may want to try out some of the many useful gadgets on the market (see figure 8.2). Every photographer swears by one or more "indispensables" that others deem totally useless; the following are some items—both exotic and practical—that you may wish to think about including on your own "must-have" list.

Antistatic brushes help to remove surface charges from film and glass carriers. When the humidity is low, it is almost impossible to remove the last traces of dust without one. Kodak makes a helpful static-eliminator unit, and small brushes containing polonium cells (such as the Staticmaster) are also excellent, but you must be sure to follow the instructions and precautions for the use and disposal of the latter.

Compressed-air blowers can be useful for clearing dust particles from the surface of a negative, but often they stir up as much dust as they remove. Some contain freon as a propellant and are therefore a serious environmental hazard — *do not use these!* Cleaning the area around your enlarger with a small battery-powered shop vacuum is an excellent way to minimize dust accumulation on your negatives.

A *small flashlight with a safelight filter* can be very handy. It will allow you to find things easily in the dark and let you check aperture settings on your enlarging lens without turning the lights on. You can either buy a flashlight designed especially for the darkroom or make one yourself by taping a red filter over an ordinary flashlight lens. Some "mini-mag" lights come with filters.

In most prints, certain areas will require either more or less light than they would ordinarily get through a simple exposure of the negative. Odd-shaped scraps of cardboard or old sheets of paper with holes in them can be used to "dodge" (hold back light from) or "burn" (selectively expose) a portion of the scene. *Dodging and burning devices* can be made out of wire clothes hangers or baling wire and tape or scraps of thin cardboard. (See chapter 9 for details on how to print with these devices.)

The best way to process and deal with wet prints is with your hands. The gelatin surface of a wet piece of photographic paper is very fragile and must be handled gently. *Tongs with rubber tips* can be used to grasp single prints if you

Figure 8.13: (A) *Rotary trimmer.* The Rotatrim cutter is a safe and precise tool, suitable for use on photographs, mounting tissue, and lightweight mounting board. A transparent plastic straightedge allows easy positioning of the material being cut and holds it firmly in place during cutting. The shielded blade sharpens itself as it cuts.

(B) *Blade trimmer.* Paper cutters that use a cleaver knife are suitable for trimming paper or heavy mounting board. To avoid the crooked edges that could result if the paper were to shift during cutting, it is helpful for the trimmer to have a pressure bar to hold the paper securely in place. Paper trimmers that lack suitable blade guards can cause serious injury and must be used with extreme caution.

A

B

take care not to damage the emulsion, but they are impractical when you are developing a stack of prints or working with papers larger than 8 x 10 inches.

A small percentage of people are allergic to metol, an important component of many developers. The substitution of a developer that contains phenidone instead will often solve the problem. If not, *thin rubber gloves* may help with allergic reactions, though they can make it difficult to hold prints, and perspiration inside the gloves can be an irritation in itself. Generous use of a hand cream such as Kerodex at the end of a darkroom session is recommended, but be careful not to handle your prints with greasy fingers!

Inexpensive *cotton hand towels* and a supply of *paper towels* are needed in a darkroom. Printing requires frequent immersion of your hands in various solutions, and it is important to avoid cross-contamination. Rinse, wash, and dry your hands after each contact with darkroom chemicals and solutions and launder towels after every darkroom session. Use a cellulose sponge to wipe up spills before they dry and leave stains that are difficult to remove.

A *notebook* is a vital accessory. Write down data for each enlargement you make, noting print size, aperture setting, exposure time, rough details of dodging and burning requirements, type of enlarging paper used, developer, and so on. All of this information is useful and will make it easier for you to reprint the negative later. Figure 9.11 shows a print-record form designed by Ansel.

Photographic Papers

Photographic films and printing papers are fundamentally similar. The only real difference between the two lies in the support used for the emulsion — transparent plastic versus paper stock. In black-and-white photography, the photographic print is the final expression of your visualization, and the printing paper you choose is a key element in how effectively that visual message will be conveyed to the viewer. When selecting a paper, you should consider the following variables.

Paper Stock

All modern photographic papers belong to one of two basic types: they are either fiber-based or resin-coated.

Fiber-based papers are high-quality rag papers that incorporate certain fillers and optical brighteners. They vary in tone from white to cream. Paper can last for centuries, and properly processed photographs should be able to endure for as long as the paper they are printed on. The papers we use today were first introduced in the 1880s, and many of those first prints still retain their original qualities.

Resin-coated (RC) papers have a thin layer of plastic over a paper or polymer base to make them waterproof. When they were first introduced in the 1970s they proved to be unstable, and the images on them degraded quickly, especially if they were exposed to light. Significant progress has been made since then, but tests still indicate that *RC papers and images undergo serious degradation over time. They should not be used to make fine prints.*

In terms of convenience, RC papers are a pleasure to work with: processing is rapid and they are ideal for making proof or study prints. A good strategy is to use RC papers while you are learning how to print and in situations where print permanence is not a concern. When you think you have an image that deserves to be hung on the wall and appreciated by future generations, print the photograph on a fiber-based paper.

Paper Surface

Photographic emulsions and papers are formulated to produce glossy surfaces, matte (dull) surfaces, or some variation thereof in the final print; some papers are even textured to look like canvas. Much of the impression that a print makes depends upon its surface characteristics. Air-dried glossy papers and papers with a matte finish are preferred by most photographers who want to make serious statements through their images.

The print surface has a direct effect on the "feeling of light" conveyed by the image. When we view a print, what we see is reflected light; thus, a glossy print will seem more "brilliant" than a matte print of the same image. Similarly, the "black" of a dry glossy print will appear to be much "blacker" than that of a dry matte print, although the two may look identical if they are compared when wet. Closely related tones, especially at the darker end of the scale, are more difficult to distinguish on matte-surface papers. For some images this may be appropriate; for others it may not. In the end, the choice of paper surface is an aesthetic decision that should reflect your personal taste.

Paper Weight

Printing papers are manufactured in *single (S), medium (M),* and *double (D)* weights. Single-weight papers are less expensive than double-weight but require extreme care when they are wet to prevent them from creasing or tearing. They must be handled with your fingers, not with tongs. Single-weight prints need less washing time than double-weight prints, but they must be dried between blotters or on a heated drum; with no such restraint, they will curl unmercifully.

Medium-weight papers are usually confined to RC stock; they behave more like double- than like single-weight papers.

Double-weight papers can withstand the rigors of normal processing and handling. Prints made from them require extensive washing but tend to be more durable than single-weight prints.

Martha Porter, Pioneer Woman,
Orderville, Utah,
circa 1961

I was traveling through southern Utah with an open eye and mind and plenty of film. The [Maynard] Dixons advised that I visit the town of Orderville, near Mount Carmel: "Should be nice things there!"

Early the next morning I drove to Orderville. I observed a nice old home with white porch pillars catching the early sun. As I came closer I became aware of an elderly woman sweeping the porch and I immediately knew there was promise in the morning air. I asked if I could photograph her by the white pillar. I made a few negatives with my Hasselblad, thanked her, and promised I would send her a print (and did).

Reconstructing the situation of this photograph I must say that the visualization was immediate and very clear. I saw the print about as you see it here. It prints handsomely now on Oriental Seagull Grade 2, although at the time I made the negative I was using Kodabromide F Grade 2 or Brovira Grade 3.

The picture haunts me. I have not yet made the print I desire. The tonal qualities of the woman's face please me, but I am not able to print through the blank sunlit area of her shoulder without getting a flat, textureless value, since the film is severely blocked in that area. The face values require a small amount of dodging because of their relationship to the background of the porch wall and roof. These values were very close in terms of black-and-white photography. In color photography the value-relationships of skin and wall would be well defined; the lightly suntanned skin again the gray-white of the wall could be well interpreted.

— ANSEL ADAMS

Image Tone

Black-and-white prints can have very subtle but distinctive colors ranging from brown to cold blue. The "white" paper base varies according to the manufacturer, and may be any shade from neutral white to ivory or buff; the hue of the print itself, moreover, can be altered by means of postdevelopment toning procedures.

The tint of a black-and-white image, like the print's other surface characteristics, strongly influences the impression that the photograph makes on the viewer. Ansel found that cold black tones deepened the emotional impact of his photographs; he used Rapid Selenium Toner to achieve the image tone he favored. Decisions regarding print tones are personal and should reflect your own aesthetic — but bear in mind that certain toning processes can cause the image to fade in time, and make your choice accordingly. (See chapter 9, pages 300–301, for more about toning.)

Paper Speed

Like film speed, the inherent speed of various photographic papers can be measured. Paper speeds are published as ANSI numbers, but unlike ASA or ISO numbers, these are seldom used by photographers or printers. Exposures are best determined by trial-and-error methods, since in making an expressive print, you are striving to create a mood, something that cannot be measured with an exposure meter.

Paper-speed numbers can be marginally useful if you decide to make a print on another type of paper (perhaps one with different contrast characteristics) after you have determined the proper exposure time for one type. By comparing the relative paper speeds, you can calculate the required adjustment in exposure time (for example, if the new paper has twice the speed of the first, half the exposure time will be needed). In practice, however, you will find that it takes longer to do the calculations than to make a new test print!

Paper Contrast Grades

As photographic enlarging papers evolved, manufacturers discovered that by altering the formulation of the emulsion, they could control a paper's *inherent contrast.* Thus, prints made on *low-contrast* paper that has been given four, eight, and sixteen seconds of exposure may show even steps of gray ranging from white to mid-gray, while an identically exposed *high-contrast* paper will produce three steps varying from white to mid-gray and black.

You can purchase papers in contrast grades from 1 (lowest contrast) to 6 (highest contrast), though not all grades are available for all types of paper. Grade 2 is generally considered to be *normal contrast,* but since there is no universal industry standard, you may find that a Grade 2 paper of one brand is approximately the same as a Grade 3 paper of another. For a given brand, however, the range of contrasts will be internally consistent.

You can also modify paper contrast through your choice of developer (see "Developer," page 265). This capability, combined with the many options available in contrast grades, provides you with a powerful creative control to exercise in printmaking.

For many photographers *variable-contrast papers* are now the preferable alternative to individually graded papers. They come in both resin-coated and fiber-based formats. Multiple-contrast papers have a blend of two emulsions (one high-contrast, the other low-contrast), each containing dyes sensitized to respond to a different part of the visible spectrum. By altering the color balance of the enlarging light with filters or using a *color head* (a variable-color light source), you can change the effective contrast grade of the paper. (*Note:* Because variable-contrast papers are sensitive to a wider spectrum of light than most other papers, you need to be certain that your safelights will not fog them; see "Testing Your Safelights," pages 278–279.)

Variable-contrast papers can be especially useful when you are learning to print, as they will save you from having to buy several different-contrast grades of the same brand of paper. See chapter 9 for a detailed discussion of printing with variable-contrast papers.

Contemporary Papers

Ansel was an exacting craftsman and constantly evaluated photographic materials. His understanding of the science of photography as well as its artistic potential made him a valuable consultant to the photographic industry. His views on enlarging papers can serve as a guide to the kinds of issues you should consider when you make your own selections.

> *Over the years I have used practically all brands of printing paper manufactured by Eastman Kodak, Agfa, Ilford, Oriental, DuPont, Zone VI Studios, and many others. Every photographer must contend with the issue of selecting papers, so it seems appropriate to comment on some of those currently available. These are personal preferences and are not intended to imply inherent superiority. I must also caution you that the manufacturers may alter the characteristics of their papers over time.*
>
> *Ilford Gallerie. This is a paper of very high quality which I use extensively. It is available in four grades. To begin with, Gallerie has a rather warm and slightly greenish color, but it tones differently from any other paper I have used. A few minutes in selenium toner changes the color to neutral. Thereafter it does not change color, but actually intensifies in contrast and depth of value — revealed visually and as a measurable increase in reflection density of the low values. Most papers intensify somewhat, but Gallerie does so to a greater extent, and without the marked color change that occurs with other papers. This ability to acquire some intensification during toning is a rewarding refinement of value control. The Gallerie papers are designed to have the same exposure speed for Grades 1 through 3, and one-half this speed for Grade 4; the matching of speed is not essential, but it helps reduce the time required to secure a good work print.*
>
> *Ilford Ilfobrom. Ilfobrom is of good quality and has been relatively consistent over the years. It is available in four contrast grades: I find Grade 2 developed in Dektol or Grade 3 developed in Selectol-Soft to be about "normal," and I can then depart from the norm as required. This paper tones well in selenium, although it does not take on the strong coloring of some other papers.*

Oriental Seagull. *This paper has had exceptional quality and consistency. It tones very well in selenium, but the toning process must be watched carefully as it is very easy to over-tone. Each of its grades appear to be higher in contrast than similarly numbered papers of other manufacturers. For example, I found that Seagull Grade 4 gives me a better print of my* Frozen Lake and Cliffs *than I was ever able to get on Agfa Brovira Grade 6, and the tone is magnificent. This is one of those significant early negatives (ca. 1932) that must be considered quite poor in quality and very difficult to print. The negative contains enough information to yield an acceptable print with great effort, and I continue to improve the "salvage" printing as best I can.*

Kodak papers. *I have used Kodak papers for decades with very good results. I have found that Kodabromide Grade 4 tones very well in selenium, but the other grades do not. Other Kodak papers, especially Azo, tone very well. I have had excellent results with Polycontrast in prints for reproduction. However, it does not tone in selenium as I would like; the two emulsions required for variable contrast tone differently, giving a good tone to the middle and low values and little, if any, tone to the high values. The result is a "split-tone" effect that I find unpleasant. [Note: Kodak has since introduced a premium-quality paper under the name Kodak Elite. It is a superb product that stands among the best photographic papers made today.]*

Zone VI Studios Brilliant. *The tests we have made on this new paper show it to be truly "brilliant," in that it has fine clean whites and an excellent value scale throughout. Its image coloring is slightly warm, but it tones very well in selenium.*

Agfa Portriga. *Portriga has a warm tone and rich value scale. I do not generally respond to warm print values, but Portriga does give excellent results for many photographers. Especially in portrait work, it can have a rewarding luminosity.*

An extensive line of high-quality graded and variable-contrast papers is now offered in the United States under the brand names of Kodak, Ilford, Agfa, Forte, Sterling, Cachet, and Luminos. The papers made by each manufacturer have distinctive features and differ in image tone, surface characteristics, paper thickness (weight), base color, and so forth. Photo stores usually have booklets provided by the manufacturer with samples of prints made on the papers they offer. Study these carefully and select a few to try — there is no one "best paper" and your selection should reflect your personal taste and aesthetic judgment. With experience you may be pleasantly surprised to find that certain of your negatives print more satisfactorily on other than your favorite or standard paper.

Chemicals
for Printing

The chemistry of development for photographic papers is the same as that for film, except that an extra step — *toning* — is sometimes added to alter the print color, intensify the blacks, and insure the permanence of the image.

Image contrast can be influenced by the temperature of development; for optimal processing, the temperatures of all the solutions should be kept near 68° F. As a practical matter, if your darkroom is within a temperature range of 65–75° F while you are printing, no additional efforts at temperature control will be necessary. If the ambient temperature is significantly higher or lower than this range, place the tray of developer in a larger tray of water (again, as close to 68° F as possible) to regulate its temperature. As long as they remain within reasonable limits, the temperatures of the other solutions are not critical.

Developer

The components of paper developers are essentially the same as those of film developer, though the formulations differ considerably. Virtually any printing task can be accomplished through the judicious use of one or both of two proprietary formulas such as Kodak's *Dektol* and *Selectol-Soft,* both low-contrast developers. The mixing of developers in varying proportions affords considerable contrast control during enlarging. Until you become highly skilled at making prints, you should restrict your use of print developers to these two or any other comparable pair that you can obtain commercially.

Dektol, in a standard dilution with water of 1:2 or 1:3, gives what we define as normal contrast with a development time of 2 to 3 minutes at 68° F. A quart of Dektol diluted with three quarts of water *can* develop sixty-four 8 x 10-inch prints or sixteen 16 x 20-inch prints, but it is never wise to use solutions to the point of chemical exhaustion. With Selectol-Soft, one ounce of stock solution, diluted 1:1 or 1:2, is required for each 8 x 10 print.

Excellent developers are offered by Ilford, Agfa, Cachet, Edwal, and others and may work especially well in combination with a specific paper. Photographers have historically liked to tinker with darkroom and developer formulas, often mixing chemicals from their basic components and insisting that Amidol or "Beer's Formula" or some other concoction works better than anything else. The truth is that all developers ultimately accomplish the same task, with only subtle nuances differentiating the final result. At the early stages of learning how to make a print it is best to stick with one or two basic commercial formulations.

Stop Bath

Development is terminated when the print is submerged in a stop bath consisting of a 1- to 2-percent solution of acetic acid. If you use 28-percent acetic acid as a stock solution, mix 1½ ounces with 1 quart of water. If you use glacial acetic acid, prepare the 28-percent acetic acid stock solution by mixing 3 parts of acid with 8 parts of water — *but be sure to add the acid to the water, not the other way around!* Some photographers simply pour a "dash" of glacial acetic acid into water to make the solution, but this is a bad habit to get into: while the exact concentration of acetic acid in the stop bath is not critical, it is always best to measure.

Mount Williamson, Sierra Nevada, from Manzanar, California, 1944

I made this photograph on one of my several trips from Yosemite to the Manzanar Relocation Camp in the Owens Valley of eastern California. It is a grand view of the Sierra from the camp; the main peaks rise more than eleven thousand feet above the desert floor.

With this high-contrast image I felt that Normal-minus-two development [about two-thirds of the normal development time] was required. On second thought I realized that ordinary minus development, while holding the extreme values within printable range, would weaken the separations in the shadows and low-middle values. Accordingly, I indicated water-bath development, which not only holds the high values within printable range, but also strengthens the shadow-area contrasts.

Printing this negative is not simple; I prefer to use a paper such as Ilford Gallerie Grade 2 with Dektol or Oriental Seagull Grade 2 with Selectol-Soft and Dektol stock solutions combined (500 cc Selectol-Soft stock, 1000 cc water and 100 cc Dektol stock). A generous toning in selenium gives a fine solidity of tone.

This is a subject that invites too-strenuous printing. I have made many prints that are too heavy because, in trying for maximum richness, I simply over-printed them. I have also made prints that are too light, as a thoughtless rebound from the heavy images.

I have been interested in the comments this photograph inspires, from its being a "paste-up" to being a plagiarism of Wagnerian moods! I have been asked, "Is this a real *photograph?" A badly enlarged blow-up was installed in the* Family of Man *exhibition at the Museum of Modern Art in New York (1955). A popular publicity photograph of this show was a picture of a child, facing the camera with arms fully extended, before the large foreground boulder; the rock was larger than his reach. It was a very literal and shallow idea and represented a questionable level of appreciation. As Queen Victoria remarked, "We are not amused."*

— ANSEL ADAMS

Fixer

"Fixers" dissolve undeveloped silver salts, which are then washed from the print. Kodak Fixer is a powdered blend of sodium thiosulfate and an alum hardening agent that toughens the gelatin to prevent scratching or peeling of the surface of the print during processing. Unfortunately, hardeners also inhibit toning and increase the required washing time. Unless you are forced to keep prints soaking for an extended period of time or use wash water at temperatures above 80° F and experience emulsion damage during print handling, *use an ammonium thiosulfate fixer without adding the hardener.*

Ilford Universal Fixer, Edwal Quick Fix, Kodak Rapid Fixer, Heico NH5 Fixer, and Agefix Rapid Fixer are all ammonium thiosulfate–based products and work very well as print or negative fixers. Fixing and washing times are markedly faster with these products and archival permanence is easy to achieve when you follow the procedure detailed in the subsequent text.

Washing Aid

Washing aids, or hypo clearing agents, accelerate and promote the elimination of fixer from the paper and the emulsion and in so doing substantially decrease washing time. Since paper is highly absorbent, this is an *extremely* important step in the postfixing treatment of the print.

Toner

Toners serve the dual function of adding color and depth to black-and-white photographs and protecting them from the elements.

Sulfide toning converts the print to a brown or sepia color, and the image is permanent. The process is used primarily by studio photographers for portraiture or for "old-time" effects.

Selenium toning causes a shift in print color to a cool black tone, or a red-brown hue if the toning is prolonged or if warm-tone papers are used. Selenium toning is inexpensive, and the toner can often be added to the washing aid, thereby saving you an extra step.

Gold toning produces a blue-black print color, but with some warm-tone papers tones ranging from red-brown to blue-black can be obtained by controlling the duration of toning and alkalinity of the bath. Gold toning enhances print permanence.

A number of toners on the market convert black-and-white prints to various colors. These should be used with caution since they often degrade the image over time and can easily result in a print that is "kitschy."

Making a Proof Sheet

Setting Up the Darkroom

To prepare for printing, separate the "dry" and "wet" areas of your darkroom, keeping the enlarger, contact printing frame, photographic paper, and negatives well away from the sink, trays, and processing solutions (see figure 7.5).

Setting Up the Wet Side of Your Darkroom If your sink is large enough to accommodate four trays, arrange them in it side by side. Set the trays several inches apart to avoid cross-contamination of solutions through accidental splashing. If you are using a tabletop or counter, cover it with a plastic sheet or carpet runner before you place the trays on it. Prepare your solutions as follows.

Developer: Dilute the developer stock solution or mix the powder according to the instructions on the package. Decide whether you want to work your way through the various processing solutions from left to right or from right to left, and then pour the working-strength developer into the first tray. Make certain that there is sufficient developer to fill the tray to a depth of at least 1 inch.

Stop bath: To make a stop bath, add 1½ ounces (about 40 milliliters) of 28-percent acetic acid, or 10 milliliters of glacial acetic acid, to 1 quart or liter of water. Pour 1 quart (or liter) of prepared stop-bath solution into the second tray.

Fixer: Measure out 1 quart (or liter) of fresh fixer and pour it into the third tray.

Water bath: Fill the fourth tray at least half full with water. This will serve as a storage tray to hold prints for further processing; it should be emptied and refilled with fresh water as new prints are added to it.

Water bucket: Fill a bucket with water and leave it in the sink; you will need to rinse your hands frequently during processing, and this will save you from having to rinse fixer solution off the faucet handles every time you turn on the tap. If you prefer, you can use the water bath for rinsing.

Towels: Make sure that you have an adequate supply of cloth and paper towels to dry your hands with and wipe up spills. When you use a cloth towel *be certain* that your hands have no chemicals on them when you wipe them off, or each print you handle thereafter may be marred by your chemical-laden fingerprints. Launder towels frequently.

A

Figure 8.14: *The darkroom.*

(A) A general view of Ansel's darkroom from near the entrance shows the 8 x 10 enlarger and magnetic easel to the left, both on a track system built into the floor. Not visible behind the easel in this view are two 4 x 5 enlargers, which can be used in a horizontal configuration to project onto the far side of the easel. An emergency exit is at the far end of the darkroom, and to its right, also not visible here, is a film-loading area, with shelves for storing enlarger lenses and related equipment. This latter area is separated from the "wet side" sinks by a partition. The most distant sink is large enough to contain three 20 x 24-inch trays, and the second sink is used for water storage after fixing. The closest sink contains two 16 x 20 archival print washers. Note the drain holes connecting the sinks; these serve to protect against the possibility of overflow if one drain becomes blocked.

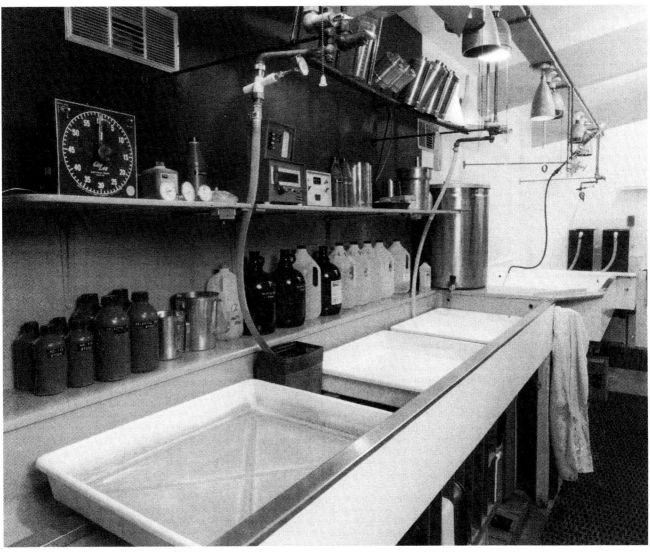

B

(B) This view is from the position of the developer tray. The storage for mixed chemicals is visible, as are the overhead racks that hold developer tanks, graduated cylinders, and funnels. The shelf over the sink holds two digital timers and the Gra-Lab, as well as thermometers and so on. The overhead lights have pull-chains, which are fully insulated. Note also the racks beneath the sink, used for trays.

Procedure for Making a Proof Sheet

The first step in the printing process is to evaluate your negatives. This can be done most easily by making a contact print on glossy RC paper and examining it carefully. Be sure to use a printing paper with a low contrast grade (1 or 2) so that a maximum amount of negative detail will be revealed in the print.

1 To begin your darkroom session, **turn on your safelights.** Remember that sodium vapor lamps take approximately 5 minutes to reach their full intensity. (See "Testing Your Safelights," pages 278–279.)

2 Make sure your negatives are free of obvious dust. If necessary, clean them with a brush or compressed-air blower. A few odd specks won't matter on a proof print.

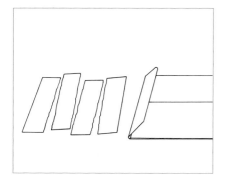

3 **Turn off the room lights**, remove a sheet of printing paper from the package, and cut or tear it in half or in fourths —whichever size will allow the negative or strip of negatives to fit on the paper with an ample margin on all sides. Place a section of the paper, emulsion (shiny) side up, in the contact printing frame and return the remainder to the package.

4 Put the negative (or strip) down on top of the paper, making sure that the emulsion (dull) side of the negative is in contact with the emulsion (shiny) side of the paper.

5 Cover the paper and negative(s) and paper with the glass top of the frame and then place the frame on the enlarger baseboard. Using a sheet of opaque cardboard (about 11 x 14 inches), expose the paper at intervals of 5, 10, 15, 20, and 25 seconds, as follows. ◄

6a If you are using an enlarger connected to a timer, set the timer for 5 seconds. Activate the timer to expose the paper. Slide the sheet of cardboard forward to cover 1 or 2 inches of paper and activate the timer once again. The second segment will now correspond to 10 seconds of exposure. Repeat the procedure three more times. You will now have a strip of exposures corresponding to 5, 10, 15, 20, and 25 seconds.

6b If you are using a metronome, set the frequency at 1 beat per second and turn on the enlarger light, making certain that the cardboard sheet is shielding the printing paper from exposure. Slide back the cardboard to expose the strip, and begin counting beats immediately. At the count of *five*, quickly move the cardboard shield forward to cover a 1- to 2-inch segment, and continue the count. Move the cardboard forward three more times, at the 10-, 15-, and 20-second marks. At 25 seconds, cover up the entire strip as fast as you can and turn off the enlarger light. You will have a strip of exposures corresponding to 5, 10, 15, 20, and 25 seconds.

7 Remove the printing paper from the frame and set the interval timer for 2 minutes.

8 Start the timer as you immerse the print in the developer. Develop the print for 2 minutes, agitating it constantly by gently raising and lowering one end of the tray so that the solution continually washes over the print's surface. Lift the print out of the developer and hold it over the tray for the last 10 seconds of the cycle to drain the excess solution. ◄

9 Transfer the print to the stop bath, agitate it for 20 seconds, and then let it drain over the tray. ◄

10 Transfer the print to the fixer and agitate it for about 2 minutes. You can **turn on the room lights** after 1 minute. Drain the print and transfer it to the water bath.

11 Examine the test proof sheet. Decide which exposure or portion of the negative looks most like a normal rendition of the scene. If the 10-second segment is too light and the 15-second segment is too dark, estimate what exposure in that range would be about right and use that time to make the final proof. For the purposes of a proof print, the exact time is not critical.

12 **Turn off the room lights.** Take out a full sheet of printing paper, insert it in the proofing frame, and place the negative(s) on top of it, as before. If you are proofing a roll of 35mm or 2¼-inch negatives, arrange them so that they are all right side up and in sequence. Cover the negatives with the glass and expose the entire sheet for the appropriate time.

13 Develop the paper. When fixing is complete, rinse the print and wash it for 4 or 5 minutes in running water.

14 Attach a film clip or clothespin to a corner of the print and allow it to dry in a clean, dust-free area of the darkroom. ◄

15 If you have other negatives, make proof sheets of them using the same procedure.

Clean your darkroom and equipment thoroughly while the prints are drying. Pour all the chemicals down the drain. (If you plan to reuse the fixer, return it to its original container and note the number of 8 x 10 prints—or the equivalent — that you processed on a label affixed to it.) Rinse all of the trays thoroughly with water and set them on end in the sink to drain and dry. Wipe up any spills or drips with a sponge that you use only for that purpose, and then rinse the sponge thoroughly.

Mark the height of the lamp housing on the enlarger and note the lens aperture you used in a notebook. These will serve as standards for future prints. As your technique improves, your negatives will begin to show a consistent density range. When you set your light source at the standard settings and use your standard exposure time, the result will be a proof print that is easy for you to evaluate.

Once you have selected the image or images that you want to pursue and have determined the approximate exposure and printing parameters, you can proceed to the final steps of making an enlargement and then a fine print, outlined in the following chapter.

For a summary of the process used for making a proof print, see pages 322–323.

Figure 8.15: *Contact sheet of a roll of 35mm film.* (Alan Ross, *Ansel and Imogen Cunningham, Carmel, 1975*)

Figure 8.16: *Proof sheet of 4 x 5 film.* Contact prints of large-format negatives provide sufficient detail to enable you to make preliminary judgments about cropping and enlarging the negative. (Alan Ross, *Tioga Lake, Clouds, High Sierra, 1979*)

Testing Your Safelights

Safelights should be bright enough to enable you to see well in the darkroom but not so bright that they fog your printing paper. Fogging is most obvious in the highlight areas of a print, where light grays are degraded to darker grays. The following tests will help you determine whether the intensity of your safelights is too great. The ease of processing offered by RC papers makes them an ideal choice for these tests and for proof prints.

Figure 8.17: *Effects of safelight fog.* The left third of this image illustrates the problems caused by too-bright safelights. Fogging primarily affects the lighter tones, degrading brilliant highlights to grays. (Ansel Adams, *Half Dome from Glacier Point, Thunderstorm, Yosemite National Park, 1947*)

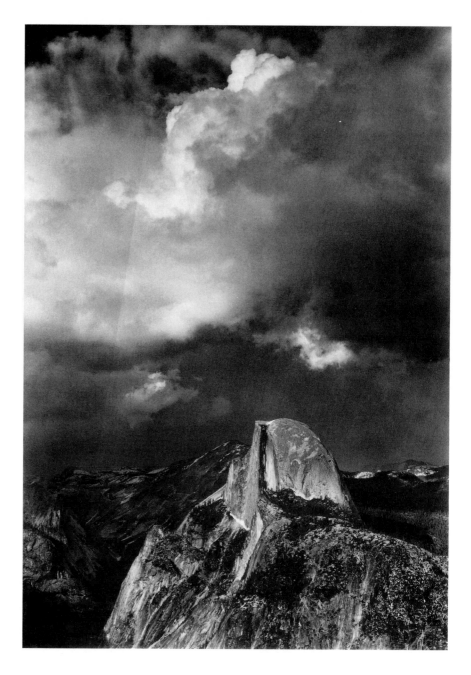

Figure 8.18: *Testing for safelight fog.*
(A) Test exposures to determine the exposure time needed to obtain a light-gray tone. The exposures correspond to 6, 12, 15, 20, and 25 seconds, from top to bottom. (B) A strip that was exposed for 12 seconds, then covered and further exposed to a too-bright safelight.

1. Place your package of printing paper, a scissors or paper trimmer, and a sheet of opaque cardboard (about 11 x 14 inches) near the enlarger. **Turn off all the room lights EXCEPT for the safelights.**

2. Remove a single sheet from the package of printing paper and cut it into a series of strips about 1 inch wide. Put all but one of the strips back in the package and reseal it.

3. Place the strip of printing paper in your contact printing frame, emulsion (shiny) side up, and close the frame. Center the frame directly below the light source and cover it with the sheet of cardboard.

4. Make a series of exposures in steps of 5 seconds as described in the procedure for making a proof print (steps 6a and 6b, page 273), leaving an unexposed segment at the end of the strip.

5. Develop and fix the test strip (see pages 273–274). At the same time, put an unexposed, undeveloped strip of paper directly into the fixer; this will serve as a reference for the *paper-base white tone.* Halfway through fixing, you can **turn on the room lights.**

6. Examine the exposed strip (see figure 8.18). Look for a segment that is just slightly off-white and darker than the unexposed section. Note the exposure time of that segment. If all of the segments are too dark, repeat the experiment, but this time stop down the enlarger lens further, raise the height of the enlarger head, or use shorter increments of exposure.

7. **Turn off all the room lights EXCEPT for the safelights** and remove two strips from the package of printing paper.

8. Place the two strips in the contact printing frame and expose them simultaneously for the amount of time required to produce the off-white tone.

9. Cover half of each of the exposed strips with the sheet of cardboard and allow them to remain on the baseboard for 3 minutes, illuminated only by the safelight that normally covers that area.

10. At the end of the 3 minutes, put one of the strips back in the package to protect it from further exposure, then develop the other strip **with the safelights on.**

11. **Now turn off all the safelights.** Remove the second strip from the package and develop it.

12. When processing is complete, **turn on the room lights** and examine both strips. If they look identical and there is no difference between the two ends of each one, your safelights are safe to use as they are. If the strip that was processed in the dark is lighter than the other one, the safelight over your processing trays is too bright; move it farther away from the trays, or use a bulb with lower wattage. If the two ends of each strip do not match, the safelight near your enlarger or light source is too bright; move it farther away from the baseboard and repeat the experiment until no difference is visible.

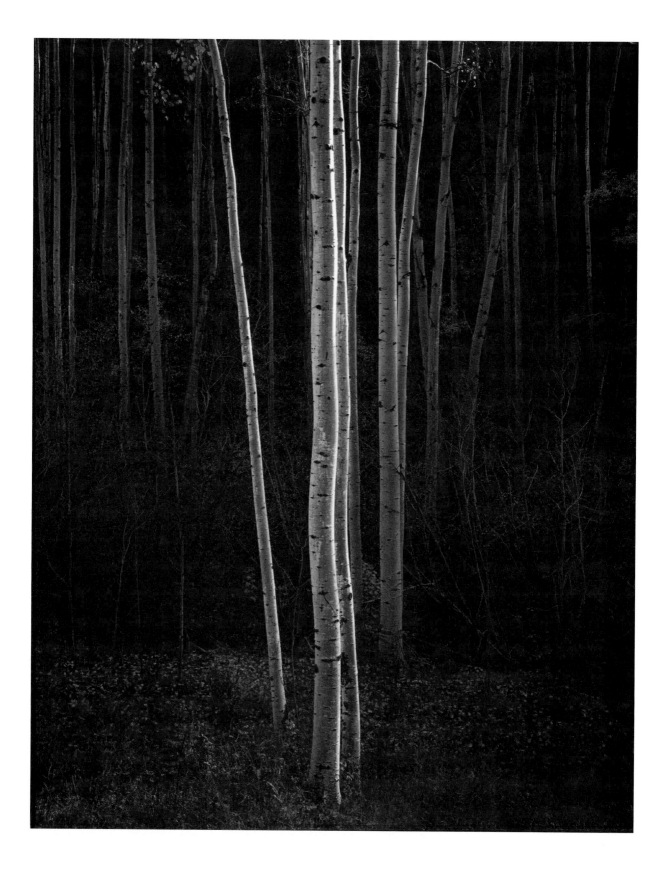

Chapter Nine

Making a Fine Print

The differences between various stages of work prints leading to the fine print are often subtle, and require meticulous craftsmanship. Even with the best equipment and competent procedure, the control of print quality is sometimes very difficult. I know from experience that there are no shortcuts to excellence. Inadequate attention to procedure or archival considerations will yield less-than-optimum results. However, the technical issues of printing must not be allowed to overwhelm the aesthetic purposes: the final photographic statement should be logical and complete, and transcend the mechanics employed.

Frequently you will find that several means are available to achieve a desired effect. Judgment and experience are required to make such choices efficiently and I urge you to approach the learning process with patience. . . .

In printing we are trying to breathe expressive life into the image, and this raises intangible issues that do not yield to formulas or measurements. — ANSEL ADAMS

Fine print is a term that Ansel reserved for those photographs that met the highest standards of technical excellence and succeeded in portraying the images he visualized. All of the intermediate prints between a contact proof sheet and the fine print are called *work prints*. Each work print represents a discrete step along the route to a fine print; taken all together, these form a visual record of the printer's efforts to extract the visualized image from the contents of a photographic negative.

Examining the Proof Sheet

I find printing the most fascinating aspect of black-and-white photography. It is especially rewarding to me, when I am going through the thousands of negatives I have never printed, to find that I can recall the original visualization as well as discovering new beauty and interest which I hope to express in the print.

The quest for a fine print begins with an evaluation of your proof sheet. If you work with a 35mm camera, the sheet will contain a record of as many as thirty-six images. It is unlikely that you will want to (or should!) make a fine print of

Figure 9.1: Ansel Adams, *Aspens, Northern New Mexico, 1958.*

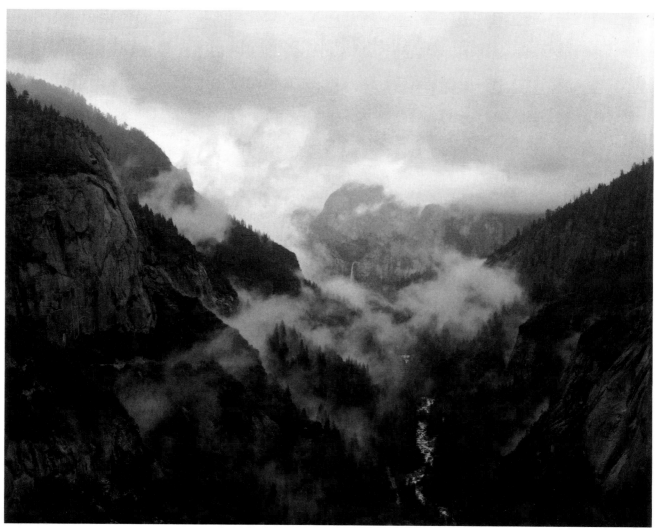

A

Figure 9.2: Alan Ross, *Bridal Veil Fall in Storm, Yosemite National Park, 1974.* These two figures provide a comparison of what the camera saw at the moment of exposure (A) and the image as visualized by the photographer (B). The fine print was made on a grade 4 paper and required significant dodging and burning to bring out the intended mood.

each: it takes time to print and finish a photograph, and you will be disappointed if you repeatedly spend hours attempting to produce a good print of a mediocre image. Your first task, then, is to select the images that have the greatest potential and concentrate your efforts on printing those. (Ansel's photographic archives contain more than 35,000 negatives; he never bothered to print the majority of those because he recognized that the images would not meet his expectations. Every photographer needs to be a critical editor of his or her own work.) When you scan a proof sheet, try to detach yourself from any emotional involvement with the subject: pretend you are looking at someone else's work, and be as objective as possible about the images you choose to pursue.

The first quality you should assess in an image is *content.* Does the image contain the message that the scene evoked when you took the photograph? Do not concern yourself with such issues as image contrast, light and dark values, or miscellaneous details that distract your eye — such problems can often be corrected or even eliminated altogether in printing. If the essence of the visualized image is recorded on the negative, a skilled printer will be able to convey it in a print.

Photographers often take multiple photographs of the same scene, each from a different point of view, refining their visualization as they proceed.

Whenever Ansel found a subject that he believed might result in an extraordinary photograph, he would endeavor to make a duplicate exposure to serve as insurance in case something should go wrong during processing. If you take alternative versions of the same subject, you will need to carefully evaluate them before making a final selection. Be sure, too, to compare the relative merits of different compositions of similar images: often a subtle feature such as the changing shape of clouds in a landscape can have a significant impact on a photograph. Inspect the proof sheet with a magnifying glass, looking for sharp focus and the presence of adequate shadow detail. Circle the most promising images with a marker and identify the corresponding negatives.

With small-sized negatives (35mm and 2¼-inch roll film), it can be difficult to make a final evaluation directly from a proof sheet. An image may be in acceptably sharp focus in a proof sheet but unsatisfactory when enlarged; then, too, enlarging also magnifies any defects in the negative. It is wise, therefore, to make an enlarged proof print of every negative that survives your first editing. A 5 x 7 or 8 x 10 photograph is much easier to analyze than one of postage-stamp size.

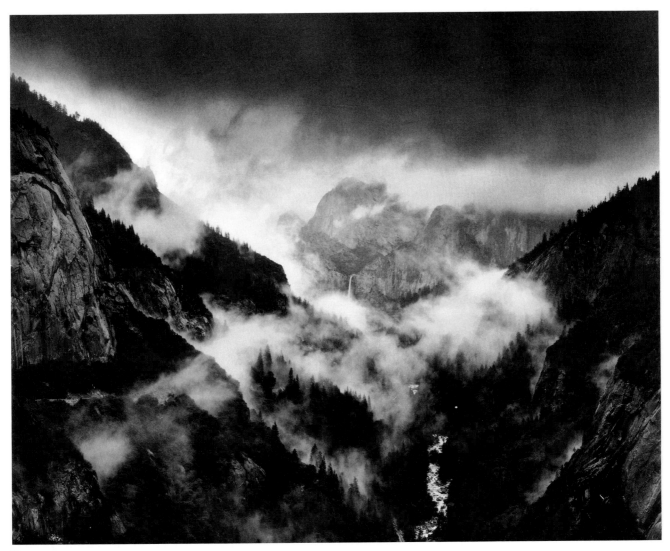

B

Procedure
for Making
an Enlargement

Making an enlargement involves the same basic procedure used in making a proof sheet (see pages 272–275), except that the image of a single negative is projected onto the printing paper by the enlarger. Your darkroom should be set up just as it would be if you were making a proof sheet, with a "dry" side and a "wet" side, and all of your solutions should be arranged as described on page 269. As you work from a simple enlargement toward a fine print, however, you will need to modify or refine some of the processing steps. RC papers are ideal for making enlarged proof prints: processing requires less than five minutes, and prints can be dried quickly with a hair dryer.

1 To begin your darkroom session, **turn on your safelights.** Remember that sodium vapor lamps take approximately 5 minutes to reach full intensity. (See "Testing Your Safelights," pages 278–279.)

2 Clean and dust a negative (use a brush and compressed air if necessary) and place it in the negative carrier.

3 **Turn on the enlarger light** and position the negative carrier in the enlarger. ◄

4 Insert a sheet of white paper in the enlarging easel. (The back of an old print will work nicely.) ▶

5 **Turn off the room lights.** With the enlarging lens set at its maximum aperture, compose and focus the projected image of the negative on the surface of the paper held in the easel. You will need to raise or lower the lamp housing to do this. Leave a margin of at least ¼ inch between the edge of the image and the edge of the paper. ◄

6 Move the blades of the easel to the edges of the image to define its borders. Do not attempt to crop the image at this point. Use a focusing magnifier (if you have one) to achieve sharp focus.

7 Stop down the enlarging lens two or three stops below maximum aperture and **turn off the enlarger light.**

8 Cut a sheet of normal-contrast (grade 2) printing paper into test strips at least 1 inch wide and store all but one of them in a light-tight package, box, or drawer. Place that strip on the easel, emulsion (shiny) side up, in an area of the image that has a range of tones; this will make it easier to judge the exposure. Using a sheet of opaque cardboard, expose the strip at intervals of 5, 10, 15, 20, and 25 seconds, as follows.

9a If you are using an enlarger connected to a timer, set the timer for 5 seconds. Activate the timer to expose the strip. Slide the sheet of cardboard forward to cover 1 or 2 inches of paper and activate the timer once again. The second segment will now correspond to 10 seconds of exposure. Repeat the procedure three more times. You will now have a strip of exposures corresponding to 5, 10, 15, 20, and 25 seconds.

9b If you are using a metronome, set the frequency to 1 beat per second and turn on the enlarger light, making certain that the cardboard sheet is shielding the printing paper from exposure. Slide back the cardboard to expose the entire strip, and begin counting beats immediately. At the count of *five,* quickly move the cardboard shield forward to cover a 1- to 2-inch segment, and continue the count. Move the cardboard forward three more times, at the 10-, 15-, and 20-second marks. At 25 seconds, cover up the entire strip as fast as you can and turn off the enlarger light. You will have a strip of exposures corresponding to 5, 10, 15, 20, and 25 seconds.

10 Develop the test strip with constant agitation for 2 minutes. Move the strip to the stop bath for 30 seconds, agitating continuously, and then transfer it to the fixing bath. Agitate for 30 seconds and then **turn on the room lights.**

11 Inspect the strip to see which section corresponds to the correct exposure. If none does, expose and develop another test strip, increasing or decreasing the exposure as appropriate by changing the aperture of the enlarging lens and/or the exposure time. Try to keep the exposure in the range of 10 to 20 seconds for convenience' sake. ◄

12 When you have determined the correct exposure from a test strip, you are ready to make an enlargement. **Turn off the room lights** and remove a sheet of paper from the package. Write the aperture and exposure time you intend to use on the back of the sheet in pencil, then place the sheet in the easel, emulsion side up.

13 Expose and develop the print. Fix it for the time recommended by the manufacturer, wash it in running water for 2 minutes, and hang it from a clip to dry.

Follow the exact same procedure for all the negatives you are evaluating. If the negatives are from a common source (such as a single roll of film that was consistently exposed), you can use the same exposure times and apertures for each without having to make individual test strips.

Clean your darkroom and equipment thoroughly and take notes as you would following any darkroom procedure.

Evaluating
Proof Prints

The creativity of the printing process is distinctly similar to the creativity of exposing negatives: in both cases we start with conditions that are given, and we strive to appreciate and interpret them. In printing we accept the negative as a starting point that determines much, but not all, of the character of the final image. Just as different photographers can interpret one subject in numerous ways, depending on personal vision, so might they each make varying prints from identical negatives.

The size of enlarged prints makes them easier to evaluate critically than proof sheets. If you have several variations of one basic image, spread them out on a well-lighted surface and consider each carefully, concentrating primarily on content and composition. Make and use a pair of L's to mask and crop the images; this will help you eliminate unnecessary or distracting details or empty spaces that surround the center of interest. Use a felt-tip pen to mark the desired edges of the image directly on the surface of the print.

Take your time in evaluating the images. Making a fine print requires considerable time and effort; careful evaluation of enlargements can save you from spending hours on prints that you will later reject. When you have made your selection, your next step is to produce a work print.

Making
and Refining
a Work Print

The process for making a work print is almost identical to that used for making an enlargement. Even though you may ultimately choose a different format, it is generally best to refine the printing of an image on 8 x 10 paper; prints of this size are easy and economical to process and large enough to convey a "presence" of their own.

The first question you need to address is which contrast grade of printing paper will be most suitable for the print you have visualized and are trying to create from the negative in hand. The following procedure will help you to determine which contrast grade you should use.

Scaling the Contrast of the Printing Paper to the Contrast of the Negative

1. Begin by cleaning the negative very carefully and placing it in the negative carrier. Examine the negative in the carrier by holding it at eye level, with the surface of the film almost directly in line with a bright light. Use compressed air to blow away any dust particles that you see, then slide the negative carrier into its compartment in the enlarger.

2. **Turn on the enlarger light and the safelights, then turn off the room lights.** Place a sheet of white paper in the enlarging easel and compose and frame the image. Mask it as needed with the blades of the easel, using the cropped image of your proof print as a guide. Leave a border of at least ½ inch on all sides.

3. Find the lightest area of the proof print and use a test strip to determine the exposure needed to reproduce *only* this tone at the appropriate gray value.

4. Place an 8 x 10 sheet of enlarging paper in the easel and expose it for the time determined in step 3. Process the paper and fix it for 2 minutes with agitation. **Turn on the room lights** and rinse the print in running water for 1

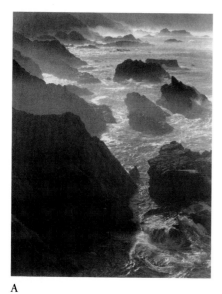
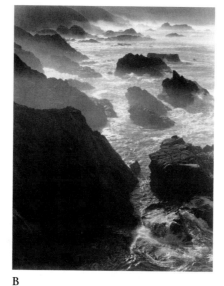
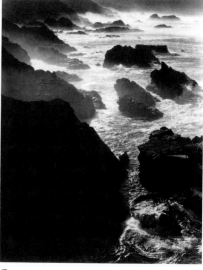

A B C

Figure 9.3: *Effect of paper contrast grade.* The interpretation of a scene can be dramatically influenced by the contrast grade of the paper it is printed on. These three prints were made from the same negative on (A) grade 0 (low-contrast); (B) grade 2 (normal-contrast); and (C) grade 4 (high-contrast) paper. (Alan Ross, *Rocks and Mist, Otter Cove, Big Sur, 1980*)

minute. Drain the print, lay it on a flat surface (the bottom of a clean tray will work nicely), and squeegee away the excess water.

5. Examine the print under a bright light. Look at the darkest tones; if they are uniformly black and show no signs of texture where texture clearly exists in the negative, then the contrast scale of the paper is too high. Remake the print on a lower-contrast paper (that is, one with a lower grade number) and repeat the process if necessary until both the textured whites and the textured blacks are appropriately rendered. If, on the other hand, the whites in the print are satisfactory but the darker areas are dark gray rather than black, then the contrast grade of the paper is too low. You will need to remake the print using a higher-contrast paper (one with a higher grade number).

When the extremes of the gray scale of the print (that is, its light values and dark areas) are close to what you visualized, the contrast of your printing paper will be correctly scaled to that of your negative. As you work toward a fine print, you can fine-tune the scaling even further by means of the following techniques.

Making a Fine Print

Altering Selected Tones by Dodging and Burning

There is no doubt that we can take an inferior negative (inferior in the technical sense, but of expressive significance) and work wonders with it by imaginative printing procedures. We cannot create something from nothing — we cannot correct poor focus, loss of detail, physical blemishes, or unfortunate compositions — but we can overcome (to some extent) such accidents as overexposure and over- or underdevelopment with reduction or intensification of the negative and numerous controls in printing.

Dodging and *burning* are two techniques for altering print tones. Dodging involves shielding selected areas of the print during normal exposure in order to lighten their tones; burning entails giving additional exposure to specific areas, resulting in darker tones. If performed with care, these techniques will enhance the visual impact of the photograph.

In dodging, light is usually held back during the basic exposure by means of a homemade wand called a *dodging tool,* which casts a shadow on a predetermined area of the print. To make a dodging tool, take a wire coat hanger or a piece of baling wire, form a loop at one end to serve as a handle, and glue or tape a disk of opaque cardboard onto the other end. The distance between the handle and the disk should be about 12 to 15 inches. Make up several, with disks of varying shapes, including a couple of small circles (perhaps 1 and 2 inches in diameter),

Figure 9.4: *Dodging wands.* (A) These helpful printing aids can be easily made with a length of stiff wire, some electrical tape, opaque cardboard, and a pair of pliers. With a large wand, you may want to fashion a simple handle out of tape to enable you to manipulate the wand during dodging. (B) When the disk is held close to the paper, its outline is quite sharp. (C, D, E) As the wand is raised, its outline becomes larger and more indistinct. The soft edge, called the penumbra, is useful for "blending" the dodged area with its surround.

A

B

C

D

E

Graffiti, Abandoned Military Installation,
Golden Gate Recreational Area, California, 1982

I have made a considerable number of photographs of subject matter other than the natural scene. I do not have different basic attitudes toward various subjects; if I am excited by a possible image — be it natural or related to the works of man — I respond with creative enthusiasm.

I used my Hasselblad 2000 with the 250mm Zeiss Sonnar lens; this gave a good perspective and revealed more of the deeply recessed inner wall than would a lens of shorter focal length. I wanted to render the white circular shape with brilliance yet enhance what little texture it contained. Actually, it was a light-gray value against a middle-gray wall. These two values could easily be controlled in themselves, but the shadowed areas were about one-sixth the luminance of the sunlit wall and presented a value-control problem. The shapes in the shadowed areas were important in terms of the total composition and required strengthening in contrast beyond their measured values. I gave the Ilford FP4 roll film Normal-plus-one development [150 percent of the normal development time for this film] in Kodak HC-110 (diluted 1:7).

Making the print was much more difficult than determining the negative exposure. The visualized values for both sunlit and shadowed areas required luminous local contrast for the shadows and a bright but textured value for the sunlit shape. The basic information was in the negative but required considerable enhancement in the print. I might have enhanced the shadow values by further increasing the development time, but this would have increased the density of the sunlit area and called for the use of a lower-contrast paper with attendant loss of brilliance. Local contrast in both areas would have suffered — not in the informational but in the aesthetic sense, relating to my original visualization.

I first made a very soft proof to confirm what the negative contained. It was obvious that the sunlit shape was rather low in texture. A print on Grade 2 paper helped it little. I then tried Oriental Seagull Grade 3 and got a full range of values and information, but the feeling of light and texture was not satisfying. I went on to Seagull Grade 4 but found that with Dektol the image was of too high contrast; it was impossible to hold desired values in both sunlit and shadowed areas. I then prepared the developer as follows: 500 cc Kodak Selectol-Soft, 1000 cc of water, and 100 cc Kodak Dektol. The print exposure was made to favor the high values, and some dodging of the shadowed areas with a rectangular card was required. Increasing the proportion of Dektol to 200 cc gave a more satisfying tonal range. — ANSEL ADAMS

an oval, and some small rectangles. For certain prints you may need to custom-design a disk of a specific shape.

If you want to darken a particular part of a print, you can burn it in. With this technique, you expose one area for a longer period of time than the rest of the print by using a piece of cardboard with a hole cut out, which serves to protect all but that area from further exposure. The hole or edge in the cardboard (old prints also work well) should be cut to match the shape of the area you want to darken. The side of the card that faces the enlarger or light source should be white; that which faces the print should be dark to prevent back-reflection of

Figure 9.5: *Burning-in cards.* (A) Scrap pieces of cardboard or mounting board with holes of various shapes cut out provide a convenient means of burning-in areas of a print that need additional exposure. (B, C, D, E) As the card is moved toward the enlarger lens and away from the paper, it affects a larger area, with a softer edge, or wider penumbra.

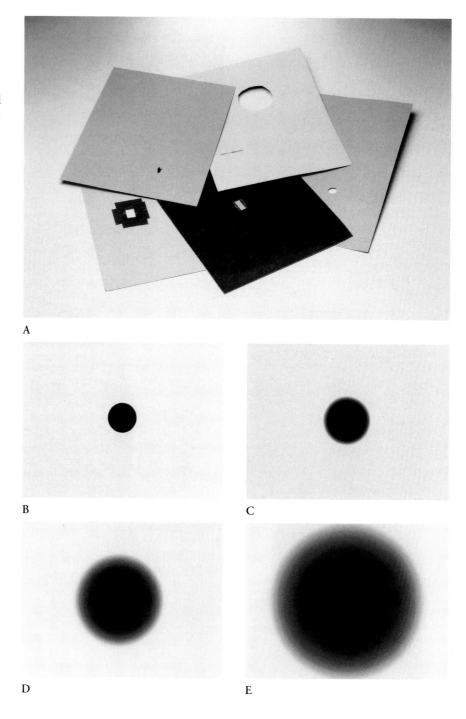

A

B

C

D

E

Figure 9.6: Alan Ross, *Leidig Meadow, Evening Clouds, Yosemite National Park, 1983.* (A) A straight print. A lower-contrast-grade paper would hold more of the values, but the overall separation of values would be weak. (B) Printing on a slightly harder-than-normal-contrast-grade paper with major dodging and burning-in creates a dramatic and satisfying image.

A

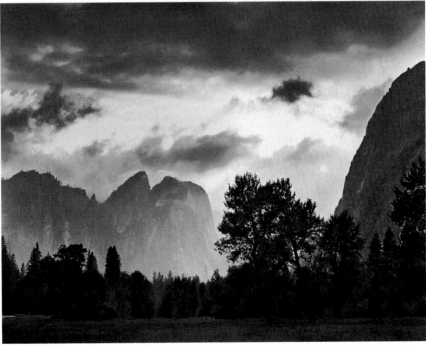

B

light from the print surface, which can fog the image. The latter is especially critical when the exposure time for burning-in is going to be very long.

To dodge or burn-in successfully, you must keep either device in constant motion so that the areas that are being exposed to additional light or shielded from exposure will blend naturally with the surrounding areas. If the tool is held far away from the print surface, it will project a softer outline of its edge, making it easier to blend in the areas.

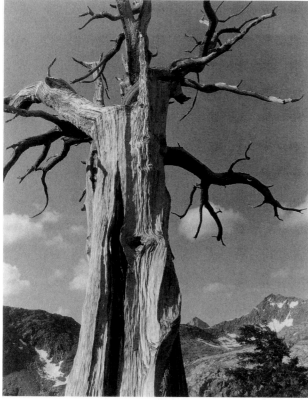

A

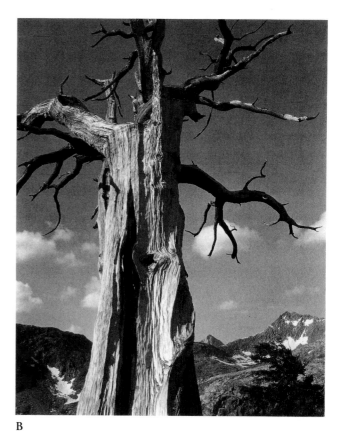

B

Figure 9.7: Ansel Adams, *Dead Foxtail
Pine, Little Five Lakes, Sierra Nevada,
c. 1929.* (A) A straight print from the 4 x 5-
inch negative. The flare on the left side
comes largely from the sun, which was
fairly close to Ansel's field of view. The lens
was uncoated and the sunshade inadequate.
(B) Judicious edge burning equalized the
values. The left and right sides were burned
down to balance the flare, and the top left
corner also received some burning; the
bottom corner areas were lowered in value
by the edge burning. Finally, a short
burning along the bottom edge gave some
solidity to the image.

Edge Burning The intensity of light at the edges of a print is often lower than
that at its center, either because the negative is overdeveloped at the edges or
because there is a fall-off of the light intensity of the enlarger between the center
and the edge. You can compensate for this variation by burning-in the individ-
ual edges of the print, separately and selectively, as follows: when you have
completed the basic exposure and selective dodging and burning of the print,
shield the enlarging lens with a sheet of cardboard and begin moving the
cardboard back and forth to expose whichever edges of the image require
additional exposure. The action should be similar to raising and lowering a
curtain. You will need to experiment to find out exactly how much additional
exposure the print requires.

Print Size

> *Photomurals . . . enlargements with a vengeance. . . . Apart from optical
> and technical considerations, the size of a photograph has an expressive
> relationship with the subject — no matter under what conditions of display
> it is seen. The subject itself is not an important factor in the determination
> of the best size of print, although we usually think of small objects requiring
> more intimate treatment than large, inclusive subjects would demand. It is,
> rather, the textural and compositional aspects of the photograph that
> determine the scale of the finished print.*

At some stage you will need to give some thought to print size. The message conveyed by an image often depends upon the size of the print itself: for example, a 5 x 7-inch print of a flower may invite you to approach and examine it more closely, while 50 x 70-inch mural of the same subject will overwhelm you and force you to see the flower in a very different way. Image size is an important aesthetic concern.

From a practical and economic standpoint, it is a reasonable strategy to make work prints in a size small enough to be within your budget and yet large enough to reveal a print's full potential, allowing you to make judgments on the resolution of details, grain, tones, and so forth. Even after you have developed considerable skill in printing, you may still need to run through a half-dozen or more trial prints before you get one that begins to satisfy you. As a beginner, you should probably limit your initial efforts to prints no larger than 8 x 10 inches; by the time you achieve a print that would benefit from further enlargement, you will have obtained enough experience to make a bigger print with ease.

Figure 9.8: Ansel Adams, *Aspens, Northern New Mexico, 1958.* **This image is an example of a scene that Ansel visualized in two distinctive ways (see figure 9.1). Each version is unique and has a presence all its own. Often a slight change of position or a shift from a vertical to a horizontal format will dramatically change the interpretation of a subject.**

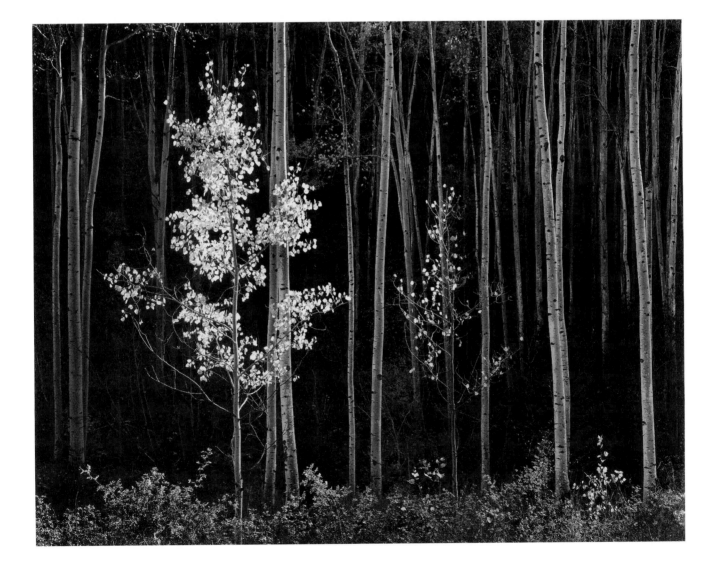

Figure 9.9: *Print viewing board.* Evaluating wet prints in the darkroom is best done by squeegeeing the wet print onto a sturdy white Plexiglas sheet and examining it above the darkroom sink under appropriate lighting. Tilt the print to minimize surface reflections.

Printmaking: A Detailed Example

We start with the negative as the point of departure in creating the print, and then proceed through a series of "work" prints to our ultimate objective, the "fine print."

The term fine print *(or* expressive print*) is elusive in meaning. The fine print represents, to me, an expressive object of beauty and excellence. The difference between a* very good *print and a* fine *print is quite subtle and difficult, if not impossible, to describe in words. There is a feeling of satisfaction in the presence of a fine print — and uneasiness with a print that falls short of optimum quality.*

When you are making a fine print you are creating, as well as re-creating. The final image you achieve will, to quote Alfred Stieglitz, reveal what you saw and felt. *If it were not for this element of the "felt" (the emotional-aesthetic experience), the term* creative photography *would have no meaning.*

The sequence of illustrations of *Clearing Winter Storm* shows how Ansel went about making this print; all of his notes on dodging and burning are included in the caption. As you gain experience (which will happen very quickly if you use these techniques), you will begin to recognize that burning and dodging are two of the most important means of modifying print values.

Figure 9.10: Ansel Adams, *Clearing Winter Storm, Yosemite National Park, 1944.* Ansel's comments on the printing of this image are as follows:

(A) "The test print was exposed for 5, 10, 15, 20, and 25 seconds."

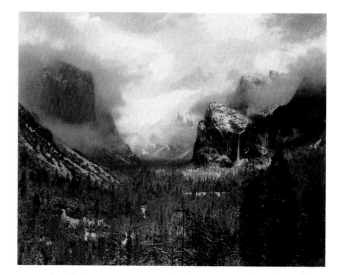

(B) "The 15-second exposure was chosen to make a 'straight' unmanipulated print. Considerable burning and dodging are required, as shown in the following illustrations."

(C) *Burning-in.* "The upper part of *Clearing Winter Storm* receives additional exposure by burning-in. Note the slight bend I give to the card to produce the shape required. The card, of course, is in constant motion from the base of the cliffs to the top of the print, in a series of up-and-down 'passages.'"

(D) *Dodging.* "I use a disk attached to a wire handle to dodge the two trees in the lower right portion of *Clearing Winter Storm.* Note that by rotating the disk sideways in relation to the light path, I can use it to cast an oval shadow."

(E) "A 'straight' print of the lower right portion of my *Clearing Winter Storm* shows very dark trees which obviously need dodging."

(F) "Careless dodging, slightly exaggerated here for emphasis, shows a typical 'halo' effect around the dodged area."

(G) "More careful dodging raises the value of the trees without producing obviously illogical values in the surrounding areas."

(continued overleaf)

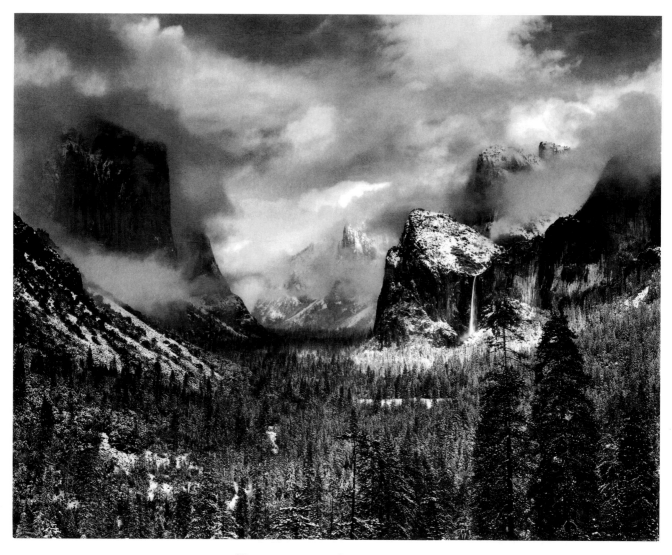

(Figure 9.10, continued)

(H) *The fine print.* "The subject was predominantly gray, but the emotional impact was quite strong; my visualization was rather dramatic; hence I gave reduced exposure and Normal-plus development. I used a Wratten No. 8 (K2) filter simply to reduce the slight atmospheric haze, but it did little to increase the basic contrast of the scene. I used my 8 x 10 view camera with a 12¼-inch Cooke Series XV lens, and Isopan film developed N+1 in Kodak D-23.

"During the main printing exposure of 10 seconds I hold back the shadowed cliff area near the right edge for 2 seconds, and the two trees in the right-hand corner for 2 seconds; too much dodging will produce weak blacks (see figure F). After the basic exposure I burn the bottom edge for 1 second and the lower left corner for 3 seconds; I then burn the left edge of the print for 2 seconds and the right edge for 2 seconds, in each case tilting the card to favor the sky.

"Burning is required from the base of the sunlit forest areas, near the waterfall, to the top of the image, with three up-and-down passages of 3 seconds each. I then burn the sky along the top for 10 seconds, continuing with 2 and 4 seconds at the upper left corner. Then, using a hole 1 inch wide, I burn the central area (between the two cliffs and the clouds above) for 10 seconds, and then bring the hole closer and burn the smaller area of cloud for an additional 10 seconds."

CLEARING WINTER STORM
24" LENS 10/60
f/22
SELECTOL - SOFT 1:2 FACTOR
 + 8
DEKTOL
100 CC TO
500 CC S.S. STOCK
SEAGULL #2
TONED IN SELENIUM

1-VW-82 6-8-82

(I) *Diagram of dodging and burning, and printing notes.* "I almost always make a sketch of printing procedure on the back of test prints and the final print. I then transfer the data to a separate sheet, which is filed for reference. This is very helpful for future printings, although I must always make small adjustments for different batches of paper.

"The basic data is in the first rectangle, and the other rectangles show the dodging and burning sequence. The areas marked with a '–' are dodged during the main exposure (light is withheld), and the areas marked '+' receive burning-in after the main exposure (light is added). The time in seconds is marked next to the symbol."

Figure 9.11: *Ansel's print-record form.*

ANSEL ADAMS — PRINT RECORD Date:

Negative No.: To Size:

Subject:

Enlarger or Contact Method:

Paper: Grade:

Developer:

Basic Exposure:

Special Fixing:

Toning:

Other Process:

Neg. Density: Low: High: Range:

A

B

Figure 9.12: Ansel Adams, *Rocks, Baker Beach, San Francisco, c. 1932.*
(A) A slightly soft print on Ilford Gallerie Grade 1. (B) An identical print treated in selenium toner.

Toning the Print

Black-and-white photographs have a slight color cast, a characteristic of the emulsion and, to some degree, the developer used to process the print. These tints are often unpleasant, and photographers usually tone their prints to remove them. Toning also protects photographs against atmospheric gases that alter prints over time just as they tarnish silver. The process requires very little time and is well worth the extra effort.

Many different kinds of toners are available, but the easiest to use is Kodak Rapid Selenium Toner. It results in tones varying from cold black to red-brown, with the final tint depending upon the emulsion characteristics and the duration of toning. Selenium toning also deepens the dark tones in a print and leads to a slight increase in print contrast. Ansel preferred to use selenium toners since the tones they produced harmonized with the images he visualized. Sulfide toners are frequently chosen by portrait photographers, who like the effect of their brown hues.

Toning Procedure The easiest way to handle the toning of prints is to do it at the end of a darkroom session, according to the following procedure.

After fixing your prints, store them in a tray of water. Prepare a tray of a nonhardening fixer (such as Kodak Rapid Fixer or Ilford Universal Fixer) by diluting the stock solution to the recommended working strength for prints. Fill a second tray with a washing aid and add 1 part of Rapid Selenium Toner for every 10 parts of solution. (If you find that toning is too rapid at this strength, use a dilution of 1:20 instead.) Remove the prints from the water bath and place them in the fixer. Agitate them by shuffling the stack, removing prints from the bottom one by one and placing them on top of the pile in a continuous cycle. After 2 minutes, transfer the prints directly to the toning bath and continue to shuffle them from the bottom of the pile to the top. You may wish to leave one print in the fixer to serve as a reference. After 1 minute, the prints in the toner should show a distinct difference in print tone; continue toning until you have achieved the desired tone, then transfer the prints to a bath of fresh water. Shuffle them for 1 minute to rinse off any excess toner and prevent uneven toning, then wash them thoroughly.

The rate of toning and its end results will depend upon which printing paper you use. With some papers, a *split toning* will occur — the lower- and middle-value tones will have added density and color, but the lighter values will remain unchanged. The effect may or may not be aesthetically pleasing.

The Dry-Down Effect

One phenomenon you need to be aware of when you make a print is the *dry-down effect.* Like wet beach stones, wet prints are remarkable for their brilliance; dried prints, however, like dried stones, can look considerably different and are often less interesting. Ansel commented on this effect:

> *As you are working you must keep in mind the visual effect of the print when dry: the glistening, beautiful print in the fixing bath or rinse tray often dries to a "dull thud." I recall, when printing the* White Church, Hornitos, California *for my* Portfolio One, *that my first prints in the fixing bath showed a subtle and pleasing value for the white clapboards on the sunlit side of the structure. They looked so good I decided to make all 120 prints required. But the next morning my fond hopes were shattered; what had been a beautiful shining white clapboard dried down to a depressing gray! It was not a major change in terms of actual measured values, but it was aesthetically unacceptable and all of the prints had to be redone. I found by experimenting that the print that properly rendered the subtle white tones showed* no *value or texture in these areas while wet, but dried down to perfect value.*

Knowing what to expect from the dried print is a matter of experience. The best way to learn is to make two identical prints, dry one (a blow dryer or microwave oven will work well for rapid drying), and then compare the two. You will see that the dried print has more details in the white areas than you can make out in the wet print, and that the black areas appear "duller." Try making a third print, giving the paper about 5 percent less exposure. When it dries, it will probably be much closer to the original wet print in appearance.

Factorial Development

In the instructions for printing, it was suggested that you use a standard development time. As you begin to refine a work print, you will find that a more satisfactory way to determine development time is to use the *factorial method,* a formula that takes into account the effects of such variables as developer temperature and developer exhaustion. First you need to ascertain the *appearance time* of a key area of the print as it is developing, and then the *total time* required to complete the development of the print. The ratio of total development time to appearance time (round both figures up to the next largest whole number) is the *measured development factor.*

To find the appropriate figures, choose a key area of the image (pick a middle-gray or darker tone), watch for it to appear as a faintly visible image while the print is in the developer, and note how much time has elapsed when you first see it: this is the appearance time. Now finish developing the print to its full

Figure 9.13: Ansel Adams, *Barn, Cape Cod, Massachusetts, 1939.* (A) Ansel used the appearance of the top of the fence against the grass as the emergence area for this photograph. The area emerged to the extent shown here in 20 seconds. (B) Based on the emergence area and the time used for figure A, a factor of 5 yields a total development time of 100 seconds (in Dektol 1:3). (C) Applying a factor of 8 to a print that has been identically exposed causes a subtle but distinct increase in contrast. Compare the barn door, the shingled walls, the grass, and even the sky areas of the two prints in figures B and C.

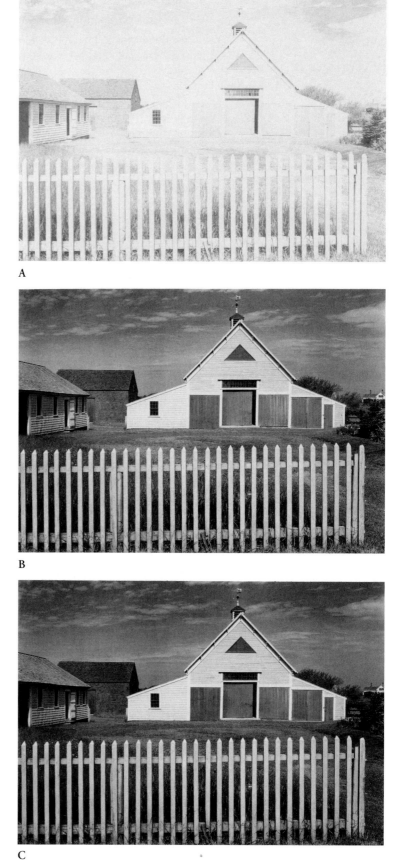

A

B

C

tonality to determine the total development time. If the appearance time is 20 seconds and the total development time is 2 minutes, the measured development factor will be 120/20, or 6. The development factor is a constant characteristic of the image, paper, and developer; you can use it to control print contrast when you are making multiple identical prints from the same negative.

Making Multiple Prints Suppose you have made a good print and want to make a dozen more, all identical to the first. If you proceed to expose and develop the image in exactly the same way each time, after a while you will notice that the new prints have less contrast and lower overall print density than the original. This is due to the progressive exhaustion of the developer by each print. Knowing the original development factor solves the problem: you simply multiply the appearance time for each print by the development factor, and then develop the print for that total time. For example, if the original ratio was 120/20, or a factor of 6, but the next print does not "appear" until 25 seconds, the total development time should be increased to 150 seconds (6 x 25), or 2½ minutes. Each print developed according to the factorial development technique should look the same.

Using the Factorial Method for Contrast Control If you want to decrease the contrast of an image, you can do it by using a *lower-than-measured development factor*. For example, if the measured factor is 6 and the resulting print is too contrasty, you can experiment and make a second print using a factor of 4; this will reduce the total development time and the print contrast. To increase contrast, raise the development factor. However, the most reliable way to alter print contrast is to change the contrast grade of the paper or use a different developer.

Local Development On occasion you may encounter an area of a print that needs "pushing" — meaning that it requires more development than the rest of the print. For example, if a highlight showed no texture because of excessive negative density, you would want to increase development of this feature without further developing the remainder of the print.

One way to achieve this is to lift the print out of the developer and apply a little hot water to the area in question with a brush or a cotton swab. The increase in temperature hastens development of the area and results in a slight degree of overdevelopment and selective darkening of the tone wherever the hot water is applied. Alternatively, you can apply concentrated stock solution of developer to selected areas of the print to darken them. This is the chemical equivalent of burning-in.

With either of these techniques, you should halt the process after about 10 seconds by resubmerging the print in the developer bath. The key to successful pushing is to develop the desired tone gradually so that it blends with the surrounding area. Use of these techniques requires considerable skill and judgment; whenever possible, it is best to avoid the problem altogether through careful control of negative exposure and development.

Variable-Contrast Printing*

The making of a print is a unique combination of mechanical execution and creative activity. . . . The basis of the final work is determined by the content of the negative.

The negative is similar to a musician's score, and the print to the performance of that score. The negative comes to life only when performed as a print.

Until recently photographers interested in maximum-quality gelatin-silver printing materials were virtually restricted to working with graded papers. In-between and other nuances in print contrast required fiddling with developer formulas, using preexposure ("flashing"), or taking advantage of contrast differences between the products of different manufacturers (e.g., a Brovira Grade 3 might have more contrast than an Ilfobrom 2 but less than an Ilfobrom 3). The few available variable-contrast papers each had drawbacks, such as a limited contrast range, weak maximum blacks, a tendency to "split-tone" in the selenium toning process, or an undesirable image color.

Today most manufacturers of photographic paper have variable-contrast fiber-based materials in their product line, and many of these papers offer extremes of contrast and richness of tonality comparable to the best papers ever made. Concurrent improvements in darkroom equipment now make contrast control easy and unless some specific quality (e.g., image color or paper color) dictates their use, graded papers now seriously limit creative options in the printing process.

With variable-contrast papers every sheet has been coated with two different emulsions. Each emulsion is sensitive to blue light but differs in its response to green. Some of the newest papers have three emulsions, but the third layer does not alter the overall response to proportions of blue and green light. Print contrast is controlled by varying the relative amounts of blue and green light that expose the paper. Blue light produces an image with maximum contrast; shifting the spectrum toward green lowers image contrast. Historically, contrast control was achieved through the use of special sets of filters, generally sold by the major manufacturers to complement their products.

Variable-contrast (VC) filters are each identified with a number, usually from 0 to 5, that corresponds to an ISO paper contrast similar to "graded" papers. An immediate advantage of this system is that the filter sets include in-between or half grades (e.g., a Grade 3½ filter). Filters are usually "speed matched," so paper contrast can be changed without changing the exposure time required to produce a particular "pivot tone," usually a light gray. Some condenser lamphouses have a filter drawer for placing filters above the negative. This eliminates optical degradation of the image. Lamphouse filter drawers make it practical to use color printing filters (see page 364) for contrast control. Like the VC filters, these are sold in sets but consist of yellow, magenta, and cyan filters in density increments of 0.05, 0.10, 0.20, 0.30, 0.40, and 0.50 rather

*This section is based on articles originally written by Alan Ross for *Camera Arts* magazine.

than in relative paper grades. Data sheets provided with VC papers usually indicate the combination of color printing (CP) filters that correspond to a particular contrast grade.

The yellow (which removes blue) and magenta (which removes green) filters from these sets can be used to regulate the amounts of blue and green light, respectively. They can be used separately or in combinations to achieve the desired filter strength (e.g., 95Y = 5Y + 40Y + 50Y). The advantage of CP filters is that contrast adjustments are much more subtle than the half-grade jumps of VC filter sets. They are not "speed matched" but a quick series of exposure tests will enable you to create a personalized exposure-compensation chart. With most incandescent light sources and no filter in place, print contrast is approximately equivalent to a Grade 2.

Dichroic color heads and variable-contrast heads are desirable accessories for printing with VC papers. Their quartz halogen lamp systems offer greater color and brightness consistency and their filtration systems are above the diffuser, out of the image-forming path. Some dichroic heads incorporate "closed-loop" systems that monitor and control lamp brightness and/or color settings, ensuring consistency from print to print. Because the dichroic filters used in these systems offer a continuous gradation of density, paper contrast is not limited to the discreet steps inherent with the use of filter sets. Table 9.1 details filtration recommended by Ilford for use with various dichroic enlarger heads and their multigrade papers.

Table 9.1

Ilford Multigrade Paper Contrast Grade and Filtration

Contrast Grade	Durst (max 170M)	Durst (max 130M)	Kodak	Meopta
00	150Y	120Y	199Y	150Y
0	90Y	70Y	90Y	90Y
½	70Y	50Y	70Y	70Y
1	55Y	40Y	50Y	55Y
1½	30Y	25Y	30Y	30Y
2	0	0	0	0
2½	20M	10M	5M	20M
3	45M	30M	25M	40M
3½	65M	50M	50M	65M
4	100M	75M	80M	85M
4½	140M	120M	140M	200M
5	170M	130M	199M	——

Note: Other tables provided by Ilford with each packet of paper include exposure time corrections for different filtrations, which column in the above table corresponds to your specific color head, and the use of other filter combinations to control print contrast. Fine tuning of the print can be achieved by slight alteration of the recommended filtration values.

Contrast adjustments with cold-light heads can be made through the use of either VC or CP filters. However, unlike incandescent light sources, the color quality and brightness of cold-light tubes vary widely. Because graded papers are primarily sensitive to blue light, many cold-light units are designed to maximize that part of the spectrum. Cold-light heads equipped with non-VC compatible tubes can often be retrofitted with a new lamp tube designed specifically for use

with VC papers, thus saving the expense of replacing the entire unit. The new Aristo V-54 tube has been specifically designed for VC use and is capable of producing a full range of contrasts.

Because of the availability of low-cost halogen-based variable-contrast heads, cold-light heads are probably no longer the best choice for 4 x 5 and smaller formats, but they remain the most practical and economical way of illuminating a negative larger than 4 x 5 inches. While Ilford multigrade filters are available in 12 x 12 size, CP filters larger than 6 x 6 are not currently obtainable. An alternative is the blue and green series of color-correction filters cinematographers use (such as Rosco Cinegel filters). These are relatively inexpensive compared to VC filters, they come in large sheets, and are available in various densities. The sheets can be cut to the desired size and can be used in the same manner as CP filters. However, they should be placed out of the image-forming path.

Happily for dedicated darkroom workers, the major enlarger manufacturers have nearly all responded to the popularity of VC papers by designing light sources expressly for variable-contrast use. As with the range of color-heads on the market, these VC heads also run the gamut from low-cost, simple mechanisms to sophisticated (and expensive) computerized systems. As with dichroic color heads, the advantage of many of these new systems is their ability to produce a full and completely stepless range of contrasts with the twist of a dial or push of a button. Their further advantage over color heads is that their controls display direct readouts of contrast settings from hard (Grade 5) to soft (Grade 0) and are factory speed-matched for the range of their settings.

Factory speed-matching points, however, may not ultimately suit your own preferences or needs. If you choose to standardize on your own "pivot tones," calibrating to a near-white or near-black, a dichroic CMY color head (especially if you plan to make color enlargements) could well be the most versatile and efficient tool.

Darkroom Preparation VC paper is sensitive to a broader spectrum of light than graded papers, and *all safelights in the darkroom must be equipped with safelight filters intended for use with variable-contrast papers.* Perform a safelight test (page 279) to make certain yours do not fog the VC paper.

VC papers respond normally to various developers and fixers. Your developer of choice is a matter of personal preference. Fine-tuning print contrast is best done by adjusting the filtration — use that control and keep the time/temperature regimen with a single developer constant. As with other papers, the choice of fixer and the way it is used can have a profound effect on the ultimate stability of the processed print.

Printing with VC papers The basic approach to printing with VC papers is the same as with graded papers. What differs is the range of contrast options and the way contrast adjustments are implemented. With VC papers, four virtues become immediately apparent: the lower cost of using a single type of paper for all prints; the availability of stepless contrast control; the potential for changing print contrast without having to make new test strips; and the ability to work with different contrasts on a single sheet of paper.

The first step in making an expressive print is to determine an appropriate overall contrast for the image. Because the very nature of printmaking is subjective, there is no "right" or "wrong." The goal is to arrive at an assembly of contrasts and exposures that illuminate the feeling you want your photograph to convey. The ultimate print is rarely unmanipulated, or "straight."

In exploring an image to determine an overall contrast level it is important to learn how the whole image responds in your enlarger. Low-contrast contact prints are useful to evaluate raw detail, tones, and possible cropping, but no enlarging light source–lens system delivers perfect illumination to the paper, and the tonal balance and contrast perceived in a contact print will not translate exactly to an enlargement. Your first objective should be to make the best-looking straight-print enlargement you can, ignoring any areas that you know you are going to dodge or burn. Concentrate on how the general ranges of tones (such as broad shadow values) look as a whole. For example, all the tones of a dramatic landscape may print at a low- to medium-contrast level, but that low contrast might cause the shadows to be muddy and lack vitality and the high values to be likewise lifeless (see figure 9.2, page 282). An increase in paper contrast may expand the tonalities within the shadow areas but also render the high values as white. Even though the high values are too white, ignore them at this stage (they can be burned-in) and set the overall contrast to support the desired shadow values.

To determine the basic exposure and overall contrast, select a light-gray to near-white tonal value not to be burned-in, and determine the exposure time needed to produce the desired tone. Next, adjust the print contrast to get the desired shadow/black tonalities. The basic rule is, *"Expose for the high values and adjust contrast for the blacks."* If the contrast filtration system you are using is speed-matched or if you have made an exposure compensation chart, you can go directly to another trial print without having to make an intermediate test strip.

Once a good starting exposure and contrast have been determined, consider those areas of the print that need special attention; the ones that were ignored earlier. As with graded papers, the usual techniques of dodging, burning, flashing, and bleaching can transform troublesome light and dark areas into the tones that we envision. With VC papers, however, there is a further technique to call into play: contrasts can be changed independently from other parts of the print. The ease with which local contrast changes can be made depends upon the equipment you use. Systems that require anything more than the gentlest opening of a compartment or movement of a filter holder to change contrasts invite disaster in the form of image shift at the easel. An enlarger that has remote digital controls for the light source is ideal.

An example of a situation calling for local filtration techniques would be a scene containing a too-brilliant high value in a place where traditional burning-in would create problems with adjacent dark areas. With VC papers, you can expose the print as you wish in all easily manageable areas first, then, without moving the paper, change the filtration to maximum "soft" and burn-in the area with as much additional exposure as it takes to get the desired print value. Because you are exposing with little to no blue light, the burning-in will have a profound effect on the troublesome high value but very little effect on adjacent (or integral!) dark areas. As a consequence, it is not necessary to be overly careful about spilling extraneous light into adjacent areas while burning-in.

A

Figure 9.14: *Printing notes:* Alan Ross, *Chair and Window, Randall Davey House, Santa Fe, New Mexico, 1996.* Negative: 4 x 5 TMax 100 developed in Ilfotec HC, N Dev. 90-sec. exp. (indicated 60-sec.). Enlarger Omega D5500 with 150mm El-Nikkor. (A) Half-sheet test strip for 4, 6, 8, 10, and 12 seconds at f/16, no filter. Even though I know it will render the chair and wall too dark, I pick the 10-second exposure to use for a straight print because it will give me the most raw information about the image, particularly in the highlights.

B

(B) A straight print for 10 seconds at f/16, no filter. To maximize the separation between the chair and the wall and increase the texture of the wall, an increase in contrast is needed. Because the window will be easy to burn-in, I set the basic exposure and contrast by the way I want the chair-and-wall relationship to look. I reconsider the test strip and decide I like the blacks of the chair in the 8-second strip. I decide to make a new print at 30M and correct the exposure to 9.0 seconds at f/16 to compensate for the filtration change. I will include a 5-second burn-in with this print for the window area to get a feel for how that control will work.

C

D

(C) 30M, 9.0 seconds at f/16 plus a 5-second burn-in with an L-shaped arrangement of two cards moving from the top-right corner of the print to the bottom-left corner of the adobe window well and back. I like the way the chair and lower wall look, so I will stay with this exposure and contrast setting and begin using local controls.

 1. The top-left quadrant of the image is too light and pulls my eye off in that direction. I'll try giving a 2-second burn-in from the top-left corner into the window well and back.

 2. The chair arm in the bottom-right corner is a bit light. I'll add 1 second here.

 3. The edge along the bottom-right corner is also a bit light. I'll add 2 seconds here.

 4. The window is still way too light. In the negative, I can see a bank of fresh snow through the right part of the window, piled up against an outside wall. I want to see some trace of this in my print. I'll try giving two 5-second burns and see what it looks like.

(D) 30M, 9.0 seconds plus the burning-in planned in C. The bottom burns are just fine, but the top-left burn is not quite enough. I'll try giving 3 seconds instead of 2. The snow outside the window is still not visible, and the shadow at the left edge of the shutter has started to get brutally black. This is a difficult area to dodge successfully, and if I give more exposure to the window area, these shadows are only going to get worse. However, by burning-in the window at a very low-contrast setting, I should be able to get detail in the brightest areas without letting the shadows get too black. For the next print I'll try doing the bottom- and top-left burns at the basic 30M setting but burn the window in with 0 Magenta and 175 Yellow for two 10-second burns.

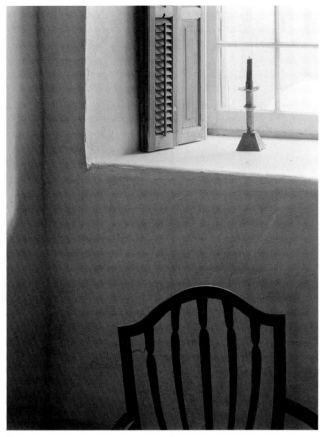

E

(E) The final print. The snow outside the window is now clearly visible, the glare on the adobe window ledge is richly textured, and the shadows around the shutter are still detailed and open.

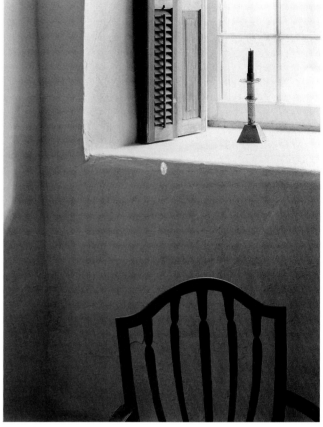

F

(F) The burning-in in this print is identical to E, but I left the contrast at 30M for the window burn. Note that the snowdrift is still only barely visible and that the shadows around the shutter are completely black and the candle is nearly so.

Variable-Contrast Calibration While none of the exercises discussed in this section are essential, the information they produce can save time and paper and provide a feel for the way your VC paper behaves in your darkroom. Once performed, these exercises need not be redone unless some major component of the system is changed.

Exposure Compensation Charts Speed-matched systems depend on selecting a reference tonal value (usually light-gray) and determining the exposure required to produce that tone at each contrast setting. Filtration adjustments made when printing with dichroic color heads, color-printing filters, color-compensating filters, or any system not speed-matched by the manufacturer require a change in exposure time when you change filtration because the new

filter settings modify the intensity of the light striking the paper. An exposure compensation chart allows quick calculation of new exposure times without the need for a new test strip each time you change filtration. The following tests for making the charts require no special equipment and can be performed quickly, using a few sheets of paper.

Very light gray to near-white reference values ("pivot points") are very useful when printing because you normally expose for the light-gray extreme of the print's tonal scale and then adjust the overall contrast until the shadow values have the desired tonal qualities. Further, just as a film's threshold speed determines exposure in the camera, the whites reflect the paper's exposure threshold. *The ratio of exposure times to reproduce a reference print tone at any chosen filtration determines the change in exposure needed when you alter print contrast.* By measuring the exposure times needed to print a light-gray reference tone at various filtrations and plotting these on a graph, you can create a calibration chart that will indicate the changes in exposure time needed whenever you change contrast.

To make a calibration chart do the following:

1. The first objective is to print an off-white reference patch using contrast Grade 2 filtration and no negative in your enlarger. Cut several sheets of the polycontrast paper that you intend to use into 2-inch-wide strips. Raise the enlarger head to its maximum height, stop down the lens to its smallest aperture, and expose a test strip in sections for 10, 15 , and 20 seconds.

2. Fix, rinse, and inspect the test strip. Look for a tone that is barely off-white that you want to be your calibration "pivot point" and note the exposure. Adjust the exposure as needed by changing the lens aperture, the enlarger height, or by using a neutral-density filter until an exposure approximating 10 to 20 seconds produces an off-white patch. When you have arrived at a setup that yields the desired tone, expose an entire strip for that time and use it as your "standard" for the comparisons described below. Keep the standard strip in the water rinse bath.

3. Next, make a series of test strips at each of the filtration values corresponding to half-step changes in contrast grades. Compare the patches from each test strip in the rinse bath to the "standard" and note the exposure time that corresponds to a match of tonal values.

4. Record the data in a table similar to table 9.2, and then plot exposure times as a function of contrast grades as shown in figure 9.15. Figure 9.15 shows two data sets obtained using two different color heads and two Ilford multigrade papers. Data obtained for one type of paper or one brand of enlarger may differ significantly from another, so it is prudent to perform these tests with each kind of variable-contrast paper that you use.

Table 9.2

**Ilford Multigrade DeLuxe
RC Paper
Beseler 4 x 5 Colorhead**

Contrast Grade	Filtration	Exposure Time
00	150Y	23
0	90Y	22
½	70Y	20
1	55Y	19
1½	30Y	17
2	0	15
2½	20M	22
3	45M	28
3½	65M	32
4	100M	36
4½	140M	38
5	170M	40

In practice, to calculate a new exposure when you change filtration, simply multiply the exposure time by the ratio of pertinent exposure times in the table. For example, if the exposure time to make a print with no filtration is 19 seconds and you want to make a new print using contrast grade 65M filtration, your new exposure time would be 32/15 x 19 = 40.5 seconds. The new print should have high values identical to the original print but much darker shadow values. If the appropriate filtration is between two listed values, interpolate to estimate the equivalent exposure time.

Figure 9.15:

**Calibration Chart for Exposure
Corrections.**

Exposure time and contrast grade with Ilford multigrade papers. This graph illustrates how exposures vary when filtration changes are made for two types of Ilford multigrade papers and different enlarger heads. The data for curve A were obtained using Ilford Multigrade DeLuxe RC Paper with a Beseler Dichro 45S Colorhead, while those for B correspond to the use of Ilford Multigrade Fiber-Based paper and an Omega 5500 Colorhead. The precise shape of the curves will depend on the paper, filtration system, and calibration point that you use.

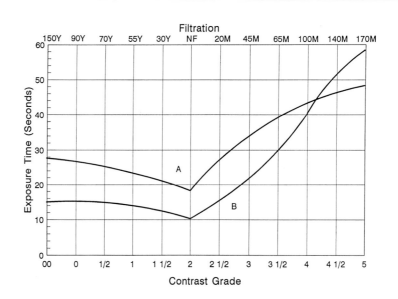

A

B

C

Figure 9.16: Ansel Adams, *House and Fern, Maui, Hawaii.* The negative for this image was made with a Hasselblad camera fitted with a 60mm Distagon lens. The film, Kodak Plus-X, was used at ASA 125 instead of its optimum of 64; hence the wall in shadow (placed on Zone III) was underexposed. Conventional printing would hold the full scale of the negative but result in a flat rendition of the shadows; increasing the paper contrast would help the shadows but "block" the high values of the sunlit ferns. The problem was solved by printing with both the number 1 and the number 4 variable-contrast filters, in sequence, as follows: (A) The number 4 filter (highest contrast) gives maximum separation of the wall values. The ferns, of course, are fully blocked out. (B) The number 1 filter (lowest contrast) suggests appropriate values of the ferns. (C) Using the two filters in sequence gives a balance of values that could be obtained in no other way (except by means of a complicated masking process).

It is important to note that there is no "formula" for this approach. For example, when the shaded rock wall is properly exposed with the number 4 filter, it is obvious that any additional exposure with the number 1 filter will add to the original exposure. Hence, the entire image was given exposure with the number 4 filter, and the wall area was then shielded while the fern area was printed with the number 1 filter. The junction of the sunlit and shaded areas was balanced by burning-in: a card with a small oval hole cut out was carefully moved from left to right across the image, following, with a broad penumbra, the contours of the foreground area.

Postdevelopment Correction Techniques

However much care you take in exposing and developing your negatives and prints, it will be a rare print that does not require some final touch-up work. Imperfections in the film and/or problems in processing may lead to "pinholes" in the negative emulsion, which print as tiny black spots. Some small areas of a print may need a lighter tone that you just cannot achieve through dodging or developing. These "print defects" can often be overcome by means of one or more of the correction techniques described below.

Spotting and Etching After a print has been toned, washed, and dried, it is ready for presentation. You will almost always notice small imperfections caused by tiny pinholes or specks of dust on the negative.

White spots caused by dust on the negative can be easily corrected with *spotting colors,* dyes that you apply to the surface of the print with a very fine brush (number 00). With a little practice, you will be able to blend these defects into the background so well that they will be indistinguishable from the remainder of the print.

Black spots that result from pinholes in the negative are more difficult to treat. While you can get rid of a black spot through careful *etching* or scraping of the emulsion of the print with a razor blade, you may also visibly damage the print surface. If this happens, you may be able to restore the surface by rubbing

Figure 9.17: *Equipment for etching and spotting prints.* (a) Distilled water. (b) Spotting color. (c) Eye dropper. (d) Glazed plate. (e) Fine-tipped paint-brushes. (f) Etching knives. (g) Single-edge razor blade.

Figure 9.18: *Technique for spotting a print.* Use a stippling motion to apply the dye, rather than "painting" it on. A good-quality brush is very important.

it briskly with a piece of silk. You can avoid the problem altogether by bleaching any black spots with Farmer's Reducer, then spotting the bleached area with dye.

Selective Bleaching *Farmer's Reducer* is a bleach that dissolves silver. It can be used to remove unwanted black spots on the print or to lighten tones in general. For overall enhancement of the whites in the photograph, place the fixed *but untoned* print in a solution of Farmer's Reducer and agitate the tray vigorously for about 10 seconds. Remove the print and submerge it immediately in clear water. Examine the image carefully; if further bleaching is required, repeat the cycle. Be cautious in your approach since it is very easy to bleach out all signs of texture in the light tones and thus ruin the print. When you are satisfied with the results of the bleaching, immerse the print in a fixing bath for a few minutes and complete the processing as you normally would. (To repeat: bleaching will work only on an untoned print; it will have no effect once a print has been toned.)

You can also apply Farmer's Reducer to selected areas of the print with a brush or a cotton swab. It is best to try several light applications, each lasting only a few seconds and followed by a fresh-water rinse. In this way you can control the process and minimize the danger of leaving an obvious ring around the area you have treated.

Figure 9.19: *Technique for etching a print.* (A) A knife with a sharp tip is the best tool for eradicating dots and small specks. (B) For more diffuse spots, a round-tipped knife is preferable. Cotton gloves will absorb any moisture or oil on your hands and prevent it from coming into contact with the print.

A

B

Processing for Permanence

The procedures described previously for processing a print are adequate for making proof prints and running tests. When you begin to make work prints and fine prints, however, you will need to take greater care in processing to ensure your prints' permanence. Inadequate fixing and washing can cause them to fade over time, as can the failure to tone them. *The procedures for fixing prints described in the first edition of this book and all of Ansel Adams' writings on the subject no longer reflect the best practices, and I do not recommend that they be used.* The following approach is the result of intensive research by Ilford and will produce prints that meet archival standards using much shorter fixing and washing times than traditional techniques.

1. Develop the print with constant agitation in the developer of your choice. Both Kodak Dektol (diluted 1:2 for 2 minutes or 1:3 for 2.5 minutes) and Ilford Multigrade (diluted 1:9 for 2 minutes or 1:14 for 2.5 minutes) are excellent general-purpose developers; other developers can be used as well. Drain the print over the developer tray.

2. Submerge the print in the stop bath, agitate it for 30 seconds, and then drain it.

3. Fix the print by agitating it *vigorously and constantly* in a bath of Ilford Universal Fixer (or in a similar ammonium thiosulfate fixer) diluted 1:4 for 50 to 60 seconds.

4. Drain the print and place it in a tray of running water for 2 minutes. At this point it can be stored in a tray of clean water bath until you have finished printing all your negatives.

5. Set up three trays in sequence, each containing a working solution of washing aid. To the middle tray add sufficient Kodak Selenium Rapid Toner to make a 10-percent solution (100ml per liter).

6. Place the prints in the first tray and agitate the prints by constant shuffling for 3 minutes. Transfer the prints to the tray containing the toner.

7. Agitate the prints by shuffling them until the desired change in density and image color is achieved — this usually takes about 3 to 4 minutes. (Note that selenium toner is actually a test for residual silver in the print; if brown stains form, the print has not been adequately fixed. The brown stains cannot be removed once they form.) Transfer the prints to the third tray.

8. Agitate the prints for 5 minutes, then transfer them to a tray of running water. Rinse them for a few minutes and then transfer the prints to an "archival" print washer.

9. Wash the prints until a Residual Hypo Test is negative. With an efficient washer such as the Zone VI or Cascade washer set at a flow rate of 1 to 1.5 gallons per minute, double-weight fiber-based prints should test clear in less than 30 minutes. Because everyone's darkroom habits, chemicals, equipment, and water vary, there is no fixed rule as to what constitutes an acceptable "wash time" without performing an occasional HT-2 test.

10. Remove the prints from the washer, place them on a sheet of plate glass or some other clean and smooth surface, and squeegee the excess water off the back, then the front surface.

Figure 9.20: *Squeegeeing a print.* Surface water should be removed from both sides of the print with a rubber squeegee. (An automobile windshield wiper is fine for this purpose.) The print should be laid on a flat surface, which must be tilted to permit the water to drain off into the sink. Apply the squeegee *gently,* and lift the print carefully to avoid tears or breaks.

11. Place each print facedown on a *plastic* (not metal!) drying screen and allow it to air-dry.

12. Store prints in an archival box. If the prints curl during the drying stage, press them for a few minutes in a warm dry-mounting press between two sheets of mounting board.

Figure 9.21: *Print washing.* The advantage of archival print washers is that they keep the prints separated throughout the washing process. If prints are allowed to stick to each other, proper washing cannot occur, and the residual contaminants are likely to remain in the print. The washer should provide good water circulation in all areas, though not all washers are equally effective in this regard.

The Fine Print: A Summary

In his comprehensive book on printing, Ansel had the following to say about the fine print:

> I have described a number of procedures for subtle print control without attempting to describe what a fine print looks like. The qualities that make one print "just right" and another only "almost right" are intangible, and impossible to express in words. Each stage of printing must involve careful scrutiny of effect and refinement of procedure. Once you know what truly fine prints look like, trust your intuitive reactions to your own prints!
>
> In evaluating the print some of the qualities to look for include:
>
> — Are the high values distinct and "open," so they convey a sense of substance and texture without appearing drab or flat?
>
> — Are the shadow values luminous and not overly heavy?
>
> — Is there texture and substance in the dry print in all areas where you sought to reveal it?
>
> — Does the print overall convey an "impression of light"?
>
> I cannot possibly describe all of the opportunities for enhancing an image, or the attendant creative satisfaction. It should be understood that the subjective process need not terminate after one printing; I have reexamined prints after a period of years and become aware of refinements which

I might put into effect. I can only urge you to approach the process with patience and an open mind. Perhaps you will now appreciate why I consider the making of a print a subtle, and sometimes difficult, "performance" of the negative!

As you will have surmised, the making of a fine print is a process in which you learn and progress through a series of corrections, failures, refinements, and successes. Study your first work print with care and at your leisure; you will notice that the character of the enlargement is quite different from that of the contact print or proof print that you first looked at, especially if you are working from a small-format negative such as a 35mm. Small areas of the print that may have been easy to overlook on the contact sheet can assume far greater importance in an enlargement, and what was once a small black spot may now loom as a disturbing, featureless void. Other sections of the print, in contrast, may show interesting details that you failed to appreciate earlier. Think about the consequences of selectively darkening or lightening the foreground or edges of the print. If any tones merge in a way that confuses the reading of the print, ask yourself whether you can take appropriate corrective action in your next print. Will you need to refine the contrast scale?

When you first begin to print, spend a generous amount of time exploring these questions — such exploration is a critical part of the learning process. You then need to go back into the darkroom and address the issues you have raised. If you are uncertain about what effect darkening the sky might have, for example, try it and see. Likewise, you will not be able to really appreciate the impact of changing paper contrast grades or developer formulas until you experiment with them. To learn more about the former, print your negative on a spectrum of paper grades and compare the prints side by side; to investigate the latter, develop prints made on the same grade of paper in Dektol alone, in Selectol-Soft alone, in a 1:1 mixture of the two, and for 1½ minutes in Selectol-Soft followed by 1½ minutes in Dektol. Then compare the results. Be sure to keep careful notes and write down which contrast grade or developer you used on the back of each print so you can identify it later.

An additional benefit of evaluating your work prints thoroughly is that it will help you to make better negatives. Trying to extract texture out of shadow areas of a negative where it barely exists will force you to be more conscious of the need to expose and develop your film properly. Your progress as a photographer will depend on the effort you put into these evaluations.

The most delightful aspect of printing a negative is that the worst consequence of making a mistake is that you waste a sheet of enlarging paper — and even that can be of value if you have learned what *not* to do next time. Work systematically and keep a notebook and a complete file of prints to refer to for study; each test you perform will give you an additional skill or tool that you can call upon later.

If you have kept careful notes on the back of your work prints and in a notebook, reprinting will also be much easier — though you should not expect your notes to provide anything more than a rough outline for you to follow. Printing papers vary from batch to batch, and different brands of paper never

Surf Sequence,
San Mateo County Coast, California,
circa 1940

Very early one morning I was driving to Carmel along Highway 1 south of San Francisco, and I frequently stopped the car to walk out to the brink of the cliffs overlooking a lively surf. At one location I noted that below me was a nice curve of rockfall fronting the beach. The surf was streaming over the beach, barely touching the rocks and creating one beautiful pattern after another. I realized that I could perhaps make a series of images that might become a sequence, so I set up the 4 x 5 view camera and awaited appealing arrangements of flowing water and foam.

In subjects of this type there are many flowing, interweaving lines and surges of white and gray; the photographer must be alert to the combinations confronting him, and must try to anticipate the position of these moving shapes in time.

Printing the sequence was not as simple as I expected. The white sunlit foam value fell rather high on the exposure scale and the D-23 developer encouraged a little blocking [that is, too much negative density build-up] of these high values. The paper I used at first was Agfa Bovira Grade 3. The most recent printing was on Ilford Gallerie Grade 2, with quite full development in Dektol. I tried Grade 3 Gallerie with Kodak Selectol-Soft developer, but I could not hold the texture I wanted in the highest values. All prints were toned in selenium.

There was, of course, need for tonal balance if the prints were to be shown as a sequence. Variations in the negative required rather intricate dodging and burning to maintain an acceptable degree of value balance in the sequence.

Since I wanted all five prints to be precisely the same size, as befits a sequence of this character, I had to work from the one that needed the most cropping on the right margin (the other three margins were but slightly changed). All the other margins would tolerate the same right-margin trim. This was necessary because of the configuration of the sand and stone: the right-hand surge of surf was channeled into a vertical shape in three of the negatives, and this was a very distracting detail. Removing it from these three images demanded that the other two images be likewise balanced.

My attention to such small details — being certain that each print is of the same cropping and values — is a matter of personal taste and a desire for perfection. There is something architectural in precise image construction. — ANSEL ADAMS

have the same emulsion characteristics.

It is not difficult to learn how to make a good photographic print. The experience that is a byproduct of each successful effort will accumulate, and you will soon find yourself at home in the darkroom, proceeding toward your goal of becoming a maker of fine photographs.

Figure 9.22: *Dry-mounting a print.*

(A) *Tacking tissue to the print.* The dry-mount tissue, which should be of a slightly larger size than the final print, is tacked to the back of the print by means of a heated tacking iron. Be sure to draw the iron gently outward, using steady pressure; be careful not to press too hard, or you may damage the print surface.

(B) *Trimming the tissue and print.* The print and tissue must next be trimmed to their final size. The cutter shown here has a "hold-down bar," which ensures that the print and the tissue are precisely aligned. If your cutter is not equipped with such a bar, you can use a straightedge, holding it down on the print as close as possible to the cutter edge to prevent the print and tissue from "creeping" during cutting. Be *sure* to keep your fingers well away from the cutting blade.

(C) *Tacking the trimmed print to the board.* The print and attached tissue are now carefully positioned on the mount and held in place. The print corners are then gently lifted, and the tacking iron is slipped underneath to tack the tissue to the board. Always use the tacking iron with a gentle *outward* motion, and be careful not to let it stray beyond the print edge and onto the mount surface, as the marks it leaves are impossible to remove.

(D) *Dry-mounting.* The tacked print is inserted between two clean sheets of museum board and then pressed. The duration and temperature of the pressing are determined by the thickness of the tissue and of the cover board; both variables should be carefully regulated.

(E) *Testing the dry-mount adhesion.* After the print has cooled somewhat, bend the board rather severely at each corner to make sure that the tissue is adhering properly to both the print and the board. If the print detaches, put it back into the press for about two-thirds of the original pressing time. Do not overdo it: too much time in the press can weaken the adhesive power of the tissue.

Caring For Your Prints

Once you have made a fine print that corresponds to what you have visualized, you will want to enjoy it and share it with others. You will also need to give some thought to organizing, protecting, and preserving all of your fine prints.

Mounting and Matting Prints for Presentation

To enhance a print's presentation, it is best to mount it on an attractive *archival mounting board* (one that will meet museum standards for preservation) and then *overmat* it. The two procedures below both work well for mounting prints.

Mounting Corners *Mounting corners* are made from archival paper and acid-free linen tape. The corners are glued onto a sheet of mounting board, and the corners of the print are then slipped into them. If you use this approach, be sure to leave a generous border around the edge of the print so that the mounting corners will not show when the overmat is put in place. One advantage of this technique is that prints can easily be removed from the mount if necessary; however, the prints will seldom lie completely flat and may buckle slightly in the frame.

Dry-Mounting Prints One way to mount prints permanently is to use heat-sensitive *dry-mounting tissue*. With this method, the tissue is tacked to the back of the print and the print is then positioned on the mounting board and affixed permanently to its surface by being heated in a dry-mounting press or with an ordinary iron. You can mount the print with or without a border, depending upon your preference.

Overmatting Overmatting a print so that you view it through a cut-out window further enhances its presentation. You will need a mat cutter and a good straightedge to make an overmat. A kit containing tools and supplies and complete instructions for mounting and matting prints is available for a reasonable price from Light Impressions in Rochester, New York. Their catalogs also contain complete descriptions of an extensive array of materials for the storage of prints and negatives.

Storing Mounted and Unmounted Prints

You should always use acid-free storage boxes for all of your fine prints. You can purchase these from a camera or art-supply store. To avoid possible contamination, be sure not to store prints that have been processed to archival standards with others over which less care may have been taken in processing.

Use empty printing-paper boxes to store your work prints so that you will have a visual record to review when you want to reprint a photograph.

Print Processing: A Summary

Action or Process	Time	Procedure and Comments
1. Prepare chemicals	—	Mix solutions of developer, fixer, and washing aid. Prepare stop bath. Bring all solutions to room temperature. Place sufficient amounts of developer, stop bath, and fixer (instructions included with the chemicals will indicate the number of prints that can be processed in a liter or quart of solution) in three different trays and arrange them in sequence. Fill a fourth tray with water.
2. **Turn on safelights**	—	Instructions included with printing papers will indicate what color safelights and what bulb wattage may be used with the paper.
3. **Turn off room lights** and transfer the printing paper you intend to use to a light-tight drawer. **Turn room lights back on**	—	Printing papers must be handled in total darkness or in light from a suitable safelight (see "Testing Your Safelights," pages 278–279).
4a. To make a proof sheet:	—	Select the negative(s) you want to print. **Turn off room lights.** Place a sheet of printing paper, emulsion (shiny) side up, in the printing frame, place the negative(s) emulsion (dull) side down on the printing paper, and cover both with a sheet of glass.
4b. To make an enlargement:	—	Select the negative you want to print and clean it thoroughly. Place it in negative carrier and insert carrier into enlarger head. Minutes spent cleaning a negative now can often save hours of laborious spotting and etching later. The emulsion side of the negative (dull surface) must face downward, or else the enlarged image will be reversed.
5. Place a sheet of blank white paper (you can also use the back of an old print) in your enlarging easel, **turn off room lights,** turn on enlarger lamp, and focus and compose the image on the paper surface	—	If this is the first print you are making of a negative, you may wish to print the entire image to help you determine optimal cropping.

Action or Process	Time	Procedure and Comments
6. Turn off enlarger light (or put a cap over enlarger lens) and place a sheet of printing paper, emulsion (shiny) side up, in easel	—	With matte-surface papers, it can be difficult to identify the emulsion side. If you hold the paper close to your eye and point an edge toward the safelight, the emulsion side will look shinier than the back of the paper.
7. Expose printing paper, using a metronome or timer to control or guide duration of exposure	—	Appropriate exposure must be determined by trial.
8. Slip exposed paper into developer and agitate print continuously. About 10 seconds before development is complete, lift print from developer and let excess solution drip back into tray	1½ – 2 minutes	Constant agitation is needed to insure uniform development and reproducible results.
9. Transfer developed print to stop bath and agitate continuously, then drain	30 seconds	Careful draining minimizes carryover of solutions and prolongs their effectiveness.
10. Transfer print to fixer and agitate continuously, then drain	Variable; depends on fixer	If you use rapid fixing procedure, 1 minute is required; with other fixers, 1½ minutes usually recommended.
11. Rinse print and store in a tray of fresh water until you complete processing of entire batch	—	As prints accumulate, change water in holding tray frequently to avoid buildup of fixer in water bath.
12. **Turn on room lights.** Prepare a solution of washing aid, pour into a tray, transfer prints to washing aid, then agitate continuously by cycling prints from bottom to top of stack. *Note:* Washing aid is not used for RC papers	2 minutes	If you want to tone prints with selenium toner, add it to washing aid. For archival processing, some procedures require a second fixing cycle and water rinse after step 11.
13. Wash prints until they are free of contaminating residual chemicals	30 minutes or more	Amount of time required for thorough washing depends upon which kind of washer you use, paper thickness, and processing conditions for fixing the image. You can test prints for residual hypo and silver with test kits, available from your photo-supply store.
14. Dry prints on a drying screen or hang them with a clip on one corner	Variable	Rate of drying depends upon paper thickness, room temperature, and relative humidity.
15. Store prints	—	Archival storage boxes are useful for storing fine prints. Empty photographic-paper boxes provide suitable protection for ordinary photographs.

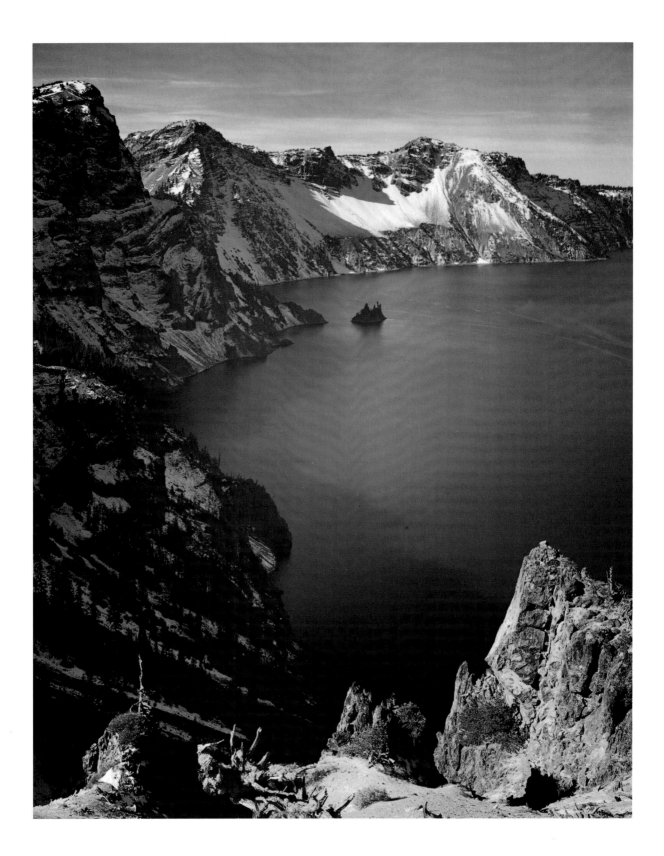

Chapter Ten

Color Photography

The creative color photographer is faced with problems quite different from those encountered in black and white. The latter is, at best, an interpretive simulation of reality in monochrome. A color photograph reflects what many consider should be a realistic picture of the world in "true" color. This is, of course, a visual illusion; the real world is not duplicated in a transparency or on a sheet of paper.

"True color" is a fiction, a false assurance that the sky was "that shade of blue" or this portrait shows "correct" flesh colors and values. I believe we should encourage non-real explorations into the world of color hitherto restricted to painting. Only the technical rigidities and the fear of the unreal have held interpretive color photography to rather narrow paths. It now appears that the horizons are opening for new creative-emotional concepts that can be achieved in the domain of color imagery in the photographic mode. — ANSEL ADAMS

Photographs are part of our visual language. As children we begin to correlate actions with sounds and soon come to understand the sound as a symbol for an action or a thought. Later we go to school and spend years learning the rules of our language, how to read and write and how to communicate, either straightforwardly or through similes and metaphors, which often have greater power — for example, the "cold ocean" can also be described as the "fish-freezing, icy-fingered sea." Education and experience expand our ability to create and interpret symbols of increasing complexity.

Through the constant exposure that begins early in our lives, we come to accept photographs as faithful copies of reality; we forget that they are *always* abstractions. Learning to look thoughtfully at a photograph is a step on the path to visual literacy, and compelling the viewer to take more than a casual look at an image is the first challenge a photographer must meet.

The fact that color photographs quite closely resemble reality often serves to lower the barrier that many people feel when they stand in front of a work of art. Who hasn't looked at an example of "modern art" and felt a bit inadequate, wondering, What am I missing? But virtually everyone can appreciate a colorful transparency of a lovely flower or a beautiful landscape. Easy recognition of the subject facilitates communication between the viewer and the image — and the artist who created it.

Figure 10.1: Ansel Adams, *Crater Lake, Crater Lake National Park, Oregon, c. 1943.*

Figure 10.2: Ernst Haas, *Bench in Autumn, Kyoto, Japan, 1981.*

While color can be the ingredient that makes a scene come alive for some viewers, it is both a blessing and a curse for those who pursue color photography as an art form because it is difficult to escape entrapment by the literal. In a black-and-white photograph, for instance, you are free to print the sky as white, gray, or black, depending upon the mood you are trying to create. The viewer will not be uncomfortable with any of those tones if they are appropriate to the subject. Photographers who work in color, however, risk distracting the viewer from the content of their images if they stray too far from "natural colors." Thus red grass in a photograph is likely to be thought of as "weird" or assumed to be the result of some horrendous processing error, rather than being seen as a creative insight on the part of the photographer.

The Role of Color in Photographs

Historically, color has fulfilled two roles in photography. Most often it has been used to celebrate form and is therefore a critical element in a strongly seen image — just as in literary terms, it is used as a visual adjective to add further dimension to a noun, so an apple becomes a *red* apple. Alternatively, color can itself be the subject of the photograph. In this case, the objects in the image are basically vehicles for transmitting color.

In *Porch, Provincetown,* Joel Meyerowitz has created an image that seems not far removed from a black-and-white photograph. Pastel shades of red have replaced light gray, and virtually all of the other tones, too, can be seen as having their gray counterpart. The warm and subtle colors of the scene trigger a

Figure 10.3: Joel Meyerowitz, *Porch, Provincetown, 1977*.

sympathetic emotional response that is absolutely different from what you would experience with a black-and-white photograph of the same scene (look at the image through a #90 viewing filter or make a photocopy of the color image for comparison). Color creates and reinforces the setting's tranquil mood.

Bench in Autumn, Kyoto, by Ernst Haas, is a straightforward still life. Here, the image itself is about color, elevating an ordinary scene to the extraordinary.

Aside from their difference in subject matter, these two images also differ in their use of color. In Ernst Haas's photograph, yellow plays an *aggressive* role, attracting attention from almost any distance. Reds dominate many areas of the photograph but essentially play only a supporting role. In *Porch, Provincetown,* conversely, the colors are distinctly *passive* and in harmony with the scene.

Figure 10.4 is a simple image printed in black and white. Use it to put your imagination to work. Make tracings and/or photocopies of it and color them with crayons or marking pens of different hues. Compare what happens when you apply the colors lightly to the effect achieved when you lay them on as heavily as possible. (In color photography, the density of color is referred to as *saturation.* Intense color of any hue — for example, the red paint on the bench in figure 10.2 — would be called highly saturated.) Try to employ varying color combinations to change the mood of the photograph. Seek out combinations that interpret the scene first as visually "passive" and then as visually "aggressive."

As you proceed through an exercise of coloring an image arbitrarily, there are certain colors that you will tend to avoid for specific objects. For example, a purple leaf would be eye-catching, but a viewer of a photograph would respond

Figure 10.4: John P. Schaefer, *Datura, 1989.*

A

B

C

Figure 10.5: *Wratten #90 viewing filter.* When you are deciding whether to photograph a scene in color or in black and white, a Wratten #90 viewing filter (see page 150) is useful. (A) A color print of the Palace of Fine Arts, San Francisco, made from a transparency. (B) The same scene viewed through a Wratten #90 viewing filter. (C) A black-and-white print of the visualized image.

by thinking there was something wrong with the leaf, because the color does not correspond to our normal range of experience and expectations for leaves. On the other hand, *any* color would be visually acceptable for the flaking paint in figure 10.2, though some colors might not necessarily be pleasing to the eye.

It is interesting to note that the "rules" that people apply to color photographs do not apply to paintings. Modern art has expanded our visual horizons, and the museum visitor has learned to accept the use of color in a painting almost without limitation. In photography, however, the association of the image with "reality" makes it more difficult for the viewer to see a color photograph as an object, divorced from his or her own experience.

Using Color Creatively

An understanding of how the color materials and processes you use will render natural colors is fundamental to visualization in color photography. Once you start to explore color's potential, however, you will begin to appreciate that you do not have to limit yourself to the colors found in the natural world. Three ways

Figure 10.6: William Lesch, *Blue Saguaro and Jupiter, 1988.*

Figure 10.7: Todd Walker, *Computer II, 1982.*

to strike off on your own are to (1) alter the lighting, (2) manipulate your negative or transparency, or (3) alter the object's color (for example, use colored makeup on your subject).

William Lesch pursues landscape photography by photographing subjects late in the day and using colored lights to illuminate certain elements in the scene. The layering of "natural" and "unnatural" colors in landscapes results in imaginative and intriguing color images that illustrate the medium's creative potential.

In many of Todd Walker's color images, the negative or transparency is merely the point of departure. Often the color is artificially generated through the manipulation of black-and-white negatives and the addition of colors that suit the photographer's imagination.

The color photography of Judith Golden provides many fine and distinctive examples of visual messages created with the help of masks, color collages, creative lighting, and altered transparencies.

Figure 10.8: Judith Golden, *Cycles VI, 1985.* Judith Golden creates provocative color images by painting her subjects; often she further modifies the photographs by painting over portions of the image, so that the frame becomes an integral part of the presentation.

While you may choose to use the potential of color photography as a means of interpreting the natural world in a relatively realistic way, the above examples illustrate that you need not settle for a "faithful recording" of a scene on color film. The visualization of images in color is limited only by the boundaries of your imagination.

Visualization in Color Photography

The previous discussion of visualization (in chapter 5) was concerned primarily with black-and-white photography, but the process of considering, approaching, and composing an image is essentially the same for color photography. Like the tones in black-and-white photographs, the colors in your color photographs are influenced by the *film, developer, paper,* and *processes* (and *processing conditions*) you use. The "color characteristics" of a scene are of fundamental importance when you take a color photograph. As in black-and-white photography, you need to understand how these variables can influence your photographs, and you need to learn how to make use of them when you begin to visualize images in color. The ability to appreciate the distinctive character of color films and papers is an especially critical aspect of the visualization of color images.

Choosing Films and Papers

In color photography you can choose to work either with films that produce *color positives* (*transparencies, slides,* or *chromes*) or with those that generate *color negatives.* Transparencies can be an end in themselves or can be used to make prints; color negatives are intended mainly for prints, though they can also be used to make transparencies.

One major difference among various color films and papers is their *palette* — that is, the range and quality of color they produce. Some films and papers provide bold, saturated, and contrasty images and colors, while others favor pastel hues. The materials you use can have a dramatic influence on the appearance of the images you create, so you will need to choose films and papers that harmonize with your visualization of your subjects.

The simplest way to illustrate this is with color transparency film. When you first begin photographing in color, you may think that "what you see is what you get." However, if you photograph any subject with two different types of color film — for example, Kodak's Kodachrome 25 and Fujichrome Velvia — and look closely at the images, you will see that they do in fact differ. Reds will be more brilliant with some films than with others, or yellows or blues may be emphasized. Such color "biases" are a consequence of the dyes and emulsions that manufacturers use to create their color films. These formulations often change over time, and the colors produced by one batch of film may differ slightly from those produced by another. The color will also be influenced by the age of the film (exposed or unexposed) and by the way the film has been stored. (Color film kept in the glove compartment of a hot automobile can undergo dramatic color shifts in a few hours — always heed the warnings on film packages!)

You can use the color bias of a film to your advantage by matching the film to your subject. Color transparency films are constantly being reviewed in detail

Figure 10.9: Todd Walker, *Chris, 1970.*

A

B

Figure 10.10: *Comparison of Kodachrome 25 and Fuji Velvia film.* Color films can differ substantially in their rendition of various hues. The Kodachrome 25 image (A), for example, shows less saturation and contrast than its Fujichrome Velvia counterpart (B).

in the popular photographic press, and it will be worth your while to go over these reports carefully before you select a film. What you need to do is to study the literature, try out the transparency films that interest you, evaluate the results for a wide spectrum of subjects, colors, and lighting conditions, and then choose the films that seem most appropriate for what you ultimately want to photograph.

The same criteria must be applied to printing papers if your goal is to make color prints from transparencies. The contrast in the appearance of the same transparency printed on Cibachrome and Ektachrome papers, for example, is startling. The two papers differ markedly in the physical nature of their print surfaces as well as their color saturation, image sharpness, and color balance. You may or may not have a strong preference for one paper over the other — this is a matter of personal taste — but in any case you need to appreciate the differences so that your choice of materials and printing processes will result in a faithful rendering of the image you visualize. The best way to make a judgment in this is to choose a few color slides that run the gamut of colors and contrast, have prints made (or make them yourself) on various kinds of papers, and then compare the results.

Different color negative films and printing papers, and the chemistry used to process each, usually lead to color prints that are themselves distinctive and dissimilar. Since every manufacturer uses unique dyes and production techniques, it is a rare occurrence for two prints that are made and processed differently to match. Differences in color print tones are often substantial: a negative that produces a displeasing color print on one brand of paper may result in a brilliant image on another. As always, the best strategy is to choose a few well-known and widely available negative films and papers and use the recommended processing chemistry to test them yourself; after you develop a baseline of experience, you will be able to evaluate other materials against the film, paper, and chemistry you started with. As with all experiments, the basic rule is to *keep the number of variables to a minimum.* This is especially important in color photography, where there is a large selection of materials to choose from and where small processing errors can have a dramatic effect on the appearance of the final print.

Merced River, Cliffs, Autumn, Yosemite National Park, 1939

This photograph was made in late autumn, on a chilly morning when the air was crystal clear and still and the silence impressive.

I find it interesting to consider how I would have visualized and made a color photograph of this scene. I can imagine a very quiet and luminous effect of subdued hues; the elements here that made a black-and-white image difficult would be most favorable to color photography. The low contrast of the subject would be compatible with color processes. My first problem would be to reduce the inevitable blue cast produced by light reflected from the open sky. We know this light is of high effective color temperature and, relative to sunlight, is recorded as an obvious blue on color film unless corrective filtration is used. Green foliage in shade takes on a cyan color from blue sky illumination, which I find very unpleasant. Autumn yellows and reds can be somewhat cooled by bluish light even though they may seem vivid to the eye. To say that this blue/cyan effect is real *may be true in the physical sense, but we must realize that the eye compensates for differences in color temperature to an astonishing degree. A normal eye does* not *see this high color-temperature effect, and I believe we should construct our color images based on our visual perception and our visualizations.*

Few subjects lend themselves to both *black-and-white and color image concepts. Years ago, at a Yosemite Workshop, Marie Cosindas agreed with me that she was seeing photographs as compositions in color; her camera visualizations were often inappropriate to black-and-white imagery. I believe this experience favorably influenced her great career in color photography. Such experiences, perhaps not fully understood at the time, may create or confirm controlling lifetime concepts and skills.*

— ANSEL ADAMS

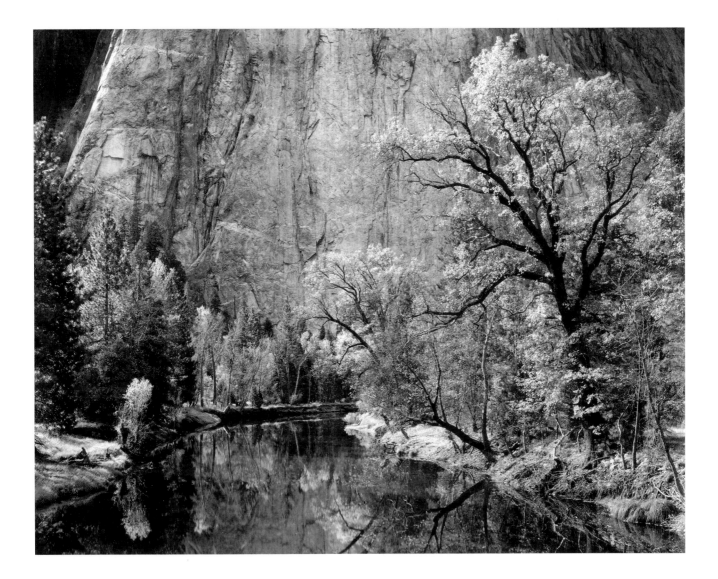

How Color Is Generated in Photographs

Soon after the invention of photography, scientists and inventors began to explore the possibility of adding the dimension of color to the photograph. In the absence of a technique for generating a colored image directly, prints and daguerreotypes were colored by hand with dyes and pigments.

The observation that it was possible to create any color in the visible spectrum by combining appropriate percentages of the three primary colors — red, green, and blue — provided the first key to producing color photographs. James Clerk Maxwell demonstrated this principle in 1861 by photographing a scene on three separate black-and-white film plates, using red, green, and blue filters, respectively. He then made positive transparencies from the negatives and illuminated them separately in three lantern slide projectors, each fitted with either a red, a green, or a blue filter so that the projected images were superimposed on the viewing screen. The combined images reproduced the original scene in color. This process came to be known as *additive mixing.*

Translating the results of Maxwell's experiment into a single sheet of film that would produce a color image required decades of additional research. Modern color films and printing papers consist of multiple layers of emulsions (often nine or more), some of which contain silver halides and are dyed to be selectively sensitive to light of one of the three primary colors. During development, silver metal and colors are formed in each layer; the saturation, or intensity, of the color is proportional to the exposure that layer received. Depending on the composition of the original emulsion and on the type of processing chemistry used, the final product can be either a color negative (from which a print can be made) or a color positive.

An alternative approach to generating color is to start with white light (which consists of all colors in the visible spectrum) and subtract certain colors from it. In the *subtractive process,* the three *complementary colors* (that is, the visual opposites) of red, green, and blue — namely, *cyan* (a greenish blue), *magenta* (a purplish red), and *yellow* — are mixed to produce other colors. In contrast to the three primary colors, if equal intensities of cyan, magenta, and yellow are superimposed upon each other, the result is black (or the absence of light).

Figure 10.11: *Cross section of color film.*

Film Canister

Kodacolor Gold 100

UV Filter Layer
Slow Blue-Sensitive Layer
Interlayer
Yellow Filter Layer
Slow Green-Sensitive Layer
Interlayer
Slow Red-Sensitive Layer
Antihalation Layer
Acetate Film Base

A

B

Figure 10.12: *Mixing complementary colors.* Through the mixture of appropriate percentages of cyan, magenta, and yellow, any other color in the visible spectrum can be produced. The varying intensities of green, blue, brown, and red in these two examples were generated by exposing color enlarging paper through a cut-out square in a sheet of cardboard. Moving the location of the opening over three separate exposures resulted in the pattern of overlaps shown. In figure B, the color intensity was increased by varying only the exposure time for each patch, which had the effect of deepening the color tones.

Mixing equal intensities of a complementary color and its opposite primary will also result in black.

It is immaterial to the eye whether you generate a color by adding other colors together or by subtracting selected wavelengths of light from the spectrum. The subtractive technique is used for modern color photography because dye chemistry makes it more practical.

Color Reproduction

While the principle of mixing three primary or complementary colors to generate other colors in the spectrum sounds simple, the process itself is fraught with problems. The major difficulty stems from the fact that it is impossible to create dyes that are "pure" cyan, magenta, yellow, red, green, or blue: if you examine the visible spectrum of any dye, you will find that its dominant color is always contaminated by varying amounts of other colors. For example, the spectrum of a "cyan" dye will trail off into the magenta and yellow regions. If you mix that "cyan" with an equal quantity of a "magenta" (also not "pure") to generate "red," the color you obtain may contain more cyan or more magenta than you would have predicted. The mixing of "impure" colors results in new colors that are only an approximation of the desired hue.

To improve color reproduction, *colored masks,* visible as additional density in the dye layers, are generated by the dye chemistry and used to compensate for the imperfections of the dyes themselves. Although the quality of color produced by all modern color films and papers is remarkably good, it is not possible to accurately reproduce all colors of the spectrum simultaneously. If you match one color out of a rainbow of hues exactly, the others will be slightly off. In color photography, you must be prepared to settle for an overall color balance that is pleasing. Each image has a "reality" of its own; do not waste your time trying for a perfect match between a slide and a print, a print and the original scene, and so forth.

Masking and the use of complementary colors in color negatives make it almost impossible to visualize a print by looking at the negative: the orange cast is distracting, and familiar elements will seem alien in their complementary hues — green leaves, for example, will be a bright magenta.

Color Emulsions

As explained briefly above, color films are a complex sandwich of three emulsions, sensitive to blue, green, and red light, respectively. Each layer contains silver-halide particles, as in a typical black-and-white film. When the film is exposed, latent images are formed in some or all of the layers, depending on the color of the light source. Development then produces silver particles in each of the exposed layers.

In color negative film, the oxidized developer combines with molecules known as *dye couplers* that are part of either the emulsion or the developer. Dye couplers generate one of the primary complementary colors in each layer where exposure of the emulsion has occurred; thus, the blue-sensitive layer of the emulsion will form a yellow image (the complementary color of blue), the green layer will form a magenta image, and the red layer will form a cyan image. Finally, a bleach is used to remove the silver from the film, leaving a transparent color image.

Figure 10.13: John P. Schaefer, *Mural, El Rio Neighborhood Center, Tucson, Arizona.* Color prints and transparencies are an assemblage of three separate images, composed of cyan, magenta, and yellow dyes, respectively. When the three images are combined, a single full-color image results.

A

B

C

D

A B

Figure 10.14: John P. Schaefer, *Graffiti, Prague, Czechoslovakia, 1990*. Compare the color negative (A) to the color print (B) of this image.

If a positive (that is, a transparency or color slide) is desired, a reversal step is required during processing. The chemistry and emulsions differ, but the principle of color formation is the same.

The image that remains on the film, regardless of whether it is a positive or a negative, is composed of *transparent* dye particles. The films are referred to as *chromogenic,* meaning that their exposure and development lead to the generation of a colored image. As a consequence of the way dye particles are formed during processing, the acutance of a chromogenic image is never as good as that of a traditional black-and-white negative, though enhancements in technology have closed the gap dramatically in recent years.

With a color negative, the image can be printed on color-sensitive paper using the same techniques that you would employ during black-and-white printing. Processing color printing paper requires chemistry that is almost identical to that used in developing the film itself. The chromogenic image formed on the paper corresponds to a positive print. (See chapter 11 for a detailed discussion of color processing and printing.)

A similar process can be used to make prints from color transparencies, except that a reversal step must be incorporated. Another alternative for printing transparencies is the Cibachrome process (see pages 363–364), which relies on a *dye-destruction* technique. The nature of the process itself and the properties of the dyes used make Cibachrome prints both sharper and more stable than chromogenic prints.

Color Balance

The term *color balance* refers to the relationship between the colors in a print or transparency and those in the original scene as it would appear in sunlight at midday. An object's color is a result of both its pigmentation and the nature of the light source used to illuminate it. For a dramatic demonstration of this, view any multicolored object in the light of a sodium vapor lamp (for example, a bright-yellow street lamp): you will be unable to determine what colors you would see in daylight. Likewise, if you photograph a spectrum of colors in full daylight, tungsten light, and fluorescent light, using a color transparency film, you will find that the results differ markedly. The midday scene will look

"normal," the tungsten photo will have an orange cast, and the fluorescent image will have a greenish tint. Even daylight varies considerably: compare your surroundings at midday and at sunset, when the quality of the light is very different, tending more toward the red as the sun disappears into twilight. All of these effects are a consequence of the different colors of the various light sources.

With panchromatic black-and-white film, the quality of a negative is virtually independent of the nature of the light source. A uniformly illuminated subject will produce almost identical negatives, whether it is lit by a tungsten light bulb, fluorescent lighting, a flash bulb, an electronic flash (strobe light), or sunlight. With color film, in contrast, the color of the light has a critical impact on the appearance of the image produced.

The eye and brain have a remarkable ability to compensate for color casts; unless you look for them carefully, you will not notice differences in the colors of commonly used light sources. In color photography, however, film exposure is complicated by the color of the lighting, so you will need to be aware of and evaluate both its intensity and its color.

If you take a color photograph and cover it with a sheet of yellow cellophane, the entire scene will appear to have a yellow cast. In the language of photographers, the color balance of the print will have shifted toward the yellow. If you view the cellophane-covered photograph under a blue light, it will look the same as the uncovered print seen in daylight. The blue light will restore the color balance.

The light spectrum is described by scientists in terms of *color temperature.* To understand the principle, think of what happens when you heat a piece of iron. At first it begins to glow, and then, as the temperature increases, it changes from a dull red to a blue-white. Table 10.1 gives the color temperatures of various light sources.

Table 10.1

Color Temperatures of Light Sources

Source	Color Temperature
Candle	1,900° K
Household (tungsten) bulb	2,800° K
Floodlamp	3,400° K
Flash bulb	4,000° K
Daylight (midday)	5,000° K
Electronic flash	6,000° K
Skylight (no sun)	11,000° K

The emulsions of most color transparency films are formulated to produce a "realistic"-looking photograph if the film is exposed in daylight (that is, at midday), with an electronic flash, or with a blue flash bulb. A note included with "daylight" film will state that it is balanced for a 5,500° K light source. If you want to use the film indoors with available lighting (either tungsten bulbs or fluorescent lights), you will need to attach an appropriate *color-correction filter* to your lens; without it, the transparency will have either a strong red cast (in the case of tungsten lighting) or a pronounced green tint (with fluorescent lights).

Kodak also makes a slide film (Kodachrome KPA, with an ISO rating of 40) that is balanced for indoor use with floodlamps (that is, balanced for a 3,400° K

Figure 10.15: *Effect of color temperature on the color balance of a transparency.* This still life was photographed using film that was balanced by the manufacturer for daylight conditions. The photographs were taken (A) under fluorescent lights; (B) under tungsten lights; and (C) in daylight. Note the distinctive green cast produced by fluorescent lighting and the warm red tones that result from tungsten lighting.

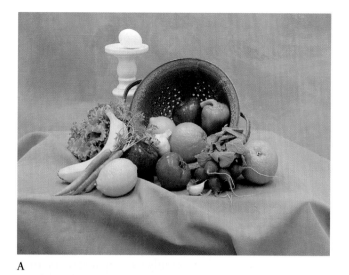

A

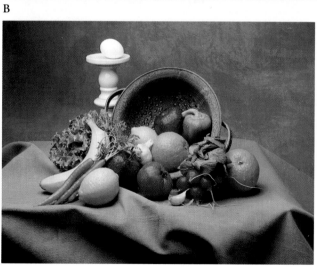

B

C

light source). You can use this film outdoors, but you must photograph through an 85B (amber) filter to correct for the color shift in the light source.

Table 10.2 summarizes the various filters that are available for color photography with transparency films. You can also use them with color negative film, though it is not absolutely necessary since color corrections can be made when the negative is printed.

Table 10.2

Filters for Color Photography

Filter	Comments	Factor*
1A	Often called a "skylight" filter. Absorbs ultraviolet rays and eliminates a blue cast that is invisible to the eye but recorded on the film. Especially useful for mountain and seaside photography and for photographing on overcast days or in the open shade. No exposure correction is required	—
81A	A light yellow filter with a more pronounced effect than the 1A. For use with an electronic flash if you find that your transparencies are too blue. Can also be used to correct color balance with transparency film balanced for tungsten light sources	1.2 (⅓ stop)
82A	A light blue filter that neutralizes the reddish cast often found in early-morning or late-afternoon light	1.2 (⅓ stop)
80	A series of blue filters for use when film that is balanced for daylight is exposed under a tungsten light source. 80A is for 3,200° K sources, and 80B is for 3,400° K lights	4 (2 stops)
85	An amber filter that allows films balanced for tungsten lights to be used outdoors	1.5 (⅔ stop)
FL	Filters that correct for the greenish cast caused by fluorescent lights. The FL-D filter is for use with daylight film, and the FL-B for tungsten film	2 (1 stop)
Polarizer	Reduces reflections from (nonmetallic) surfaces and darkens blue sky. Does not affect overall color balance	2.5 (1⅓ stops)
ND	Increases exposure times without altering the color balance	Varies

* The first number corresponds to the filter factor; the second indicates the increase in exposure required as a function of either f-stop or shutter speed.

The polarizer is particularly useful for color photography, as it has the virtue of increasing the saturation of colors without altering them, producing a print that has richer and purer coloration than would otherwise be the case. You do need to be careful, however, when using a polarizer to photograph a scene in which a broad expanse of sky is included (see figure 10.17). Since the degree of polarization of the sky is a function of the position of the sun, the sky may look bizarre in a polarized photograph, often appearing to shift from deep blue to light blue from one corner to another. (For more details on the polarizer, see pages 123–124.)

A

B

Figure 10.16: *Effects of a polarizing filter in color photography.* Polarizers cut through haze and increase color saturation by eliminating unwanted reflections on surfaces. (A) A photograph of the Golden Gate Bridge, taken without a polarizing filter. (B) The same scene photographed with a polarizer. Note particularly the effect on the sky tones and the degree to which the color saturation of the red bridge is enhanced.

Color Balance and Film Storage The color balance of both color negative and color transparency films is sensitive to both the age of the film and its storage conditions. Most color films are manufactured with the average consumer in mind; they are balanced to optimize performance when used within a specified time span, which is stamped on the container. Professional films are balanced at the time of shipment, and the ISO speed is measured and printed on a sheet of paper included with the film; these films should be refrigerated and used promptly for optimal results. In all other aspects, ordinary and professional color films are of identical quality.

As mentioned above, the color balance of a color film will change significantly if the film is heated. If you are planning an extensive field trip, be sure to store your color film in sealed plastic bags inside an insulated cooler. Avoid letting the film bake inside a hot car, and process it as soon as possible after exposure. Processed color film is more tolerant of heat.

Types of Color Films

Color Transparency Films

Color films that produce transparencies (that is, direct "positives" that correspond to the scene) are known as *reversal films.* By common convention, their names generally end in *-chrome* (Kodachrome, Agfachrome, Fujichrome, Ektachrome, and so on), though Polaroid One film is an exception to this rule. Reversal film is available in 35mm cassettes, rolls, and sheets.

As with black-and-white film, *film speed, grain,* and *inherent contrast* are the fundamental properties that you need to consider when selecting a color transparency film. The general rules are the same: *the slower the film speed, the finer the grain and the greater the inherent contrast.*

With color reversal film, there is little room for error in exposure: the latitude is approximately one-half stop over or under the proper setting. Underexposure will result in a dark transparency, with very dense colors; overexposure will lead to a transparency that looks washed out, with very pale colors. Underexposure is more tolerable than overexposure. For especially important photographs, you should *bracket* your exposures — that is, make additional exposures one-third or one-half stop above and below the indicated

light-meter setting — until you have developed a high degree of confidence in your camera and light meter.

In choosing a reversal film, it is important that you consider the "color" or hue of the manufacturer's dyes. Since there is no "standard" red, green, blue, or yellow, and since each manufacturer uses its own dyes, no two reversal films will reproduce the colors of a scene in precisely the same way. Some films will feature vibrant reds, others will favor yellow, and still others will emphasize blues and greens. Furthermore, new films are constantly being introduced, and dyes are often changed. There are no guidelines for you to follow on the merits of the various films; your choice must be based on your own personal taste.

There are a great number of color transparency films on the market, presenting you with an abundance of choices. Kodak alone offers more than twenty different kinds of slide film, in speeds ranging from ISO 25 to ISO 1600. With such an array of possibilities, how should you go about selecting a transparency film?

One good place to start is with Kodachrome KM 25 (ISO 25), a convenient standard against which to measure all other films. It is widely available and has extremely fine grain, excellent color rendition and saturation, and superior sharpness. If the film speed is high enough for your purposes, Kodachrome KM 25 will deliver superb results. Kodachrome KR 64 is a faster version of the same product, with slightly greater (but still extremely fine) grain. Kodachrome films must be developed by a film laboratory. If you prefer to process the film yourself, consider using one of the Kodak Ektachrome films.

Once you have gained some experience with Kodachrome, try some other brands of films. (The properties of some common brands and types are given in table 10.3 below.) The quality and stability of modern color transparency films are excellent, and you can use almost any product with confidence; ultimately, your own personal preferences about color values are the best reason for choosing a particular brand and type of film.

Figure 10.17: *Polarizing filter and wide-angle lens.* (A) Taken with a 80mm lens fitted with a polarizer. (B) Taken with an 24mm lens with a polarizer.

The polarization of blue sky depends upon the location of the sun and is not uniform. Since wide-angle lenses can encompass a substantial segment of the sky, you must carefully examine the polarized image on the camera's viewing screen for any unnatural color variations, as seen in figure B.

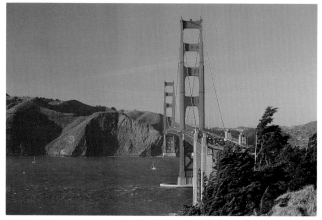

A

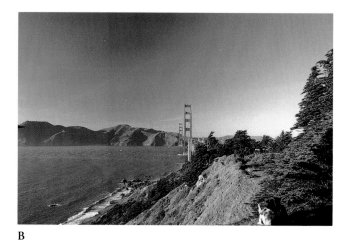

B

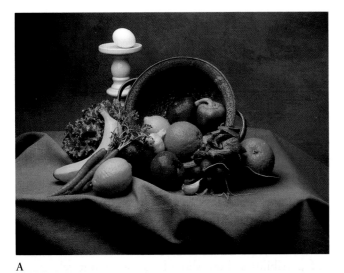

A

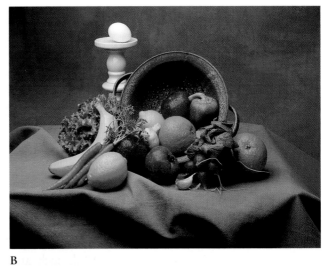

B

C

D

Figure 10.18: *Effect of changes in exposure on color transparencies.* In this sequence of five images, each exposure differs from its neighbor by ⅓ stop. Underexposure (A) enhances color saturation, while over-exposure (E) results in a loss of highlight detail.

E

Table 10.3

Some Common Color Transparency Films

Film	ISO	Grain	Resolution
Kodachrome 25	25	Extremely Fine	High
Kodachrome 64	64	Extremely Fine	High
Fujichrome Velvia	64	Extremely Fine	High
Agfachrome 100	100	Fine	Medium
Fujichrome 50	50	Very Fine	High
Fujichrome 100	100	Very Fine	High
Ektachrome 50	50	Very Fine	High
Ektachrome 64	64	Very Fine	High
3M Color Slide Film 100	100	Very Fine	High
Kodachrome 200	200	Very Fine	High
Fujichrome 400	400	Fine	Medium
Ektachrome 200	200	Fine	Medium
Ektachrome 400	400	Fine	Medium
3M Color Slide Film 400	400	Fine	Medium

Note: This is not intended to be a definitive list of all available color transparency films. Marketing considerations seem to dictate the introduction of "new and improved" films at a rate sure to bewilder consumers. Most of the new "chrome" films offer improved brilliance, color saturation, sharpness, resolution, and permanence and do perform significantly better than comparable films from a decade ago. Both Kodak and Fuji have made significant breakthroughs in color film technology in recent years, and their products clearly have a technical edge over others at the present time. The best way to choose a film is to read the reviews that appear in the popular photography magazines, expose a roll yourself, and compare the output to one of your established favorites.

Exposure/Development Controls with Color Transparency Films Because the first step in the development process for color transparency (*not* color negative) film produces a regular black-and-white negative, you can use the same variables of exposure and development times that you would with black-and-white negatives to control the contrast of color transparency films. (Complete step-by-step procedures for processing color films are given in chapter 11.) Kodak Ektachrome film, which is designed for home processing, readily responds to these controls. The technique is most useful when the subject brightness range is excessive (leading to a transparency that is too contrasty) or when the lighting is flat (resulting in a transparency with limited contrast) and you visualize the scene otherwise.

Reducing the contrast of a color transparency involves *increasing the exposure that the film receives and reducing the normal development time in the first developer.* You will need to experiment with exposure-development combinations to achieve predictable results with your particular film, camera, and development procedures and chemistry. The transparencies you produce with this technique may not always be ideal for viewing by projection, but they will yield superior prints. Table 10.4 shows the exposure and development changes recommended by Kodak for expanding or contracting Ektachrome transparencies.

Table 10.4

Adjustments for the Expansion and Contraction of Contrast for Ektachrome Transparencies

Exposure Change	Change in Development Time	
−3 Stops	+10 Minutes	
−2 Stops	+5 Minutes	Expansion
−1 Stop	+2 Minutes	
Normal	None	
+1 Stop	−2 Minutes	
+2 Stops	−3 Minutes	Contraction

Note: Only the first development time should be changed. All other processing steps remain identical.

Color Negative Films

Color negative films are intended primarily for producing color prints. By common convention, most of their names end in *-color* (Kodacolor, Fujicolor, Agfacolor, and so on). You use them just as you would a black-and-white film, though the processing steps and chemistry are completely different (see chapter 11). As is the case for all other types of film, slower color negative films have finer grain, better resolution, and greater contrast than their faster counterparts.

With color negative film, in contrast to color transparency film, color correction filters serve little purpose, as the differences in color that stem from variations in the color temperature of the light source during exposure can be corrected during printing.

Color negative film, like black-and-white film, allows a relatively wide exposure latitude for average scenes. One-stop underexposure or two-stop overexposure will result in a negative that is still easy to print with all of its essential details. With color negative film, in contrast to color transparency film, overexposure is vastly preferable to underexposure. Some color films are formulated to perform optimally in clearly defined exposure ranges with specific light sources. These are designated either Type S or Type L films. Type S films are balanced for daylight or electronic flash and are intended to be used with exposures of $^1/_{10}$ second or less. Type L films are formulated for floodlamps (3,400° K) with exposures in the range of $^1/_{50}$ second to 60 seconds.

As with color transparency films, there are a staggering number of color negative films available. (Table 10.5 below lists the properties of some common types.) Choose any slow- or medium-speed film to begin with, and then use it as your personal standard. You should by all means experiment with other types and brands, since color rendition can vary widely.

The quality of the prints produced by ordinary commercial processing is highly variable. It is not unusual for two prints from the same negative to differ significantly in terms of color balance if they are printed on different days by the same color lab. In order to make valid comparisons between various types or brands of film, you will need to include a negative that will serve as your "standard," which must be matched each time you have a roll of film processed. By matching your standard from batch to batch, you will have a basis for judging other films. An easy way to do this is to set up a color chart (a spectrum of colored pencils or crayons will do) and photograph it at the beginning or end of every roll of film you expose, making sure that the lighting remains constant for each roll.

Ask the color lab to match the standard print you enclose with each new roll of film you have printed. (The surest way to make meaningful comparisons, of course, is to process and print your own color films — see chapter 11.)

Film	ISO	Comments
Kodak Royal Gold RZ-25	25	This film defines the state of the art for grain and resolution among color negative films. Ideal for 35mm photography when a high degree of enlargement is required.
Kodak Royal Gold RA-100	100	A superb general-purpose color print film for both amateur and professional use. Very fine grain, high resolution, and saturated colors make this film an excellent choice — and it can be processed and printed well almost anywhere in the world.
Kodak VPS-160 or Fuji NPS	160	Low-contrast color print films designed especially for wedding photography and situations where you want to show texture in high-contrast scenes — e.g., white wedding gowns and black tuxedos, flash photography.
Kodak Royal Gold RC-400 or Fuji Super G Plus	400	Both of these films are excellent for use in low-light situations and produce fine-grain images with excellent color saturation.
Fuji NHG II 800 or Kodak Gold RF-1000	800 or 1000	Popular with photojournalists. Good contrast and color saturation, but grain limits the degree of enlargement that is acceptable for prints (5 x 7 inches from 35mm negatives).

Table 10.5

Some Common Color Negative Films

Note: This is not intended to be a definitive list of all available color negative films. The pioneering efforts and research by both Kodak and Fuji on color negative films during the past decade has resulted in remarkable advances in the quality and performance of films now on the market. Films made by manufacturers other than Fuji and Kodak lag significantly in capability, though efforts are being made to close the current gap. Films made by other companies are certainly acceptable for general-purpose photography but, for critical applications, color negative and slide films from either Kodak or Fuji are a better choice at the time of this writing (1999).

In this review I have purposely not listed any ISO 200 films. The film speed is not fast enough than ISO 100 (one step) to justify the loss of image quality that results on enlargement, and the grain does not differ significantly from an ISO 400 film. Generally you will be better served by choosing either the ISO 100 or 400 film and avoiding the compromise.

Figure 10.19: Ansel Adams, *Leaves, Valley Meadow, Yosemite National Park, c. 1936.*

Recent advances in color negative technology have resulted in images that are dramatically improved in terms of quality and stability over those seen just a decade ago, and new products are continually being introduced. Again, photography magazines are an excellent source of information on these new films.

Chromogenic Black-and-White Film

Ilford XP-2 and Kodak TMX- 400 CN are chromogenic films that use color-negative (C-41) chemistry and technology to produce a negative suitable for black-and-white printing. Both are processed in the same way as color negative film: the image is made of dye particles, instead of a silver deposit on the film.

One intriguing property of XP-2 film is that you can expose it at any film speed between ISO 25 and ISO 400. The lower the film speed (ISO 400 is optimal), the finer the grain — or, stated in another way, *grain decreases with overexposure.* The overall density of the negative increases with increasing exposure, but the density of the shadow areas increases much more rapidly than

Figure 10.20: Marie Cosindas, *Tulips and Snapdragons, 1976.*

that of the highlights. In practice, this means that the highlights in chromogenic films do not "block up" as they do in traditional black-and-white films. Ilford XP-2 is an excellent film to use for subjects that have an extended brightness range, as a generous exposure will ensure that you capture both shadow details and highlights in the negative.

Chromogenic films are an intriguing alternative to traditional black-and-white films and are worth exploring. If you choose to have them processed by a ubiquitous "fast photo" shop, you will receive a set of black-and-white prints that will serve as proof prints of the roll.

While the stability and life expectancy of chromogenic films are still a matter of concern (they will fade under certain conditions), this is probably less important with negatives since they are easy to store in a cool, dark place that will keep them relatively stable.

Polaroid Color Films

Polaroid makes several "instant" films that produce color prints. Polacolor prints are exceptionally beautiful and can be made with cameras that accommodate Polaroid film. Special holders designed for use with 4 x 5 and 8 x 10 view cameras allow you to create instant color prints in the field; the holder secures the film during exposure and initiates processing when the film is withdrawn. After approximately a minute, you peel the packet apart to reveal a 4 x 5 or 8 x 10 print. No coating of the print is necessary, and print stability is excellent.

Polaroid SX-70 and Spectra films are intended primarily for the snapshooter, but they have also been used by serious photographers to produce images that constitute genuine works of art.

Polacolor 2 Type 58 (ISO 80), commonly called Polacolor, generates color prints with a lovely unique pastel quality. The film is balanced for daylight and electronic flash. Type 808 fits the 8 x 10 format; Types 88 and 668 are pack films that produce prints up to 3¼ x 3⅜ inches and 3¼ x 4¼ inches, respectively.

Polaroid also makes a 35mm color slide film (ISO 40) that you expose in your camera and process yourself in a manual or automatic processor. Polaroid "Professional Chrome" film (ISO 100) is available in individual packets of 4 x 5 sheet film that you expose in a Polaroid holder and subsequently develop with standard Kodak E-6 processing.

Preexposing Color Film

Preexposure (see pages 190–191) can be used in color as well as black-and-white photography. By preexposing any color film with a low level of light, you can correct the color and support the lower tones of the subject as you would in black-and-white photography. For example, if you are photographing a subject in which there is either considerable shade or areas that are illuminated primarily by open skylight, those regions will have a distinctive blue cast. Preexposing the film on Zone II using a light-yellow card (the complement of blue) will neutralize much of the blue coloration.

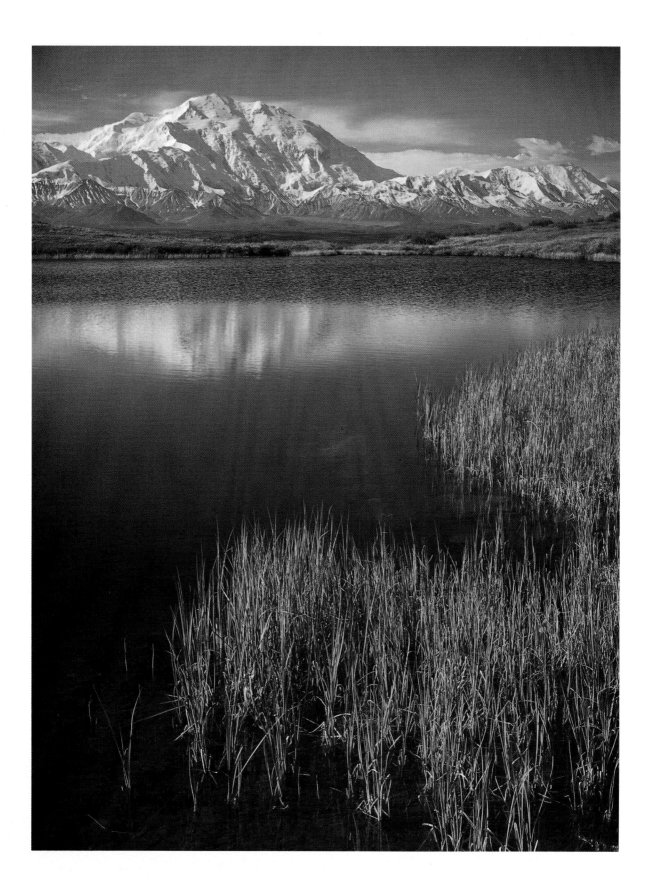

Chapter Eleven

Color Film Development and Printing

While color photography demands precise exposure and processing, the basic approach does not differ greatly from other forms of photography. Our visualizations must take into account various factors of light and film color balance, exposure scale limitations, and so on, and we must refine our reactions to color hue and saturation. In recent years color images have dominated in many fields. Knowing the potentials as well as the limitations of the process, we have no reason not to learn to see the world and visualize the image in terms of color with impact equal to or greater than in black and white. — ANSEL ADAMS

When you begin to do your own color processing, you will be amazed at how easy it is to make a color print — and how difficult it is to make two that are identical! *Temperature control* and *a consistent and reproducible pattern of agitation* are critical elements in achieving predictable results in processing films and printing papers. If you cannot regulate these variables precisely, you will be unable to control print or film density and color balance. In color processing, consistency is as important as accuracy.

Color darkroom work can be enormously simplified with a good semiautomated processing system that will allow precise control of both the processing temperature and the agitation pattern. JOBO has taken the concept of processing color films and prints in light-tight tubes and created a system for tabletop processing that is convenient to use and delivers excellent results. Furthermore, JOBO units work with any kind of color process. If you intend to do color processing yourself (and you should if you want to seriously pursue color photography), acquiring a processing unit should be high on your list of priorities — your savings in materials and time (not to mention frustration!) will quickly cover the purchase price.

A JOBO Starter Kit contains everything you need for processing color prints as well as negatives or slides. Agitation is controlled by a motor drive, and all processing takes place in a constant-temperature water bath that also serves to store and heat the required chemicals. A mechanical lift is available to facilitate the addition and removal of solutions. JOBO units can also be used for black-and-white film processing; they are moderately priced and are a valuable accessory in any darkroom.

Figure 11.1: Ansel Adams, *Mount McKinley, Denali National Park, Alaska, c. 1948.*

Developing Color Negative Film

The techniques used for processing color negative and black-and-white films are similar, but color processing requires a few more steps and much more precise temperature control. While commercial laboratories generally provide excellent service in developing and printing color film, it is both easy and more economical to process the film yourself.

Kodak invented the *C-41 process* for developing color negative film. It has become virtually an industry standard and is used for almost all of the common color negative films currently on the market. The Kodak Color Negative Film Kit contains all of the chemicals you will need to process color negative film. Kits are also available from Beseler, Unicolor, and Photocolor; you may find some of these systems easier to use because they permit you to develop film at lower temperatures than required with Kodak chemistry. Any of these products will provide excellent and consistent results if you follow the directions carefully. Read the product literature and choose the system that will work best for you.

An Overview of the Development Chemistry

When you expose color film, a latent image forms in each of the three silver-salt-bearing emulsion layers, which represent the primary colors (blue, green, and red) of the spectrum. In the first processing step, the silver-halide crystals in each layer are turned into silver metal to create a negative. During processing, dye couplers that are present either in the developer or in the emulsion react and form dyes, the intensities of which are in direct proportion to the amount of silver in each layer. Next, the developed negative is chemically bleached to convert the silver suspended in the emulsion layers to a soluble salt. The film is washed briefly, and the silver salts are dissolved with a fixer (ammonium thiosulfate). When fixing is complete, the film is washed again and then submerged in a chemical stabilizer to insure the stability of the dyes. Finally, the film is dried in the usual way (see pages 224 and 234).

Getting Ready to Develop

The equipment needed to develop color film is the same as that used for black-and-white negatives (see chapter 7). Many photographers prefer stainless steel developing tanks for color film since the processing chemicals will stain plastic tanks. While stains will have no effect on the actual performance of the tank, chemical contamination of color processing solutions must be avoided at all costs. If you are careful to clean your equipment thoroughly after each session, you should have no problem with either type of tank.

Remember: *temperature is the most critical variable in color film development*. With Kodak's C-41 process, you must develop the film at 100° (+/− ¼°) F for 3¼ minutes; all of the remaining processing steps can be carried out in the fairly liberal temperature range of 75–105° F. The best and simplest way to maintain constant temperatures is to keep all of your processing solutions *and* the developing tank in a large pan filled with several gallons of water at the proper processing temperature. If you don't mind going to a little extra trouble, you can

Figure 11.2: *JOBO CPE2 processor*. JOBO makes several rotary processors that are ideal for home darkrooms. The basic unit consists of a constant-temperature bath that uses circulating water to regulate the temperature of solutions, as well as a processing drum and an attached motor drive that allows precise control of the drum's rotation speed. Optional features include semi- or fully automated introduction and removal of processing solutions. A large variety of drums for processing photographic papers and films is available.

set up a self-regulating constant-temperature bath with an inexpensive thermostat and heater of the sort normally used in tropical fish tanks.

Total processing time for color negative roll film should be no more than 30 minutes.

Developing Color Negative Roll Film

1. Arrange the equipment you will need in the same way you did when preparing to develop black-and-white roll film (see page 219).

2. Prepare the solutions according to the instructions enclosed with the kit and store them in plastic bottles. The solutions will keep for only two to six weeks (except for the bleach solution, which will keep indefinitely), and you must take care to expel all of the air from the storage containers to prolong their shelf life. Place the solutions in the constant-temperature bath and allow them to reach and stabilize at 100° (+/– ¼°) F. (*Note:* Heating water and solutions can take a long time with a low-wattage heater such as one designed for a fish tank. To shorten the heating time, fill the constant-temperature bath to about two-thirds of capacity with cold water and then pour in hot water from a pitcher until the bath is as close to 100° F as you can manage. You can then fine-tune the temperature with the heater and thermostat. Use a tray of very hot water, about 120–140° F, to heat the individual containers of solutions, stirring them vigorously with a glass thermometer. When they are at approximately 100° F, place them in the bath and allow the entire system to equilibrate. You must stir the bath frequently — or, if possible, use a circulating pump — to keep the temperature uniform throughout.)

3. **Turn off all the lights in the darkroom** and load your film onto the reel in the usual way. Place the reel in the developing tank. If you are using a multiple-reel tank, fill the extra space with empty reels (Kodak warns that failure to do so may result in streaks on the film due to excessive agitation of the film as it moves through the tank when inverted). Cap the tank and **turn on the darkroom lights**.

4. Set the timer for the interval required to develop the film.

5. Hold the developing tank in the constant-temperature bath until it reaches approximately 100° F (this will take about 1 minute). Lift the tank out of the bath, remove the vent cap, and pour in the developer. Cap the tank and start the timer immediately.

6. Tap the developing tank sharply against the tabletop once to dislodge any air bubbles, then agitate it by inverting and righting it constantly for the first 30 seconds. Place the tank in the water bath and let it sit. Agitate in the usual way by inverting and righting the tank 3 times at 15-second intervals. Keep the tank in the water bath between agitation cycles.

7. When there are 10 seconds left before the end of the development cycle, remove the vent cap and pour the developer back into its container. (*Temperature control is no longer critical at this point. Steps 8–14 can be carried out in the range of 75–105° F.*)

8. As quickly as possible, fill the tank with the bleach solution. Agitate the tank in the usual way, first for 30 seconds and then for 5 seconds at 30-second intervals until the bleaching cycle is completed. Pour the bleach back into its container.

9. Wash the film for 3¼ minutes. Fill the tank with water, agitate vigorously, and drain; refill the tank with fresh water and continue to repeat the cycle for the duration of the wash period.

10. Fill the tank with fixer. Agitate for 30 seconds and then for 5 seconds at 15-second intervals for the remainder of the fixing cycle. Pour the fixer back into its container.

11. Wash the film as before.

12. Fill the tank with stabilizer, agitate it for 5 seconds, and allow it to stand for 1½ minutes. Pour the stabilizer back into its container.

13. Remove the film from the tank and hang it up to dry. *Do not squeegee the film unless you see water spots on it. The emulsion is very soft and will scratch easily.*

14. Clean and dry all of your equipment thoroughly.

Developing Color Negative Sheet Film

If you are planning to develop color negative sheet film, *do not attempt to process it in trays* using the techniques described for black-and-white film. Keeping solutions at 100° F in open trays is virtually impossible, and furthermore, color sheet film is extremely slippery and very difficult to handle when wet. The simplest way to develop sheet film is to use two hard rubber sheet film developing tanks and special sheet film holders. (You can also use a JOBO processing unit — see below.) For tank development, proceed as follows.

1. Prepare the solutions you will need according to the instructions enclosed with the kit, store them in plastic bottles, and bring them to 100° F in the constant-temperature bath. Pour sufficient developer into a half-gallon hard rubber tank to enable the film to be completely submerged when it is placed in the tank. Pour the bleach solution into the second tank. Set the developer tank and the bleach tank in a water bath to maintain the proper 100° F temperature.

2. Set the timer for the interval required to develop the film.

3. **Turn off all the lights in the darkroom.** Remove the sheets of film from their holders and slip them into development racks, the stainless steel holders that fit into the tank. Close the gate on the racks so that the film will not become dislodged during agitation.

4. Lower the racks into the developer tank, start the timer, and begin to agitate the film by gently moving the racks as a group up and down, lifting them out of the developer and then immersing them again. Repeat this action continuously for the first 30 seconds and thereafter agitate for 5 seconds at 15-second intervals.

5. When the development cycle is complete, transfer the racks to the bleach tank, letting any excess developer drain off. Set the timer for 6½ minutes and start it. Agitate the film for 30 seconds, then for 5 seconds at 30-second intervals. You can **turn on the room lights** at the end of the bleaching cycle.

6. Pour the developer back into its storage container. Rinse out the developer tank and fill it with tap water. Transfer the film racks from the bleach tank to the water tank, insert a hose from the tap into the tank, and wash the film for 3 to 4 minutes.

7. Pour the bleach back into its storage container. Rinse out the bleach tank thoroughly and then fill it to the appropriate level with fixer. When the wash

cycle is complete, transfer the film from the water tank to the fixer tank. Set the timer for the recommended fixing time and start it. Agitate the film for 30 seconds, as before, and continue to agitate it intermittently for the remainder of the fixing cycle.

8. When fixing is complete, transfer the film racks back to the wash tank and wash the film in running water for at least 4 minutes.

9. Pour the fixer back into its storage container. Rinse out the fixer tank thoroughly and fill it with stabilizer solution.

10. At the end of the wash cycle, transfer the film racks to the stabilizer solution, agitate for 30 seconds, as before, and then allow to stand for approximately 1½ minutes (the precise time is not critical).

11. Remove the film from the stabilizer one sheet at a time and take it out of the rack. Attach a film clip to one corner of each sheet and hang it in a dust-free place.

12. Pour the stabilizer back into its storage bottle and then clean and dry all of your equipment thoroughly.

Developing Color Negative Film with the JOBO Processor

The easiest and most consistent way to process color roll or sheet films — and papers — is to use a JOBO Color Processor.* (The unit can also be used to develop black-and-white films.) To develop color film with a JOBO unit, proceed as follows.

1. Prepare the solutions you will need according to the instructions enclosed with the kit and store them in the widemouthed plastic containers provided by JOBO. Place the containers in the unit's water bath, turn on the heater and water-circulating pump, and bring all of the solutions to the processing temperature.

2. **Turn out all the lights in the darkroom** and load the film (either sheet film or roll film) into the processing drum. Cap the drum and **turn on the room lights.** Connect the drum to the rotation motor.

3. Set the timer for the development time you intend to use. Remove the drum from the bath, take off the vent cap (*not the cover!*), pour the developer into the tank, replace the vent cap, reconnect the drum to the rotation motor, and start the timer. (With the JOBO lift, solutions are added to and drained from the unit semi-automatically, making it unnecessary to detach the drum. This saves time and greatly facilitates processing.)

4. About 10 seconds before the end of the development cycle, remove the drum from the bath, take off the vent cap, and discard the spent developer. Pour the bleach into the tank, replace the vent cap, reconnect the drum to the rotation motor, and then set the timer for the duration of the bleach cycle and start it.

5. Repeat the above steps using first fixer and then wash water.

6. When washing is complete, remove the vent cap and submerge the film in stabilizer solution. With roll film, you can pour the stabilizer into the drum

*Note: Rather than the plastic sheet- and roll-film reels made by JOBO, I prefer to use a JOBO metal reel and a special insert for roll-film processing, or one of their Expert series drums (which do not require reels) for sheet film.

and let it stand for 1½ minutes after initial agitation. With sheet film, it is easier to fill a tray with stabilizer and let the film soak in it after carefully removing it from the drum.

7. Hang the film up to dry in a dust-free place.

8. Clean and dry all of your equipment thoroughly.

Developing Color Transparency Film

Color transparency films are designed to be processed either commercially or by the photographer. The Kodak E-6 process has become the industry standard for developing virtually all types of transparency film, with the exception of Kodachrome, which must be processed in specially equipped laboratories.

In the E-6 process, a black-and-white developer is first used to produce a negative image on the film, which is then washed and placed in a reversal bath to activate the remaining silver-halide particles. Next, a color developer generates a positive color image wherever there are grains of silver halide, and a conditioner prepares the film for further processing. Bleaching, fixing, washing, stabilizing, and drying complete the process. (With the Kodak Color Slide Kit, several of these steps are combined to simplify the procedure; other manufacturers offer kits that work equally well.) Processing can be carried out anywhere in the temperature range of 70–110° F. Development kits give directions for both "push" and "pull" development, allowing you to either increase or decrease the contrast of your transparencies by using the techniques of exposure and development control described earlier for black-and-white film (see pages 200–201). The equipment needed for processing transparencies is the same as that used for black-and-white and color negative films.

Developing Color Transparencies

The following procedure pertains specifically to the Kodak Color Slide Kit. If you are using another system, follow the instructions included with the product.

1. Prepare the solutions you will need according to the directions enclosed with the kit. (*Note:* The solutions will have a shelf life of about five weeks if they are stored properly, in full, air-tight bottles.) Place them in a water bath and bring them to the processing temperature that you intend to use.

2. **Turn off all the lights in the darkroom.** Load the film onto the reel and place it in the developing tank. If you are using a multiple-reel tank, fill it with empty reels. Cover and cap the tank and **turn on the room lights.** Place the tank in the water bath.

3. Set the timer for the appropriate interval, pour the developer into the tank, and start the timer. Rap the tank sharply against the tabletop once and begin the agitation cycle by inverting and righting the tank repeatedly for the first 15 seconds. Return the tank to the water bath. Thereafter, agitate the tank at 30-second intervals, inverting and righting it rapidly twice each time. Approximately 10 seconds before the end of the development cycle, remove the vent cap (*not the cover!*) and pour the developer back into its storage container.

4. Fill the tank with water of about the same temperature as the developer, replace the vent cap, agitate the tank by inverting and righting it several times, and discard the water. Repeat this process using fresh water until the film has

A

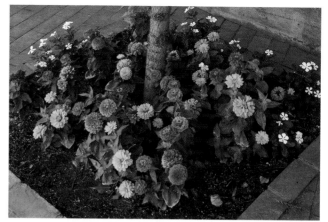

B

C

D

Figure 11.3: *Contrast control with color transparencies.* The first step in processing a color transparency is to develop a black-and-white negative, which means that the exposure and development variations for contrast control described in chapter 6 are applicable. (A) Note the pronounced blue cast of the "red" bricks and the low contrast of this shaded image, a consequence of the fact that the blue sky is the dominant light source. (B) Reducing the exposure by one stop and doubling the development time increases the contrast of the image but also results in a slight red shift. (C) Normal exposure of this high-contrast scene produced a transparency in which details in the shadow areas are difficult to see. (D) One stop additional exposure with shortened development produced a low-contrast transparency in which shadow detail is clearly visible and color saturation is reduced.

been rinsed at least 4 times. The last wash should be a very light yellow in color. It will do no harm to expose the film to light at or beyond this point.

5. Fill the tank with the color developer (for particulars, consult the time-temperature table provided with the instructions) and agitate the film, continuously at first (for 15 seconds) and then intermittently (every 30 seconds) as described in step 3. When the color development cycle is complete, pour the color developer back into its storage container.

6. Wash the film again as described in step 4. The last rinse should be a very light blue.

7. Fill the tank with bleach-fix. Agitate continuously at first (for 15 seconds) and then intermittently (every 30 seconds) for 10 minutes. A longer bleach-fix time will not harm the film. When bleach-fixing is complete, pour the solution back into its storage container.

8. Wash the film for at least 4 minutes in running water.

9. Fill the tank with stabilizer, agitate briefly, and then allow the film to sit in the solution for at least 1 minute.

10. Remove the film from the reel and hang it from a film clip to dry. *Do not squeegee the film unless you see water spots on it. The emulsion is very soft and will scratch easily.*

11. Clean and dry all of your equipment thoroughly.

Monument Valley, Arizona,
circa 1958

The photographic rendition of color may be approached in three ways: literal or accurate simulation, aesthetic simulation, and abstract, or nonrealistic, interpretations. For literal simulation it is necessary to match carefully the color temperature of the light source(s) to the film's color balance and to use filters as required to correct for color temperature variations, length of exposure, and other factors affecting color.

Aesthetic simulation replaces the objective judgment of color rendering with subjective evaluation. We can visualize a great variety of interpretations in which the impression of light, substance, and color may not be based on the "realistic." Colors have varying emotional effect, alone and in relation to other colors, depending partly on their depth (saturation).

In interpreting color in an abstract manner we can literally "paint" with color, creating departures-from-reality in great variety. We can use strong filters, direct light of varying colors on the subject, and use optical "distortions," double-exposure, and processing alterations to lead us away from the obvious.

Perhaps the most difficult subject for color photography is the landscape. We may choose to deal with the complexities by a number of means, including simply waiting for appropriate lighting and other environmental conditions. We may work with the close and minute aspects of nature, where a splendid and complex world of color is revealed. If we enter the urban world, we have great varieties of color and color effects that allow interpretive explorations beyond what is ordinarily possible in the natural scene. — ANSEL ADAMS

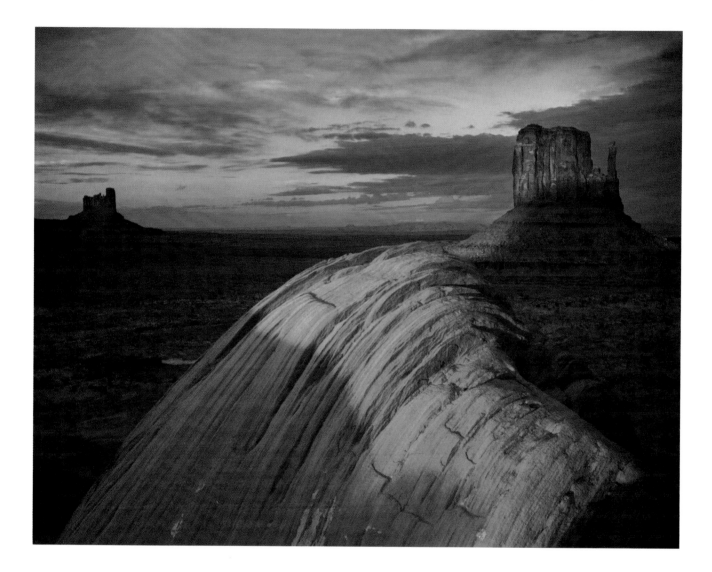

Color Film Development: Summing Up

The only real difference between developing color and black-and-white films is that temperature control is much more critical with color film. If you fail to maintain proper temperature control, you may adversely affect both the *color balance* and the *contrast* of the film, though neither problem is necessarily irreparable.

When you print a color negative, for instance, it is not difficult to make corrections that will compensate for variances in color balance. If you can refine your technique to the point where your development of color negatives is consistent, however, you will no longer need to use widely differing filter packs for each set of negatives you produce.

Processing errors that result in color shifts or a contrast level different from that intended for a color transparency can be more troublesome. Your best option in this case is to make either a print of the transparency or a duplicate, copying the original with your camera and correcting the deficiency with appropriate filtration.

Color Printing

Equipment for Color Printing

Printing color negatives and transparencies in your own darkroom gives you the opportunity to make enlargements that are superior to those routinely obtained through commercial processing. You can crop images as you choose, dodge and burn for special emphasis, and optimize the color balance of the print to reflect your personal vision.

Although color films and printing papers have a broad range of distinctive characteristics, there are a relatively limited number of processes available for making color prints from color negatives or transparencies. You should choose the combinations of film, paper, processing chemistry, and processing equipment that are most convenient (and affordable) for you and that will produce the quality of colors that will harmonize best with your visualization of your subjects. Experiment with different brands of printing paper and processes until you find the materials and processing chemistry that best satisfy your needs.

In addition to the equipment you normally use for black and-white work, you will also need certain items designed especially for color printing.

Color Printing Papers

Color printing papers vary according to the method used to generate the print. Unlike black-and-white printing papers, all color printing papers are sensitive to light of any wavelength and *must be handled in total darkness.*

Papers for Printing Color Negatives The structure of the printing paper used with color negatives is very similar to color negative film, except that the color sensitive emulsions are coated onto paper stock rather than a plastic base. After exposure, the paper is processed with C-41 chemistry, like the negative, though the concentrations of various components that make up the developer

Figure 11.4: John P. Schaefer, *Tarahumara Indian.* The Cibachrome process produces prints that resist fading and vividly reproduce color transparencies. To print a transparency of a subject that contains both shadow details and textured highlights, however, you must either resort to using complex transparency masking procedures (beyond the scope of this book) or be prepared to sacrifice some detail in the highlights or shadow areas of the print.

differ slightly from those used for processing the negative. The names of papers designed for use with color negatives generally end in the suffix *-color* — for example, Ektacolor and Agfacolor. Papers are available in both glossy and matte ("pearl") finishes.

Papers for Printing Color Slides When printing color slides, you have two choices: you can use either a paper intended for color reversal processing or the Cibachrome process.

The paper for *color reversal processing* is similar in structure to color transparency film, with the emulsion coated onto a paper base. Processing involves exposing the paper, developing a black-and-white image (a negative image), reversing that image on the paper to create a positive, and then developing color to correspond to the positive. Bleaching the silver, washing, and stabilizing the image complete the processing steps. In practice, the chemistry is formulated so that the steps proceed sequentially and processing is no more complicated than printing from color negatives.

The *Cibachrome process* is based upon an entirely different principle. Three azo dyes corresponding to the three complementary colors are incorporated into the paper's emulsion, along with light-sensitive silver salts; when the paper is exposed, latent images are formed in the cyan, magenta, and yellow layers of the emulsion. A black-and-white developer is then used to develop a black-and-white negative image. In the second step, a powerful acid is used to bleach the silver, which catalyzes the destruction of dye particles in the immediate vicinity of the crystals of silver metal. Fixing and washing complete the processing of the print. (For processing times and temperatures, see table 11.6, on page 380.)

The dyes in Cibachrome prints resist fading and bleaching, and the color prints themselves are the most stable of all of the color-print materials currently produced. Cibachrome prints' highly saturated and brilliant colors and glossy surface have become hallmarks among color photographers (a pearl surface is also available).

Color Filters for Printing

The color temperature of the printing light is an essential factor in color printing. It can be controlled by equipping the enlarger (see figure 8.5) either with *acetate or gelatin filters* or with a special *color head* (see figure 11.5). Filters are the least expensive way to regulate the enlarger's color output; they are available in matched sets that correspond to a graded density scale of the three complementary colors. The filters do begin to fade after extensive use, and may need to be replaced.

Filters are best used in the lamphouse, so that they lie between the light and the negative; this placement eliminates any possibility of a filter's imperfections' affecting the quality of the image. Filters designed to be positioned above the negative, called *Color Printing Filters* by Kodak (designated by the letters *CP*), are made of a tough acetate film and come in yellow, magenta, and red. Table 11.1 lists the filters available in the CP format, arranged by color and *intensity* (see below).

Table 11.1

CP Filters for Color Printing

Magenta	Yellow	Red	Ultraviolet
CP05M	CP05Y		CP2B
CP10M	CP10Y		
CP20M	CP20Y		
	CP40Y	CP40R	
	CP80Y	CP80R	

If you must place your filters below the enlarging lens, you will have to use the more expensive *Color Compensating Filters* (designated by the letters *CC*). These consist of thin layers of quite fragile gels and should be handled only by their edges; it is important that you keep them free of dust, dirt, and scratches since these may distort the image. Like CP filters, CC filters are sold in graded sets of yellow, magenta, and red, but their filtration values differ. Table 11.2 lists the available CC filters by color and intensity.

Table 11.2

**CC Filters
for Color Printing**

Magenta	Yellow	Red	Ultraviolet
CC05M	CC05Y	CC05R	CP2B
CC10M	CC10Y	CC10R	
CC20M	CC20Y	CC20R	
CC30M	CC30Y	CC30R	
CC40M	CC40Y	CC40R	
CC50M	CC50Y	CC50R	

Regardless of which kind of filter you use, you will need an *ultraviolet filter* (designated CP2B), which should be installed permanently above the lens.

Both CC and CP filters are rated in terms of *units of intensity* for each of the three colors (CC10M, for example, corresponds to 10 units of magenta filtration; *Y* and *R* stand for *yellow* and *red,* respectively). It is generally necessary to use a combination of two different colors to achieve the needed corrections. Since cyan is the complement of red, its intensity as a component of the enlarger light can be controlled by either adding red to the filter pack or subtracting it. (The addition of equal amounts of magenta and yellow will also produce red; again, because red is the opposite of cyan, this is equivalent to a reduction in the level of cyan filtration.)

In each packet of color printing paper you purchase, you will find the manufacturer's recommendation for an appropriate starting filter pack for that particular paper. Since filters also reduce the overall intensity of the light output of the enlarger, you will need to change the exposure time whenever you alter the composition of the filter pack. Table 11.3 gives the filter factors for both CC and CP filters. When you add a filter to a pack, simply multiply the previous exposure time by the new filter's filter factor to obtain the new exposure time; conversely, if you take away a filter, divide the original exposure time by the factor of the filter you are removing. For example, if the starting filtration was CC50Y and the exposure time was 8 seconds, and you add a CC20R filter (factor 1.5), multiply 8 by 1.5 to find the new exposure time, 12 seconds.

Table 11.3

**Filter Factors
for Kodak Filters
(CC and CP)**

Filter	Factor	Filter	Factor	Filter	Factor
05Y	1.1	05M	1.2	05R	1.2
10Y	1.1	10M	1.3	10R	1.3
20Y	1.1	20M	1.5	20R	1.5
30Y	1.1	30M	1.7	30R	1.7
40Y	1.1	40M	1.9	40R	1.9
50Y	1.1	50M	2.1	50R	2.2

Color Enlarger Heads

A simpler (but more expensive) way to control filtration for color printing is to attach a color head to your enlarger. The color head consists of a bright white light source (usually a quartz/halogen bulb) and three *dichroic filters.* These filters are special optical devices, called *gratings,* that act as a prism and separate the white light into its components of cyan, magenta, and yellow, which can then be

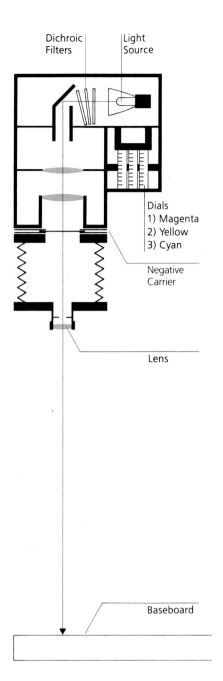

Figure 11.5: *Color enlarger head.* The salient feature of a color enlarger head is the small, bright light source (usually a quartz iodide lamp) that sits behind the three dichroic filters. The filters themselves separate the white light into components of magenta, yellow, and cyan. The intensity of each complementary color is controlled by a dial on the face of the enlarger head, which adjusts the position of the appropriate filter. The light beam is projected onto the negative from a mixing box, by means of condensers.

mixed in a chamber within the lamp housing in any desired proportion before being projected through the negative or transparency and onto the printing paper. Dials on the lamp housing allow you to select the exact filtration you want to use.

One advantage of dichroic filters is that they are stable and do not fade over time, as do gelatin and acetate filters; another advantage is that the units of intensity of the various colors can be much greater with a color head. Color heads can also be used for printing variable-contrast black-and-white papers; instructions enclosed with the papers will indicate what filtration corresponds to which contrast grade.

Most high-quality modern enlargers are available with either a black-and-white or a color lamp housing. You can add the color head as a module if you choose. If you intend to do a good deal of color printing, a color head will greatly simplify the process.

Processing Equipment

If you wish to obtain consistent and predictable results when you make color prints, it is imperative that you maintain rigid control of the developing step. Any variations in temperature or processing conditions will lead to color shifts and changes in print densities.

Processing of color prints can be carried out in ordinary developing trays, special light-tight drums, or machines, with varying degrees of automation. Although automation might seem to limit creativity, creative manipulation is in fact impossible during color print processing. The more color printing you do, the more you will benefit from automated processing.

Tray Processing The least expensive way to develop color prints is in trays. You will need two of them, one for the developer and the other for the bleach-fix (often abbreviated as *blix*).

The major difficulty with tray processing is temperature control. With Ektaprint chemistry, the recommended processing temperature is 91° F, and you must maintain the developer at a temperature within (+/–) ½° F of that for the development step. (The paper can be processed at other temperatures, but the development times may be uncomfortably long.) You can achieve a degree of control by placing the developing tray inside a larger tray filled with water at the appropriate temperature, but if the room temperature is significantly lower than the processing temperature, you will find that the developer will cool rapidly in the open tray, and your results will be inconsistent. Tray processing is usually not a realistic option for critical quality control.

Tube (Drum) Processing Tube processing represents a significant advance in color printing, as it enables you to carry out all the processing steps with the darkroom lights on. Furthermore, the procedure calls for relatively small amounts of chemicals, each used on a one-shot basis, which insures consistent results. The tube itself is an inexpensive (about $25), light-tight plastic pipe with a removable cap on each end.

Figure 11.6: Ansel Adams, *Aspens, North Rim, Grand Canyon National Park, Arizona, c. 1942.*

To process with a tube, you expose the paper **in total darkness,** place it in the tube (with the emulsion side facing inward), and replace the cap. Then you **turn on the darkroom lights** and begin processing. Holding the tube upright, you pour the appropriate solution through an opening on one end, where it is caught in an internal cup until you turn the tube to a horizontal position. The solution then flows into the tube, which is rotated constantly during each processing step. When the step is complete, you hold the tube upright again, and the solution drains out through a baffle in the bottom while you pour the solution for the next step into the top. This procedure is repeated with each processing solution.

You can rotate the tube during processing by rolling it either along the surface of a tabletop or in a tray of warm water (the latter will provide better temperature control). For a modest price, a motorized roller will relieve you of this chore.

To maximize temperature control and to prevent streaking due to the fact that the developer will reach some parts of a dry print before others, a presoak step is necessary for tube processing. To presoak the print, pour a large amount

Figure 11.7: Ansel Adams, *Autumn, Merced River, Yosemite National Park, California, c. 1950.*

of water (about 500 milliliters, if possible) heated to the processing temperature into the tube after you have placed the paper inside. This will thoroughly soak the paper and bring the inner surface of the tube itself to the proper processing temperature. After 30 seconds, let the water drain from the tube and pour in the developer. Because the tube is made of a plastic that has excellent insulating properties, it will maintain the temperatures of the solutions during the various processing steps.

With care and standardization of your working habits, you can realize consistently good results with tube processing. Conversely, failure to control the time and temperature of each step in the print-development process will make it impossible for you to obtain consistent results. If the temperature of your solution changes significantly during processing (if the tube is cold, for example, thereby chilling the developer when it is introduced), the print will be under-developed and the color balance may shift. Trying to compensate for an incorrect processing temperature by increasing the exposure and changing the filtration is not a productive use of your time.

To find out whether you are achieving satisfactory temperature control, add 70 milliliters of water at 91° F to an *empty* tube and proceed to rotate it as if you were processing a sheet of printing paper. After 3½ minutes, pour out the water and measure its temperature as it leaves the tube. If it is less than 90° F, you need

to work on your system of temperature control. If you are using a water bath, make certain that the water is circulating freely; if you are using a heater, be sure it responds quickly and effectively as the temperature of the water bath begins to drop.

If you make all the adjustments you can and are still unable to achieve absolute temperature control, you can adopt the *drift-through* method of processing, in which you average the starting and final temperatures of the developer to determine the development time. To apply the principle, check the temperature of your water bath, pour some water from the water bath into the tube, rotate the tube for a few minutes, and measure the temperature of the water as you pour it out. Then look up the developing times corresponding to the starting and final temperatures in the time-and-temperature chart supplied with the developer (table 11.4 gives values for Ektaprint 2 chemistry) and calculate the average of the two values. For example, if the temperature of your water was 91° F when you poured it into the tube and 86° F when you poured it out, you would take the average of 3:30 and 5:10 and use that (4:20) as your developing time.

Table 11.4

Tube Processing Times and Temperatures for Ektaprint 2

Temp.	Time (min:sec)	Temp.	Time	Temp.	Time
91° F	3:30	83° F	6:40	75° F	12:45
90° F	3:45	82° F	7:15	74° F	13:50
89° F	4:05	81° F	7:50	73° F	15:00
88° F	4:25	80° F	8:30	72° F	16:20
87° F	4:50	79° F	9:10	71° F	17:40
86° F	5:10	78° F	10:00	70° F	19:10
85° F	5:40	77° F	10:50	69° F	20:50
84° F	6:10	76° F	11:50	68° F	22:30

If you find it too difficult to control the temperature of your solutions at the higher temperatures, do your processing at a lower temperature and increase the development time.

Color Processing Machines In addition to the JOBO unit mentioned at the beginning of this chapter, several tabletop machines that completely automate the processing of color prints are available for use in the home darkroom (see figure 11.8). With these systems, exposed sheets of printing paper are fed into the machine and taken up by rollers that move them at precisely controlled rates through the various solutions. A typical machine can process as many as twenty-five 8 x 10 prints in an hour. Temperature control is precise, and results are reproducible with minimal effort. Prices begin at about $1,000 and rise steeply, depending upon the features you choose.

Processing machines do require large amounts of chemicals (a minimum of a half-gallon of each solution for most processors), however, so they are only practical if you plan to make a substantial number of prints in each darkroom session. Note that not all machines are capable of accommodating the chemistry required for different processes—for example, most machines can handle either color negative print or Cibachrome chemistry, but not both. If you are thinking of buying a machine, investigate its limitations carefully before you make the capital investment.

Color Analyzers

A *color analyzer* is a color light meter designed to be used in the darkroom with an enlarger. The biggest problem in color printing is determining the correct exposure and filtration for a negative or transparency; when you first begin to print color, you will inevitably have to go through an impressive number of sheets of paper before you arrive at a print that pleases you. A color analyzer can reduce the time and the number of trials required to make a good print.

To use a color analyzer, you must first make a "perfect" print of a negative or transparency that you have chosen as your "standard." The subject should have a reasonable spectrum of tones, including some that will serve as a reference. A portrait of someone holding a gray card is ideal. When you have made the "perfect" print, place the analyzer's photocell on the enlarging easel and rotate the dials on the analyzer until the needle readings for yellow, magenta, and cyan filtration and the white light are at zero for the gray card (or whatever tone represents your standard). Write down the enlarger filtration that corresponds to those settings, the corresponding settings on the analyzer dials, and the exposure time required to make the print.

To make a print of another negative or transparency, position the photocell in such a way that it will read the color values of a print tone that is the same as your standard. Change the filtration on your enlarger for each color, so that the indicator needles on the analyzer return to zero. Next, adjust the white-light reading back to zero by increasing or decreasing the aperture of the enlarging lens. If you use the same exposure time that you used for your standard negative or transparency, you should obtain a print that is both color-balanced and correctly exposed.

An alternative procedure that many people prefer makes use of the general rule that most prints will average out to "gray" when all of their colors and light values are blended. To try this method, after you make a "perfect" print of your standard, cover the enlarging lens with a *diffuser,* a filter made of a thin sheet of frosted glass. The diffuser blends all of the tones and light values of the negative or transparency and projects a totally diffused image onto the easel. Put the analyzer on the easel and rotate its dials until the indicator needles for each color are set at zero. Write these settings in your notebook alongside the values you recorded for a spot reading.

To make a print of another image, compose and focus it on the easel, then cover the enlarging lens with the diffuser. Change the filtration on the enlarger until the indicator needles on the analyzer are set at zero. A print made with those settings — and the same exposure time as the standard print — should be very close to being color-balanced and correctly exposed. However, you must remember that the diffuser technique is only as good as its premise — that most prints will "average" out to gray. If you are trying to make a print of a purple flower against a background of dark-green leaves, the analyzer will not help you.

Most color prints will need some "fine-tuning" even when you use a color analyzer, since lighting conditions often change between the beginning of a roll of film and the end. Furthermore, different batches of film and paper will vary, depending upon how they were formulated, stored, and processed.

To simplify printing, many photographers who work with color roll film photograph a gray card at the beginning of each roll to serve as a reference. This

Figure 11.8: *Beseler 8 x 10 Color Drum and Unicolor Roller.* Automated or semiautomated color processing units such as this one provide ease of operation and ensure consistent results.

Figure 11.9: *Beseler PM2A Color Analyzer.*

standard tone can be used to determine the approximate filtration required for all of the other frames on the roll that were taken in similar lighting.

Equipment for Judging Color Balance

The light in which you view a color print will influence your judgment of its color balance. If you inspect a color print in daylight, with tungsten illumination, and under fluorescent lighting, you will find that its appearance varies quite a bit because of the difference in the color temperature of the lighting. A print that looks fine in fluorescent light may look awful under tungsten lighting, and vice versa. If you know exactly where a print will be hung, you should try to color-balance it for that setting, but failing that, a good strategy is to try to balance all of your color prints for "daylight."

To judge prints in the darkroom, you will need to acquire a lamp that produces illumination with a color temperature corresponding to daylight. You can obtain one either at a store that specializes in lighting or through a camera store. Position the lamp so that it will be the sole source of illumination of the print. The print must be completely dry, since wet prints have a pronounced color cast. Look at those areas that are most sensitive to small color changes, such as flesh tones and light grays and whites. Decide which color, if any, is in excess, and make the appropriate corrections in filtration (see below) for the next print.

An alternative technique is possible if you have an enlarger with a color head whose white-light output is of the same color temperature as daylight. Place the dry print on your easel, open the lens to its maximum aperture setting, and view the print. Decide which color, if any, is in excess, and dial in the complementary color until the print appears to be balanced. (Try not to stare continuously at the print, since your eyes will adapt to the color shift and cloud your ability to perceive small differences in tints.) Use the filtration values that you dial into the color head as a guide in correcting the filtration for your next color print.

Miscellaneous Accessories

Voltage Regulator The color temperature of your enlarger light depends upon the kind of light source you use and the lamp's voltage. For an ordinary tungsten enlarging bulb, the color temperature can change substantially as the voltage changes, tending toward red as it is lowered. The line voltage in your darkroom will vary according to the power demands in your area, but you can eliminate this variable with a *voltage regulator,* which will insure that the light intensity and color characteristics of your enlarging lamp remain constant during a printing session. Voltage regulators can be obtained in most electrical supply shops or hardware stores.

Hair Dryer Depending upon which approach you are using, processing of a color print will require 5 to 10 minutes on average. The print must be dry before you can judge whether the exposure and filtration were correct and determine what changes, if any, need to be made in the next print. A good *hair dryer* will reduce the drying time for a print to a minute or two. Gently *squeegee* the excess water from the print surfaces (with Cibachrome prints you can scrape off the

emulsion if you press too hard), lay the print faceup on a clean, lint-free towel, and blow it dry. When the front side is dry, transfer the print to a second towel and dry the back side.

Viewing Filters *Viewing filters* are invaluable aids for determining the *color* and *magnitude* of the corrections that need to be made in a color print. They are available in kits consisting of a series of red, green, blue, cyan, magenta, and yellow acetate filters. Two good choices are the Kodak Color Print Viewing Filter Kit and the Calumet Viewing Filter Kit.

To decide what changes you will need to make in filtration, place the print so that it is well illuminated and look at the lighter neutral tones (those that should be a light shade of gray and free from color tints) through each of the filters. One of the series of filters should cause a color shift, making it appear that the print has been color-corrected. For example, if the print has a slight magenta cast, a green filter will neutralize it, since green is the complement of magenta, and when you mix the two, the result is gray. Information printed alongside the viewing filter will indicate what adjustments you should make in filtration in the next print to achieve color balance, saving you hours of guessing and experimentation.

Dataguides The *Kodak Color Dataguide* and the *Kodak Color Darkroom Dataguide,* two of the great bargains in photography, are compact storehouses of information that are useful in the field as well as in the darkroom. The manuals summarize information pertaining to color films, the use of filters, and reciprocity-effect corrections, and also outline the steps you should follow in processing film and prints with Kodak materials.

The Color Dataguide contains a gray card, a gray scale, and a spectrum of color-control patches that can serve as reference colors in a scene. It also includes a 35mm guide negative and a color print that you can use as a standard test negative. By following the detailed instructions for printing the negative, you will be able to correctly calibrate your enlarger, color analyzer, printing papers, and so on for color printing.

Retouching Materials Defects such as dust spots are more difficult to correct on color prints than on black-and-white prints since the colors must be matched as they are applied. Most paper manufacturers also sell dyes that you can use for spotting prints.

If large areas of a print need to be treated, the *Dry-Dye* technique works well. Kodak offers a set of nine jars of retouching colors (red, green, blue, cyan, magenta, yellow, orange, brown, and neutral) that you can apply either in powder form or as watercolors. You spread the dye on the print with a cotton tuft or swab until you achieve the desired effect; then you steam the print with a vaporizer until the colors are absorbed by the surface.

For smaller areas, blend the colors to obtain the proper hue and then apply the dye to the surface of the print. Use the same technique you use with black-and-white prints, stippling the surface with minute droplets of dye. Begin with weak solutions and gradually build up the color density. Let the print area you are working on dry between applications (you can use a hair dryer to speed up

the process), since the wet area of the print will take on an opalescent appearance, making it difficult to judge the final color balance of the spot.

Safety Equipment and Considerations

The chemicals used for color processing are more corrosive than those used for black-and-white photography, and you will need to exercise greater care when you handle them. *Avoid skin contact with any of the chemicals involved in color printing.* The bleach for the Cibachrome process, in particular, is strongly acidic; be sure to wear *safety glasses* to protect your eyes when you are mixing and using it and other corrosive chemicals. Many people have allergic reactions to or suffer skin irritation from the color developers and bleach-fix solutions; if you have sensitive skin, wear *rubber gloves.* Finally, make certain that your darkroom is well ventilated at all times, and always flush the drain with an ample amount of water when disposing of spent chemicals in the sink. If you develop careful work habits, color processing should pose no real safety problems in a home darkroom.

Printing Color Negatives

One notable difference between black-and-white and color-negative printing papers is that the latter generally do not come in different contrast grades. The exception to the rule is Kodak's *Ektacolor Plus,* a paper whose contrast is about one grade higher than normal.

Another difference between the two kinds of paper is that you must handle all color printing papers in complete darkness. (It is possible to use a safelight fitted with a 7½-watt bulb and an amber filter, kept at least four feet away from the paper, but under no circumstances should you expose the paper to the safelight for more than a few minutes — and it is best to do without it altogether.)

Making an 8 x 10 Ektacolor Print

The following instructions for printing a color negative apply specifically to Ektacolor paper and Ektaprint chemicals; other types of printing papers and chemistry usually call for only minor variations on the steps described below. For your first print, choose a negative that will produce a number of print tones that will be easy to evaluate for color balance (neutral colors and flesh tones work best). In the future, this negative can be used as a "standard" for reference.

These instructions assume that you are using a tube processing system and a water bath for temperature control. For other types of processing equipment, follow the manufacturer's guidelines where applicable.

1. Prepare the developer, stop bath, and bleach-fix according to the instructions provided with the chemicals. Use distilled or purified water to mix your solutions, and store them in plastic bottles so that you can squeeze out the excess air. Clear bottles (which you should store in the dark) are preferable to opaque ones since you can see the changes that occur when the chemicals begin to deteriorate. Do not use any solution that has developed a residue of sludge in the bottle.

2. Bring all the solutions you will need to the processing temperature by means of a water bath. Measure out 500 ml of water, 70 ml of developer, 70 ml of stop bath, and 70 ml of bleach-fix and store them in the constant-temperature bath in capped jars. Make certain that the water level is low enough and the jars are heavy enough so they do not float or tip easily. Check to see that the temperature of each solution corresponds to the processing temperature. Set up your processing tube, placing a large jar or bucket next to it to hold the chemicals you will drain off after each step.

3. If you are using an enlarger that does not have a color head, place a Kodak CP2B or 2B (ultraviolet) filter above the negative carrier.

4. Clean the negative thoroughly and place it in the negative carrier, with the emulsion (dull) side facing toward the easel. Insert the negative carrier in the enlarger. **Turn off the room lights, turn on the enlarger light,** and compose and focus the image on a sheet of white paper or the back of an old print that is framed in the easel.

5. Set the color head or use filters to create an initial filtration of 50M and 90Y (or whatever the paper manufacturer recommends). You may need to make a significant change in filtration in subsequent prints; this is intended only as a starting point.

6. Set the aperture of the enlarging lens at f/5.6 and the interval timer at 10 seconds. If you use a metronome, activate it. **Turn off the enlarger light.**

7. In total darkness, open the packet of printing paper. Remove a sheet of paper and place it in the easel, emulsion side up. Reseal the packet of printing paper. (*Note:* When you buy a package of printing paper, all of the sheets in the packet have their emulsion facing in the same direction. The emulsion side of the paper is shiny. If you cannot identify the emulsion side by feel, turn on the enlarger light and hold one sheet of paper close to your eye while you look toward the light. The shiny surface will be apparent.)

8. Using an exposure easel, expose the paper in four sections, for 10 seconds each, at apertures of f/5.6, f/8, f/11, and f/16, respectively.

9. Place the print in the processing tube, cap the end, and **turn on the room lights.** The remaining steps can be carried out with the lights on. (You may need to vary the following procedures slightly according to the characteristics of your particular processing tube.)

10. Before you begin processing, recheck the temperatures of all of the solutions you will use. Warm or cool them, as necessary, to the desired temperature. To presoak, pour 500 ml of water (at the processing temperature) into the tube, turn it to a horizontal position, and rotate it by hand or mechanically for 30 seconds (the exact time is not critical). (*Note:* If the tube will not hold 500 ml of water, it is all right to use less.)

11. Set the timer for the correct development time, drain out the water, and pour in the developer (70 ml). Start the timer the instant you tip the tube to allow the developer to flow onto the paper. Agitate the tube by rotating it for the entire development time. The precise development time you use is a critical factor in your ability to obtain reproducible results.

12. About 10 seconds before the end of the development cycle, drain out the developer and add the stop bath (70 ml) to the tube, but *wait until the development cycle is complete before you turn the tube* to allow the stop bath to flow into it. Agitate the tube for 30 seconds (the exact time is not critical).

13. Drain out the stop bath and add the bleach-fix (70 ml) to the tube. Set and start the timer (a longer time than that recommended will not harm the print) and agitate the tube throughout the step.

14. Drain out the bleach-fix, then uncap the tube and gently remove the print. Place it in a tray of water and wash it under a stream of running water for at least 2 minutes. Extended washing will not harm the print and will improve its long-term stability.

15. Thoroughly clean and dry your processing equipment while the print is being washed.

16. Squeegee the excess water from the surface of the print and dry it with a hair dryer.

17. Study the print carefully for both exposure and color balance. Identify the quarter of the test print that comes closest to being properly exposed and examine the tones that should be neutral in color. Try to decide which colors are in excess, and by how much. Use the viewing filters as a guide to help you make an estimate. Judging print tones becomes easier with a little practice.

18. Adjust the filtration in the enlarger if necessary. Remember that when you change the filtration, you must *add* to the filter pack the color that you want to *remove* in the print.

19. Change the aperture of the enlarging lens to the setting that resulted in the best exposure, making certain that you also adjust the exposure to compensate for any changes necessary in the filter pack (see table 11.3). If the exposure should be longer or shorter, you may want to either use an intermediate stop or change the exposure time.

20. Make another print using your corrected exposure and filtration values. This print should be fairly close to what you had in mind in terms of color balance and exposure. If not, try again.

21. When you have made a print that is properly exposed and color-balanced, study it carefully and consider how you might be able to improve it. The techniques described for dodging and burning black-and-white prints (pages 288–294) can also be used for color negatives.

Figure 11.10: *JOBO exposure easel.* Hinged panels that can be folded back to expose only a quarter of a sheet of printing paper at a time make the JOBO easel a useful aid in determining appropriate exposure and filtration during color printing.

Figure 11.11: *Test exposure patches.* Using a JOBO exposure easel, all sections were exposed for 10 seconds, at apertures of f/5.6 (darkest), f/8, f/11, and f/16 (lightest). The optimal exposure, clearly, would fall somewhere between f/11 and f/16 at 10 seconds; a test print showed that an exposure of 14 seconds at f/11 was correct (see figure 11.12).

The Color "Ring-Around"

Making a color print can often be a matter of educated guesswork, whereby you arrive at the "perfect print" through a process of successive approximations of filtration and exposure times. Each pack of color printing paper will contain the manufacturer's suggested starting filtration for producing a color-balanced print. Follow these guidelines in making your first print; if the color is "off," you will have to decide which color needs to be added or subtracted. To further refine a print that is close to being balanced, or to clear up any confusion as to precisely what filtration changes are needed, you should make a color *ring-around*. A ring-around is a series of prints, each of which varies by a set number of units of filtration from the print in hand toward green, yellow, cyan, magenta, blue, or red, respectively. When you begin color printing, you may also find it helpful to consult an accurate color transparency of the scene, or to make use of a recognizable color standard such as a skin tone or other feature in the image. These reference points will enable you to monitor the color shifts that occur in the ring-around.

Using Your "Standard" Negative

Once you know what filtration and exposure are needed to produce a "perfect" color print on a particular paper with the negative that you have chosen as your "standard," you can use that negative as a reference for future printing. All

photographs taken on the same type of film under roughly the same lighting conditions as your standard and printed on the same batch of paper should require approximately the same filtration and exposure.

Before you begin to print other negatives, make a proof sheet. Include your standard negative in every group of negatives you proof, and use the filtration you worked out for your standard to make a contact print of each roll of film you expose. The contact sheet will then serve as an excellent guide in printing all of the other negatives, since it will allow you to compare both the exposure and the color balance of any negative on the sheet to those of your standard.

Each new batch of color printing paper will have its own basic color balance, which you can calibrate with your standard negative. The difference in filtration between the first batch of paper you used and the new batch will be a constant that you can apply to printing other negatives on the new paper. Let's say that the original filtration required to make a good print of your standard negative was 40M + 80Y, at an exposure of 10 seconds, and that the new paper requires filtration of 30M and 90Y and an exposure of 12 seconds to produce an identical print. The difference in filtration is –10M and +10Y, and the increase in exposure is 20 percent. To reprint any other old negative on the new paper, simply subtract 10M and add 10Y to the previous filtration and increase the exposure time by 20 percent. These prints should also be identical to the earlier ones.

Figure 11.12: *Correctly exposed and balanced color print.* This final print was arrived at by using an exposure easel test with a color "ring-around." A transparency of the scene was also used for purposes of comparison.

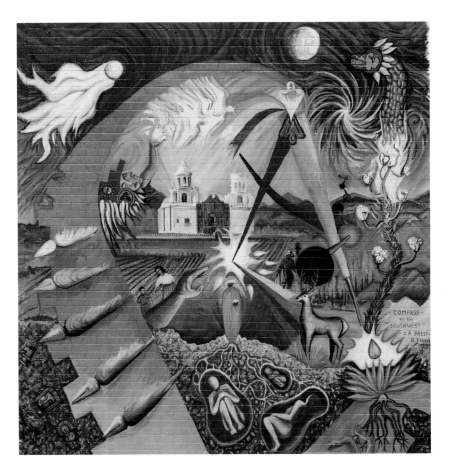

Color Print Stability

The stability of color prints made from color negatives (often called *C-prints*) is a matter of continuing concern. The dyes in these prints do not fare well if they are given prolonged exposure to light and the atmosphere; they slowly bleach out and fade. Continued research on dye stability and modified processing techniques have led to significant improvements in recent years. Fujicolor prints are

C

D

B

A

E

G

F

Figure 11.13: *Color ring-around.*
The starting print (A) is placed in the center of an array of prints, each of which varies from the original by 20 units of filtration. Clockwise from upper left, the placement is (B) green, (C) yellow, (D) cyan, (E) magenta, (F) blue, and (G) red. Encircling the starting print is the best way to judge which print looks closest to what was visualized. To attain the "perfect print," you may need to make another ring-around using smaller increments (for example, 5 units).

now reported to have a print life exceeding fifty years, which clearly makes Fujicolor materials the current leader in the field of color print stability.

The marriage of digital technology and photography has led to new ways of making very stable color pigment and dye prints. With the ability to store and display photographic information using a computer and the new techniques that are emerging for printing color photographs, issues of print permanence may decrease in importance for many applications. These topics are discussed in detail in Book 2 of *Basic Techniques of Photography*.

Making a Black-and-White Print from a Color Negative

There may be occasions when you would like to make a black-and-white print from a color negative, and you can do this by using a panchromatic paper such as Kodak Panalure. These papers are sensitive to red, green, and blue light, and a print made on one of them from a color negative will have tonal values corresponding to those in the scene photographed.

When printing with panchromatic papers, you can use the same filters that you would have used in the field with black-and-white film to achieve similar results. For example, if you want to emphasize the clouds in a scene by darkening the sky, try printing the negative with a yellow or red filter over the enlarging lens.

Kodak Panalure paper produces black-and-white prints of excellent quality. Processing requires the same chemicals needed for other black-and-white papers; either tray or tube processing procedures may be used. Like color papers, panchromatic papers are best handled in complete darkness.

Printing Color Transparencies

You can either print a color transparency directly, using special paper and processing chemicals (see pages 363–364), or you can make a color negative (called an *internegative*) from it and print that in the same way that you would print a color negative.

Kodak Processing Laboratories will make internegatives from transparencies at a cost of about $2 each. Internegatives from 35mm slides are enlarged to 2¼ x 3¼ inches, and transparencies in a square format are copied as 2¼-inch-square negatives. Alternatively, you can use a slide copying device to photograph your transparencies with color negative film, or make internegatives with your enlarger by projecting the slide onto internegative film.

Ektachrome Processing

Ektachrome RC paper, type 1993, is one of several papers that allow you to make a color print directly from a transparency. In the Ektachrome printing process, the dyes are generated in the print during processing. The process, which uses Ektaprint R-500 chemicals, is summarized in table 11.5.

Table 11.5

**Processing Kodak
Ektachrome Paper**

Processing Step	Time (min:sec)	Solution Volume
1. Prewet (water)	0:30	150ml
2. First Developer	1:30	70ml
3. Stop Bath	0:30	70ml
4. Wash	0:30	150ml
5. Wash	0:30	150ml
6. Color Developer	2:00	70ml
7. Potassium Iodide Wash	0:30	150ml
8. Bleach-Fix	1:30	70ml
9. Wash	0:30	150ml
10. Wash	0:30	150ml
11. Stabilizer	0:30	70ml
12. Rinse	0:30	150ml
13. Dry		

Note: The processing temperature used for this table is 100° F. Processing times for alternative temperatures are included in the instructions provided with the materials upon purchase. Color processes are constantly being improved, and the outline presented here may change in the future. Read the inserts included with the paper and chemistry *carefully* before you begin.

One major difference between printing negatives and printing transparencies is that *with a transparency, the longer you expose the printing paper, the lighter the print.* As a result, on a print made from a transparency, dodging and burning have just the opposite effect that they do on a print made from a negative. If you want to darken the sky, for example, you must hold back light during the basic exposure; if you want to lighten a shadowed area, you will need to give it additional exposure.

Filtration changes are also the reverse of those you make when printing a color negative. If a print is too yellow, for instance, you should subtract yellow from the filter pack instead of adding it.

The Cibachrome Process

Ilford's Cibachrome process represents a different approach to the printing of color transparencies. The quality of Cibachrome prints and their long-term stability have made this the method of choice for printing from transparencies; as a further bonus, it is in many ways the easiest process to learn and use. Table 11.6 gives times and temperatures for the various processing steps.

Table 11.6

**Processing Times
and Temperatures
for Cibachrome
A-II Prints**

Processing Step	68° F	71.5° F	75° F	79° F	84° F
1. Developer	4:00	3:30	3:00	2:30	2:00
2. Water Rinse	0:30	0:30	0:30	0:30	0:30
3. Bleach	4:00	3:30	3:00	2:30	2:00
4. Fixer	4:00	3:30	3:00	2:30	2:00
5. Final Wash	4:00	3:30	3:00	2:30	2:00
6. Dry	—	—	—	—	—

Note: A 30-second presoak is recommended for prints larger than 8 x 10 inches. If you plan to reuse your chemicals, a water rinse is necessary between the bleach and fixing steps.

Caring For and Displaying Color Prints

All dyes share one common failing: they fade with prolonged exposure to air and light. It is vital that color prints be thoroughly washed to remove all the processing chemicals from the emulsion and the paper; after processing, slides and prints can be protected by being stored in a way that will slow down the deterioration of the dyes.

Color prints and transparencies that are not on display are best stored in the dark. If possible, you should try to refrigerate or freeze them, after first sealing them in air-tight plastic bags from which you have squeezed out as much air as you can. If you do chill your materials, be sure to let the contents of the bag warm up to near room temperature before you open it again. That way, moisture will not condense on the prints or slides.

Mounting Color Prints

One way to prepare color prints for display is to dry-mount them on a suitable board. Color prints are more sensitive to heat than black-and-white prints, so you will need dry-mounting tissue made especially for color and resin-coated paper, and you will have to use a lower temperature (180° F to 210° F) to mount the print. In all other respects, the procedures for dry-mounting are identical to those used with black-and-white prints (see pages 320–321).

Some photographers prefer to use archival adhesive mounting corners to affix the print to a mounting board. Overmatting makes the print suitable for display. This method avoids the necessity of heating the print in a dry-mount press.

Displaying Color Prints

In contrast to black-and-white prints, color prints often look better in colored mats that complement the image. Colored mats are a matter of personal taste. Some photographers let a dominant print color determine their choice of a mat, but it is generally best to exercise restraint: when in doubt, choose an off-white or gray tone to overmat your print.

Sunlight and fluorescent lighting cause color prints to fade at an accelerated rate; in unfavorable lighting conditions, some prints will begin to show signs of deterioration in less than a year. If possible, you should keep your prints out of direct sunlight and fluorescent lighting. Covering color photographs with glass will serve to filter out some of the destructive UV rays, and special kinds of glass that offer slightly greater protection of the print are also available. Cibachrome prints have been shown to be extremely stable under normal display conditions and are superior to other color prints in this regard, though progress continues to be made in the field of color print stability.

Chapter Twelve

Field Trips: Applying What You've Learned

The Zone System becomes an intuitive process in practice — a way of thinking and applying technical principles while visualization is taking place. If I had to work out the Zone System details from scratch with every photograph, I would fail as a photographer and artist. Visualization is in two principal steps:

First, image management, which relates to the construction of the image as the lens delivers it to the film, and,

Second, value management, which relates to exposure and development of the negative, thereby securing the information for the expressive print.

With practice this becomes a rapid process, almost entirely intuitive and immediate. I note, with regret, that many of the photographers of the day are not concerned with basic technique. Their work clearly shows this sad fact. There have been many excellent ideas rendered in ineffective craft; the message simply does not come through. . . .

I agreed with Edward Weston's frequently spoken Louis Armstrong quote, "Man, if you has to ask, 'What is it?' you ain't never goin' to know." For me, a photograph begins as the visualization of the image which represents the excitement and the perception of that moment and situation. The print represents excitement, perception, and expression (performance). Meaning is found in the final print only in terms of the print itself. For me, this meaning may vary a little over time and circumstance. For the viewer, the meaning of the print is his meaning. If I try to impose mine by intruding descriptive titles, I insult the viewer, the print, and myself. I hope to enhance, not destroy, that delicate imaginative quality that should be expected from any form of art. — ANSEL ADAMS

Figure 12.1: John P. Schaefer, *The Facade, Mission San Xavier del Bac, Tucson, Arizona, 1977.*

Most of us acquire a camera with the intention of taking specific kinds of photographs. Our motives may vary from keeping a visual diary of the important events in our lives to pursuing photography as an art form and a means of artistic expression. As you begin to explore the unique potential of photography, you will need to give some thought to the kinds of photographic images that you want to create and to the visual messages that you want to share with the viewer.

Searching for Photographic Themes

Writing a colorful phrase or sentence is one thing, but crafting a poem or an essay is another matter altogether. Beginning photographers often use their cameras to create images at random, responding to momentary impulses; while individual photographs taken in this manner may be successful, the viewer is usually left with the impression of having received fragments of messages rather than fully developed ideas. As you learn to master your equipment and expand your skills as a photographer, you should work toward creating photographic "essays" that examine themes in depth. A portfolio of a dozen superb prints organized around a single idea is often much more effective than an assembly of prints of a dozen unrelated subjects.

Most well-known photographers built their reputations by exploring carefully selected photographic subjects in great detail. Some of Ansel's most memorable images were products of his essays on Yosemite, Yellowstone, Manzanar, San Xavier, and so forth. Eugene Smith's stunning series of essays for *Life* magazine ("Spanish Village," "Country Doctor," "Albert Schweitzer," "Pittsburgh," "Minamata," and many others) established him as one of the premier photojournalists of all time. Henri Cartier-Bresson's fascination with "the decisive moment," Arnold Newman's memorable environmental portraits, Edward Weston's vegetables and nudes, Judy Dater's revealing portraits, Barbara Kasten's intriguing constructions and use of lighting, Marie Cosindas's color portraits and still lifes — these and the hallmarks of virtually every other noteworthy photographer came into being because the artists concentrated their efforts in one or more well-defined areas and attempted to see and reveal them as no one had done before. By exploring specific themes in depth with your camera, you can transform isolated thoughts into eloquent and definitive statements.

One of the best ways to progress in photography is to select a subject that is accessible and of interest to you and make a commitment to create a portfolio of prints on that topic. Some of the themes that lend themselves well to such an approach are the landscapes of a region; the natural scene and nature; portraiture; people and their culture, rituals, and history; architecture; current events. Pick one of these or any other subject that stimulates your enthusiasm. Be prepared to work on your project for several months, and plan to persevere until you have assembled a collection of fine prints that you would be pleased to share with an audience. You will be delighted to find that along the way you have become a reasonably accomplished photographer.

Developing a Strategy

Understanding Your Subject

Effective photographs are those that penetrate the surface of a subject and reveal its underlying spirit. In order to make insightful photographs — images that communicate a vision to the viewer — a photographer must develop a profound understanding of his or her subject. The empathy or revulsion that leads to memorable images requires a commitment from the photographer to learn as much as possible about the subject and to become emotionally involved with the theme.

To know what visual questions to ask with your camera, you need to explore the background of your subject and the issues you wish to address. Ideas are generated by experience, and few themes prove to be as simple as they might appear at first glance. A sound way to begin any project is to go to a library and seek out books or articles that deal with your theme. Try to understand your subject in terms of its historical context, and study the ways in which other artists and writers have treated it. If your subject has social or political overtones, look for opposing points of view so that you can speak visually to those issues as well.

Approaching Your Subject

As your knowledge of your theme increases, think about how you might best approach the subject. Having access to and being accepted in the environment you are photographing are vital factors in the success of any project, but acceptance is especially important if you are photographing people who are not well known to you. You must work toward becoming an "invisible" intruder in their lives so that your presence will not materially alter your subject.

Friendships are often the best entree to any unfamiliar setting, and sharing your photographs can be an excellent way to establish a rapport with strangers. Many photographers find that beginning a photographic session by making Polaroid prints that can then be left with people helps to build trust and acceptance.

If your theme involves photographing a notable building, a wildlife preserve, or a park, find out who is in charge and get permission to photograph. Most professionals (architects, park superintendents, social workers, ministers, and so forth) are delighted to meet someone who shares their enthusiasm and will often go to embarrassing extremes to be helpful. As a further bonus, conversations with professionals can frequently lead to insights into your subject that serve as valuable supplements to your research.

Equipment Considerations

Finding and acquiring the appropriate equipment for the field can be of paramount importance. On April 27, 1920, for instance, Ansel sent the following telegram to his father, Charles Adams, from Yosemite National Park.

> CAN BUY BURRO FOR TWENTY INCLUDING OUTFIT.
> CAN SELL AT END OF SEASON FOR TEN. FINE INVESTMENT
> AND USEFUL. WIRE IMMEDIATELY AS OFFER IS FOR TODAY ONLY.
> ANSEL

When your preliminary research has been completed and you are ready to begin photographing, you will need to decide what camera format to use and whether the project is better suited to black-and-white or color imagery or both. Your equipment should complement the theme you choose. For example, if you are going to photograph sporting events, you will probably want to use a small- or medium-format camera with a telephoto lens. If you intend to make large black-and-white prints of landscapes, a view camera will probably be more appropriate.

The logistics of getting to wherever it is that you want to photograph may be an important factor in determining your choice of equipment. If you are able to drive to the site, you can load every piece of photographic equipment you own into the trunk of your car. If, on the other hand, you need to hike for twenty miles before you begin to take pictures, you will want to pare your equipment down to the essentials. I once hiked thirteen miles down to the bottom of the Grand Canyon with a heavy view camera, tripod, and a number of wonderful accessories. On the way back up I would have gratefully sold the entire assembly at a substantial discount to any passerby who was remotely interested in pursuing a career in photography!

Before you set out on a photographing session, make a detailed checklist of all of the equipment you anticipate needing, be sure that everything is in good working condition, and pack it carefully. When you return home, clean your equipment thoroughly and check to see that it is all still in good working order.

Getting Started

Our participation in events that are not central to our lives is generally confined to the perimeter of activity, not to its center. But while spectators can watch a football game from the stands, photographers really need to be as close as possible to what is happening in the middle of the field.

Successful photographs, regardless of whether they are of placid landscapes or of human turmoil, take the viewer into the center of interest, which means that the photographer needs to penetrate the *psychological* perimeter of the subject. While this is not usually a problem when you are photographing an inanimate object, it can be an intimidating hurdle when you attempt to photograph people. Most of us have strong psychological barriers that inhibit us from intruding in unfamiliar environments and "invading other people's space" — especially people whom we do not know. Photographers who intend to photograph the human condition need to overcome those psychological barriers, but it is also important to respect the rights and sensibilities of individuals and not to abuse the trust that must be part of any close working relationship. A callous attitude on the part of the photographer toward the subject will manifest itself in the images that are produced. Building trust and mutual respect is your first task as a photographer, and it is the key to being able to move toward the heart of your subject.

A comfortable way to begin any photographic session is to take a photograph that defines the setting from a distance. This often accomplishes two goals, at once establishing your presence and allowing you to start refining your impressions and visualization of the scene. Next, move from the general to the specific by selecting a few elements that attract your attention and inspecting

them from a closer vantage point. Work on visualizing new images as you move in closer, and photograph those that strike some chord in you. As your familiarity with the setting increases, press on and photograph details to add depth to the visual narrative you are creating.

Every photographic project is a learning process. Any preconceived notions that you may have as a result of your early research or experiences may change as you work on your theme. As you study the images from one photographic session, new ways of looking at the same subject matter may occur to you, and you may find that you want to return and photograph the setting in a slightly different way. One advantage of an inanimate theme is that you can return to it and rephotograph it as often as necessary until the exposure and composition suit your visualization. Conversely, an advantage of photographing people in action is that you have only one chance to capture a particular image, which forces you to cultivate work habits that will enable you to get it right the first time.

Mission San Xavier del Bac: A Photo Essay

Mission San Xavier del Bac in Tucson, Arizona, has been acclaimed as the finest example of mission architecture in the United States. The church was first planned by Father Eusebio Francisco Kino in 1692, and the present church was constructed during the eighteenth century and has served the local Native American population since that time. The mission was the subject of a lyrical 1954 photo essay by Ansel Adams and Nancy Newhall, which was printed in booklet form and sold as a guide to thousands of tourists.

In 1977 Father Kieran McCarty asked if I would be kind enough to speak to Ansel about the possibility of reprinting his essay, since it was out of print by then and no guide to the mission was available. In response to my request, Ansel explained that his other commitments made reprinting the essay infeasible, and then he surprised me by saying, "You live there. Why don't you do a photo essay on the mission yourself?"

I thought over Ansel's suggestion and shared it with Father McCarty. After considerable thought and discussion, we decided to attempt the project together — I would undertake to provide the photographs, and Father McCarty would write the text. Both of us were anxious to avoid direct comparison with Newhall and Adams, but we committed ourselves to producing a publication of high quality that could withstand critical scrutiny.

At the time I had just acquired my first view camera — a 5 x 7 Deardorff with a 4 x 5 back — and thus had little experience working with that format. In addition to having to teach myself how to use the camera and work with sheet films, I now had to learn about the history of the mission and the people it served. And I was determined not to rephotograph any of the views that Ansel had taken.

The friars were very cooperative and allowed me to photograph early in the morning and in the evening, when the mission is normally closed to the public, as well as during the day. If weather conditions were particularly favorable for outdoor photography, I would not hesitate to visit on the spur of the moment to photograph a scene I had been thinking about. By the end of four months (at the rate of at least two photo sessions a week), I had made more than 350 exposures and, more important, developed confidence in my emerging skills as a photographer.

The experience of photographing the mission allowed me to put into practice techniques that I had only read about, and it eventually led to other projects and interests in photography that I still pursue as an enthusiastic amateur. The publication that resulted from my collaboration with Father McCarty, meanwhile, continues to be a success. The discussion that follows does not reflect the order in which the photographs were made, but instead attempts to give some insight into how a few of them were conceived and presented.

Mission San Xavier del Bac — Front View A day when summer storm clouds were building provided an ideal background for this photo. I carefully positioned the camera so that the wrought-iron cross on the dome (mostly hidden) would be framed by one of the supporting arches for the central tower. A green filter contrasted the clouds against the sky and darkened the elaborate entrance facade of the mission, which is a reddish color (a red filter would have lightened the facade and further darkened both the blue sky and the foliage). I measured the reflectance of the barely textured white surface of the mission with a spot meter and placed it on Zone VIII. The negative was developed normally. All of the important shadow areas are well defined, and the negative prints on a grade 2 paper with little need for manipulation. Because the surface of the mission and the clouds are such a brilliant white, an ordinary hand-held reflectance meter would have given a reading resulting in a negative that was two stops underexposed.

Dome Through Arch Taken from the rear of the church, this photograph (figure 5.16) proved to be a considerable technical challenge. The post on the right side of the image was only a few feet away from the camera, and both the front and the rear stanchion had to be skewed to keep the entire scene in focus. In addition, the camera is pointed upward, and both the rising front of the camera and its rear tilt had to be used to keep the vertical lines of the image from converging. Moving the camera just a few inches in any direction would have destroyed the composition.

The photograph was taken just before noon, as the sunlight grazed the surface of the post and was reflected most strongly off the dome. I had set up a similar photograph the previous day but had taken too long to make the necessary camera adjustments and missed the lighting that I visualized for the image. A #25 red filter was used to deepen the value of the sky.

Door Handle The mission abounds in fascinating details. The heavy, weathered mesquite doors withstood assaults by Apache raiders in the nineteenth century; the door handle is a delightful bit of wrought-iron artistry from the shop of a local blacksmith. I chose to photograph the handle with the door slightly ajar, deliberately creating a dark void for aesthetic reasons. The photograph was made late in the afternoon to take advantage of the sidelighting, which emphasized the texture of the wood.

Figure 12.2: John P. Schaefer, *Door Handle, Mission San Xavier del Bac.*

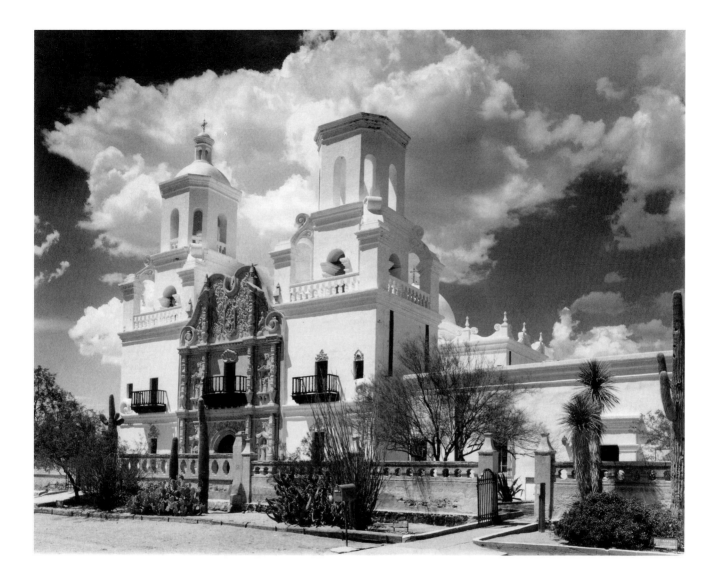

Figure 12.3: John P. Schaefer, *Mission San Xavier del Bac — Front View.*

The Facade The entrance to the mission is enveloped in an elaborate display of artistry in masonry. There are four deep niches, each featuring a full-size statue of a saint, and the intricately sculptured surface abounds in symbols and signs of folklore that are delightful to look at and analyze. The greatest difficulty in photographing the facade — which extends to a height of approximately forty feet — is that the wall surrounding the church prevents you from backing up far enough to easily encompass the image in your camera's viewfinder. To prevent *keystoning* — the convergence of parallel lines that occurs when you point a camera upward at a building — it is necessary to keep the back of the view camera parallel to the surface of the wall and adjust the position of the lens by raising the lensboard until the image is satisfactorily placed on the ground-glass focusing screen. To compose the image as I visualized it, I used a 90mm Super Angulon lens (an extreme wide-angle lens) on a 5 x 7 Deardorff view camera. The camera adjustments required were extreme, and some vignetting occurred at the top of the image since a portion of the sky fell outside the image circle. Fortunately, I was able, by dodging this area of the negative in printing, to make it look like a normal part of the sky. (See figure 12.1.)

The Bell Tower The western tower of the mission houses three bells that signal calls to worship and other important events in the Papago Indian community. With almost no room to maneuver within the tower, I composed this image using my 90mm Super Angulon lens and the 5 x 7 back on the camera. I took great care in setting up the camera since small changes of position, either up or down or to the right or left, would have created major differences in the relationships between the bells, arches, flywheel, and ropes.

The subject brightness range of the scene as measured by my spot meter indicated that contraction of the normal density range of the negative was necessary. I accomplished this through increased exposure and a shortened development time. The negative is still difficult to print and requires considerable dodging and burning; water-bath development or a comparable procedure to further reduce the density range of the negative would have resulted in a negative that was easier to work with.

Jesus Christ in the Baptistry Sunlight from a single window provided the only source of light in the baptistry of the mission and created a dramatic image. The statue of a bleeding Christ crowned in thorns is dressed in a white silk robe by the local Papago women. I exposed the negative by placing the highlights of the robe on Zone IX and reduced the normal development time for the film by 25 percent.

Figure 12.4: John P. Schaefer, *Jesus Christ in the Baptistry, Mission San Xavier del Bac.*

The Altar This photograph was taken to illustrate a narrative section of the booklet; it was made in the evening, when the church was closed to the public. Photographing the scene was a challenge since the only available light barely lit the lower portion of the wall behind the altar, and anything more than fifteen feet above the floor was barely visible. I solved the lighting problem by setting up the camera, opening the lens shutter for a time exposure, and illuminating the wall with the beam of a bright flashlight. I accomplished this last by walking around behind the camera and sweeping the flashlight beam continuously across the walls and ceiling in as random a fashion as I could manage. With a bit of experimenting, I found that an exposure of about ten minutes produced a satisfactory negative. I later learned that this technique is well known and referred to as "painting with light." One result of this method is that all of the shadows that you would expect to see with a single light source are "erased" by the moving light beam.

Figure 12.6: John P. Schaefer, *The Altar, Mission San Xavier del Bac.*

Figure 12.7: John P. Schaefer, *Crucifix,
Mission San Xavier del Bac.*

Crucifix This almost-life-size crucifix is mounted on a wall in an extremely dark corner of the church. Mexican statuary of religious figures can be uncomfortably gory for anyone who is unfamiliar with the culture, and the bloodstained figure of Christ is particularly arresting. As I was passing by on one occasion, I noticed a very large wolf spider clinging to the cross and seeming to stare at Christ's head, adding to the ominous mood of the scene. I quickly set up my camera, opened the front doors of the church in an effort to get a little light on the subject, and hoped that the spider would not move during the three-minute exposure required. In the end I was actually able to make several different exposures before the spider decided to move on.

Feet of Crucified Christ The feet of Christ on the crucifix are often clutched in prayer by the pilgrims who visit the church and kneel before the figure. Over the centuries the paint has been worn away by thousands of hands, revealing the wood grain underneath. The silver and gold *milagros* (small castings of figures and objects, similar to the charms on a charm bracelet) are hung on or pinned to the statues to whom the supplicants' prayers are addressed. A single white plastic rose completed the image, which seemed to provide a fitting close for the essay.

Typical Field Trips

While working on a clearly defined photographic project is one of the best ways to learn how to put the ideas presented in this book into practice, you should by no means feel that all of your photographic excursions must be oriented toward specific goals. Regardless of whether you are an amateur or a professional, you should see photography as an enjoyable pastime that leaves ample room for spontaneity. When the temptation to photograph strikes, respond with enthusiasm. Surroundings that appeal to you will encourage you to identify and visualize images that you will then want to photograph.

Alan Ross worked as Ansel's assistant for several years and is now a successful commercial photographer in his own right. When he is not working on an assignment, he enjoys relaxing and pursuing his favorite pastime — photography. Alan is a superb teacher and practitioner of the values that Ansel held so dear. The following is a description of several field-trip experiences that Alan and I have had over the years in southern Arizona, both jointly and separately.

Much of the American West consists of scenic views that are a hymn to the power of nature. The land has served as an inspiration to artists and writers for centuries, and it has an unmistakable appeal for photographers. It requires very little persuasion to convince Alan to visit southern Arizona for a few days of photographing.

One overcast morning, we set off for Chiricahua National Monument, an interesting region of unusual rock formations in southeastern Arizona. I have photographed parts of the monument on several occasions, but this was Alan's first opportunity to visit the site. I was curious to see how he would respond to the unusual scenery.

Prior to our departure, each of us had assembled the camera equipment that we anticipated we might use during the course of the day. We had no special purpose in mind other than to look for fragments of the landscape that inspired us to photograph. I had packed a 4 x 5 view camera and a 35mm camera, while Alan had brought along both a 4 x 5 and an 8 x 10 view camera. Each of us had a generous assortment of lenses that we thought might come in handy.

Our drive to Chiricahua National Monument took us through some interesting countryside, all of it curtained by a steady rain and drizzle. We stopped occasionally to appreciate the scenery, but leaden skies and uninspiring lighting offered us no opportunities to photograph. When we arrived at the summit overlooking the monument, we were disappointed to find that it just escaped being draped in dark gray clouds, and that the light was still far from ideal for photographing. Nonetheless, we had driven a long way and were determined to try to wring an image or two out of the scene before us. I wondered which of the countless possibilities that lay before us Alan would select as a subject for his camera.

We spent approximately fifteen minutes hiking around the summit of the monument, each of us making individual general assessments of views that had possible potential as photographs. Alan finally paused in an area that had an appealing combination of foreground rocks and trees and overlooked a canyon filled with rocky spires of wind- and water-sculpted stone. When you are confronted with a subject that abounds in interesting detail, you need to think

Figure 12.9: *Using a viewing card.* Alan Ross is shown making use of a viewing card during a field trip to the Chiricahua National Monument.

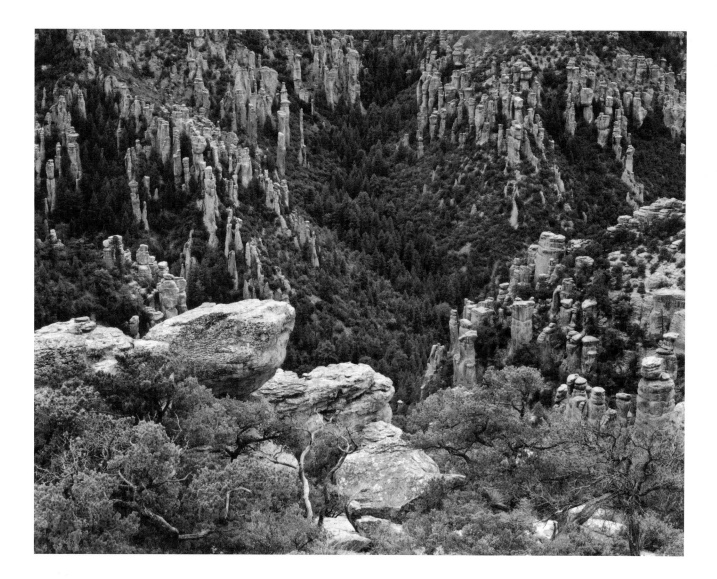

Figure 12.10: Alan Ross, *Spires and Gorge, Chiricahua National Monument, Arizona, 1990.*

carefully about which portion of the subject you wish to photograph. Was it the forest or the trees that attracted your attention, and what is the difference?

Alan used a 4 x 5 viewing card to study selected segments of the scene, which allowed him to refine his "seeing," narrow his choices, and visualize the photographic potential of each possibility. He soon isolated a composition that he wanted to photograph and set up his camera. Using the distance between his eye and the card to estimate the required focal length, he chose a lens that would yield an image corresponding to the portion of the scene that he had isolated. The card makes it easier to decide how to organize and compose a photograph, and it can save you from having to carry a lot of equipment that you won't use to the place where you want to set up your tripod.

Spot-meter readings of shaded areas and the lighter rocky outcroppings confirmed that the contrast of the scene was low and indicated that in order to translate the scene into the photograph he had visualized, Alan would have to expand the contrast range of the negative through longer-than-normal development. The image Alan made is shown in figure 12.10. The photograph required very little burning or dodging and printed easily on a paper of a normal contrast grade.

I was busy making notes and taking snapshots of Alan working and did not have an opportunity to use my own view camera, but I didn't mind since I had taken a few photographs in the vicinity on a previous outing. When Alan sent me a print of his photograph, I checked my own files to see what I had photographed three years earlier. I was startled to see that out of the literally hundreds of possibilities, we had chosen the same basic scene!

On the day when I photographed it, the sun was low and the landscape strongly backlit and contrasty. Captivated by the sight of the enormous stone spires rising from the canyon floor and slopes, dwarfing the surrounding trees, I set up my camera at the rim of the canyon. In my first visualization of the scene, I concentrated on the visual texture of the pattern created by the stone columns and trees, and deliberately avoided including any foreground objects, thereby enhancing the two-dimensional aspect of the image. The print that I subsequently made from the negative fell far short of my expectations. Flare from the sun, which is pronounced in the horizon area on the negative, makes printing difficult because the image contrast varies so significantly from the top to the bottom. I still occasionally take a crack at reprinting the negative, since the scene continues to fascinate me — the feeling is similar to what we all experience when we want to say something but do not know quite how to put the words together at that moment.

Not every visualization lives up to initial expectations, and in this instance I sensed that the photograph might not be very interesting even as I exposed the negative. If I am certain that a subject will not lead to a worthwhile photograph, I will not expose a negative, but if I think that there is a possibility that a scene I have framed on the ground glass of my camera will result in a satisfying image, I will make an exposure. I long ago decided that my time is much more valuable than a piece of film, and that I would rather live with a wasted sheet of film than with the idea that I might have missed an image that could have been worthwhile if I had risen to the challenge and taken advantage of the opportunity. Every photographer has many more negatives that have never been carried beyond the proofing stage than negatives that have resulted in fine prints. It is just as important to be selective *after* you expose a negative as it is to choose your subject carefully in the first place.

Figure 12.11: John P. Schaefer, *Rainstorm, Chiricahua National Monument, 1987.* Inclement weather can often lead to interesting photographs. The monochromatic gray lighting in this scene created a mood not usually associated with the desert environment.

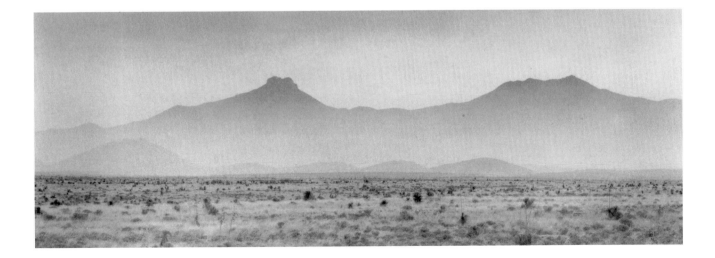

To get closer views of the geological features of the area, Alan and I packed our camera gear into an empty backpack and hiked into the canyon, pausing to photograph when some aspect of the landscape caught our eye. In spite of our best efforts to create some exciting photographs of our surroundings, the weather refused to cooperate.

As the day began to fade, the sky started to clear and each of us tried to capture the spectacular sunset. Alan used his 8 x 10 camera (figure 12.12), while I made a pinhole photograph (figure 12.13). Part of the fun of photographing with other people is that each person responds uniquely to the shared environment and visualizes scenes individually, often resulting in images that differ dramatically from each other. By comparing photographs, you can share your various visual responses to similar circumstances and discover new ways of seeing and visualizing images.

Figure 12.12: Alan Ross, *Road and Clouds, Gardiner Canyon, Arizona, 1990.*

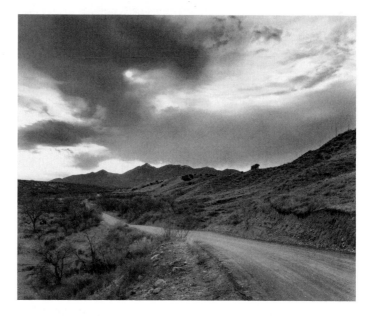

Figure 12.13: John P. Schaefer, *Sunset, Gardiner Canyon, Arizona, 1990.*

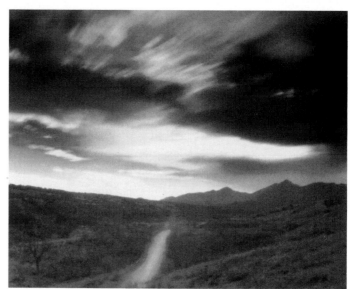

Figure 12.14: Alan Ross, *Clearing Storm, Catalina State Park, Tucson, Arizona, 1986.*

Weather is always an important determinant in the success of landscape photographs, since clouds are one of the primary conveyers of mood. When you are far from your home base and in an interesting environment, you may be tempted to try to take pictures even when the weather or time of day is not what you would have hoped for; the results are usually disappointing, but on occasion pleasant surprises occur.

On an earlier trip, Alan had ventured out alone early one morning with the intention of photographing the desert landscape, which is so different from that of his native San Francisco. The grasslands that are part of the surrounding mountain foothills glistened with rain and were brilliantly illuminated by the early-morning sunlight. Alan set up his tripod and his 8 x 10 camera facing toward the sun and composed an image as the storm clouds were dispersing. He used a minus-blue filter (#12) to separate the tones of the emerging blue sky and the sunlit clouds. The negative was exposed and developed normally; Alan considered contracting the density range of the negative by reducing the development time, but he eventually rejected this option because he felt that less-than-normal development would not produce sufficient detail in the darker tones. The excessive negative density in the sky portion of the negative was

Figure 12.15: Alan Ross, *Adobe Ruin, Mowry, Arizona, 1975.*

Figure 12.16: Alan Ross, *Adobe Ruin, Mowry, Arizona, 1975.*

instead compensated for during printing with extensive burning-in. While the photograph that Alan made (figure 12.14) is hardly representative of the desert environment, it is a beautiful, arresting image taken on an unusual day.

Fortunately, the weather we experienced on our visit to the Chiricahuas was not typical of all our excursions. One brilliant day we drove out to explore several ghost towns in the vicinity, with no other intention than to respond to any subjects that struck our fancy. In these towns and villages, crumbling adobe structures that once housed miners working claims have fallen into ruin, a sight that evoked a sense of nostalgia in both of us, as well as an appreciation for the often artistic way that time and nature work together to undo the handiwork of people. Alan was fascinated by the windows and walls of the slowly dissolving adobe mud-brick buildings in the towns of Harshaw and Mowry. He made several photographs of the ruins, one a close-up of a mud-streaked plaster wall. The exposure and printing of the photographs were straightforward, and no special camera adjustments were required. While all of the images please Alan, figure 12.15 remains his favorite in this sequence; it has a degree of order and simplicity that strikes a note of harmony for him. You may prefer one of the others.

Figure 12.17: Alan Ross, *Adobe Wall, Mowry, Arizona, 1975.*

Figure 12.18: Alan Ross, *Solar Telescope, Kitt Peak, Arizona, 1976.*

Kitt Peak National Observatory lies to the west of Tucson, in the midst of an Indian reservation, and offers many interesting photographic possibilities. One year we drove to the summit and were delighted to find it bathed in cloudless sunshine. Alan was taken with the striking view of the white solar telescope contrasted against a deep blue sky. He composed the image carefully and gave considerable thought to how he might best execute the photograph. A filter was clearly called for to convey the sense of visual drama inherent in the view, which would be lost if the tones of the telescope and the sky merged (panchromatic film is very sensitive to blue and ultraviolet light, and in the absence of a filter, skies will be rendered in a light-gray or white tone). Too strong a filter — a #25 red, for example — would have the effect of depressing the shadow values around the scope, which were illuminated primarily by the surrounding blue skylight; the sky would be coal-black, and the darker tones of the telescope would merge with the tone of the sky. The choice of a #12 (minus-blue) filter proved to be ideal, and the result is a memorable photograph (figure 12.18).

Alan made a second image of the telescope from approximately the same location by pointing the camera upward (figure 12.19). To accentuate the

graphic nature of the composition, he used a #25 red filter so that the sky would print black. While the image has an interesting geometric aspect, it seems to lack the emotional appeal of the first photograph.

The desert surrounding the Tucson area abounds with cactus forests and other plant forms that are unique to this part of the Southwest. First-time visitors to the area are often so captivated by the contrast between the desert landscape and their home environment that they take an enormous number of indiscriminate snapshots to document their impressions for themselves and their friends. An important part of becoming a good photographer lies in maintaining the enthusiasm you feel when you find yourself in a visually exciting environment, and at the same time restraining your impulse to photograph everything in sight. The moments that you spend visualizing the photographic potential of a scene will be fully repaid by the images you produce.

In Saguaro National Monument, the cacti often reach heights of thirty-five to forty feet during their two-hundred-year lifespan. Bringing photographic order to a visually chaotic panorama of giant cacti is a challenging task. On a hike through the monument, Alan's attention was drawn to one cactus whose arms seemed to be spread in benediction over the surrounding field of younger giants. The strong sidelighting caused by the low angle of the sun lit one side of the cactus brilliantly and cast long shadows across the landscape. Alan placed his 8 x 10 view camera close enough to the saguaro to reveal its surface details and protective thorns. By moving in close and truncating the cactus at both the bottom and the top, he forces the viewer of the photograph (figure 12.20) to confront the object. This technique is a compositional device that artists often use to advantage. Most beginning photographers move *away* from the subject in an effort to get the entire object within the frame of the viewfinder, but the result is usually a weaker, less compelling composition than might otherwise be the case.

Figure 12.19: Alan Ross, *Solar Telescope, Kitt Peak, Arizona, 1976.*

Figure 12.20: Alan Ross, *Saguaro Forest, Saguaro National Monument, Tucson, Arizona, 1986.*

Note here that the trunk of the saguaro was placed to the right of center, and that the horizon line is likewise below the center of the scene; dividing photographs into symmetrical vertical or horizontal halves seldom makes for visually interesting images. One criticism that you might make about this photograph is that the distant cactus is merged visually with the left side of the main saguaro trunk; ideally, the camera should have been moved slightly to the left, to separate the two, or else slightly to the right, to obscure the far cactus altogether. Unfortunately, either of these alternatives would have revealed other unsightly background details, and Alan decided that the image shown here represented the best compromise.

Landscape photographers generally try to avoid large expanses of blank, cloudless sky. In this image, however, the featureless sky emphasizes the stark desert surroundings. If the day had offered the billowing cumulus clouds that are typical of the desert during the rainy season, Alan probably would have visualized this scene quite differently.

One advantage in photographing the environment in which you live is that it is accessible to you throughout the day and the year and under a great variety

of weather conditions. You can wait for the appropriate "decisive moment" to come along, a luxury that the average tourist does not have.

Ansel constantly advised his students of the value of "dry-shooting":

Whether I walk at Point Lobos, fly in an airplane, move in a new environment, or relax in my home, I am always seeking to relate one shape or value to another, seeing an image in my mind's eye. It is a glorious and rewarding exploration. If something moves me, I do not question what it is or why; I am content to be moved. If I am sufficiently moved and it has aesthetic potential, I will make a picture.

He was always on the lookout for possible photographs. On occasions I would accompany him on an afternoon stroll. He would often pause in the midst of a sentence, use his hands to create an approximate frame for his eye, look at something critically, and say, before continuing to walk, *"That might make an interesting photograph."*

Figure 12.21: Alan Ross, *Saguaro Skeleton, Sabino Canyon, Tucson, Arizona, 1976.*

Figure 12.22 is a photograph of a saguaro cactus I took at the monument in the wake of a rainstorm. I had been wanting to use this particular giant as the subject of a photograph for more than a year, but the mood during my previous visits had never been in harmony with the image I visualized. The cactus stands on the ridge of a hill that descends onto a flat about fifty feet below; from where I stood, the saguaro always took on a heroic aspect, thrusting skyward above the sparsely vegetated, rocky soil, rising high above its diminutive neighbors. The clear blue sky typical of desert days never seemed to provide an inspiring enough backdrop for the cactus. One day, as the clouds of a winter storm began to disperse, I thought of the cactus and quickly packed my view camera into my car for the short drive to the monument.

When I arrived at the site, it was obvious to me that the sky had the potential to provide the perfect foil for the saguaro. I set up my 5 x 7 view camera, fitted with a 300mm lens, on a sturdy tripod and made the adjustments necessary to compose the image: (1) camera bed parallel to the upward slope of the hill; (2) camera back vertical and parallel to the cactus trunk; (3) lensboard tipped slightly forward to ensure sharp focus from the foreground to infinity. I used a green filter to darken the sky and lighten the skin of the saguaro (a red filter would have had a more pronounced effect on the blue sky but would also have darkened the green cactus to a near-black tone). A fast shutter speed was required because of the brisk, gusting wind, which caused the foreground vegetation to sway continuously. I instinctively set the exposure at f/16 and $1/100$ second (I was using Kodak Tri-X film, ISO 400, with a two-stop correction for the filter factor), inserted the film holder into the camera, and made an exposure immediately since the clouds seemed to be perfectly situated. I reversed the film holder to make another exposure, but by then the pattern of the clouds had changed, and the resulting image was inferior to the first.

In this instance, if I had had to pause to use my light meter to judge the appropriate exposure, I would have missed getting this photograph. Since the intensity of desert sunlight is remarkably constant during the midday hours throughout the year, experience has taught me that for a scene with a normal brightness range, the exposure rule of shooting at f/16 and 1/ISO (see page 169) is invariably valid. The negative is perfectly exposed and easy to print on a normal grade of paper.

Summing Up

Field trips that you undertake with no specific goal in mind are not really very different from those occasioned by well-defined assignments that you have accepted or created for yourself. Assignments are useful, however, in that they demand a degree of discipline that you may never cultivate if all of your photographic efforts are unstructured. In either case, the images that you make reflect your personal interests and interpretation of your world. If you begin your study of photography by working logically and mastering the basic skills detailed in this book, the mechanical aspects of the art will soon be transformed from a conscious into a natural routine, and the messages you want to share will be your only concern.

Sources for Quotations by Ansel Adams

Sources for the writings by Ansel Adams excerpted in the present volume (indicated in the text by italics) are listed below by chapter. For the purposes of this book, some of the excerpts have been abridged or edited. The reader will find the complete reference for each quotation in the work cited.

Chapter One:
The Language of Photography

"All art is a vision …": Ansel Adams, *Yosemite and the Range of Light* (Boston: New York Graphic Society Books/Little, Brown and Company, 1979), p. 7.

"The picture we make is …": Ansel Adams, *Camera and Lens,* Book 1 of the Ansel Adams Basic Photo Series (Hastings-on-Hudson, New York: Morgan and Morgan, 1970), p. 15.

"When I first made snapshots …": *Yosemite,* p. 12.

"The snapshot is not …": Ansel Adams with Mary Street Alinder, *Ansel Adams: An Autobiography* (Boston: New York Graphic Society Books/Little, Brown and Company, 1985), p. 23.

"While to many the snapshot …": Ansel Adams with the collaboration of Robert Baker, *Polaroid Land Photography* (Boston: New York Graphic Society Books/Little, Brown and Company, 1978). p. x.

"With all of my analysis …": *Autobiography,* p. 79.

"Once completed, the photograph …": *Polaroid Land Photography,* p. 72.

"I had a fine north-light …": Ansel Adams, *Examples: The Making of 40 Photographs* (Boston: New York Graphic Society Books/Little, Brown and Company, 1983), pp. 33–35.

"Clear weather in Denali …": *Examples,* pp. 75–76.

Chapter Two: Camera Systems

"I am often asked …": *Examples,* p. 134.

"Photographers are restless, questing individuals …": *Camera and Lens,* p. 42.

"This is one of my first …": *Examples,* pp. 7–8.

"It is significant …": *Camera and Lens,* p. 40.

"A small camera does not imply …": *Camera and Lens,* p. 42.

"At one rim-edge I was walking …": *Examples,* pp. 154–157.

"The photographer who uses this format …": Ansel Adams with the collaboration of Robert Baker, *The Camera,* Book 1 of the New Ansel Adams Photography Series (Boston: New York Graphic Society Books/Little, Brown and Company, 1980), p. 22.

"The twin-lens reflex was …": *The Camera,* pp. 22–23.

"The small camera, held in hand …": *Camera and Lens,* p. 27.

"Large-format cameras are heavier …": *The Camera,* p. 29.

"The next time you pick up a camera …": *The Camera,* p. xiii.

Chapter Three: Lenses and Accessories

"There is something magical …": *The Camera,* p. 43.

"Shopping for a lens …": *Camera and Lens,* p. 107.

"One evening in San Francisco …": *Examples,* pp. 37–38.

"In the early '30s …": *Examples,* pp. 29–31.

"It has been said …": *Camera and Lens,* p. 38.

"With the advent of optical coating …": *Camera and Lens,* p. 119.

"I recall previous summer trips …": *Examples,* p. 58.

"The great variety and volume …": *Camera and Lens,* p. 39.

Chapter Four: Black-and-White Film

"The key to the satisfactory application …": Ansel Adams with the collaboration of Robert Baker, *The Negative,* Book 2 of the New Ansel Adams Photography Series (Boston: New York Graphic Society Books/Little, Brown and Company, 1981), p. ix.

"This photograph was not made …": *Examples,* p. 113.

"Different films can have …": *The Negative,* p. 21.

"When photographing very light objects …": *Polaroid Land Photography,* pp. 17, 29, and 45.

Chapter Five:
Visualization: The Art of
Seeing a Photograph

"The steps in making …": *Camera and Lens,* p. 21.

"Art takes wing …": *Polaroid Land Photography,* p. 69.

"As with all art …": *Autobiography,* p. 79.

"Photography is an analytical medium …": *Camera and Lens,* p. 13.

"The eye has enormous …": *Camera and Lens,* p. 17.

"In my early days …": *Examples,* pp. 11–13.

"Anticipation is a prime element ...":
Autobiography, p. 78.

"At dawn, on a chill ...": *Examples,* pp. 3–5.

"I remember seeing ...":
Autobiography, p. 71.

"The visualization of a photograph ...":
Autobiography, p. 78.

"The following sequence breaks down ...":
Polaroid Land Photography, p. 116.

Chapter Six: Determining Film Exposure

"Although modern equipment ...":
The Negative, p. 31.

"As we chatted, Meg ...":
Autobiography, p. 265.

"The Zone System is ...": *Examples,* p. 177.

"Experience enhances intuition ...":
Autobiography, p. 254.

"Getting up at dawn ...":
Examples, pp. 45–47.

"Photography was conceived ...": Ansel
Adams, *Natural Light Photography,* Book 4
of the Ansel Adams Basic Photo Series
(Hastings-on-Hudson, New York: Morgan
and Morgan, 1952), p. 1.

"The light was quite harsh ...":
The Negative, pp. 36–37.

Chapter Seven: Developing the Negative

"After the creative visualization ...":
The Negative, p. 47.

"What developers, then, can be recom-
mended? ...": Ansel Adams, *The Negative,*
Book 2 of the Ansel Adams Basic Photo
Series (Hastings-on-Hudson, New York:
Morgan and Morgan, 1948), p. 68.

"This serene subject ...":
Examples, pp. 53–54.

"One beautiful storm-clearing ...":
Examples, pp. 19–21.

**Chapter Eight:
Introduction to Basic Printing**

"A negative is only ...": Ansel Adams with
the collaboration of Robert Baker, *The
Print,* Book 3 of the New Ansel Adams
Photography Series (Boston: New York
Graphic Society Books/Little, Brown and
Company, 1983), p. 1.

"I was traveling through ...":
Examples, pp. 71–72.

"Over the years I have used ...":
The Print, p. 49.

"I made this photograph ...":
Examples, pp. 65–69.

Chapter Nine: Making a Fine Print

"The differences between ...":
The Print, p. 90.

"I find printing ...": *The Print,* p. 7.

"The creativity of the printing process ...":
The Print, p. 1.

"There is no doubt ...": *The Print,* p. 2.

"I have made a considerable number ...":
Examples, pp. 167–169.

"Photomurals ... enlargements with a
vengeance ...": *Autobiography,* p. 188.

"We start with the negative ...":
The Print, pp. 3–6.

"As you are working ...": *The Print,* p. 84.

"The making of a print ...":
The Print, pp. 1–2.

"I have described ...": *The Print,* p. 127.

"Very early one morning ...":
Examples, pp. 23–26.

Chapter Ten: Color Photography

"The creative color photographer ...":
Ansel Adams, personal notes, 1981.

"This photograph was made in late
autumn ...": *Examples,* pp. 141–143.

**Chapter Eleven:
Color Film Development and Printing**

"While color photography demands ...":
Polaroid Land Photography, p. 62.

"The photographic rendition of color ...":
Polaroid Land Photography, pp. 58–59.

**Chapter Twelve: Field Trips:
Applying What You've Learned**

"The Zone System becomes ...":
Autobiography, p. 326.

"CAN BUY BURRO FOR TWENTY ...":
Autobiography, p. 39.

"Whether I walk at Point Lobos ...":
Autobiography, p. 320.

Illustration Credits

Illustrations other than the copyrighted photographs by Ansel Adams, John P. Schaefer, and Alan Ross or those commissioned by the Trustees of The Ansel Adams Publishing Rights Trust for use in this book or in the New Ansel Adams Photography Series are used with the kind permission of the following:

Dedication: Photograph by Nancy Newhall © The Estate of Nancy Newhall, courtesy of Scheinbaum & Russek Gallery, Santa Fe, New Mexico

Figure 1.3: International Museum of Photography at George Eastman House

Figure 1.4: Gernsheim Collection, Harry Ransom Humanities Research Center, The University of Texas at Austin

Figure 1.5: International Museum of Photography at George Eastman House

Figure 1.6: The Royal Photographic Society, Bath, England

Figure 1.7: Collection of the Deutsches Museum, Munich, Germany

Figure 1.8: Philadelphia Museum of Art, purchased with funds contributed by The American Museum of Photography

Figure 1.9: Copyright © JoAnn Frank 1991, courtesy The Witkin Gallery, Inc.

Figure 1.10: Carbon print, circa 1845, 21 x 15.7 cm, The Alfred Stieglitz Collection, 1949.685. Photograph copyright © 1990, The Art Institute of Chicago. All rights reserved.

Figure 1.11A: International Museum of Photography at George Eastman House

Figure 1.12: Trustees of the Science Museum, London, England

Figure 1.13: Jacob A. Riis Collection, Museum of the City of New York

Figure 3.6: Leica Camera Group

Figure 4.8: Reproduction courtesy of The Minor White Archive, Princeton University, copyright © 1982 by The Trustees of Princeton University

Figure 5.9: Copyright © Henri Cartier-Bresson/ Magnum Photo Inc.

Figure 5.10: Copyright © Wynn Bullock, courtesy Wynn & Edna Bullock Trust

Figure 5.12: Copyright © Michael Kenna, courtesy Stephen Wirtz Gallery, San Francisco

Figure 5.14: Copyright © 1971, Aperture Foundation, Inc., Paul Strand Archive

Figure 5.18: Copyright © Dick Arentz

Figure 10.2: Copyright © Ernst Haas

Figure 10.3: Copyright © Joel Meyerowitz

Figure 10.6: Copyright © William Lesch

Figure 10.7: Copyright © Todd Walker

Figure 10.8: Copyright ©1955 Judith Golden

Figure 10.9: Copyright © Todd Walker

Figure 10.20: 8 x 10 Polacolor photograph, Marie Cosindas

Figure 11.12: Mural by David Tineo, Copyright © 1989 University of Arizona Press

Alan Ross is responsible for most of the technical photographs in this book, including those used to demonstrate photographic principles in figures 2.19, 3.3, 3.7, 3.14, 3.17, 4.3, 4.4, 4.6, 5.3, 8.15, 8.16 and 9.3.

Index